THE TOLEDO

ALLIANCE DESIGNS

OF FOR A

ART AND MODERN

INDUSTRY AMERICA

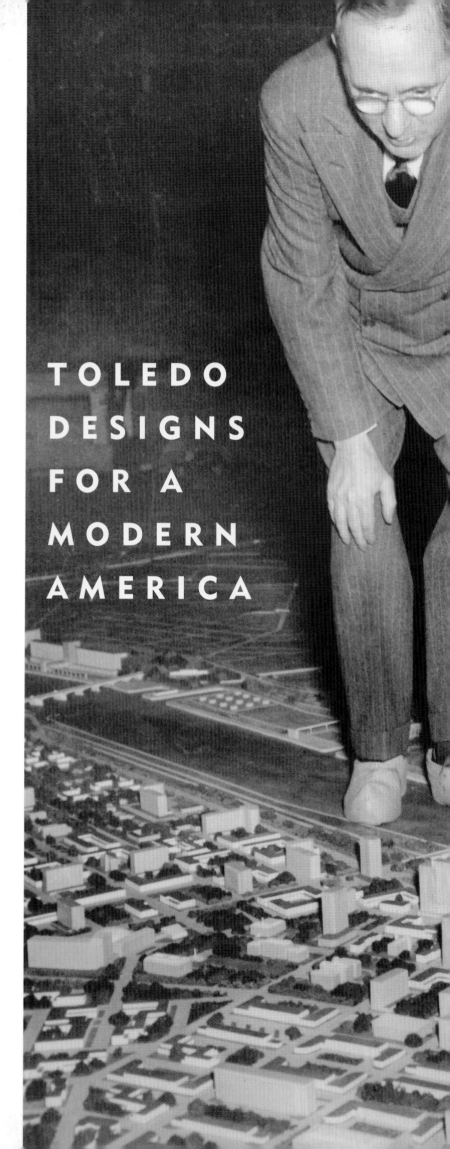

THE ALLIANCE OF ART AND INDUSTRY

TOLEDO DESIGNS FOR A MODERN AMERICA

TOLEDO MUSEUM OF ART

DISTRIBUTED BY
HUDSON HILLS PRESS
NEW YORK

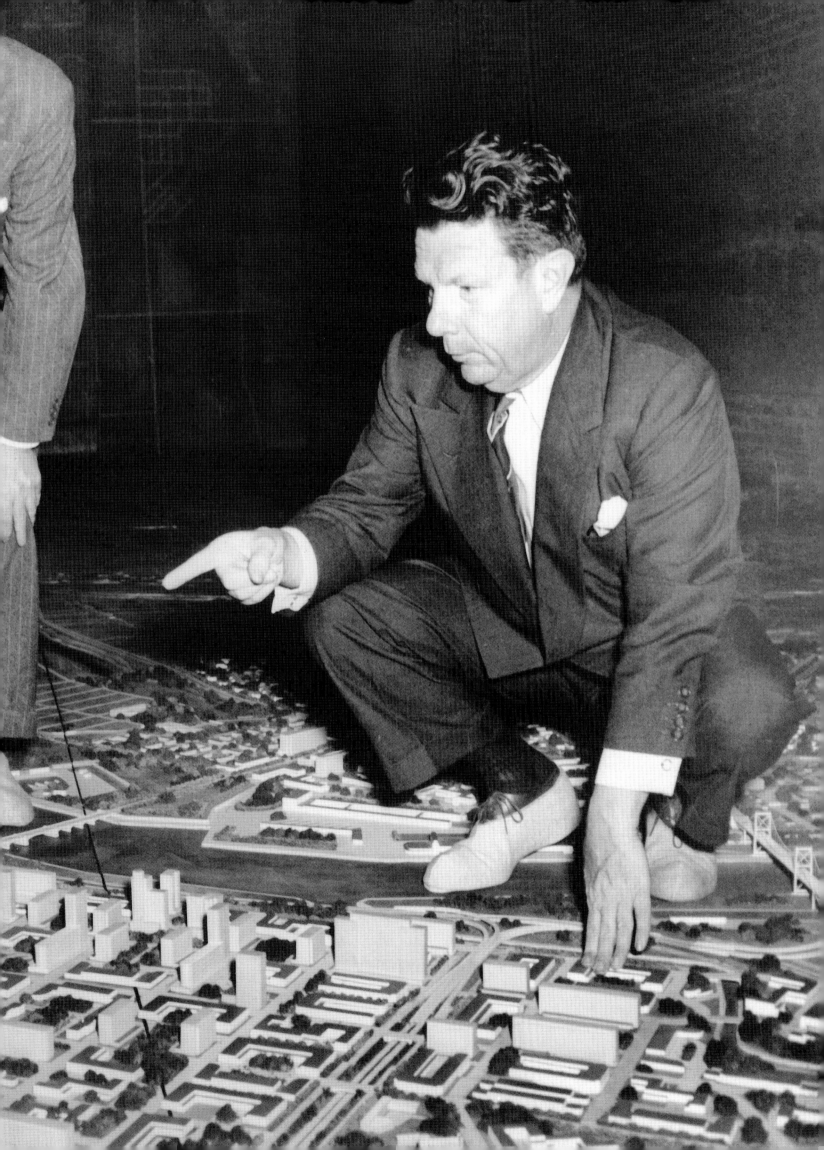

The Alliance of Art and Industry: Toledo Designs for a Modern America was published on the occasion of the exhibition of the same name, organized by the Toledo Museum of Art and on view in Toledo from March 24, 2002 through June 16, 2002; at the Ohio Arts Council's Riffe Gallery, Columbus, from August 8, 2002 through October 19, 2002; and at the San Francisco Airport Museums, San Francisco International Airport from mid-January 2003 through early July 2003. The exhibition was part of the museum's celebration of its centennial.

Exhibition Curator: Davira S. Taragin, Toledo Museum of Art
Exhibition Designer: Boym Partners Inc., New York

This exhibition and accompanying catalogue are supported in part by the National Endowment for the Humanities, expanding our understanding of the world; the National Endowment for the Arts; the Clement O. Miniger Memorial Foundation; The Stranahan Foundation; the Ohio Arts Council; and the Members of the Centennial Society of the Toledo Museum of Art. Additional support for the catalogue is provided by The Andrew W. Mellon Foundation.

Distributed by Hudson Hills Press, Inc., 1133 Broadway, Suite 1301, New York, New York 10010-8001
Editor and Publisher: Paul Anbinder

Distributed in the United States, its territories and possessions, and Canada through National Book Network.
Distributed in the United Kingdom, Eire, and Europe through Windsor Books International.

Library of Congress Cataloging-in-Publication Data
The alliance of art and industry : Toledo designs for a modern America / Dennis P. Doordan . . . [et al.].
 p. cm.
 Includes bibliographical references and index.
 ISBN 1-55595-218-6 (cloth : alk. paper)—ISBN 0-935172-15-7 (pbk.: alk. paper)
 1. Design, Industrial—Ohio—Toledo—Exhibitions. 2. Decorative arts—Ohio—Toledo—Exhibitions. 3. Toledo Museum of Art—Exhibitions. I. Doordan, Dennis P. II. Toledo Museum of Art.
T180.T65 T65 2002
745.2'09771'13—dc21 2001053391

Frontispiece: Hamilton Wright, photographer, *Norman Bel Geddes and Unidentified Man in the Toledo Tomorrow Model*, 1945, gelatin print, 8⅛ × 10 inches, The Norman Bel Geddes Collection, The Performing Arts Collection, Harry Ransom Humanities Research Center, The University of Texas at Austin, by permission of Edith Lutyens Bel Geddes, Executrix.

Coordinated and edited by Terry Ann R. Neff, t.a.neff associates, inc., Tucson, Arizona.

Designed by John Hubbard.
Proofread by Sherri Schultz.
Typeset by Jennifer Sugden.
Produced by Marquand Books, Inc., Seattle.
 www.marquand.com
Color separations by iocolor, Seattle.
Printed and bound by CS Graphics Pte., Ltd., Singapore.

CONTENTS

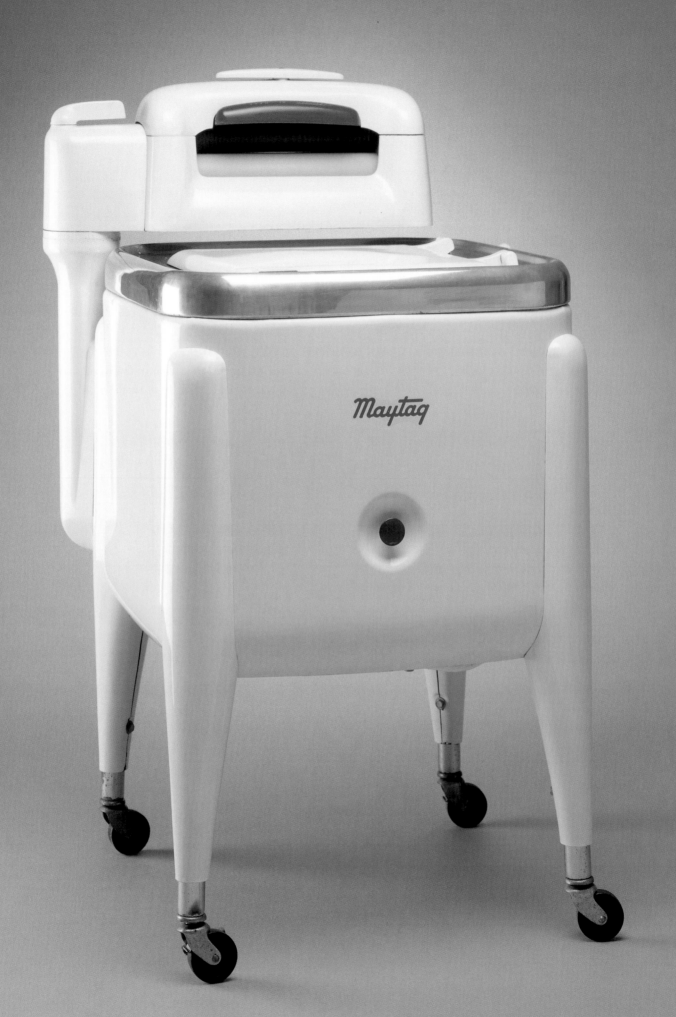

FOREWORD

The exhibition and publication *The Alliance of Art and Industry: Toledo Designs for a Modern America* are a fitting way to conclude the Toledo Museum of Art's centennial celebrations and to usher in its second century. One of the reasons Edward Drummond Libbey founded the museum in 1901 was to create an identity for the city of Toledo as a highly attractive place to live. To that end Libbey not only built a superb museum of art, but he also urged its direct involvement and interaction with the business community. This exhibition demonstrates unequivocally that the successful collaboration between the museum and many of Toledo's industries during the first half of the twentieth century not only improved the lives of the city's inhabitants, but also significantly contributed to shaping the identity and lifestyle of "every person's every day" in modern America. The show examines the reasoning and processes behind the designs of select mass-produced products created in Toledo during an era when appearance was more important to sales than marketing, and the emerging industrial design profession was dramatically altering American life through product design. This exhibition provides important insights into Toledo's pioneering role and engagement of the professional designer in shaping consumer products and mass taste in this country. In addition, it demonstrates the critical impact that mid-sized Midwestern cities such as Toledo have had as centers of manufacturing and product design during the last century.

This exhibition displays nontraditional objects for an art museum—automobiles, air compressors, washing machines. In its celebration of daily life, it underscores the museum's mission to "integrate art into the lives of people" by reawakening our consciousness about the pervasiveness of design in our lives. The city itself has played a key role in the organization of this show. Its inhabitants and the individuals who were affiliated with its industries have been primary sources of information for many of the objects included in the exhibition; they have served as a living history in unraveling the stories behind many often overlooked, but ground-breaking designs.

The initial idea and enthusiasm for *The Alliance of Art and Industry* developed from research conducted by Davira S. Taragin, the museum's curator of Modern and Contemporary Glass. She was assisted in the further development of the concept for the show by independent curator Victoria K. Matranga, who served as industrial design consultant, and a scientific committee consisting of the following scholars: Dennis Doordan, University of Notre Dame; Neil Harris,

The University of Chicago; John Heskett, Illinois Institute of Technology; Jeffrey L. Meikle, The University of Texas at Austin; Timothy Messer-Kruse, University of Toledo; William Porter, independent lecturer on automotive design and former chief designer at Buick; and Terry Ann R. Neff, who, in addition, served as publication coordinator and editor. I would like to thank all these individuals for their dedication and the spirit with which they have addressed this pioneering show's numerous and oftentimes complex issues.

It is also significant that an exhibition using Toledo as a case study to explore the larger issue of the influence of the professional designer on America's lifestyle will travel to two other venues. I would particularly like to acknowledge the foresight and assistance of Wayne Lawson, executive director of the Ohio Arts Council, and Mary Gray of the Riffe Gallery, Ohio Arts Council, Columbus, Ohio; and Blake Summers of the San Francisco Airport Museums.

The Toledo Museum of Art is indebted for the imprimatur and support it has received from the National Endowment for the Humanities, expanding our understanding of the world, and the National Endowment for the Arts. We also gratefully acknowledge the generosity of the Clement O. Miniger Memorial Foundation and The Stranahan Foundation, which have supported this exhibition as part of their ongoing recognition of the importance of documenting and preserving Toledo's past to build a better city. We would also like to thank the members of the Centennial Society of the Toledo Museum of Art for their support for this project. Additional support for the catalogue was provided by The Andrew W. Mellon Foundation.

The museum's centennial was designed to bring the museum and its public together in celebration of the past one hundred years. *The Alliance of Art and Industry: Toledo Designs for a Modern America* salutes this distinguished record of collaboration between industry and art, and welcomes its continuation into a new century.

Roger M. Berkowitz
DIRECTOR

ACKNOWLEDGMENTS

Since mass-produced design has played a major role in the definition and realization of the American social vision of democracy, the exploration of industrial design and the professional designer is particularly relevant as America enters a new century. In recognition of the fundamental role of design in American social history, noted author Arthur Pulos began his two-volume history of design with the following observation:

> Design is the indispensable leavening of the American way of life. It emerged with the need for the colonists to transform the wilderness into a secure haven and expanded as a natural component of the industrial revolution in the New World. The United States was in all likelihood the first nation to be designed—to come into being as a deliberate consequence of the actions of men who recognized a problem and resolved it with the greatest benefit to the whole. America did not just happen; it was designed. . . . History will prove that, if a humane democracy is to be this country's legacy to mankind, its unique contribution to world culture may well be the democracy of its manufactured products.[1]

More immediately relevant, within the past few years, phenomena such as the success of designer Michael Graves's housewares line for the retailer Target Stores have demonstrated a resurgence of interest in America in well-designed products for mass taste and consumption. It was within this climate that the idea for the exhibition "The Alliance of Art and Industry: Toledo Designs for a Modern America" was conceived.

Toledo was an ideal city to use as a case study of industrial design because its professionally designed products were primarily made for mass consumption throughout America. Products such as the Jeep, Libbey's Golden Foliage tumblers, the picture window, and the Toledo "honest weight" scales have become a part of everyday American culture. Moreover, a number of Toledo's products have also received recognition from the design world in the form of awards and commendations in recognized periodicals or in respected museum exhibitions shortly after they were introduced. Finally, the question of why in the early 1930s Harold Van Doren selected Toledo to establish the first professional industrial design office in the Midwest has always intrigued scholars. The challenge for the Toledo Museum of Art was to institute a study of the interaction of select Toledo manufacturers,

designers, merchandisers, and the consumer to learn more about the alliance of art and industry that led to the development of a body of diverse products that significantly shaped American middle-class taste and lifestyle during the first half of the twentieth century. *The Alliance of Art and Industry* establishes the initial phase of this research; future generations will uncover additional designs and information.

Research for the show began with identification of those designs that had received recognition in the design world. In turn, this helped to identify those companies that, realizing the increasing importance of well-designed products to sales, had made a long-term commitment to design, resulting in its transformation from a trade activity to a strategic profession. It also unveiled previously undocumented information about the first-generation industrial design professionals who were employed by Toledo firms and used their consultancies to help define the new profession. An examination of their work in Toledo demonstrates that local industries offered them challenges that helped the profession to evolve from the shaping of objects to strategic planning. The city also witnessed the changes in the workplace that resulted from expanding globalization and better communications in the post–World War II period, with design evolving from a local and regional practice into an international concern.

Because much of this story has until now remained undocumented, the organizers of this show relied upon countless individuals with a variety of backgrounds to reconstruct it, thereby in the very process reinforcing the democratization of design: design historians and archivists, the families of the designers, the factory workers who took pride in their companies, and even repairmen who helped identify the designs as they were located and adjusted the machinery to function within the exhibition. Company officials frequently took time from their busy schedules to research queries. Although it is not possible to list all of those who have participated in the research for this show, I would like to express my deepest gratitude to each and every one of them for their invaluable contribution. I would also like to thank the lenders to the show, many of whom have parted with objects that they use on a daily basis. Particular thanks go to John Wilkerson for lending his Owens-Illinois glass blocks to the exhibition in Toledo.

The organization of an exhibition of this scope also requires the active participation of numerous scholars and museum professionals. My special thanks go to Victoria K. Matranga, industrial design consultant, and all the members of the scientific committee who so

willingly assisted me during every phase of the conceptualization of the show. Ms. Matranga deserves special commendation for her excellent research for the exhibition, some of which is included in the captions and biographies that she prepared. Much of the success of this show is due to Terry Ann R. Neff, whose personal and professional support throughout the project is valued immensely. Tim Thayer is responsible for the beautiful photographs of the works in the exhibition. Clifford Craine, Daedalus, Inc., and Elizabeth I. Coombs are to be acknowledged for their creativity in conserving objects that do not normally fall within their realm. Carol Forsythe and Barbara Heller at The Detroit Institute of Arts should also be thanked for their assistance with conservation. Constantin Boym should be commended for developing an installation design that makes the exhibition a pleasurable as well as an educational experience. Keith Wilkowski's efforts in finalizing the tour are particularly appreciated. I am grateful to Ed Marquand and his staff, especially John Hubbard, for the brilliant book design. Finally, I want to thank Paul Anbinder, president of Hudson Hills Press, for his commitment to this publication even though its subject falls outside his usual purview.

My efforts in preparing this book and organizing the accompanying exhibition have been met with continual support and guidance from Director Roger M. Berkowitz. I also want to thank Director Emeritus David W. Steadman, who early on saw the validity of such a study and encouraged me to begin this research. I would also like to express appreciation to Robert Phillips, curator of Modern and Contemporary Painting and Sculpture, for the advice and assistance he has provided during the entire project. Michael Dorn is to be commended for his superb assistance in the administration and coordination of the exhibition. Special gratitude is also due to the museum's library staff, headed by Anne Morris; the registrarial staff, Patricia Whitesides and Karen Serota; and former staff members Deborah Miller, Amy Duvendack, and Gina Lemmons. Other members of the staff who provided invaluable assistance include Todd Ahrens, Jeff Boyer, Kathy Gee, Julie Gibson, Sandra E. Knudsen, Tom Loeffler, Tim Motz, Kim Oberhaus, Barbara Stahl, and Holly Taylor.

Many of the designers whose work is in this exhibition were strongly motivated by a desire to create a utopian world. In retrospect, we can see that the alliance of art and industry that existed in Toledo, Ohio, during the first half of the twentieth century brought them one step closer to realizing this dream for all Americans.

Davira S. Taragin
DIRECTOR, Center for Glass
CURATOR, Modern and Contemporary Glass

1. The author wishes to thank Dennis Doordan for identifying this as one of the themes of the exhibition, and bringing this quotation to her attention. See Arthur Pulos, *American Design Ethic, A History of Industrial Design to 1940* (Cambridge, Massachusetts: The MIT Press, 1983), preface page.

Julie A. McMaster and Davira S. Taragin

PIONEERING THE ALLIANCE OF ART AND INDUSTRY
THE TOLEDO MUSEUM OF ART

In 1888 Edward Drummond Libbey chose Toledo as the new location of his New England glass factory, not only because of the natural gas and high silica content of the rock from area quarries, but also because the town had amenities that promised a good lifestyle. Influenced by the Chicago Arts and Crafts reformer Frank W. Gunsaulus, Libbey felt strongly that industry had to do more for the community than merely provide jobs for workers.[1] In the spirit of his conviction, he established the Toledo Museum of Art in 1901. Twenty-one years later, in an address at the Sorbonne in Paris, Libbey stated that his philosophy concerning the purpose of an American museum was "to bring to our citizens the understanding of the principles and the benefits of art in their lives and in their work. To this end our museums of art have within the past few years become active educational institutions, as well as safe and necessary repositories of art."[2] From this early, broad definition of the museum, Libbey and the museum staff developed over the ensuing years a practical application of integrating art into life. The Toledo Museum's philosophy and practice ultimately contributed to America's nationwide interest in well-designed industrial objects during the first part of the twentieth century.

The potential for interaction between the Toledo Museum and local industries was evident as early as 1911 when Robert M. Corl, a staff designer[3] at Libbey Glass Works, wrote an article for the *Toledo Times* encouraging workers to avail themselves of the museum's resources:

> To anyone working in industrial art, especially in the field of design, a museum is a necessity, and to not take advantage of the large library and the well-arranged collections is a very grave mistake for anyone who wishes to thoroughly understand his work, as it contains a record of the best which had been done in the past, and this is an absolute necessity for the production of good work in the future. . . .

There are industries in Toledo which do not require the entire time of a designer, yet are forced to compete with large manufacturers, who do have the advantage of trained workers in this line, and those who have been forced to meet the competition of such large firms have felt their lack of knowledge of the artistic side of their products and realize what a tremendous bearing good design has on the sale of an article.

Anyone working in the lines of furniture, glass, jewelry, printing, engraving, or in fact almost every business, can get in touch with new and practical ideas in his line of work—ideas which he can use every day in his business—ideas which can be turned into cash. . . .

The museum holds unlimited ideas for the milliner, the window trimmer, the dressmaker, the arts and crafts worker, the china decorator, the decorator, and in fact everyone who uses the laws of applied art. . . .

In this industrial age success means knowledge, and anyone needing help along the lines of applied art will find material at the Toledo Museum, of which they should not fail to take advantage.[4]

Although Corl's words indicate support and appreciation for what the museum had to offer, Libbey and the first prominent director of the museum, George W. Stevens, were interested in a more aggressive educational program for the institution, one that would lead to "art entering into every human activity, into the making of our homes and the building of our cities—into every product of the manufacturer, and into every detail of merchandising."[5] In 1918 Stevens wrote, "America, to compete in the world's markets, must have designers for her wares if they are to find favor in the eyes of the world."[6] Advocating this strong alliance between the museum and local industry as early as 1913,

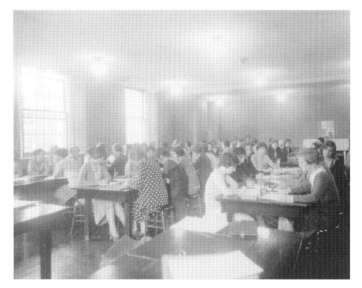

Stevens urged the trustees to expand the museum's educational classes
to teach art to artisans and manufacturers, hoping that they would apply
art-historical styles to fashion, home furnishings, and city planning.[7]

Stevens wanted a staff that would support these sentiments. In
1916 Blake-More Godwin was hired as curator and Stevens's assistant,
succeeding him as director following Stevens's death in 1926. Like
Stevens, Godwin believed museums could be of service to industries.
In a 1938 report supporting the establishment of a new department of
design at New York's Museum of Modern Art, Godwin noted that the
effectiveness of museums lay more in their impact on manufactured
products than in the acquisition and preservation of works of art.[8] He
was later to write, "Good design is important in clothing, in a home,
in an automobile, in a public building, in a factory, or in a city plan. Appreciation for color, form, and line in manufactured products, in containers and packages is important to obtain customer satisfaction.
These things which contribute to good living may be enhanced by the
influence of the person who is trained in sound principles of good design."[9] Stevens and Godwin were so evangelistic in their approach that
museum trustees such as John North Willys of the Willys-Overland
Company, Alfred B. Koch of the department store LaSalle & Koch,
Thomas A. DeVilbiss of The DeVilbiss Company, Hubert D. Bennett
of the Toledo Scale Company, and Joseph W. Robinson and William
Levis from the Owens-Illinois Glass Company were comfortable in implementing in their own companies programs that valued sound design.

By 1915 the active implementation of this alliance between Toledo's
art community and its industries had begun. First, in order to encourage interaction between the museum and the labor force in Toledo,
Libbey prompted the trustees to create a new class of membership to
benefit the workmen and craftsmen, in hopes that it would spark their
interest in the museum and enlist their financial assistance.[10] Then,
three years later, the Toledo Museum of Art and the Toledo Board of
Education jointly created a School of Design. Its purpose was not only
to cultivate those students who had exceptional talent in art, but also
to bring art into the life of the average person.[11]

The first School of Design classes were based on a combination
of educators and art theorists Denman Ross' and Arthur Pope's systems of design theory. Ross' philosophy of uniting harmony, rhythm,
and balance to create an ordered composition was combined with Pope's
elaboration on a Ross concept, advocating the sequential repetition of a
form with only minor modification. As a result the primary philosophy
of design behind the museum's classes promoted a union of repetitive
elements, sequence, and balance to create a unified composition.

Initially the courses offered included the theory of design, toy
making, needlework, dress design (plate 1), weaving, lettering, batik,
and printmaking. Over the next few years, additional classes were
added, such as interior decoration, interpretive drawing, advanced
design, nature study, watercolor painting, theory of color, landscape
drawing, clothing appreciation, fashion drawing, poster design, and
painting. A broad range of Toledo's populace took advantage of these
classes, including decorators, florists, window trimmers, buyers,
librarians, dressmakers, commercial artists, printers, photographers,
landscape artists, sign writers, jewelers, contractors, teachers, architects, heads of Toledo industries, and homemakers.[12]

Engineers, decorators, and craftsmen attended the museum's general classes on the theory of design as early as 1920. Evening classes
for adults were fundamentally the same as those given to children during the day. By 1924 art schools in cities such as Cleveland, New York,
Chicago, Boston, and Pittsburgh began recognizing the Toledo Museum's School of Design by admitting its graduates to their advanced
art and design programs.

A major development in the program occurred in 1927 when, at
the request of the department stores Lamson Brothers Company and
LaSalle & Koch Company, a series of classes was instituted to train
department store buyers, managers, and salespeople to take a new
approach to merchandising by creating coordinated ensembles of
related clothing and furnishings (plate 2). The classes were adapted
to fit the specialized needs of the store. Color, line, form, and arrangement were taught in the classrooms and illustrated by works of art in

Plate 2
Toledo Museum School of Design Exhibition, May 1929
photo panel

This spare, tasteful display exhibited the garments designed and
sewn by students with the coordinated accessories completing the
ensemble. In addition to proportion, line, and color, students were
taught to consider the combinations of clothing suitable for the
businesswoman, homemaker, and student according to various
personal budgets.

the museum's collection; these sessions were immediately followed by
instruction at the store, where the particular problems of salespeople
in fulfilling consumer needs were addressed. These courses were
greatly in demand, in some years requiring the school to offer multiple
sessions to accommodate the student load.

Following the success of the department store classes, the School
of Design began specialized courses in industrial design in spring 1928
at the request of individual companies. These courses marked the shift
from an industrial art approach that advocated the use of the museum's
collections as inspiration to the emergence of a true machine aesthetic.
The first class was held for seven employees of the Owens Bottle
Company.[13] It was given by Idene McAleese (later Ayers), who was
one of three professional art instructors hired in 1925 to teach design
courses.[14] Ayers was a strong proponent of the philosophy of dynamic
symmetry popularized by the early twentieth-century American edu-
cator Jay Hambidge, which was a method of proportioning space and
establishing the relationship of areas in a composition. This method
established a system for design that utilized mathematical proportions
in form by uniting curves of nature with rectilinear elements. Contem-
porary newspaper accounts viewed Ayers's approach as part of the
new, nationally emerging philosophy toward industrial design: to strip
the ornamentation of the past from the products of the present and to
allow the function of the product to command its design.[15] The stu-
dents designed a series of bottles from one- to sixteen-ounce capacities
to fill both existing and speculative orders that could be produced on
the Owens Bottle Machine (plate 3). When this firm acquired Illinois
Glass leading to the formation of Owens-Illinois Glass Company in
1929, the latter continued for several years to rely on the design ser-
vices of the museum for their products (plates 4–7). Several of the bot-
tles that were designed through this collaborative effort were selected
by The Museum of Modern Art for their critical 1934 "Machine Art"
exhibition and subsequently were acquired by this museum (plate 8).

Other companies such as DeVilbiss (plate 9) and several local
printing firms soon took advantage of the school's new educational
offerings. For example, employees from the Libbey Glass Company
developed several designs for inexpensive tableware, including the long-
lasting Governor Clinton line and glassware that the Dayton Art Insti-
tute subsequently selected for use in its lunchroom.[16] Similarly, the
Toledo Scale Company requested a specialized industrial design course
for its employees in 1933. While these offerings continued well into the
1930s, they were augmented by a series of more generalized industrial
design courses that brought together employees from various companies.

An important part of the program was the student exhibitions
held annually in the museum galleries. These were complemented by
frequent survey shows that featured either local or national develop-
ments in architecture and design. For example, in the early 1930s, ex-
hibitions of recent Toledo architecture and the cutting-edge work of
Toledo industrial designers Harold Van Doren and John Gordon Ride-
out were held in close proximity to exhibitions exploring design piracy
in manufacturing and the recent work of members of the American
Union of Decorative Arts and Craftsmen (AUDAC), an organization
formed several years earlier to protect designers from such practices.
Similarly, an exhibition of Toledo's industrial designers in 1949 that
included designs by J. M. Little and Associates for Toledo Scale and
glassware by Freda Diamond for Libbey Glass followed the presen-
tation of the first major traveling exhibition of the newly founded
national Society of Industrial Designers (SID). Because Libbey Glass
played such a prominent role in the establishment of the museum, its
products were frequently the subject of exhibitions during this period.

By 1942, when industrial design classes were terminated because
of wartime obligations, Toledo's program had gained considerable

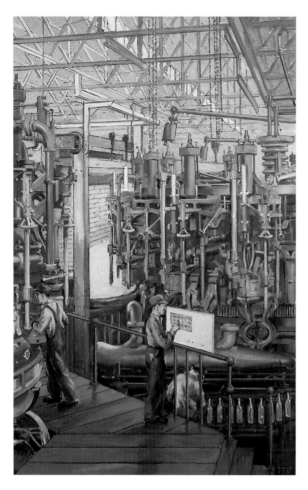

In the first decades of the twentieth century, American corporations commissioned artists to produce paintings that recorded and celebrated achievements and were used in promotion. This painting depicts skilled workers operating the fifteen-armed Owens automatic bottle-making machine, which by 1920 was the company's high production model.

90,023. BOTTLE. EDWIN W. FUERST, Toledo, Ohio, assignor to Owens-Illinois Glass Company, Toledo, Ohio, a Corporation of Ohio. Filed Oct. 31, 1932. Serial No. 45,667. Term of patent 14 years.

The ornamental design for a bottle substantially as shown.

The fluid form of this Classic line of pharmaceutical and proprietary bottles, accented by the simple triple ridge, provided a large flat surface for a label and a wide front plane that allowed for maximum display on a retail shelf.

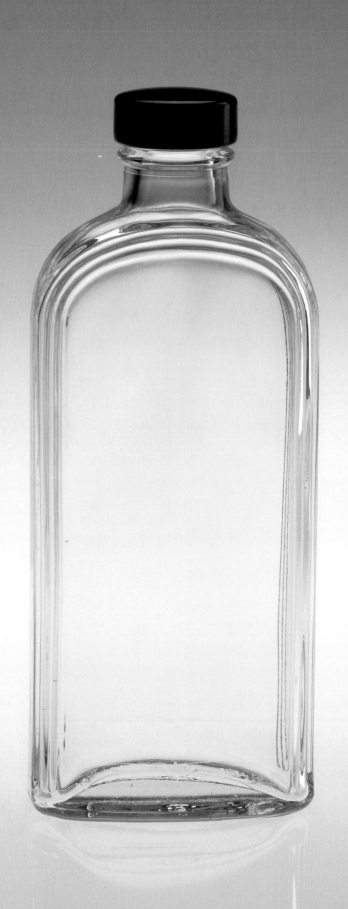

Plate 6
Toledo Museum School of Design Exhibition, May 1929: Examples of Works Designed by Industrial Design Students from Owens Bottle Company and The Libbey Glass Manufacturing Company
photo panel

The unusual industrial arts vocational training begun in 1918 by the Toledo Museum of Art educated selected staff in design for local employers. These workers brought actual shop problems into class to solve as they developed products for manufacture on their machinery. Students applied principles of dynamic symmetry and proportion in their designs. Their work was sometimes featured in special exhibitions organized by the School of Design.

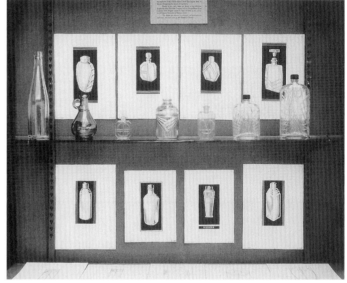

Plate 7
Toledo Museum School of Design Exhibition, 1930, Owens-Illinois Glass Company, Designed by Edwin W. Fuerst
photo panel

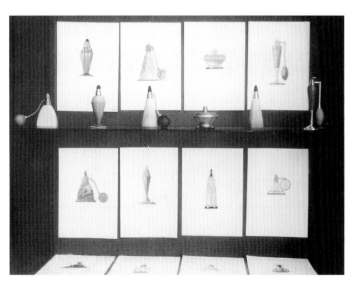

Plate 9
Toledo Museum School of Design Exhibition: DeVilbiss Atomizer Designs, 1929–30
photo panel

Designed for The DeVilbiss Company, these elegant Art Deco perfumizers aimed to bring upper-class refinement to middle-class dressing tables. As DeVilbiss employees, industrial art students would have understood the practical limitations of the bottle shapes, appropriate materials, and the mechanics of the atomizer bulbs.

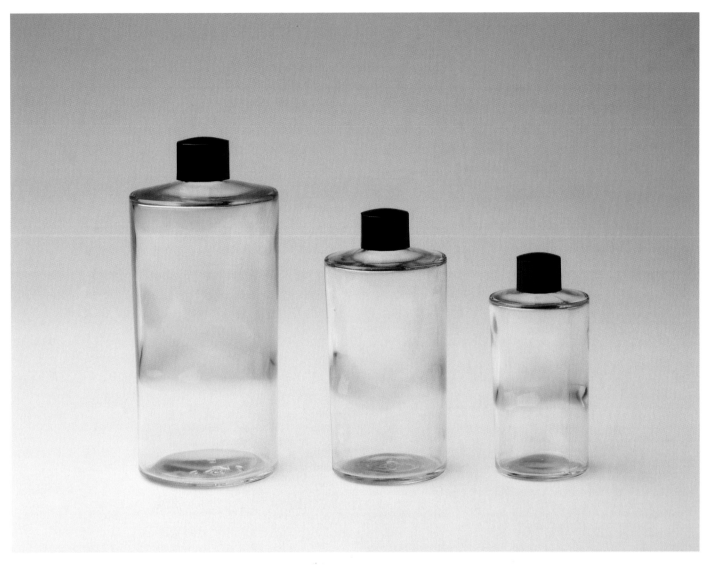

Plate 8
Edwin W. Fuerst and Toledo Museum School of Design
Owens-Illinois Glass Company

Taper Round Bottles, ca. 1932
glass and plastic
6½ × dia. 3¼ inches; 5¼ × dia. 2⅜ inches;
4¼ × dia. 2 inches

Cream Jar with Metal Closure, ca. 1932
glass and metal
4⅜ × dia. 3⅜ inches

The Museum of Modern Art, New York, Gift of the manufacturer, 246.34.1–3 and 247.34.sc

In March 1934, New York's Museum of Modern Art opened its landmark "Machine Art" exhibition, which embraced the beauty of functional, machine-made, everyday objects. Ordinary products grouped into six categories celebrated geometric forms devoid of surface ornamentation and made of straightforward materials. Retail prices and stores were listed alongside the names of the products, manufacturers, and designers. These Owens-Illinois taper round bottles and utilitarian cream jars were featured in the house furnishings and accessories division. Because they were made for cosmetics or food processing companies, not private consumers, no retail prices were listed.

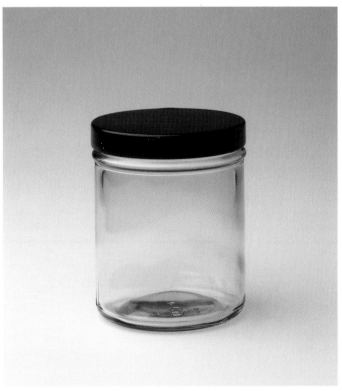

recognition. Using the School of Design as a model, the Philadelphia Museum of Art received an endowment fund of $150,000 to hire an art consultant who would do for Philadelphia industries what the museum had been doing for those in Toledo.[17] Moreover, several Toledo students held highly respected positions in the design world. The most notable was Donald Dailey, who was first employed by Harold Van Doren & Associates and went on to create in his own practice such notable designs as the Duracell CopperTop battery. Other students who were part of Van Doren's design office included Ralph Knoblaugh and Edna Remmert Johnson, the latter a member of the design team for the 1938 Toledo Guardian Duplex scale. Robert Vuillemenot,[18] who was a student at the School of Design from 1925 to 1934, went

on to become the executive vice president of the industrial design firm Donald Deskey Associates in the New York office; while Edwin W. Fuerst, who was at the school from 1927 to 1932, gained renown through his Modern American line for Owens-Illinois's Libbey Glass. Other students made significant contributions to local industries, including the Willys-Overland Company, Toledo Porcelain Enamel Products Company, and LaSalle & Koch's display department.

Prior to the war the museum's alliance with industry largely impacted local companies and their nationally distributed consumer products. With the end of the war, the museum became more internationally focused in its collecting and programs under the guidance of Associate Director Otto Wittmann, who became director in 1959.

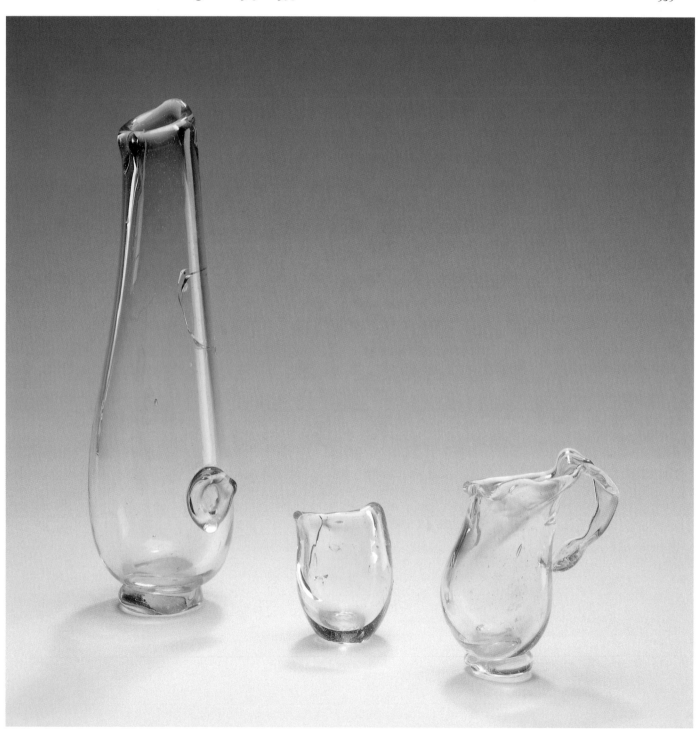

By 1962, with the first of two workshops on the museum's grounds for artists experimenting with glassblowing in a nonindustrial environment, the alliance between local industry and the museum had dramatic international implications, revolutionizing the glass industry as well as inspiring a major new international art movement.[19] The workshop was the brainchild of ceramist Harvey K. Littleton (plate 10), then a member of the University of Wisconsin faculty. As a result of research conducted primarily in the 1950s, Littleton realized that the ideal way to move from the centuries-old relationship between designer and artisan in the glass industry was to conduct a workshop. Although workshops were a common occurrence in the craft world, the site for this particular one was critical in order for artists to be able to draw on the expertise of the glass industry in "building the kiln, making glass from the raw materials of silica sand, soda, lime and lead and blowing and molding the molten 'gather.'"[20] Littleton probably also realized the advantages of having great examples of glass nearby. Turned down by The Corning Museum of Glass, Littleton considered Toledo as a viable alternative location to conduct this research because of the long-term connection between the city's glass industries and the museum and its highly supportive director, Wittmann.[21]

Littleton's assessment of Toledo's potential was accurate—the success of the first workshop was due largely to the museum's relationship with local industry. Libbey Glass provided blowpipes, while one of its retired glassblowers, Harvey Leafgreen, was responsible for demonstrating their usage to the participants who were ceramists or had modest experience with glass technology.[22] Tours of the Libbey glass factory as well as a local custom lightbulb manufacturing shop

were arranged. However, most significant to the workshop's outcome was the key technological assistance provided by inventor, scientist, and then emerging artist Dominick Labino, who was vice president and director of research at nearby Johns-Manville Fiber Glass Corporation. Persuaded by Wittmann to join the workshop on the third day when the artists were experiencing difficulty melting the glass batch in their newly constructed furnace, Labino not only suggested important modifications to the furnace's design, but had Johns-Manville provide two hundred pounds of the #475 glass marbles that it used for making fiberglass in order to develop batch that had a suitable consistency for blowing but could be melted at lower temperatures.

While this and later workshops (plate 11) did not attract many of the city's glass workers,[23] the impact of this ten-day alliance of art and industry in advancing glass design remains unparalleled. For Littleton, it was "not simply a matter of bringing the designer and artisan together in scaled down industrial procedures . . ." but of allowing the artist "to create beautiful objects which would be completely unsuitable as uniform, mass-produced articles of industry."[24] With this collaboration of artist and glass manufacturer, another innovative new product in the venerable history of glass had been created in a city that

Plate 11
Toledo Museum of Art Studio Glass Workshop, June 1962: Elaine Lukasik Adding a Ladle to a Piece
photo panel

Plate 10
Harvey K. Littleton, *Vase*, 1962
glass
8 × dia. 2 inches
Harvey K. Littleton

Edith Franklin

Vessel Made at the Toledo Museum of Art Studio Glass Workshop, March/April 1962
glass
1¾ × 1⁷⁄₁₆ × 1½ inches

Pitcher Made at the Toledo Museum of Art Studio Glass Workshop, March/April 1962
glass
3¼ × 1¼ × 1⅜ inches

Edith Franklin

The artists at Toledo's first studio glass workshop learned the perils of improper annealing: without tempering, the glass shattered as it cooled too quickly. Participating artist Edith Franklin recalled that few pieces survived those early experiments. Harvey K. Littleton blew this vase, which was accidentally touched by a cold glassblowing rod, resulting in a check, or crack, that was not removed because the annealing process had not yet been perfected.

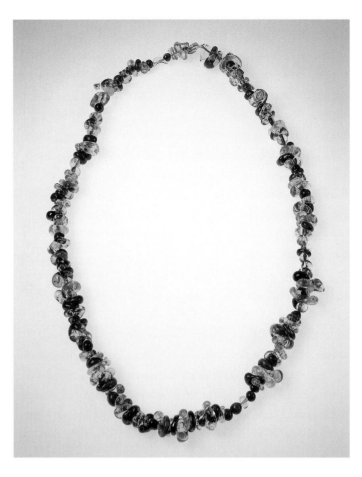

Plate 12
Clayton Bailey, *Necklace Made at the Toledo Museum of Art Studio Glass Workshop*, June 1962
glass
12⁵⁄₁₆ inches long
Betty Bailey

Experimenting with three lampworking techniques to make this necklace, Clayton Bailey formed some of the beads by wrapping glass threads around a graphite rod; others by melting drops of glass around a copper wire, then dissolving the metal out of the glass to retain holes for threading; and flat beads by squeezing melted glass into a mold. The swirling colors and iridescence resulted from the incomplete mixing and reduction of copper oxides in the smoky flame of a kerosene burner that Dominick Labino loaned the artists to use in this workshop.

Plate 13
Dominick Labino, *Vitrana*, 1969
glass
88¾ × 104 inches
Toledo Museum of Art, Gift of Mr. and Mrs. Dominick Labino

Industrial inventor, engineer, and artist Dominick Labino, who founded the Studio Glass Movement with artist Harvey K. Littleton on the grounds of the Toledo Museum of Art in 1962, perfected his own sculptural glass statements in the 1960s and 1970s. His *Vitrana* glass mural for the entryway to the museum's Art in Glass Gallery was the culmination of a long association with the museum and its director, Otto Wittmann, and symbolizes the museum's commitment to a partnership of art and industry.

had already developed several new forms and uses for the medium (plate 12). Eight years later the museum acknowledged this highly significant union when it opened the Art in Glass Gallery, devoted to glass. Wittmann, who "wanted . . . a creative modern doorway to show what glass really is,"[25] collaborated with Labino on the commission of *Vitrana*, a monumental, multipaneled cast glass composition for the gallery's entrance (plate 13).

During the first half of the century, the museum exerted a leadership role in providing practical instruction for its local and regional commercial audiences. In the postwar period, as city businesses expanded and became more nationally and internationally oriented, Toledo's companies began to look toward other European and American cities. The need for such design programs in Toledo was no longer necessary.[26] The museum responded by increasingly modifying its direction to attract national and international culture to Toledo. Its legacy of fostering an alliance between art and industry, however, will live on in the products it helped shape for a modern America.

1. Blake-More Godwin, untitled essay commemorating the centenary anniversary of Edward Drummond Libbey's birth, July 8, 1954, Toledo Museum of Art Archives.

2. Edward Drummond Libbey, "An Address at the Sorbonne, Paris, France, On the Occasion of the First Congres d'Histoire de l'Art," September 26, 1921, p. 19.

3. The term "designer" has evolved from describing an artisan who appropriated historical forms as ornamentation on machine-made objects to characterizing a professional seeking an aesthetic that responds to methods of manufacturing.

4. Robert M. Corl, *Toledo Times*, February 17, 1911.

5. Nina Spalding Stevens, *A Man and a Dream: The Book of George W. Stevens* (Hollywood, California: Hollycrofters, 1941), pp. 194–95.

6. George W. Stevens, Report of the Director (Toledo: Toledo Museum of Art, 1918), p. 3.

7. Nina Spalding Stevens (note 5), p. 186.

8. Monroe Wheeler, "A Report Covering a Proposed Industrial Art Project of The Museum of Modern Art," June 1938, Ryerson and Burnham Libraries, The Art Institute of Chicago, p. 77.

9. Blake-More Godwin, *Watercolors by Joseph W. Jicha, A Description of Commercial and Fine Art Paintings* (Toledo: Libbey-Owens-Ford Glass Company, 1949), p. 6.

10. Edward Drummond Libbey, "Report of the President," *Museum News* (Toledo) 25 (February 1915).

11. Molly Ohl Godwin, *The Museum Educates* (Toledo: Museum of Art, December 1936), pp. 2–4.

12. George W. Stevens, Report of the Director (Toledo: Toledo Museum of Art, 1924), p. 5.

13. It is not clear whether the employees sent to these classes were designers or engineers.

14. Ayers was hired in 1925 and trained at the New York School of Fine and Applied Arts. She also worked as an art instructor at the Highland Manor Boarding School, Tarrytown, New York. See "Come to Augment Staff of Museum School of Design," *Toledo Times*, October 4, 1925.

15. "Art Now Takes Place in Industry, Toledo Firms Find Attractive Design Pays Big," *Toledo Times*, January 25, 1931.

16. Blake-More Godwin, Report of the Director (Toledo: Toledo Museum of Art, 1929), p. 9.

17. Ibid.

18. Robert Vuillemenot was the son of Frederic Vuillemenot, who was first hired as a designer for Libbey Glass in 1915. Seven years later Frederic Vuillemenot accepted the position as head designer of the atomizer division of The DeVilbiss Manufacturing Company. He continued in that position until the Depression, when he worked part-time for both DeVilbiss and Libbey from 1932 to 1934, resuming full-time work for DeVilbiss in 1934.

19. The discussion of the birth of the Studio Glass Movement at the Toledo Museum of Art is based upon the following interviews: McMaster in conversation with Otto Wittmann, January 1999; Taragin in conversation with Harvey K. Littleton, October 1998; Taragin in conversation with Norman Schulman, October 1998; McMaster and Taragin in conversation with Edith Franklin and Tom McGlauchlin, October 1999; Taragin in conversation with Otto Wittmann, November 1999; Taragin in conversation with Clayton Bailey, February 2000. See also Susanne K. Frantz, *Contemporary Glass* (Corning, New York: The Corning Museum of Glass, 1989), pp. 50–53.

20. Louise Bruner, "Could the Glass Capital Become Glass Arts Center," *Toledo Blade*, April 22, 1962.

21. Littleton had developed a close relationship with Wittmann when he served as instructor of ceramics at the Toledo Museum's School of Design from 1949 to 1951.

22. Among the artists at the first workshop were designer-craftsmen Michael and Frances Higgins, who were involved in pioneering work in their studio, heat-shaping sheet glass to form a range of wares with enamel decoration.

23. Two other workshops followed, the second on June 18–30, 1962, at the museum and the third at Labino's studio in Grand Rapids, Ohio, November 14–19, 1966.

24. Bruner (note 20).

25. Taragin in conversation with Otto Wittmann, November 1999.

26. Taragin in conversation with James Fulton, May 2000.

DeVilbiss

Timothy Messer-Kruse

OUT OF THE BONDAGE OF THE COMMONPLACE
THE CONSTRUCTION OF A CULTURE OF
INDUSTRIAL DESIGN IN TOLEDO, OHIO

No city is great unless it rests the eye, feeds the
intellect and leads its people out of the bondage
of the commonplace.

—George W. Stevens, from his poem read at
the dedication of the Toledo Museum of Art[1]

From the beginning of the mass production of consumer goods in
the nineteenth century until the 1930s, most American manufacturers
gave little attention to artistic design. They prided themselves on the
quality of their products ("Ivory Soap $99^{44}/_{100}\%$ Pure!"), their efficiency
and durability ("The Packard gets you there and gets you back"), and
their ability to steadily push more widgets out their shipping room
door. The appearance of mass-produced objects was usually an after-
thought. This state of affairs was epitomized by America's large auto-
makers, who distinguished their products not by their styling, but by
their features, size, horsepower, and price. America was a land divided
between decorative luxury goods and functional mass-produced ones.
When Secretary of Commerce Herbert Hoover was invited by the
French government to exhibit examples of good American design at
a Paris exposition in 1925, he declined, saying that America did not
have any. In America, art and industry were largely strangers.[2]

This situation changed in the 1920s as a number of American
artists and architects became enthralled by Europe's success in inte-
grating art and industry, by both mass producing fine objects and
reshaping ordinary objects in new forms. A circle of men whose careers
had carried them through the worlds of both art and commerce sensed
the possibilities for improvement in the design of the objects gushing
forth from American factories. They formed an association dedicated
to raising the aesthetic quality of everyday objects and organized a
landmark exhibition of pioneering design. Reflecting the lack of inter-
est of American manufacturers in the topic, the majority of the show
was made up of architecture, business interiors, and fine crafts, with
the smallest section comprising mass-produced industrial objects. And
though most of the show celebrated the works of designers and manu-
facturers from the Mecca and Medina of American industry, New York
and Chicago, the industrial design section was overrepresented by a
small city: Toledo, Ohio. Prominently featured were Toledo scales, To-
ledo glass, and metal hinges turned out by Toledo's Dura Corporation.[3]

At the time of this show, there were only a half-dozen industrial
design firms in the nation, and these scratched and hustled to keep
their staffs at work. Many firms were interested in obtaining help
in decorating their products, especially their packaging, but few were
willing to incur the costs of retooling to allow their products to be re-
designed from the inside out, as a new generation of industrial design-
ers insisted on doing (see Heskett, "The Emergence of the Industrial
Design Profession"). It was not until the 1930s, when American busi-
ness was deep into the economic quagmire of the Depression, that
American industry turned to designers in the hope that stylish prod-
ucts could revive their sagging sales.

While corporate America still waited to be sold on the idea of
hiring expensive consultants to redesign their products, corporate
Toledo employed an impressive roster of pioneer designers.[4] In 1924
The DeVilbiss Manufacturing Company hired Frederic Vuillemenot,
a graduate of the prestigious Ecole des Arts Décoratifs in Paris, as
chief designer (plates 1 and 2). Toledo Scale was one of Norman Bel
Geddes's first major clients. The Libbey-Owens Sheet Glass Company
had designs by Walter Dorwin Teague in 1928 (plates 3 and 4). In
1933 Donald Deskey was involved with The Libbey Glass Manufac-
turing Company (plate 5). The man who literally wrote the book on
industrial design, Harold Van Doren, set up his first design studio in
Toledo, attracting a number of talented young designers to the city.
By the 1930s Toledo firms were hiring high-priced artists to design
not only their fashionable goods, stemware, and perfume bottles, but
also their tools and hardware. Toledo's manufacturers did not invent

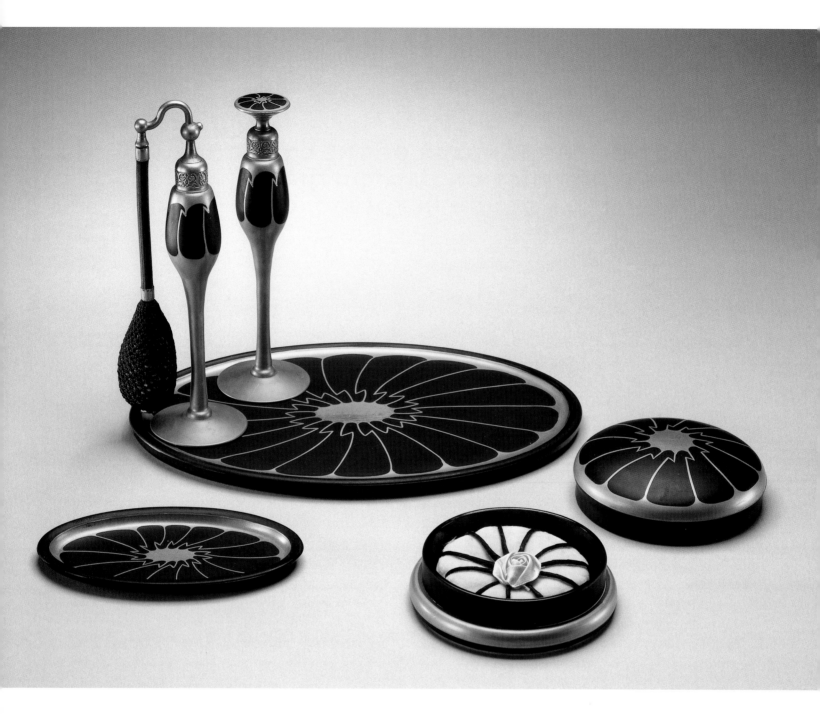

Plate 1
Frederic Vuillemenot and The DeVilbiss Company design staff
The DeVilbiss Company

Atomizer, Dropper, Tray, and Powder Box with Puff, 1927
glass, enamel, gold luster, and rubber bulb with textile
atomizer: 7¾ × 3 × 2⅛ inches; dropper: 7⅛ × dia. 2¼ inches;
tray: ¼ × 10¾ × 7¼ inches; powder box: 2⅛ × dia. 4 inches
Harvey K. Littleton

Pin Tray, 1927
glass, enamel, and gold luster
¼ × 5⅝ × 3³⁄₁₆ inches
James Fuller

In 1924 Thomas DeVilbiss hired a graduate of the Paris Ecole des Arts Décoratifs, Frederic Vuillemenot, to lead the company's decorating department. In 1925 the two men attended the Paris Exposition Internationale des Arts Décoratifs et Industriels Modernes, from which the Art Deco style took its name. Subsequently they developed an extensive line of elegant, ornamented perfumizers that provided an inexpensive alternative to their European counterparts. Under Vuillemenot's direction, innovative designs included geometric, complex, and sinuous shapes, as in this elegant dressing table set.

Plate 2
Frederic Vuillemenot and The DeVilbiss Company design staff,
DeVilbiss Perfumizers and Perfume Lights Catalog, 1926
The DeVilbiss Company
color lithography, printed text, and embossing on paper
12 × 9 inches
Toledo Museum of Art Archives

Plate 4
Walter Dorwin Teague, *Proof for Saturday Evening Post
Advertisement*, 1928
The Libbey-Owens Sheet Glass Company
offset printing
14⅞ × 10⅞ inches
Department of Special Collections, Syracuse University Library,
Syracuse, New York

In 1928 Walter Dorwin Teague did a series of *Saturday Evening Post* advertisements for Libbey-Owens that projected an image of product quality and reliability. Here, symmetrical organization balances the narrow modernistic cityscape implied by the two planes of glass at the left with a similar shape filled by dense copy and the dramatic L-O logo, whose shield and four ornaments echo the delicate decorations Teague employed in his 1920s advertisements for Chesterfield cigarettes and Cadillac automobiles.

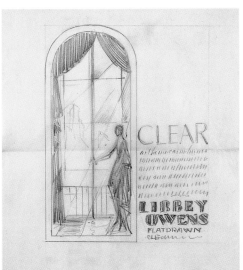

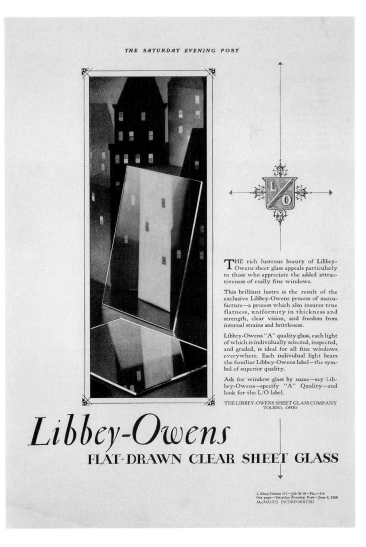

Plate 3
Walter Dorwin Teague, *Sketch for Advertisement*, 1928
The Libbey-Owens Sheet Glass Company
graphite on tissue
16⅝ × 13⅝ inches
Department of Special Collections, Syracuse University
Library, Syracuse, New York

This drawing by Walter Dorwin Teague, one of the leaders of the emerging industrial design profession, indicates his thought process in laying out text and illustration. The large word "CLEAR" and the heavy forms of the Libbey-Owens name are balanced by a window shape of diagonally highlighted glass. The arch suggests elegant contemporary residences, and the graceful figure is typical of the stylized human forms Teague drew during this period.

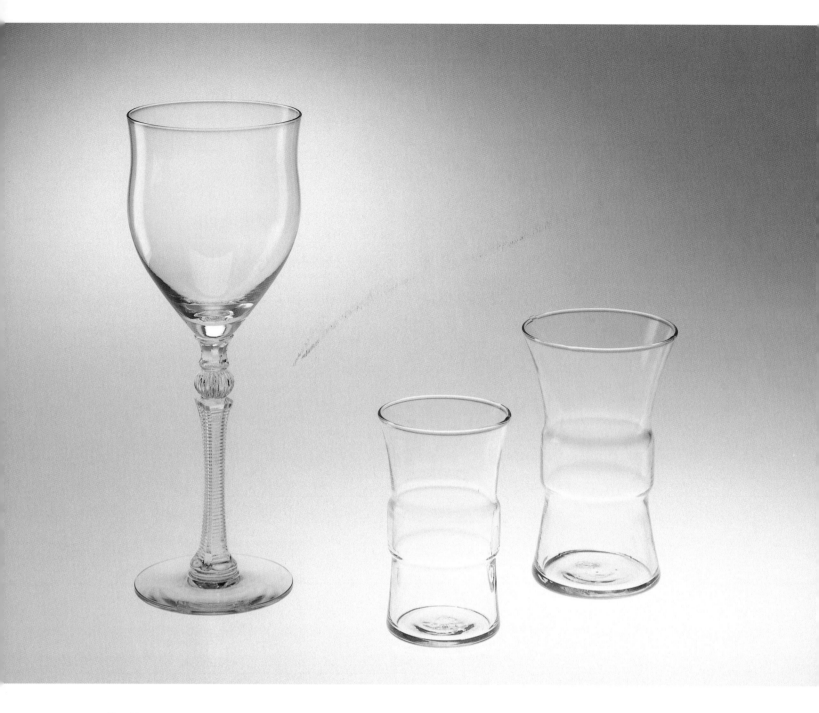

Plate 5
Donald Deskey

Water Goblet, patented 1935
The Libbey Glass Manufacturing Company
glass
8¹¹⁄₁₆ × dia. 3⅛ inches
Toledo Museum of Art, Gift of Owens-Illinois Glass Company

370 Pattern, patented 1936
The Libbey Glass Manufacturing Company and Owens-Illinois
Glass Company
glass
juice: 3¾ × dia. 2¾ inches; tumbler: 4⅝ × dia. 2⅞ inches
Libbey Glass Inc.

Hired by Libbey to improve the company's position during the
Depression, Donald Deskey designed several lines of glassware,
including the central-banded 370 pattern that Libbey marketed
as a special promotion or premium. This line of glasses in rose
or clear glass with the option of applied color on the band was
sold in 1941 at Walgreens with a two for five cents coupon with
a limit of six.

Plate 6
NYC Terminal, Toledo, Ohio, n.d.

Bird's Eye View of Shipyards, Toledo, Ohio, n.d.

Toledo & Hawking Valley Coal Docks, Toledo, Ohio, 1909

Ore Docks, Toledo, Ohio, n.d.

postcards, tinted relief half-tone
Toledo-Lucas County Public Library, Toledo, Ohio

industrial design, nor did they take the lead in innovating designs, but they do stand out for their early and enthusiastic embrace of the idea of design.[5]

Toledo's pioneering enthusiasm for modern industrial design was decades in the making. Its roots lay deep in the nineteenth century, in the speculative dreams of the city's early boosters, and grew through its eccentric economic development that saw the accumulation of medium-sized firms in different industries, rather than the usual pattern that saw the rise of single corporate behemoths or the concentration of firms in a single industry. By the 1920s Toledo was a city of diverse industries with a stable and skilled labor force, progressive businessmen who were early to recognize the power of advertising, and a civic elite whose overheated boosterism promoted aesthetic progress as a means to social uplift and economic development. Toledo's early involvement in industrial design was the natural expression of a city that reached its heyday, that lived its golden age, at the very moment that the modern design movement was on the horizon.

By the early twentieth century, Toledo's industrialists were a close-knit group of businessmen whose interests were tied as much to the future of the city as to that of their particular industries. A few were the descendants of pioneers whose families still held significant swaths of urban property. Others had reinvested their profits into new enterprises in the area. Even as late as the 1920s, most investment capital was raised locally, and the boards of directors of the local banks were fully interlocked with those of the city's biggest companies. As a result the city had an intensely boosterist business culture that made the quality of products turned out of local factories a matter of local pride.

Such boosterism was as old as the city itself. Indeed, the intense boosterism of Toledo's early years actually acted to slow its industrial development. The city was the victim of its own ideal location, on the mouth of the largest river emptying into any of the Great Lakes (plate 6). Toledo's early promoters saw beyond its expanse of malarial swamp to visions of a future metropolis. With the opening of the Erie Canal in 1825, Toledo's prospects boomed, and land speculators engrossed miles of riverfront land and surveyed fifteen paper towns along its banks. A few bettors reaped quick fortunes by selling out early, but more were ruined when the bubble burst. Hope springs eternal, however, and once land prices dropped sufficiently and credit was easy again, new investors, dreams of skyrocketing land values swimming in their heads, bought in and boosted the city once more. As a result of this speculative cycle, manufacturing was retarded as capital was poured into real estate rather than industry. But the city survived on the merits of location—the canals knitting together the eastern and western halves of the country ran through it and the railroads converged on it—and Toledo emerged in the second half of the nineteenth century as a significant, if small, shipping and mercantile center.[6]

By 1880, when the city had slowly grown to be the fourth largest in Ohio, Toledo's business was moving goods, not making them.

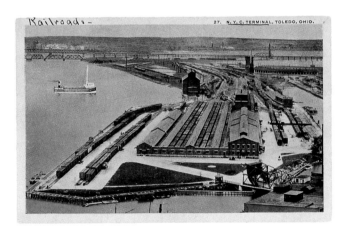

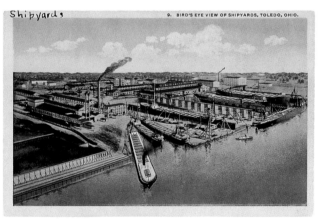

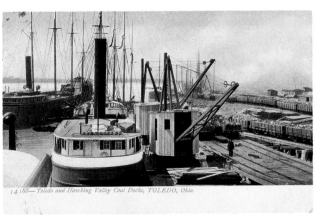

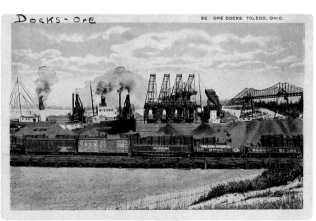

Railroads running east to west converged on Toledo as they snaked toward Chicago or bent into Michigan, taking advantage of its extensive lake dockage. Between Chicago and Pittsburgh, only Cleveland had more railroad property. Most of the city's unskilled laborers worked for the railroad. Toledo had no large factories; none of the city's workshops produced even $100,000 worth of goods that year, and the city had so few factories of any size that over a dozen other Ohio communities manufactured more goods than it did.[7]

Unlike other Midwestern cities that were dominated by a class of conservative industrialists, Toledo was a city run by merchants. Middlemen made fortunes peddling to Midwestern workers and farmers the hardware, tools, clothing, shoes, and boots made in the East. Wholesalers sent farmers their seed and grocers their spices and coffee. And because many of these coffee barons, hardware princes, and wheat kings had inherited or married into large tracts of land, their fortunes were linked to the city's overall growth and prosperity. To these men civic-mindedness was not charity, but good business. When a leading merchant and land baron died in 1893, he was eulogized as "a man of broad mind, [who] realized fully the fact that any project which conserved the prosperity of Toledo as a whole, which added to her trade facilities or to her manufacturing interests, benefited himself. . . ."[8] Coffee barons printed advertisements for the city on the bags they shipped to millions of homes as an investment in the area's future growth.[9] The family that owned the largest newspaper also owned large tracts of land around the city, and the paper crusaded for growth, hoping for the day when "the tall chimneys of factories shall dot the outskirts of the city like a forest. . . ."[10] The businessmen's association offered bounties to entrepreneurs who would relocate to the area.

By the 1890s the dreams of the boosters were close to being realized: Toledo more than doubled her population in a decade, becoming a city of over 100,000. Tall chimneys rose in numbers sufficient to prompt the city fathers to pass a smoke nuisance ordinance in 1892.[11] It had become a cosmopolitan city with a long mansion row, paved streets, and a large shopping district (thanks to the connections of its wholesalers, some of whom diversified into the department store business). On the other end of things, it possessed the most wide-open entertainment district outside of Chicago, with as many as five hundred saloons, many open all hours and even, shockingly, on Sundays.[12] The boom was fueled by the discovery of oil to the south of Toledo, a strike that caused the area to eclipse Pennsylvania as the nation's center of drilling. Cheap gas and local silica sands brought Eastern glassblowers and bicycle makers. The need for hardware in the oil fields brought new tool-making industries. And the flow of oil itself ran into new refineries built on the city's East Side.[13] Importantly, these industries moved to the city along with their owners. These newcomers readily adopted the same boosterist perspective of the old-timers and reinvested their profits in the city.

Thus Toledo made good use of its oil boom and used its newfound wealth to invest in new manufacturing ventures. Its wagon-making industry was brought to the city from Indiana, but a host of parts firms, from canvas buggy top makers to seat makers, were founded by local entrepreneurs. Its bicycle industry was founded by an inventor from Springfield, Massachusetts, but was soon crowded with half a dozen other homegrown firms. Even the publisher of the *Toledo Blade* invested his profits in a steel tube–making plant that could supply the city's bike factories. Local inventors readily found local credit to get their schemes off the ground. An ear, nose, and throat doctor established a factory to make spray atomizers (plates 7–11). His son started a factory to make scales.[14] As a result, unlike other small Ohio cities such as Akron and Youngstown, whose high rates of growth were based on a single industry—rubber in Akron and steel in Youngstown—Toledo prospered upon a wide array of industries.

Toledo's eccentric pattern of industrial growth and its continuous land speculation combined to produce a city whose labor population was disproportionately highly skilled and well paid. For the United States, the decade of the 1890s was one of depression, popular protest, and labor unrest, but these troubles largely bypassed Toledo. Oil stabilized the region's economy, and Toledo's burgeoning bicycle, machinery, and glass industries attracted a large influx of skilled artisans who had been idled by hard times elsewhere.[15] In 1896 one Columbus businessman exclaimed: "Toledo is a marvel. Every other city I have visited is full of unemployed men, and the merchants are complaining of light trade and dull times. Here the reverse is the case."[16] Toledo's consumer industries had an advantage over their competitors elsewhere because of the low transportation costs that were a benefit of occupying a hub of the interstate rail system. Toledo's advantageous freight rates were lowered even further by the end of the century as belt lines were built, encircling the city and connecting all the competing interstate railroads, thereby allowing each of the city's companies to contract with the cheapest shipper.[17]

Toledo's transportation advantages made it an attractive site for industrialists looking to relocate established industries. The city made the short list for a number of gargantuan industries that ultimately went elsewhere. In the 1890s John D. Rockefeller considered it as the site for a massive refinery complex, but settled instead on Cleveland. U.S. Steel surveyed Toledo for the flagship steel factory that eventually was built in Gary, Indiana. Henry Ford thought Toledo might be a good place to put the giant River Rouge complex that ultimately went to Detroit.[18] Though local boosters carried on when these deals fell through, complaining bitterly about the avariciousness of the land sharks who bid up site costs and the deterring high cost of labor in the area, in the end Toledo preserved a higher proportion of skilled workers in its population. Until World War I, Toledo was a city dominated by skilled glassmakers (plate 12), machinists, toolmakers, and

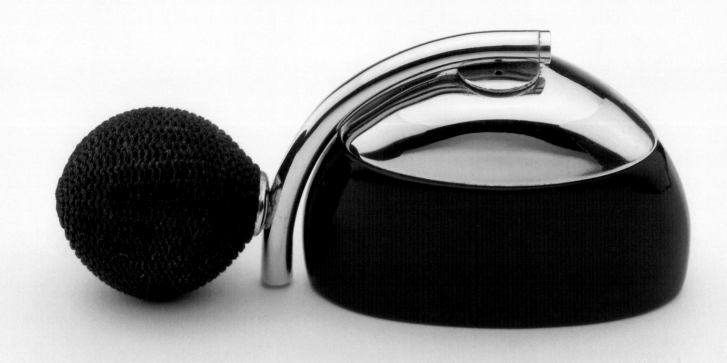

Plate 7
The DeVilbiss Company design staff, *Perfume Atomizer*, 1935
The DeVilbiss Company
glass, chrome-plated metal, and rubber bulb with textile
2½ × 4⅞ × 1⅛ inches
Harvey K. Littleton

The dramatic geometry of this atomizer reflects the glamorous 1930s. The chrome arch, black hemisphere, and round pump are united into a harmonious whole.

Plate 8
Frederic Vuillemenot and The DeVilbiss Company design staff,
DeVilbiss Perfume Sprays Catalog No. 30, 1930
The DeVilbiss Company
rotogravure, color printing, and typeset on paper
11¹¹⁄₁₆ × 8⁷⁄₁₆ inches
James Fuller

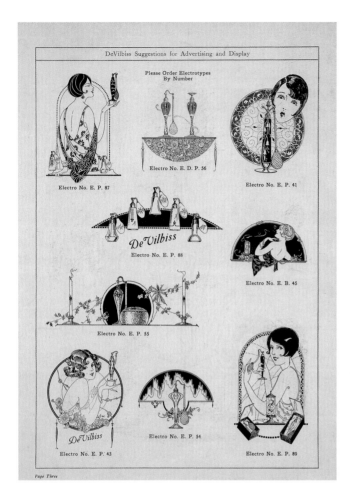

Plate 9
Frederic Vuillemenot and The DeVilbiss Company design staff,
DeVilbiss Advertising Service, 1927–1928 Brochure, n.d.
The DeVilbiss Company
printed text and electrotype with black illustrations on paper
12 × 9 inches
Toledo Museum of Art Archives

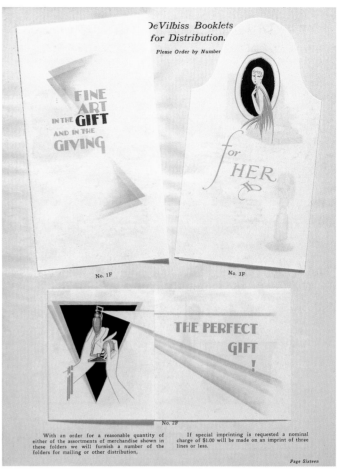

Plate 10
Frederic Vuillemenot and The DeVilbiss Company design staff,
DeVilbiss Advertising Service, 1928–1929 Brochure, n.d.
The DeVilbiss Company
printed text and electrotype with black illustrations on paper
12 × 9 inches
Toledo Museum of Art Archives

Founded in 1888 by Dr. Allen DeVilbiss, The DeVilbiss Company produced atomizers for nasal sprays; it began selling perfume atomizers in 1905 at the urging of Allen's son, Thomas DeVilbiss. US soldiers returning from World War I brought home gifts of French perfume, inspiring a wave of romantic fashion during the prosperous and sophisticated 1920s. DeVilbiss' product line expanded to include many types of perfume sprayers and aromatic nightlights. New designs by company artists trained at the Toledo Museum of Art and at the factory appeared each year. Sales catalogues included pricing and merchandising hints for retailers.

Plate 11
Frederic Vuillemenot and The DeVilbiss Company design staff,
Perfume Atomizer Box, 1930
The DeVilbiss Company
printed silver, black, and green on cardboard with paper
7⅛ × 2⅝ × 2⅝ inches
James Fuller

Frederic Vuillemenot and the DeVilbiss staff designed elegant graphics for merchandising materials and packaging in the 1920s and early 1930s. However, because of slumping sales, around 1932 the company invited Harold Van Doren to redesign this atomizer package as well as some perfumizers.

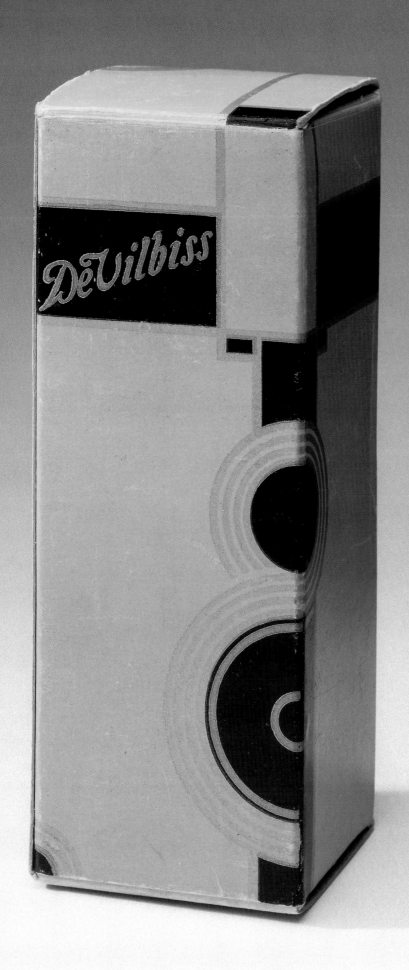

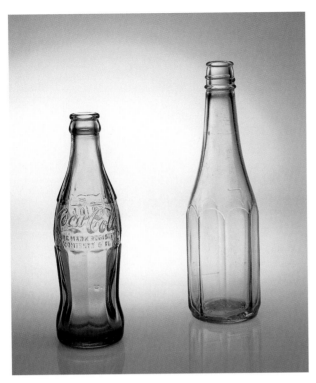

The Owens Bottle Company sold licenses for its machines to other manufacturers such as the Root Glass Company of Terre Haute, Indiana, a maker of beverage bottles, which designed and produced the famed Coca-Cola bottle. In 1932 the Owens-Illinois Company acquired Root Glass and assumed the production of Root products. The H. J. Heinz Company of Pittsburgh contracted with the Owens Bottle Company to produce its signature narrow-necked Heinz ketchup bottle, which was featured in a 1920 Owens Bottle publication that showed a variety of distinctive bottle shapes among the company's capabilities.

Bicyclists of the 1880s rode precariously on bicycles with large front wheels and smaller rear wheels. The 1890s saw the development of "safety" bicycles with two equal-sized wheels. Among Toledo's many bicycle manufacturers at the turn of the century, the Gendron Wheel Company was one of the most successful. Gendron patented numerous inventions, notably the cross-laced wheel spoke design, which, years later, was also used in the company's wheelchairs. This bicycle's form is remarkably modern, with its welded tubular steel frame construction, stamped-steel fenders, and inflatable vulcanized rubber tires. Its unique features included a toolbox hung from the center support and a holder for packages or passengers on the back wheel.

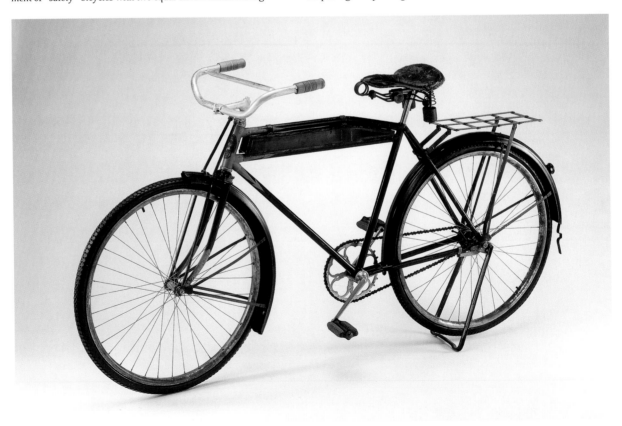

printers. From 1900 to 1905, Toledo led Ohio in the rate of increasing wages.[19] In this same period, Toledo led the nation in the proportion of its workers who owned their own homes.[20]

By the first decade of the twentieth century, the expanding population of skilled workers allowed Toledo to incubate a substantial tool- and die-making industry. Among the most successful firms in Toledo in the 1890s were not the bicycle makers (plate 13), but companies that built the parts bicycle makers used and companies that constructed the specialty tools that the parts makers used. One firm, the Snell Fittings Company, never sold a complete bike, though it produced every type of bicycle part. Had it assembled its own products, it would easily have been the largest maker of bicycles in the United States.[21] Other firms easily made the leap from manufacturing

bending and grinding machines for bicycle tubes to making machine tools for the nascent automobile industry. By World War I The Toledo Machine & Tool Company (plate 14) could boast that its shops were "the largest manufacturers in the United States devoting their entire time and attention to the building of presses, Drop Hammers, Shears, Dies and Special and Automatic Machinery for the economical production of Sheet Metal, Bar Iron and Drop Forged products . . ."[22] Such a claim was probably not too far off the mark, as it was reported that in 1940 Toledo built more presses and dies for the auto industry than any other city.[23] The concentration of toolmaking firms in Toledo, by providing essential know-how and by keeping down retooling costs, made it easier for Toledo companies to redesign their products (plate 15).

Thus by the 1920s, Toledo had the proper raw material to incubate industrial design: a prospering local economy supported by civic-minded elites, a skilled workforce, and a diverse collection of consumer industries. The city had the means and was fast developing the ideas with which to use them.

Many of Toledo's industries were pioneers in bringing luxury goods to the mass market. Bicycles for most of the nineteenth century were rich men's sporting goods, but Toledo's first bike producer boasted that his "company [was] constructing ladies' boys' and men's wheels at . . . greatly reduced prices, so that the poor, as well as the rich, will be able to purchase its production."[24] Decorative glassware was an exquisite wedding gift that was out of the reach of most working-class families until Toledo glassmakers automated much of the process (see Taragin, "Breaking Patterns"). Toledo had its own version of Henry Ford, automaker John North Willys, who lowered the price of his Overland cars successively in lock step with the Model T, helping bring this luxury product to everyone (see Porter, "Toledo Wheels").

With the proliferation of consumer industries came a growing sophistication in the selling techniques among the city's businessmen. Toledo would produce a number of firms that blazed trails in the infant art of advertising. As Toledo's businesses were so closely knit and interconnected, the experience and example accumulated by

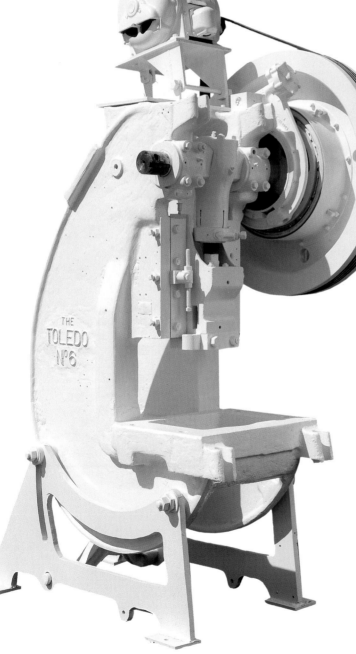

Plate 14
The Toledo No. 6, ca. 1929
The Toledo Machine & Tool Company
cast iron
116 × 56 × 68 inches
Acklin Stamping Company

From the late nineteenth to the mid-twentieth century, Toledo earned its prominent place in industry because of its skilled workers who produced bicycles, metal furniture, typewriters, kitchen appliances, agricultural implements, and countless other products using dies and presses that cut and shaped metal. The Toledo Machine & Tool Company was a chief producer of the industrial equipment necessary for the manufacture of such products.

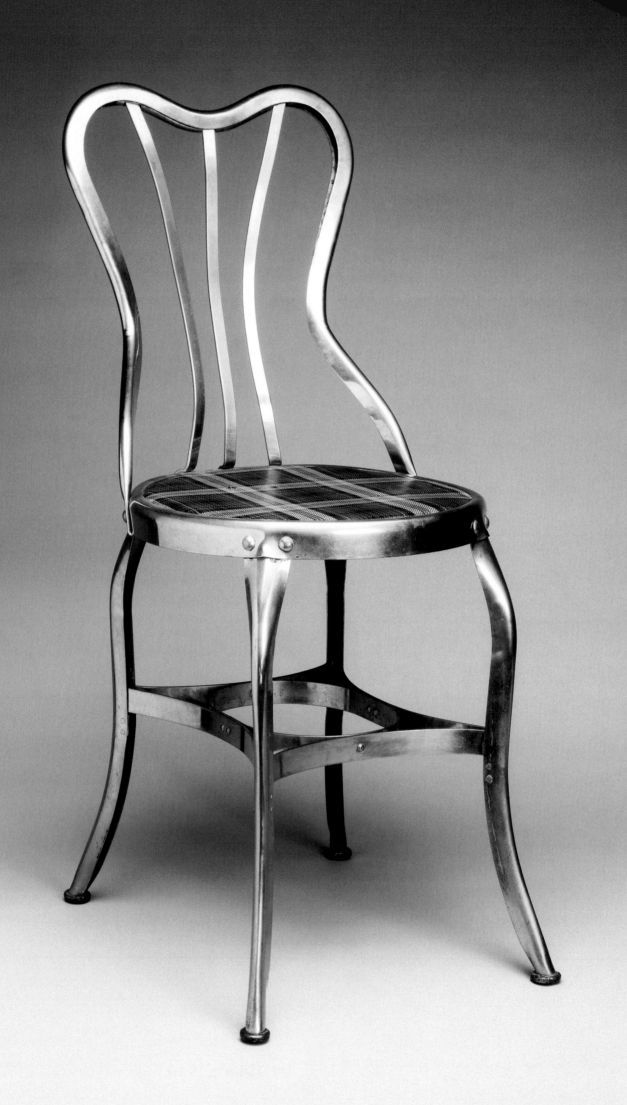

its advertising pioneers was readily spread throughout the entire business community. Decades before they were among the first to jump on the industrial design bandwagon, Toledo's businessmen were early advocates of the power of advertising. Once they adopted the idea that great sums needed to be spent on continuous advertising campaigns, it was not a great leap for them to expend large sums on changing the form or appearance of their products so as to better market them.

As far back as the city's grain trading and wholesaling era, its merchants had gained a reputation for innovative salesmanship. Toledo's Lion Coffee was one of the first to advertise nationally, purchasing space in *Harper's New Monthly Magazine* in 1868. Shoe wholesalers made Toledo the largest Midwestern shipper of shoes and boots outside of Chicago.[25] Its largest coffee merchant innovated the use of premium coupons placed in every coffee sack, which could be redeemed for merchandise. So aggressive were Toledo's wholesale houses that one Chicagoan wrote to the editor of a Toledo paper saying that "at least one half of that class of travelling men [he] . . . met in Michigan, Indiana and Illinois, hail from Toledo."[26]

Modern advertising arose by selling three products: patent medicine, soap, and bicycles. Toledo, as the nation's largest producer of bicycles and bicycle parts by the late 1890s, was a major consumer of advertising space. A city editor who did not yet grasp the fundamentals of modern advertising criticized bike company owners, who he said had "been reckless about placing advertisements and have gone to heavy expenditures when it was not really required."[27] Bicycle advertising marked a watershed in the history of advertising, not only for its innovative use of poster art and its penchant for the full-page ad, but in simply showing that durable goods could be pitched as successfully as everyday items, like soap.[28]

Toledo's industrialists learned more about the power of advertising when Edward Drummond Libbey, owner of the largest glassworks in town, made the Libbey name famous across America through a bold advertising campaign. Libbey saw the promotional potential of the Chicago World's Fair of 1893 and borrowed heavily to finance purchasing one of the choice lots just outside the fairgrounds to construct what was to be one of the most prominent private pavilions.[29]

Like other bold early advertisers, Libbey understood that advertising, while expensive, often had a benefit that increased geometrically compared to its cost. After early experiments with weaving delicate glass fibers into material, it became clear that the process was far too expensive to be profitable—it took the entire manpower of Libbey's factory to produce a single yard of glass fabric—but Libbey nevertheless created a stunning glass dress for a famous actress, Georgia Cayvan, and another for Princess Eulalie of Spain, who happened to be touring the United States at the time. Very impressed, the princess announced that Libbey was to be the royal glassmaker to the Spanish crown, a promotional coup that the glassmaker from the aptly named town of Toledo certainly viewed as well worth his investment. To keep up the campaign, Libbey sold glass fiber neckties, handkerchiefs, napkins, and bonnets as souvenirs of the fair.[30] For several years following the great fair, Libbey's plant could not keep up with orders, a happy outcome that Libbey himself told his fellow businessmen was entirely the result of the power of advertising.[31]

Libbey's example was noticed by Toledo's smaller firms, many of which distinguished themselves as pioneer advertisers in their own fields. At a time when most dental companies bought space in dental journals merely to please the supply companies that published them, Ransolm and Randolph Company, makers of fine dental cabinets and appliances, employed their own technical ad writer, used extensive direct mail techniques, emphasized eye appeal and graphic composition in their ads, and invested heavily in continual ad placement.[32] Toledo Cooker Company, maker of the Ideal Steam Cooker (plate 16), an elaborate tin pot that could "cook a complete meal over one burner of any stove," placed tiny ads in seventy-five major American magazines every month; the punch line was an offer for a free catalogue and recipe book. The key to Toledo Cooker's system was not the ads, but the information they derived from requests for their catalogue. Their office maintained a scientific tabulation system that allowed it to assess quickly the impact of each column inch in each periodical and hone their ad buying accordingly.[33]

The Toledo Scale Company, though a small producer of precision scales prior to World War I, had a sales force of over a hundred traveling salesmen, and an innovative advertising strategy that sold their scales by appealing not to the grocers who actually purchased them, but to the grocers' customers. Toledo Scale warned consumers that they were continually cheated by merchants who used crooked scales, and that its own scales were the only guarantee of honesty in weighing. This "honest weight campaign" was so successful that grocers not only bought Toledo scales, but even paid to advertise that fact.

Plate 15
Phillip Uhl, *Side Chair*, ca. 1910
The Toledo Metal Furniture Company
nickel-plated metal, plastic, and wood
34½ × dia. of seat 14¼ inches
Brooklyn Museum of Art, New York, Gift of Mr. and
Mrs. Jonathan Holstein, 75.108

The Uhl Brothers Cycle Shop opened in 1897 to make bicycle parts; the men soon turned to producing furniture and renamed their business The Toledo Metal Furniture Company in 1908. Based upon their design for an "ice cream chair" they introduced in 1903, this channel-stamped chair appeared in their line from roughly 1910 to 1930 with wood-inset seats and with several color finishes for the wood and metal parts. Sales catalogues promoted this sturdy chair as "designed and adapted for use anywhere and everywhere. . . . Shaped to fit the human body . . . giving utmost comfort." The claim to ergonomic fit and the chair's overall structural integrity anticipate later developments in functional seating.

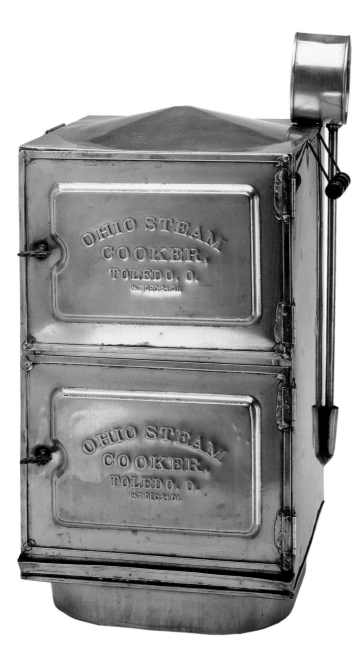

Many merchants purchased expensive electric signs that lit up with
a Toledo Scale advertisement every time the scale was used. The com-
pany obligingly provided their customers with complimentary adver-
tising copy, printing plates, grocery bags (plate 17) with the Toledo
Scale logo, and even photographic slides to be shown before the movies
at neighborhood nickelodeons.[34]

Toledo's newspapers helped promote good advertising: its five
daily newspapers fought to sell their column inches. One publisher not
only solicited advertising, but also helped local merchants coordinate
their print campaigns with their window displays. Advertising accounts
supported a growing printing industry in Toledo. Though Cincinnati
had historically been the center of publishing in Ohio, by the turn of
the century Toledo's publishers had the most modern presses, includ-
ing the only press in Ohio capable of color newspaper work.[35]

Toledo's businessmen were ahead of the advertising curve even
before one of the trailblazers of modern advertising, Colonel Albert
Pope, selected Toledo as the location of his luxury automobile plant.
Pope, like many automakers, got his start making bicycles, and it was
he who first invested heavily in artistic bicycle advertising. His Toledo
venture was similarly advertising driven. In an age before New York's
Madison Avenue had conquered the advertising industry, Pope's
Connecticut company relied on a local Toledo advertising firm to sell
its Toledo cars.[36]

Pope, as flamboyant with his financing arrangements as he was
with his advertising, went bankrupt in the Panic of 1907. The man
who picked up the pieces of his Toledo automobile business, John
North Willys, had worked his way up in life not as a tinkerer or inven-
tor, but as a salesman. Willys poured his profits into advertising. He
was one of the first automakers to spend a million dollars a year on
promotion and the first to purchase a lavish double-page spread in the
Saturday Evening Post, the most expensive magazine per column inch
in the nation.[37] By 1915, though forty other American corporations
were larger than Willys's car company, it outranked all others except
for Quaker Oats in the amount it spent on national magazine advertis-
ing. No other automaker even ranked in the top dozen.[38]

The pool of advertising experience that had gathered in Toledo
included not only the city's innovative businessmen, but a number of
remarkable ad men as well. Most notable was Theodore F. MacManus:
in 1903, with a $25,000 investment advanced by some well-established
Toledo businessmen, he founded an advertising firm in Toledo. Before
his first year was out, his receipts surpassed his capital by 400 percent,
enabling this son of an Irish laborer to buy a posh home in Toledo's
mansion district on the same street as glass baron Edward Drummond
Libbey. MacManus serviced the advertising needs of Toledo's bur-
geoning industries for the next six or seven years until General Motors
persuaded him to move to Detroit.[39] He is remembered as the inventor
of "atmosphere advertising," the use of indirect, impressionistic copy

whose purpose is to build a good image of the company rather than sell a particular product. By the mid-1920s, MacManus's ad agency was one of the top ten in the nation.[40]

Out of this culture of advertising grew Toledo's importance as an industrial design promoter. When local boosters—bankers, industrialists, corporate lawyers—raised money to support the new museum of art, they selected as one of their first directors not a noted artist or scholar, but a former advertising manager. This man, George W. Stevens, not only successfully built the museum from a collection consisting of a single painting and a mummified cat into a prominent institution, he did so by preaching the connection between good art and good industrial design. Indeed, Toledo's museum of art distinguished itself internationally as a pioneer in popular art education.

The Toledo Museum of Art educated its founders as well as the public. As the centerpiece of Toledo's high society, the museum served to spread a new art ideal among Toledo's captains of industry. At dinners, fundraisers, exhibition openings, and ribbon-cutting ceremonies, the city's well-heeled boosters and trustees dedicated themselves to educating Toledo's masses in the value of high art. In the process they themselves were developing and learning a new philosophy of art and industry (see McMaster and Taragin, "Pioneering the Alliance of Art and Industry").

At the time the Toledo Museum of Art was founded, most museum curators fulfilled their educational mission by simply hanging the best work they could. Reformers exhorted museums to place greater emphasis on raising the public's knowledge and appreciation of fine art, because beauty was the salve that eased the drudgery of modern industrial society.[41] A few pioneering institutions, such as Boston's Museum of Fine Arts, had a practical and educational focus, but even Boston's public museum conceived of itself primarily as a trainer of specialists—artists, designers, and artisans were to be educated so that they in turn could produce new American art—rather than as a missionary of art to the masses.[42] In America, like country clubs, museums remained comfortably the preserve of fashionable society.

Motivated by their own business experience, civic boosterism, and contacts with art reform advocates, the Toledo Museum founders broke with the elitist aloofness of American museums and dedicated their institution to popular art education. Elbert Hubbard, the Hoosier soap salesman who popularized the teachings of William Morris, the great English advocate of combating industrialization with art and craftsmanship, was a friend to many in the inner circle of the museum's founders.[43] Edward Drummond Libbey was a close friend of Dr. Frank Wakely Gunsaulus, an early advocate of art as means of social progress and a leader of the Armour Institute, the Art Institute, and the Field Museum of Chicago. One of the first men invited to lecture at Toledo's new museum was Professor Oscar L. Triggs, secretary of the William Morris Society recently formed in Chicago. He suggested the museum host an Arts and Crafts exhibition and preached that "the application of the principles of art and beauty to the common achievement of the hand, brings art within the ken of the masses."[44]

Long before it was fashionable to associate the high art of museums with the competitive world of industry, the Toledo Museum's founders gushed with enthusiasm for the industrial potential of the museum's educational programs. George W. Stevens built up the museum with what his wife, Nina, called his "strange and revolutionary theories that took art away from exclusive capitalism and gave it to the

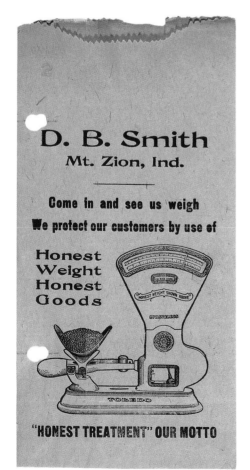

Plate 17
Designer unknown, *D.B. Smith, Mt. Zion, Ind., Grocery Bag*, n.d.
Manufacturer unknown
letterpress printing on paper
8½ × 4⁷⁄₁₆ × 2⅝ inches
Lucas County/Maumee Valley Historical Society, Maumee, Ohio

From roughly 1900 to 1915, the Toledo Scale Company mounted a multifaceted advertising and public relations campaign to associate its brand name with "honest weight." Although the purchasers of Toledo scales were stores and not consumers, the company influenced retailers by encouraging housewives to frequent shops that used Toledo scales.

people." Stevens's dream, remembered Nina, was of a museum that helped bring beauty to the world of industry:

> A useful museum of art, he thought, should provide the mind and the hand, by the intelligent analysis of the works of the masters of all ages, from prehistoric times to the present, with the means of developing a sense of proportion and color. He meant the ordinary minds and hands, not necessarily those with predilections for art. The hands that fashion the common things in life, the homes, the gardens, the clothes, the minds that conceive the designs of things in use, the pots, the kettles, the bottles, on and up through furnishings, facades, fences, boulevards, parks and city plans, were what he meant.[45]

Stevens was not alone among the museum's founders in his "strange and revolutionary theories," though the businessmen among them viewed the same ideals in terms of the bottom line. The museum's great patron, Edward Drummond Libbey, connected the museum's mission with uplifting the taste of the city's working class, though he and other businessmen emphasized the economic logic behind such work (see McMaster and Taragin, pp. 12–13).

By the end of its first decade, the Toledo Museum of Art had done much to educate the public's art palette, but had also won laurels for its work in buoying the commerce of the city. When the president of the Associated Advertising Clubs of the World spoke before Toledo's Chamber of Commerce, he singled out for praise the city's art museum, saying that it was bound to lead to "better advertising, advertising that really was beautiful to look upon, artistic of conception and achievement," "finer workmanship of all kinds," and, all in all, "a more noble city."[46] Local editors raved about the museum's success in serving "the purposes of industry as well as those of culture."[47] The commercial ties of the museum were made more formal when Director George W. Stevens was made an honorary member of the Chamber of Commerce and given a complimentary membership to the elite Toledo Club. Art and industry were also married when the city undertook its first industrial survey and selected Stevens and Libbey to join its five-member task force.[48] In the end, no one at the time recognized that out of the experience of founding a "people's art museum," Toledo's business community had themselves arrived at a greater appreciation of the importance of art in industry.

By the 1920s, Toledo was fulfilling the dreams of its early boosters, who had hoped for its growth as a major industrial center. Though it was only the twenty-sixth largest city in America, it was the seventeenth-largest producer of manufactured goods, outranking much larger cities such as Kansas City, Indianapolis, Seattle, and Denver. Toledo ranked in the top ten in the production of more than a dozen different types of manufactured products—so many that it was said that "a Toledo resident could spend his life, if he chose to do so, by the exclusive use of Toledo Made products."[49] Toledo rode the crest of prosperity in that booming decade and by its end enjoyed the highest rate of growth in manufacturing employment in the entire nation.[50] Bullish developers responded by platting enough lots to comfortably house a population of nearly one and a half million, over five times the city's actual headcount.

Though this golden age would not last long—the Depression hit Toledo especially hard—it came at just the right time for the city to make its mark in industrial design. The Toledo Scale Company led the way, becoming, as one historian of industrial design has noted, "one of the first manufacturing organizations in America to be consciously aware of the commercial benefits of sound design."[51] But it was not just Toledo Scale. The same was true of an entire coterie of Toledo industrialists whose base in a diverse array of consumer industries, pioneering experiences in advertising, urban boosterism, and leadership in building the local art museum contributed to a unique business culture that valued good design.

1. "The Toledo Museum of Art Dedication and Inaugural Address" (Toledo: Toledo Museum of Art, 1912), unpag.

2. Jeffrey L. Meikle, *Twentieth Century Limited: Industrial Design in America, 1925–1939* (Philadelphia: Temple University Press, 1979), p. 17; Juliann Sivulka, *Soap, Sex, Cigarettes: A Cultural History of Advertising* (New York: Wadsworth Publishing, 1998), pp. 73, 132.

3. R. L. Leonard and C. A. Glassgold, *Annual of American Design* (New York: Ives Washburn, 1930), pp. 71, 84, 98.

4. Raymond Loewy, *Never Leave Well Enough Alone* (New York: Simon & Schuster, 1951), p. 64.

5. Stephen Bayley, *In Good Shape: Style in Industrial Products, 1900–1960* (New York: Van Nostrand Reinhold Co., 1979), p. 125.

6. Harold E. Davis, "Elisha Whittlesey and Maumee Land Speculation, 1834–1840," *Northwest Ohio Quarterly* 15, 3 (July 1943), pp. 138–58; Morgan Barclay and Charles N. Glaab, *Toledo: Gateway to the Great Lakes* (Tulsa: Continental Heritage Press, 1982), pp. 20–29.

7. *Annual Report of the Secretary of State . . . for the Year 1880* (Columbus, Ohio: State Printers, 1881), pp. 727–33.

8. *Toledo Blade,* January 31, 1893.

9. *Toledo Blade,* April 14, 1894.

10. *Toledo Blade,* November 2, 1889.

11. *Toledo Blade,* December 29, 1892.

12. *Toledo News-Bee,* November 15, 1928.

13. Randolph C. Downes, *Industrial Beginnings: Lucas County Historical Series* 4 (Toledo: Historical Society of Northwestern Ohio, 1954), pp. 70–98.

14. Harry Scribner, *Memoirs of Lucas County and the City of Toledo* (Madison, Wisconsin: Western Historical Association, 1910), vol. 2, pp. 442–45.

15. Donald G. Bahna, "The Pope-Toledo Strike of 1907: Part One," *Northwest Ohio Quarterly* 12, 1 (January 1940), pp. 1–4; *Toledo Blade,* December 8, 1894, and May 8, 1907.

16. *Toledo Blade,* May 26, 1896.

17. *Toledo Blade,* August 7, 1905.

18. *Toledo Blade,* December 13, 1906; July 8, 1908, and June 24, 1911; Harry R. Illman, *Unholy Toledo* (San Francisco: Polemic Press Publications, Inc., 1985), p. 178.

19. *Toledo Blade,* February 2, 1907.

20. Gregory R. Zieren, "The Propertied Worker: Working Class Formation in Toledo, Ohio, 1870–1900" (University of Delaware, PhD dissertation, 1982).

21. *Toledo Blade,* July 18, 1895, and January 9, 1897.

22. *The "Toledo" Presses and Other Machinery Dies and Special Tools* (Toledo: The Toledo Machine & Tool Company, Catalogue No. 11, 1917), p. 9.

23. *Northwest Ohio Quarterly* 12, 1 (January 1940), pp. 1–4.

24. *Toledo Blade,* December 31, 1889.

25. *Printers' Ink* (New York), September 23, 1903, p. 13.

26. Downes (note 13), p. 105; *Northwest Ohio Quarterly* 50, 3 (Summer 1978), pp. 90–91.

27. *Toledo Blade,* August 20, 1897.

28. Frank Presbrey, *The History and Development of Advertising* (New York: Doubleday, Doran & Co., 1929), pp. 410–13.

29. E. William Fairfield, *Fire & Sand . . . The History of the Libbey-Owens Sheet Glass Company* (Cleveland: Lezius-Hiles Co., 1960), pp. 39–42.

30. J. W. Buel, *The Magic City* (St. Louis: Historical Publishing Co., 1894), p. 143; *Toledo Blade,* June 13, 1893.

31. *Toledo Blade,* January 2, 1895.

32. *Printers' Ink* (New York), September 10, 1902, pp. 3–6.

33. *Printers' Ink* (New York), September 24, 1902, p. 32.

34. *The Toledo System* (Toledo), January 20, June 17, August 12, 1910; September 28, 1911; February 4, 1913; May 26, 1914; and April 6 and April 22, 1915.

35. *Printers' Ink* (New York), October 8, 1902, p. 22.

36. *Toledo Blade,* June 22 and August 15, 1907.

37. *Toledo Blade,* March 4 and April 22, 1911; December 10, 1913.

38. Daniel Pope, *The Making of Modern Advertising* (New York: Basic Books, 1983), pp. 42–45.

39. Scribner (note 14), vol. 1, p. 612; Clarence M. Burton, *The City of Detroit, Michigan, 1701–1922* (Detroit: S. J. Clarke Publishing Co., 1922), pp. 59–60.

40. Roland Marchand, *Advertising the American Dream: Making Way for Modernity, 1920–1940* (Berkeley: University of California Press, 1985), pp. 32–33.

41. Helen Horowitz, *Culture and the City: Cultural Philanthropy in Chicago from the 1880s to 1917* (Chicago: The University of Chicago Press, 1989).

42. Neil Harris, "The Gilded Age Revisited, Boston and the Museum Movement," *American Quarterly* 14, 4 (Winter 1962), pp. 545–66; Kathleen McCarthy, *Noblesse Oblige: Charity and Cultural Philanthropy in Chicago, 1849–1929* (Chicago: The University of Chicago Press, 1982).

43. *Toledo Topics* (Toledo), February 1926, pp. 18–19; *Toledo News-Bee,* January 21, 1929.

44. Toledo Museum of Art Scrapbooks (MMS-1371), vol. 1 (to February 1906).

45. Nina Spalding Stevens, *A Man and a Dream: The Book of George W. Stevens* (Hollywood, California: Hollycrofters, 1941), pp. 13–14.

46. *Museum News* (Toledo), April 1915, p. 5.

47. *Toledo Times,* December 25, 1910.

48. *Toledo's Business,* October 1926; Stevens (note 45), pp. 13–14; *Industrial Survey* (Toledo: City Plan Commission, 1924).

49. *The Toledoan* (Toledo), October 1926, p. 8. See also Bureau of Business Research, *Industrial and Commercial Ohio Yearbook 1930* (Columbus: The Ohio State University, 1930); *Toledo's Business,* May 1927, p. 23.

50. Glenn McLaughlin, *Growth of American Manufacturing Areas: A Comparative Analysis with Special Emphasis on Trends in the Pittsburgh District* (Westport, Connecticut: Greenwood Press, 1970, orginally published 1938), p. 117.

51. Bayley (note 5), p. 125.

Neil Harris

ACRES OF DIAMONDS
TOLEDO AND THE PURSUIT OF REPUTATION

Cities, like human beings, enjoy life histories marked by changing moods and self-images. In the United States, where active city development is only a few hundred years old, the need to characterize and justify the special nature of urban community has been particularly intense. The rapid growth of so many towns and cities competing for residents and economic development, and the huge stakes involved, as well as the sense of boundless opportunities and golden futures, helped seed whole literatures of aspiration as well as promotional institutions that were remarkable in their scope and energy.[1] For various reasons, having to do primarily with the timing of their founding and the movement of population, Midwestern cities were particularly active sites for boosterist activities. A chain of ambitious, would-be metropolitan complexes studded the continent's interior from Buffalo, Cleveland, Detroit, and Cincinnati west to Chicago, Minneapolis, Milwaukee, and St. Louis. In a matter of decades, struggling villages transformed themselves into dense concentrations of people, industries, and commercial and cultural institutions. Their autobiographies, recounted in a cascade of promotional histories, tracts, manifestos, and newspaper editorials, sought to define the special qualities that had nurtured their growth, and promised greater achievements in the future.

The pursuit of reputation in the American heartland had social, economic, and psychological objectives. Differentiating one place from another was part of a larger strategy to encourage investment and migration, and reassure those who already had made their choice of residence. It meant, among other things, creating a sense of collective memory and taking active steps to ensure that a place became known elsewhere for its special assets. In doing all these things, in calling attention to its singular virtues and institutions, in celebrating special anniversaries and erecting commemorative monuments, in commissioning studies and plans, in lobbying for subsidies or improvements, the city of Toledo, and its various representatives, acted no differently than most urban neighbors, near and far (plate 1).

Toledo, however, did possess an uncommon, if sometimes frustrating, history. Its location, resources, and early ambitions offered a promise of growth and prominence that would not be fully realized. Indeed, an elegiac tone soon surfaced in both the primary literature and the historical commentaries. More than a century ago, it was clear that Toledo would never blossom into the 1868 promise of its leading early booster, the "Future Great City of the World."[2] In fact it would not even become the Future Great City of Ohio. Instead its character and personality would eventually be associated with non-quantitative achievements, despite the fact that a passion for ranking across a variety of categories would never entirely be abandoned by the city's champions.

Some historians have interpreted this shift from economic and demographic claims to cultural affirmations as a sign of failure.[3] Having lost the race for industrial primacy, many Toledoans, the argument runs, turned necessarily to less central, more peripheral grounds for defending their community. But shifting emphases did not necessarily indicate failure. And cultural features were not marginal. Almost every major American city, having missed the chance to be first or second or third, would need at some point to consider just how to describe and emphasize the things that seemed important to it, the trophies that drew admiration from others and sustained pride from the residents. Tracing the efforts made by Toledo to designate and defend its urban character should remind us that this is a continuing need within the United States, going far beyond the commercial goals of increased tourism and higher investment levels to something else: a sense of shared identity and common destiny that, however temporarily and tentatively in the lives of a mobile people like our own, gives meaning to our acts of physical location.

Did Toledo ever have a golden age? Was there some magical period when life seemed boundless, when prosperity, good order, and creativity all flourished? In the nineteenth century at least, this state of things

Page 40
Plate 1
Charles E. Thompson, You will do better in TOLEDO, where rail and water meet . . . , 1913 (reconstructed 2002)
photo panel

always seemed around the corner, just about to develop, on the eve of appearing (see Messer-Kruse, pp. 27–28). Toledo, like many other towns and cities, sought a formula to guarantee its future. As several chroniclers have put it, the most powerful note in these decades must have been disappointment. Blessed by advantageous location astride a natural water system, and quickly linked to other places by a web of railroads, Toledo seemed destined to greatness by nothing less than divine intention. This same mantra was adopted by any number of competitors, but there was plausible reason to think that in Toledo's case, the hopes might be fulfilled. A prominent position on the Great Lakes, an ample bay, the nearby availability of timber, iron ore, coal, and in later years, oil and natural gas, a temperate climate, these possessions promised an almost unlimited growth, in the eyes of local optimists. "All the commerce commanded by the Gulf of St. Lawrence and Hudson's Bay may be more conveniently brought into connection with Toledo," wrote the most expansive and ambitious of the city's proponents, Jesup W. Scott, in the mid-nineteenth century. Only Chicago, because of its proximity to the prairies, seemed a worthy challenger. Toledo was still surrounded by forests, but they would yield to cultivation year by year, making Chicago's advantage steadily diminish.

When Scott published these views (in the late 1860s, long after he had first announced them), they were far more persuasive as testaments of faith than predictions of the future. Many cities had clearly begun to outdistance Toledo in size and industrial activity. Chicago already possessed ten times the number of Toledo's million-dollar industries, St. Louis fifteen times, while even St. Paul, Buffalo, and Detroit had multiples, although much smaller. In 1870 Toledo stood thirty-ninth in population among American cities, making Scott's pronouncements even more incredible, and while over the next thirty years the city would experience considerable growth, its comparative position, by 1900, had risen only to twenty-sixth. Toledo could not really be considered the "Future Great City of the World" by any standard.

Despite this, dramatic efforts were continually being made to improve the city's standing, and reassurances offered to occasional skeptics. "Our manifest destiny is clearly outlined," declared the *Toledo Blade* in the 1870s; "there is no doubt that the future Queen of the West is she who sits at the head of Lake Erie."[4] One industrial or commercial novelty after another seemed to hold the key to Toledo's future. Randolph C. Downes, perhaps the most insightful chronicler of Toledo's nineteenth century, pointed to a succession of doomed romances with various resources and commodities. In the 1870s Toledo presented itself variously as the Corn City of the West, the Grain City, and then the Millers' City. In their "self-centered approach to American growth," Downes observed, with tempered sympathy, Toledoans "indulged in their usual delusions of grandeur. . . ."[5] In 1876 the *Toledo Blade* could report that "comparatively speaking she is now far ahead of either Chicago or Milwaukee with regard to the grain and commission business."[6] But revolutions in wheat farming and ever larger ships doomed Toledo's hopes, and the city became instead—and only temporarily—the clover-seed capital of the world. When narrow-gauge railroads seemed to hold high promise of liberation from discriminatory railroad rates, "Toledoans indulged in their usual great expectations," Downes continued. If railroad matters had only worked out, a *Blade* writer insisted in 1900, Toledo might have become the largest city in Ohio.[7] In the 1880s, with discoveries of natural gas deposits in Findlay, Ohio, Toledoans thought they had found a new basis for success. A city-owned pipeline was built to attract private industry. But the gas supply was not permanent. Once again "Toledoans went through the oft-repeated process of seeing their dreams of becoming citizens of the 'future great city of the world' turn to dust and ashes," Downes wryly observed.[8] The Grand Gas Celebration of 1887, one of a series of regional carnivals acclaiming the latest novelty, soon turned into a dirge for another lost opportunity. There just was not enough natural gas in northern Ohio to support local ambitions.

A slightly different but equally unhappy variation appeared after oil was discovered in northwest Ohio. Despite the newly rich oil tycoons who flocked to the city, Toledo became a merchandiser rather than a producer of oil. "How strange are the paradoxes of history," Downes observed, narrating this latest episode.[9] Grand delusion after grand delusion had obsessed Toledoans since the 1830s. Canals, lake shipping, railroads, coal, ore, iron and steel, grain, natural gas, each succeeded one another. Oil was just the latest. Most refiners went to other cities after Toledo's failure to attract the Standard Oil Company. Some oil-inspired industrial development brought jobs and investment to Toledo, but not on the scale necessary to power a breakthrough in size and prominence (see Messer-Kruse, p. 28).

Bad judgment and bad timing also attended two other developments that briefly promised economic prosperity: wagon making and bicycle manufacturing. As the century began (plate 2), Toledo achieved

considerable dominance in both areas, only to see the bicycle and the horse outrun by the newly developed motorcar. Here again, as Downes reports, Toledo missed out. Bicycle makers were deeply linked to tire production, and the secrets of seamless webbing were actually uncovered by a Toledo businessman. But Joseph L. Yost decided to go elsewhere after concluding that property values were too high in Toledo to allow for development of the projected factories. Automobile making and associated factories would, in time, enrich many cities, including twentieth-century Toledo, but never to the extent that might have been possible with better planning and shrewder judgment. Many cities have similar stories to tell of missed opportunities. As Mark Twain once remarked, "There isn't a Parallel of Latitude but thinks it would have been the Equator if it had had its rights."[10] But Toledo's string of disappointments became almost a part of the city's traditions.

The city, of course, also had its considerable successes, many of them apparent by the early twentieth century. Machine tool makers, furniture manufacturers, elevator companies, specialized iron and steel products, paint sprayers, scale makers, and, above all, glassmakers signaled Toledo's adjustment to industrial age enterprises. The happy arrival of Edward Libbey in 1888 with his New England Glass Works was seized upon by locals as the triumph it was. Crowds, celebrations, and banquets greeted the manufacturer; and timing, for once, was on Toledo's side, for it was the electrical revolution and the

Plate 2

Corner, Cherry and Summit Sts., Showing Steadman Monument, Toledo, Ohio, ca. 1916

Summit Street Looking North, Toledo, Ohio, n.d.

Bird's Eye View of Toledo, Ohio, ca. 1909

Madison Avenue Looking West, Toledo, Ohio, ca. 1909

postcards, tinted relief half-tone
Toledo-Lucas County Public Library, Toledo, Ohio

need to supply unending numbers of lightbulbs that helped assure Libbey's future.

Edward Libbey's own dramatic turn to promotional campaigns was also a factor in linking Toledo with an enormously successful company. Impressed by the publicity glassmakers received through elaborate exhibits at the 1876 Centennial Exposition in Philadelphia, Libbey, overruling corporate management, went heavily in debt to finance his ornate display at Chicago's Columbian Exposition in 1893. The Libbey Glass Pavilion, designed to resemble a palace with a huge dome constructed to encircle (and hide) its smokestack, occupied a prominent place on the popular Midway, and turned out to be the best-attended concession at the fair.[11] With its own glass factory and an extensive range of merchandise, the pavilion sold almost $100,000 worth of glass souvenirs during the six months that the fair was open. Each of the two million visitors could receive a small spun-glass bow on a stickpin. So effective was the exhibition that Libbey was able to place his elaborate (and expensive) cut glass in prominent specialty stores after the fair closed. Like George Pullman, Henry J. Heinz, George Eastman, and other entrepreneurs of the day, Libbey understood the value of public relations, and brought attention not only to his company, but to his newly adopted city as well.

In the late nineteenth century, Toledoans fought aggressively on their own for a share of public attention, particularly when it came to the state of Ohio. Some of this involved rituals of commemoration, celebrations employed by cities throughout the United States to call attention to their status and prosperity. The Ohio Centennial, celebrated (for various reasons) in 1902, was a rich prize for any city to gain, and Toledoans hoped to host a great exposition in honor of the occasion. The *Toledo Blade,* always jealous of the city's reputation, suggested, as early as 1895, a fair to be held in Bay View Park, but the state legislature refused to vote the million dollars that locals thought was a minimal necessity, and the honors, small honors though they were, went to Chillicothe, the first capital, in 1903.[12]

More successful as a civic promotion was the 1909 summertime pageant on the Maumee known as Wamba Week, an extension of the elaborate festivities associated with Mardi Gras and Veiled Prophets in cities such as New Orleans, Mobile, and St. Louis. With $50,000 in subsidies available, hundreds of costumes imported from New York, and floats designed by creators of the Veiled Prophet pageant in St. Louis, and supported by a recently organized Chamber of Commerce, the event emphasized Toledo's links with Spain. At its center was King Wamba, a seventh-century Spanish king who had inspired a rich store of legends. The pageant featured a Spanish court presided over by royalty, played, of course, by leading citizens, suitably costumed, and had in attendance Spain's minister to the United States. Despite the caustic comments of Mayor Brand Whitlock, who labeled it a "sublime and commercial idiocy" whose motto should be "stupidi-

tas stupiditatum! Omnia stupiditas!" it proved an immense, if temporary, success. It spawned, according to Randolph Downes, "Wamba sewing circles, Wamba amateur baseball leagues, Wamba department-store sales, Wamba regattas, Wamba musical comedies put on by fraternities, Wamba marches and two-steps, King Wamba sundaes," and even "Wamba cigars."[13] The "northwestern metropolis of Ohio," Charles Ware wrote in 1909, "casting into history for a festal background, has boldly transported a slice of another century and another nation to its gates. . . ." This was a creation of "prosaic, matter-of-fact Ohio business men," who realized the modern carnival "is not entirely an amusement institution. It is a commercial project, an industrial tonic, an educational exhibit. The twentieth-century city must advertise . . . must attract new population, new business, new wealth. It must show what it has done," insisted Ware. The carnival was "one form of modern civic advertising," and this one managed, in the summer of 1909, to attract 100,000 visitors to the city.[14]

Although it has been labeled the end of an era of civic promotionalism, succeeded by a more sober and efficient operation known as the Toledo Industrial Exposition Company, Wamba Week also belied the increasingly conservative reputation Toledo had been gaining in some circles during the late nineteenth century. Commentators and promotional literature alike had started to emphasize, not audacious energy in undertaking new enterprises or rapid growth, but the appeals of a place with established traditions and a stable structure. Visiting newspaperman Theodore Dreiser found Toledo, in the 1890s, "as clean and fresh and comfortable looking as any human city could well be, I fancy." The "well-kept lawns, their shuttered and laced and light-tinted windows. . . . Swings and hammocks on their lawns and porches. Flowers radiant in their windows."[15] Strangers will find Toledo to be "one of the most pleasant and agreeable cities in the middle west," *Harper's Weekly* declared in 1891. "The people here have built a solid, substantial, and altogether comfortable city, with few outward signs of material ostentation," a city of wealth, leisure, and culture. While "their more ambitious neighbors" may consider Toledoans "as being too conservative and slow," all cities "are more or less likely to fall into conservative habits. . . ." But there are signs, the article concluded, that Toledo may be following Eastern cities by becoming broader, more open to new people and new ideas. And as evidence of such changes, *Harper's* singled out the *Toledo Blade.*[16]

The *Blade* in 1891 was already an old newspaper, older indeed (by some months) than the city itself.[17] It was created, in some ways, specifically to boost the town that would shortly become incorporated, and the fortunes of newspaper and city were inextricably linked. The *Blade,* and its new weekly, became nationally known in the 1860s and 1870s, when its managing editor, David Ross Locke, published a series of enormously popular texts on politics and the plight of the freedmen under the nom de plume of Petroleum Vesuvius Nasby.[18]

Locke's homespun humor, deployed to satirize unregenerate Confederate values, suited the times and brought him and his paper a considerable audience, but the *Toledo Blade* became even more significant as a newspaper in the twentieth century, first under the editorship of Locke's son, and then, starting in the 1920s, as part of the newspaper empire of Paul Block, Jr. There were other popular newspapers in the city—especially the *Toledo News-Bee,* which it would absorb in 1938— but the *Blade* epitomized Toledo's spirit of self-celebration and continued to link itself as intimately as possible with the city's traditions.

The *Blade's* close links to local identity were firmly expressed in the elaborate and expensive building it completed in 1927. Opened by President Calvin Coolidge (through remote control from the White House), in its Moorish and Spanish Renaissance touches it emphasized Toledo's links with Spain; the coat of arms adorning the building consisted of a gift that came directly from Spain at the time of the Philadelphia Centennial in 1876. Everything about the *Blade,* from its name to its architecture, sought to evoke the romance of Spain. This quality, along with its longevity, distinguished it somewhat from the other local newspapers, but all of them played roles as advocates of the city's merits and shapers of its reputation. Deeply committed to the city's expansion and improvement, the *Blade* especially, like many other American newspapers, interested itself in a whole series of institutional and physical reforms, from establishment of a medical school and improvement of its port to downtown renewal (plate 2). It sustained the city's belief in itself through decades of editorializing.

Early twentieth-century Toledoans had organizations besides the newspapers to spread the word about their virtues. The Chamber of Commerce, organized in the 1880s to promote industrial development and an active supporter of a whole series of municipal improvements, shared certain promotional responsibilities with other local organizations such as the Toledo Advertising Club. Boosterist energy was by no means confined to the nineteenth century, as American cities continued to try to parade their assets and accomplishments to potential investors. After several decades of activity, in the late 1920s the Toledo Chamber of Commerce broke new ground by creating a national campaign that, in the words of its secretary, would "inseparably link the thought of Toledo with the thought of success."[19] Eight full-page advertisements in the *Saturday Evening Post,* set approximately one month apart, trumpeted Toledo's advantages for business operations.[20] Each ad, with a couple of exceptions, focused on the achievements of a Toledo businessman, beginning with Clement O. Miniger, president of the Electric Auto-Lite Company, and John North Willys, who ran the Willys-Overland Company, and continuing through Thomas A. DeVilbiss of The DeVilbiss Company, the Stranahan brothers of Champion Spark Plug Company, Gordon Mather of the Mather Spring Company, and the entire board of directors of the Air-Way Electric Appliance Corporation. In one instance, for Toledo Scale, the Chamber

of Commerce chose two senior foremen as the focus of attention, and for Toledo Edison, the final entry in the series, no individual at all was featured.

The ads were remarkable because they were practically unique in a journal like the *Saturday Evening Post,* and because of their efforts to marry successful business enterprise with the character of Toledo life.[21] Typically, several paragraphs of prose would pay respectful tribute to the specific individual or company—"Toledo fully expresses its belief in Mr. Miniger and its other leaders"— and then go on to praise their levels of public spirit and community participation. Thus Thomas DeVilbiss put parks around his factory, served on the school board and on both county and city planning commissions, presided over the Chamber of Commerce, and led a Community Chest campaign. Clement Miniger, another chairman of the Community Chest, put in his time as a trustee of the local YMCA, Toledo Hospital, Zoological Society, and the Toledo Museum of Art. Willys and the Stranahan brothers received commendation for their merchandising and industrial innovations. Though more tempered rhetorically than the claims of an earlier century, the advertising programs rested upon the same competitive needs: to single out for attention a community's special assets and define the appeals that argued for possible relocation. Every advertisement contained the same promotional information, which now included, aside from the usual obeisance to its railroads and natural harbor, a listing of cultural institutions: a well-respected school system, an important municipal university, and a wealthy art museum. All of them, and the city's churches, stores, and industries, had combined to create "a comprehensive, fully rounded and intensively developed, progressive community of more than three hundred thousand people." No longer privileging location or insisting on primacy in Ohio or the world, early twentieth-century boosters attempted to emphasize the attractions of a medium-sized city with an active, benevolent leadership, a city where quality of life was more significant than commercial and industrial dominance, and a city where local loyalty nurtured distinctive philanthropy (plate 3).

Twenty years later the *Toledo Blade,* as tireless a local publicist as the Chamber of Commerce, created another version of this advertising crusade by running almost thirty magazine advertisements touting the city's key features—and itself—in a series of trade publications ranging from *Advertising Age* and *Printers' Ink* to *Drug Trade News, Editor & Publisher,* and *Women's Wear Daily.*[22] The art museum, the public library, the University of Toledo, and the zoo, along with Toledo Scale, the National Supply Company, Woolson Spice, Champion Spark Plugs, Haughton Elevators, and Willys-Overland, became the centerpieces of brief texts extolling Toledo's spirit and energy. "Only a great market can support a great newspaper," declared the *Blade,* eager to represent its community as progressive, dynamic, and innovative.

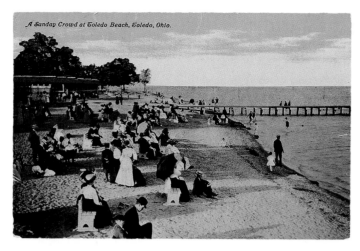

Collingwood Ave., Toledo, Ohio.

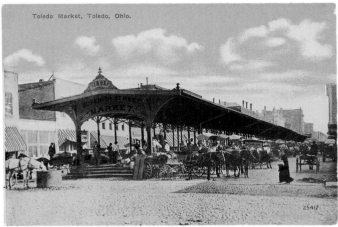

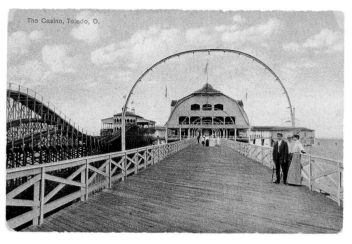

Plate 3

A Sunday Crowd at Toledo Beach, Toledo, Ohio, n.d.

Collingwood Ave., Toledo, Ohio, n.d.

Toledo Market, Toledo, Ohio, n.d.

The Casino, Toledo, Ohio, ca. 1905

postcards, tinted relief half-tone
Toledo-Lucas County Public Library, Toledo, Ohio

Various journalistic pieces during these decades aided this projection. In 1921 Allen D. Albert, writing for *Collier's,* declared that unlike many other cities wrecked by factories, Toledo has been "building a city with the support of factories instead of supporting the factories at the expense of the city."[23] In 1920 the twenty-sixth largest city in the United States, Toledo had apparently abandoned its expectations of greatness. "By 1910," Albert wrote, "the area that had seemed in 1845 to belong to Toledo so incontestably had been divided among competitor cities like an American Poland."[24] Chicago, Detroit, Cleveland, and Indianapolis were the beneficiaries. And while Toledo had gained dozens of companies over the previous ten years, led by the arrival of the Overland Company, what stood out were the local institutions nurturing home, schools, health, religion, and art: a city university, sixteen baseball diamonds, swimming pools, and above all, the art museum. "Toledo is the only city I can cite where any stranger can find the Art Institute by asking any child on any street."[25]

The rapid emergence of the Toledo Museum of Art as a symbol of civic virtue was striking. Five years before Albert's essay, in 1916, Lyman Abbott told readers of the *Outlook,* a popular liberal journal, that the "city of Toledo is neither very large nor very rich, and until recently was better known as a center of intersecting railways than as an art center." But that had changed. Toledo, "which a few years ago was neither more nor less materialistic and sordid than the average American railway and manufacturing city, is being transformed by this museum into a

city of beautiful homes inhabited by a people of great and growing artistic appreciations."[26] How did it happen that a city that had toyed with railroads, canals, sea-borne shipping, oil, natural gas, and bicycles as the basis for economic growth and international reputation, now, in the early twentieth century, became identified most closely with an art museum as its most representative institution? There was probably not another relationship quite like it in the entire country.

In fact, the Toledo Museum of Art (plate 4) was something of an oddity among its American counterparts. Even by the 1920s, only a few decades old and before the true growth of its fabled collection, it had achieved a remarkable and distinctive national reputation. It epitomized a conception of museum activity that emphasized, above all else, community service and responsibility. This would constitute a beneficial legacy to Toledoans in search of qualities that would service reputation.

The Toledo Museum of Art was created at a time when quite a number of Midwestern cities were discovering that their resources were sufficient to support a new art museum: Cincinnati and Chicago in the 1870s, Detroit and St. Louis in the 1880s, and, at various moments in the same period, Indianapolis, Milwaukee, Minneapolis, and Columbus. But Toledo's story was nonetheless distinctive. It was not merely that it was smaller than these other sites when its museum was founded in 1901, although that was certainly part of the surprise. Instead, it was the presence of a single extraordinarily rich and generous patron, Edward Drummond Libbey, who for a quarter of a century lavished funds on the institution, capping it off with a spectacular, multimillion-dollar inheritance. And Libbey was seconded by a sequence of active, promotionally minded, community-oriented directors, notably George W. Stevens and Blake-More Godwin, who,

from the first, conceived of the museum not as a civic refuge for masterpieces, a lure for tourists, nor even as a training ground for American craftsmen and artisans, although all of these would become part of its function. Rather, they foresaw the institution as a place where schoolchildren and pensioners alike could feel comfortable, engaged, and stimulated. As one museum supporter, attorney Charles S. Ashley, wrote to the building architect, Edward Green, in a letter that captures some of their sentiment, "I shall not consider this Museum a success unless it attracts the generality of citizens as much as the popular shows of the day. A Museum ought not to be a cold-storage ware-house, but a place of true and real human interest. This Museum aspires to be the headquarters of every Club or Society" working "for the higher intellectual and aesthetic development of Toledo and vicinity."[27] When the first of the specially designed museum buildings was opened in 1912, it was paid for not simply by Edward Libbey's money but through a large public subscription, inspired in large part by the effectiveness George Stevens displayed in gaining the confidence of community members. Subsequent additions in the 1920s and 1930s gave the institution extensive and commodious spaces to meet its rising scale of visitation.

Once again, popular support and large memberships were not unique to Toledo. In the early twentieth century, a Midwestern neighbor, The Art Institute of Chicago, boasted both the largest museum membership in the world and the biggest attendance in the country. But this was in the nation's second-largest city and, at that time at

Plate 4
New White Marble $300,000 Art Museum, Toledo, Ohio, ca. 1912
postcard, tinted relief half-tone
Toledo-Lucas County Public Library, Toledo, Ohio

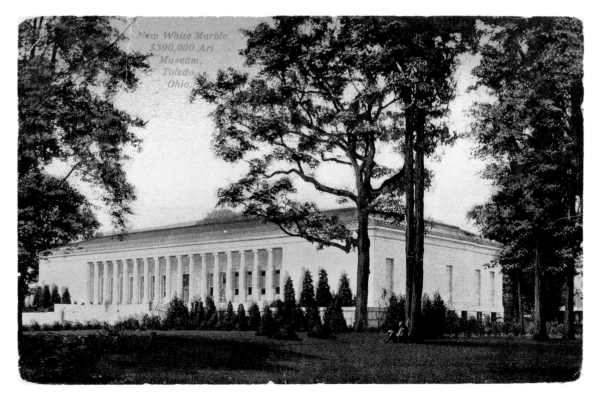

least, one of the half-dozen biggest cities on the globe. What made Toledo special was its combination of true museological distinction and medium city size, along with the enthusiasm of local residents and publicists for the institution as a whole.

The museum became something of a happy anomaly. It seemed to exemplify the values of community integration without abandoning a reputation for high professional quality. Stevens and the staff pioneered in a whole series of areas, innovations that were sustained by his immediate successor, Blake-More Godwin. The establishment of an elaborate program of free art education, the exploitation of motion pictures, accessibility to unaccompanied children, free symphony concerts, and similarly inspired innovations added up to a unique institutional personality.[28] Decades before most American museums had begun to concentrate on audiences rather than collections, and on user-friendly methods, the Toledo Museum was already heading the field. *Fortune* magazine, in the 1930s, professing astonishment at the thousands of children who lined up to enter the building on Saturdays, labeled the museum "The Pied Piper of Toledo" and termed it "the most striking and most representative example" of the democratic museum movement. "It doesn't oppress you, as do so many museums, with a sense of mass. And when you go inside, you will be struck immediately with the remarkable simplicity of the place and with its harmony of proportion. The galleries, medium-size and friendly, are arranged in such a simple sequence that you can wander from one to another without retracing steps or wasting time on things that don't interest you. There is no jumble of showcases, no crowding of pictures."[29]

Fortune did more than admire the display of art; it pointed to the specially built classrooms and assembly rooms, school offices, and children's lunchroom. Educational facilities on this scale were highly unusual in the 1930s, and by that decade the museum itself was attracting visitors whose numbers amounted to more than 100 percent of Toledo's total population. The Metropolitan Museum of Art, by contrast, at the same time was hosting a visitation equal to just 15 percent of New York City's population.[30] While the New York comparison may well be unfair, a better example might be Toledo's closest museum rival in this respect, Omaha, whose visitors amounted to 49 percent of that city's population.[31] The Toledo Museum's prominence as an instrument of promotional rhetoric anticipated the turn to cultural institutions as a basis for reputation, tourism, and investment some seventy years later, in cities all across the United States. Linking prestige with culture, as turn-of-the-century Toledoans increasingly did, was not then, as some scholars have argued, a position born of frustration or desperation, a result of failed competitive strategies, but a reasonable and even creative response to the challenge of defining a civic personality.

By the 1920s, particularly after the nationally celebrated political administrations of Mayors Sam Jones and Brand Whitlock, Toledoans

could point to evidence of a special civic ideal that characterized their community.[32] Other cities, even other Ohio cities, had their reform mayors during the so-called Progressive Era—Hazen Pingree in Detroit; Tom Johnson and Newton D. Baker in Cleveland; Seth Low in New York; James Phelan in San Francisco—but it was, once again, the combination of Toledo's secondary rank with the prominence of its leadership that made the story so compelling.[33] Mayors Jones and Whitlock appeared to transcend party and class loyalties, espousing philosophies of civic revivalism that were almost religious in character. In Jones's case, notions of brotherhood and justice were paramount; he conceived of the city as an extended family, whose members would be loyal to and considerate of one another. Municipal ownership will awaken in a man the fact "that he is a member of a family which owns its own streets, which owns its own bridges, which owns its own water works. . . ."[34] "Any government that recognizes the idea and brings about a condition of brotherhood is good government," he wrote journalist and social reformer Henry Demarest Lloyd in 1897. Influenced by a heady combination of sources, ranging from the bible to socialist leader Eugene V. Debs, Jones exemplified the compassion and inclusiveness of his philosophy in daily life. His disciple and mayoral successor, Brand Whitlock, was more the artist in politics, eventually abandoning his political career for life as a writer and émigré. Both personified conceptions of an ideal community that probably were possible only in a smaller American city like Toledo, where endless growth did not overwhelm a sense of neighborhood.

Toledo history, then, political and cultural alike, contained strong and repeated elements of utopianism, social and civic programs that concentrated on lessening the distance between the real and the ideal. Local spokesmen, from Libbey and Stevens to Jones and Whitlock, were unashamed of their appeals to some higher life. "Toledo claims to have outdone her sister American cities in linking art with daily life," noted the *Literary Digest* in 1927, commenting specifically on Arthur Covey's murals for a local department store but, more generally, on an oft-stated community ideal.[35] Even the most hardheaded economic promoters, like the Chamber of Commerce, acknowledged this special flavor to local culture.

It must have been all the more disconcerting to the city's champions, then, that Toledo, in the 1920s and 1930s, also became identified with Prohibition gangsterism and, even more, with bitter and sometimes violent clashes between capital and labor, fissures exposing a fractured and polarized community. There were older precedents, of course, and the Willys-Overland strike of 1919 had set an ominous tone.[36] Moreover, nearby Michigan and Illinois possessed their own lengthy traditions of bitter labor violence. But the strikes and sitdowns that followed in the 1930s reflected an increasingly desperate local situation, and came as something of a shock to local leadership. Both the Auto-Lite strike of 1934 and the strike against Toledo Edison

attracted national attention, first because of the deaths involved, and second because of the potential impact they posed. But these were only two in a series of difficult confrontations as unions attempted to organize what had been largely a nonunionized workforce. "The name of Toledo was synonymous throughout the nation with violent strikes," Roger Riis complained in *Reader's Digest* in 1938. "Poison gas rolled in the city streets, militia patrolled the sidewalks."[37] Others projected their worst fears upon the city. When "the police protection in a city breaks down and virtual chaos ensues," David Lawrence wrote for the *Saturday Evening Post* in 1936, "something dangerous is in store for the future pay roll of such a city. And when a big plant moves away, a pay roll moves away. . . ."[38] Toledo had become, by the mid-1930s, a "testing ground for labor strife," the *New York Times Magazine* noted in 1946. "We used to air-condition our factories by throwing bricks through the windows," observed one municipal official.[39] Sam Jones's "Golden Rule" city seemed further from reality than it had a generation earlier, when he had first formulated it.

In fact, Toledo soon reemerged on the national scene with an ingenious and apparently effective instrument to resolve such conflicts. The Toledo Industrial Peace Board, created in 1935, represented an innovative and nationally celebrated attempt to clarify the basis of misunderstandings between labor and industry, in the hope of avoiding strikes or lockouts.[40] When initial plans were announced to create an independent board to conciliate and mediate, local organizations,

Plate 5
Aerial View of Toledo, Ohio, 1941
postcard, tinted relief half-tone

Looking Down the River, Toledo's Manufacturing District, ca. 1909
postcard, tinted relief half-tone

Aerial View Downtown Toledo, Ohio, n.d.
postcard, four-color mechanical tint

Portside, n.d.
postcard, four-color mechanical tint

Toledo-Lucas County Public Library, Toledo, Ohio

Plate 6
Norman Bel Geddes for Norman Bel Geddes & Company, Inc.,
Frank Scherschel, photographer, *Toledo Tomorrow, General View*,
1945
gelatin print
10 × 12⅝ inches
The Norman Bel Geddes Collection, The Performing Arts Collection,
Harry Ransom Humanities Research Center, The University of Texas
at Austin, by permission of Edith Lutyens Bel Geddes, Executrix

ranging from the Chamber of Commerce to union officials, saw it as
a very special opportunity. "Toledo Can Lead the Way to Industrial
Peace," the *Blade* declared on June 29, 1935, and assume a position of
national leadership in so doing. The success of the "Peace Board" over
several years must have reassured those in doubt about the commu-
nity's capacity to cohere, and about its continuing power to demand
the loyalty of its residents.[41] Eleven years later admirers were still
trumpeting the virtues of the "Toledo Plan." "These men try to settle
local disputes as you would settle a family quarrel," Gilbert Bailey of
the *New York Times Magazine* observed, noting the spread of the insti-
tution to several other American cities.[42] Toledo, Ohio, "once the scene
of almost continuous labor tumult," reported another writer, is "now

virtually strikeless."[43] The eighteen-member board consisted of five
labor representatives chosen by the Central Labor Union, five employ-
ers selected by the Chamber of Commerce, and eight citizens repre-
senting the community at large. In its first two and one-half years, the
board handled 138 cases, and in a majority of them the board avoided
either a strike or a lockout. The cost to the city was just $6,000 or so
a year, to pay an executive director and maintain an office. The Peace
Board, in conjunction with a new charter that mandated a city man-
ager system, gave Toledo a refurbished political reputation, which a
group of leading citizens, the Toledo Associates, polished incessantly
for the rest of the country.[44] And civic institutions continued to hammer
through, as best they could, the themes of Toledo's personality.[45] How
many people "really know their own city?" the Toledo Public Library
asked Toledoans. "How many of you know about Toledo and what
makes it stand out from other cities?" it continued, presenting a cata-
logue of industrial, commercial, geographical, and cultural features
that would make local citizens proud of their community.[46]

There were other signs of recovery. Certainly the spirit of commit-
ment to Toledo (plate 5)—as evidenced in the distinctive political tradi-
tions, the art museum, and the Chamber of Commerce advertisements,

among many other things—received a boost after World War II from the ambitious city plan developed by Norman Bel Geddes. The fact that the $250,000 Toledo Tomorrow project was conceived and paid for by Paul Block, Jr. (plate 6), the publisher of the *Toledo Blade*— and featured in its advertising series for the city—highlighted the intimate links connecting the various components of Toledo promotionalism. Observers connected the willingness of the "traditionally torpid burghers" of Toledo to vote tax increases for improved municipal services with the four-month exhibition of the sixty-foot model in the Toledo Tomorrow exhibit.[47] The president of Owens-Corning contended that "more favorable publicity and attention came to Toledo because of Toledo Tomorrow than from anything else in recent years," a view seconded by other community leaders and suggesting the reputational functions of the scheme. *Life* ran an elaborate, well-photographed article on the scale model, noting that "Toledoans see solutions not only for their own problems but for civic ills which make all big U.S. cities such inconvenient places in which to live and work and get around."[48] Some industrialists argued that population growth was not so unsullied an ideal. It "seems nicer to be where people can get to work, move around conveniently and have some leisure time . . . ," observed a vice president of Libbey-Owens-Ford Glass Company in 1948.[49] In assessing its planning, particularly its transportation needs, Toledo now was acting not as the "Future Great City of the World," but as a representative American community, seeking to make a virtue of the ordinary, the typical, the unexceptional, and the average rather than highlighting its uniqueness. This sense of being an American microcosm rather than a world metropolis was furthered by the award of "All American City" status some years later.[50]

More than a century ago, a Philadelphia clergyman, Russell Conwell, made a fortune (which he effectively gave away to his church and his college, today's Temple University) by repeating a lecture, "Acres of Diamonds," some six thousand times.[51] Its popularity rested partly on its energetic endorsement of economic ambition and partly on a lengthy and colorful parable constructed around Ali Hafed, a wealthy Persian farmer, who died, poor and exhausted, after wandering the world in an unsuccessful search for diamonds. Ironically enough, his own soil yielded, soon after his death, the fabulous diamond mine of Golconda, the source of the Kohinoor and the Hope diamonds. But the profits went not to Ali Hafed, but to the man who had purchased his farm. From the story, Conwell mined lessons richer than diamonds.

There was no shame in being rich or even in striving to be rich, Conwell argued, subverting ancient religious inhibitions about money making and vigorously endorsing the American capitalist spirit. The bible condemned the love for lucre, not lucre itself, Conwell pointed out. But the surest place for gaining wealth, he insisted, was at home. "If you wish to be great," Conwell concluded, "you must begin where

you are and with what you are, now." He "who would be great anywhere must first be great in his own community. Right here. Right now." Prosaic and humdrum as they might seem, local resources held more promise than any distant search for glory. Wealth, like charity, began at home.

Conwell's popularity rested on his blend of glitter and homespun truth, a marriage between the exotica of the *Arabian Nights* and the needs of industrial America. His fanciful story, supported by a series of homely anecdotes and personal observations, reassured doubters about the virtues of economic competition. And it strengthened old-timers urging the young to sink their roots into home soil, and make the best of what they found.

Toledo's search for reputation could be read as a gloss on Conwell's sermon. The leaders of this medium-sized city sought to harness older dreams of dominance to existing strengths in campaigns of community persuasion, to survive unreasonable expectations and damaged dreams of glory by nurturing the prosaic industries and activities that supported the local economy. Some fantasies did remain. Toledo's Spanish linkage provided occasional flavoring, for example, but the legacy of aspiration, in the mid-twentieth century, found restatement in programs of physical renewal and cultural uplift. Successive devices to capture the city's special nature—promoting local heroes, staging great events, lauding specific industries and distinctive institutions, commissioning new plans—made up, over time, a multi-layered tradition of self-celebration.

But it was rarely retrospective. In Toledo the Golden Age always lay ahead, somewhere in a brighter future. What better place, then, for designers to flock, convinced that they could improve what had gone before? And what designs could be more appropriate than those involving the work and leisure of daily life, the implements, utensils, vehicles, and machines that symbolized physical progress and personal release? Thus the flowering of industrial design in mid-twentieth-century Toledo is an understandable event. Yoking together practical talents with utopian visions had become something of a local specialty, nurtured on dreams of materialist progress that eventually would become known as the American Dream. Toledo's continuing efforts to present itself as a distinctively desirable community were paralleled by similar crusades in cities and towns across the continent. But the special, if bittersweet, flavor of grand schemes and limitless ambitions lingered in northern Ohio, encouraging visions indispensable to art. And from this would emerge, in time, those products and designs that constitute its physical legacy.

1. There are many descriptions of this booster literature. One of the best summaries can be found in William Cronon, *Nature's Metropolis: Chicago and the Great West* (New York and London: Norton, 1991), pp. 31–54 and note 45, p. 396. See also the discussion in David Hamer, *New Towns in the New World: Images and Perceptions of the Nineteenth-Century Urban Frontier* (New York: Columbia University Press, 1990), chap. 5, "The Growth of Towns," pp. 113–38.

2. This was the phrase associated with Toledo's greatest booster, Jesup W. Scott, whose 1868 pamphlet, *A Presentation of Causes Tending to Fix the Position of the Future Great City of the World in the Central Plain of North America* (Toledo: Blade Steam Book and Job Print, 1868, 1876), remains the most elaborate and detailed statement of early aspiration. Scott's work is analyzed in Cronon's *Nature's Metropolis* and featured in other texts on Midwestern boosterism. The "Future Great City" was also a phrase adopted by boosters of other places, including St. Louis.

3. Most notably, in a text that I have learned much from and am indebted to, David Rich, "Urban Promotion: A View of Toledo in the Nineteenth Century," University of Toledo master's essay, 1972.

4. *Toledo Blade*, January 11, 1877, as quoted in Randolph C. Downes, *Industrial Beginnings: Lucas County Historical Series* 4 (Toledo: Historical Society of Northwestern Ohio, 1954), p. 27.

5. Downes (note 4), p. 9.

6. *Toledo Blade*, November 11, 1876, as quoted in ibid.

7. *Toledo Blade*, April 28, 1900, as quoted in ibid., p. 23.

8. Downes (note 4), p. 43.

9. Ibid., p. 79.

10. This is one of a string of mottoes from "Puddn'head Wilson's New Calendar" that precedes Mark Twain's novel *Following the Equator*, published in 1897. This particular maxim precedes chapter 69.

11. The planning of the pavilion and its impact are discussed in *Libbey Glass: A Tradition of 150 Years* (Toledo: Toledo Museum of Art, 1968).

12. Randolph C. Downes, "Toledo and the Ohio Centennial of 1902," *Northwest Ohio Quarterly* 25 (Autumn 1953), pp. 189–200, describes the event. It is also treated in his book *Industrial Beginnings* (note 4). See also E. O. Randall, ed., *Ohio Centennial Celebration* (Columbus: Ohio State Archaeological and Historical Society, 1903).

13. Randolph C. Downes, "Wamba Week: The End of an Era in Toledo Civic Promotionalism," *Northwest Ohio Quarterly* 27 (Autumn 1955), pp. 160–72.

14. Charles Ware, "King Wamba Rules Toledo," *World To-day*, October 1909, pp. 1096–99.

15. Theodore Dreiser, *Newspaper Days*, ed. T. D. Nostwich (Philadelphia: University of Pennsylvania Press, 1991), pp. 466–67.

16. William Willard Howard, "The City of Toledo," *Harper's Weekly* 35 (March 28, 1891), p. 230.

17. The best history is John M. Harrison, *The Blade of Toledo: The First 150 Years* (Toledo: Toledo Blade Co., 1985). See also William Howard Taft, "The *Toledo Blade:* Its First One Hundred Years, 1835–1935," Western Reserve University PhD dissertation, 1950; and Grove Patterson, *I Like People: The Autobiography of Grove Patterson* (New York: Random House, 1954).

18. For more on Locke, see John M. Harrison, *The Man Who Made Nasby, David Ross Locke* (Chapel Hill: University of North Carolina Press, 1969).

19. Benjamin H. Bonar, "Leading Industries and Chamber of Commerce Cooperate in Community Advertising," *American City*, July 1927, p. 94.

20. The first ad ran in the *Post,* May 21, 1927; the eighth and final one appeared January 28, 1928.

21. The period, however, was rife with elaborate public relations efforts by individual corporations. For some of this rich history, see Roland Marchand, *Creating the Corporate Soul: The Rise of Public Relations and Corporate Imagery in American Big Business* (Berkeley: University of California Press, 1998).

22. *This is.* ([Toledo: Toledo Blade Co., 1946]). The pamphlet reprinting the twenty-eight different advertisements ended with a tribute to April 11, 1946, the day Toledoans voted to impose a payroll income tax on themselves. In the view of the *Blade*, this "was the spirit of Toledo Tomorrow translated into action through the amazing loyalty of the citizens of Toledo Today. . . ."

23. Allen D. Albert, "Toledo—the City Young Blood Built," *Collier's,* January 8, 1921, p. 10.

24. Ibid., p. 11.

25. Ibid., p. 25.

26. Lyman Abbott, "The Glory of Going On," *Outlook* 114 (October 25, 1916), p. 408.

27. Charles S. Ashley to Edward B. Green, July 10, 1908, Toledo Museum of Art Archives.

28. All this brought considerable national attention. See, for example, *Outlook*, October 25, 1916, pp. 407–408; *International Studio*, September 1919, pp. lx–lxii.

29. "The Pied Piper of Toledo," *Fortune*, January 1938, pp. 69–76, 109–110, 112.

30. This characteristic of visitation far exceeding local population was still being commented upon decades later. See Louise Bruner, "The Toledo Museum of Art," *American Artist*, April 1966, p. 33.

31. See "Toledo Selection," *Time*, September 27, 1937, pp. 29–30, for the Omaha comparison.

32. For Jones there is a large literature, but for a recent study, see Marnie Jones, *Holy Toledo: Religion and Politics in the Life of "Golden Rule" Jones* (Lexington: University Press of Kentucky, 1998). For Whitlock, see David D. Anderson, *Brand Whitlock* (New York: Twayne, 1968).

33. For Ohio's special version of urban reform, see Robert H. Bremner, "The Civic Revival in Ohio," *American Journal of Economics and Sociology* 8 (October 1948), pp. 61–68.

34. Samuel M. Jones, *The New Right: A Plea for Fair Play Through a More Just Social Order* (New York: Eastern Book Concern, 1899), p. 305.

35. "Marrying Art and Industry," *Literary Digest*, November 26, 1927, p. 22.

36. For more on this strike, see the three-part article by David A. McMurray, "The Willys-Overland Strike, 1919," *Northwest Ohio Quarterly* 36, 4 (Autumn 1964), pp. 171–80; 37 (Winter 1964–65), pp. 33–43; and 37 (Spring 1965), pp. 74–79.

37. Roger William Riis, *Reader's Digest*, April 1938, p. 27.

38. David Lawrence, "I Saw America," *Saturday Evening Post* 209 (December 5, 1936), p. 97.

39. Gilbert Bailey, "Toledo Offers a Plan for Industrial Peace," *New York Times Magazine*, November 24, 1946, p. 16.

40. For more on this, see the four-part article by Tom Clapp, "Toledo Industrial Peace Board, 1935–1943," *Northwest Ohio Quarterly* 40, 2 (Spring 1968), pp. 50–67, pp. 97–110; 41, 1 (Winter 1968–69), pp. 25–39; and 42, 1 (Winter 1969–70), pp. 70–84.

41. The plan brought many admiring articles in its wake. See William Hard, "Toledo Proves That No Town Need Have Labor Troubles," *Reader's Digest*, June 1941, pp. 18–22.

42. Bailey (note 39), p. 16.

43. Hard (note 41).

44. Toledo's decision to take municipal management "out of the hands of a political amateur" and turn it over "to a non-partisan professional" brought national attention, as these words from *Time* indicate. See *Time*, January 6, 1936, p. 11.

45. This continued in succeeding decades. Thus in 1952 the Toledo Area Chamber of Commerce started a Know Your Community Month, with plant tours, air shows, building dedications, and other activities, touched off by a special four-day train trip around the city. See "Toledo Talks to Itself About Itself," *Business Week*, September 12,1952, p. 42.

46. "Toledo," *Bulletin: Historical Society of Northwestern Ohio* 1 (January 1940), pp. 1–5.

47. *Time*, May 24, 1946.

48. "Future Toledo," *Life*, September 17, 1945, p. 87.

49. As quoted in Mark Murphy, "Toledo," *Saturday Evening Post*, January 10, 1948, p. 29.

50. See *American City*, March 1954, p. 161. Toledo had been a runner-up in the 1942 contest. *American City* made it clear that the reason for Toledo's selection was its "constructive" and "resourceful" civic leadership, which had surmounted various obstacles to develop an airport, the first large city airport financed without federal aid since the Federal Airport Act had been passed by Congress in 1946.

51. The lecture, delivered originally to a reunion of Conwell's regiment in the 1870s, has been reprinted many times. See, for example, *Acres of Diamonds: Russell Conwell's Inspiring Classic About Opportunity*, ed. William R. Webb (Kansas City, Missouri: Hallmark Editions, 1968).

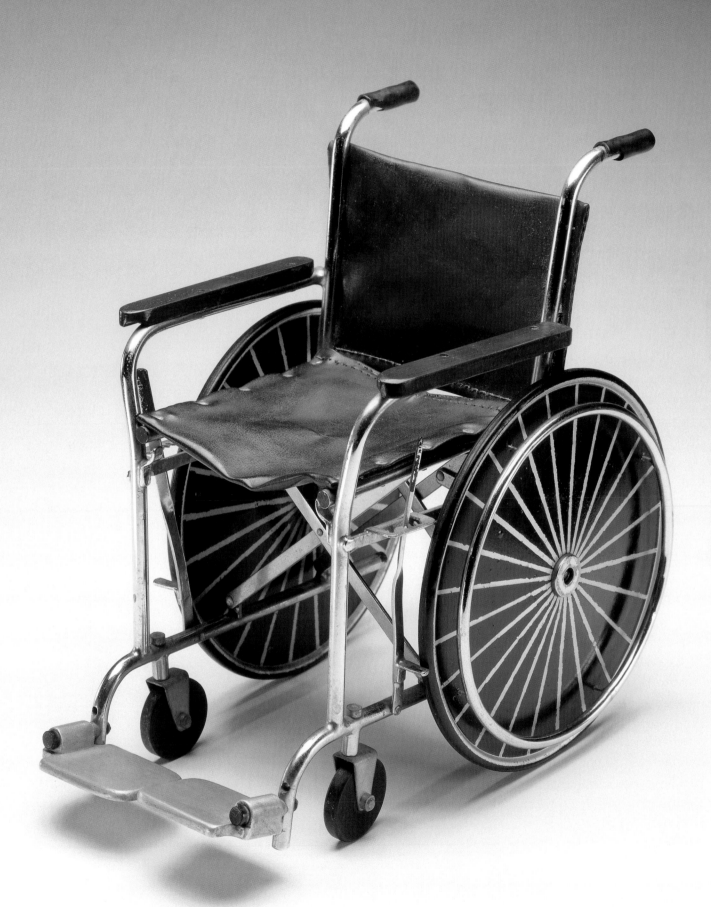

Dennis P. Doordan

TOLEDO TOMORROW

Banner headlines in a special edition of the *Toledo Blade* announced the opening: "Eyes of the Nation on Toledo Tomorrow." The list of official hosts for the special preview reception was a who's who of Toledo industrialists and included the presidents or board chairmen of Toledo Scale, Libbey-Owens-Ford Glass, Owens-Corning Fiberglas, Willys-Overland, Owens-Illinois Glass, Electric Auto-Lite, and Champion Spark Plug.[1] The governor of Ohio attended and hailed the event as a "gigantic step" toward meeting the challenge of the future. As visitors entered the exhibition in the Stratford Theater on the grounds of the Toledo Zoological Park, they heard a soothing voice coming from a specially installed sound system:

> Welcome, ladies and gentlemen, to Toledo Tomorrow.
> The fairyland you see before you is your own city, bathed
> in the slanting rays of the late afternoon sun. There have
> been many changes from the city of yesterday . . . it is still
> Toledo but it is Toledo of Tomorrow, as men of imagination,
> imbued with the driving spirit of progress, have visualized
> it could be.[2]

The date was July 3, 1945, and Toledo's future never looked brighter.

Toledo Tomorrow, the focus of all this attention, was a giant model fifty-nine feet in diameter depicting Toledo transformed by a major reorganization of the city's transportation infrastructure (plate 1). At the scale of one inch equals one hundred feet, the model showed an area of approximately 150 square miles. Limited-access expressways crisscrossed the metropolitan area, allowing traffic to flow smoothly across the city. A new passenger depot—described as the first of its kind in the nation—located only minutes from the city's center, served air, rail, and bus travelers in a single terminal (plate 2). Additional new airports for commercial, private, and air freight services were distributed around the city. Rail lines serving Toledo were consolidated, the number of at-grade crossings in the city reduced, and a new freight depot and

marshaling yard created. Heavy industry was relocated away from the Maumee River or concentrated in an area near the river's mouth, which allowed extensive stretches of the river frontage to be redeveloped as parkland (plate 3). New port facilities were created at the mouth of the river and integrated with the revised rail system, thus reducing the congestion that resulted from raising bridges to accommodate river traffic. Finally, street patterns were altered so that small neighborhoods could be consolidated into "communities" based on larger block sizes (plate 4).

Sponsored by the *Toledo Blade* and created by designer Norman Bel Geddes, Toledo Tomorrow was an ambitious effort to set the course for Toledo's postwar development by providing the citizenry of Toledo with a vivid image of their city as envisioned by "men of imagination." While the exhibition was indeed long on imagination, it was short on details. The *Toledo Blade* published a brochure in conjunction with the exhibition that described the various elements of the plan, but left unspecified the date of "tomorrow"; the text alluded to a time "10, 20 or even 50 years in the future." The brochure encouraged visitors to view the model "not as a blueprint for the city's planners and builders, but as an inspiration for future living."[3] No attempt was made to estimate the cost of achieving the goals outlined in the proposal. Instead, the brochure suggested, the real question was not cost but rather whether Toledo could afford *not* to do the things described in the model. In the absence of any legally sanctioned mechanism to finance or implement its proposals, the entire project can best be described as an exercise in civic boosterism. As such, it is an excellent example of the alliance of art and industry that is at the heart of the story of twentieth-century design in Toledo. It also belongs to a tradition of visionary urban plans that crystallize planning ideals at different moments in the nation's history. Finally, Norman Bel Geddes's participation in the Toledo Tomorrow project also illustrates the changing role of designers in modern society.

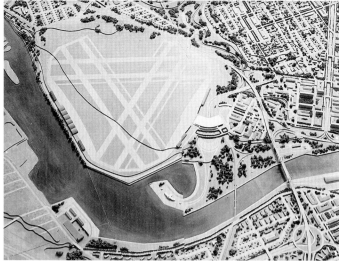

Plate 1
Norman Bel Geddes for Norman Bel Geddes & Company, Inc.,
Frank Scherschel, photographer, *Toledo Tomorrow: The Anthony
Wayne Bridge and Shoreline of Maumee River*, 1945
gelatin print
7 × 9⅜ inches
The Norman Bel Geddes Collection, The Performing Arts Collection,
Harry Ransom Humanities Research Center, The University of Texas
at Austin, by permission of Edith Lutyens Bel Geddes, Executrix

Plate 2
Norman Bel Geddes for Norman Bel Geddes & Company, Inc.,
Frank Scherschel, photographer, *Toledo Tomorrow: Airport and
Terminal (Union Tri-Terminal Depot)*, 1945
gelatin print
6⅞ × 9¼ inches
The Norman Bel Geddes Collection, The Performing Arts Collection,
Harry Ransom Humanities Research Center, The University of Texas
at Austin, by permission of Edith Lutyens Bel Geddes, Executrix

Plate 3
Norman Bel Geddes for Norman Bel Geddes & Company, Inc.,
Frank Scherschel, photographer, *Toledo Tomorrow: The Anthony
Wayne Bridge and Shoreline*, 1945
gelatin print
9¼ × 6¾ inches
The Norman Bel Geddes Collection, The Performing Arts Collection,
Harry Ransom Humanities Research Center, The University of Texas
at Austin, by permission of Edith Lutyens Bel Geddes, Executrix

Plate 4
Norman Bel Geddes for Norman Bel Geddes & Company,
Inc., Frank Scherschel, photographer, *Toledo Tomorrow:
Express Highways—Woodville in foreground*, 1945
gelatin print
9¼ × 6⅞ inches
The Norman Bel Geddes Collection, The Performing Arts Collection,
Harry Ransom Humanities Research Center, The University of Texas
at Austin, by permission of Edith Lutyens Bel Geddes, Executrix

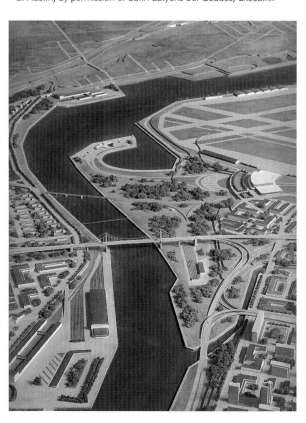

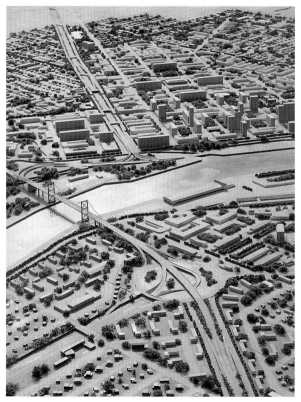

The Genesis of Toledo Tomorrow

In the wake of the Columbian Exposition of 1893, the ideals of the City Beautiful Movement influenced American planners. The Senate Parks Commission Plan of 1902 for Washington, D.C., and Daniel Burnham and Edward Bennett's 1909 Plan for Chicago are two examples. These plans called for monumental boulevards and imposing public spaces lined with classically inspired architecture. In the 1920s a different conception of planning, based on skyscrapers, emerged. The architectural delineator Hugh Ferriss captured the idea of skyscraper urbanism in his 1929 book *The Metropolis of Tomorrow.*[4] The creation of New York's Rockefeller Center in the early 1930s is one of the best examples of this approach. Toledo Tomorrow reflected the growing concern among planners in the late 1930s for facilitating the flow of traffic.

The impetus for the creation of Toledo Tomorrow came from Paul Block, Jr., publisher of the *Toledo Blade.* Concerned about Toledo's image, Block began a campaign to create positive impressions of the city. In 1944 the *Toledo Blade* published in various trade journals and several New York newspapers a series of full-page advertisements promoting the city. These were collected and published, along with a statistical description of the city's economy and population, in a special pamphlet entitled *This Is Toledo.*[5] In its brief historical account, the Depression was identified as the low point in the city's recent history.

> After a century of progress, the city seemed to have halted, indeed to have turned backward. Decreasing population reflected the trend away from, rather than to, the city, which suffered from the reputation—whether or not fully deserved—of a city on the decline.[6]

Block was convinced that Toledo had weathered the worst, and he was interested in a dramatic gesture that would signal the city's resurgence.

In March 1944 Block commissioned Norman Bel Geddes to prepare a study suggesting future developments for Toledo. His choice of Geddes for the job is not difficult to understand. Geddes was a familiar name in Toledo both socially and professionally. His first wife, Helen Belle Sneider, was from Toledo, and Geddes had previously done work for Toledo Scale Company (see Meikle, "Weighing the Difference," pp. 133–37). In addition, Geddes's recent accomplishments included the Futurama exhibit sponsored by General Motors at the 1939 New York World's Fair.[7] The enormous Futurama model, envisioning an American metropolis and surrounding region in 1960, was widely acknowledged to be the most popular exhibit at the fair.[8] The terms of the initial contract were vague. Geddes was asked to study the future needs of Toledo and present the results in the form of a model. The contract specifically called for a model that "should be inspirational to the people of Toledo . . . [and] of such a nature as to provide excellent publicity."[9] The contract specified a

time frame of between six and nine months for completion of the project. In return Geddes was to receive a fee of $50,000 plus travel expenses.

The project provided Geddes with an excellent opportunity to apply to a specific American city ideas about city planning, traffic control, and exhibition design that he had been working on since the late 1930s. In 1936 Geddes had been commissioned by Shell Oil to create material illustrating ideas for traffic planning as part of an advertising campaign. Geddes created a model city of the future to describe his solutions.[10] Triangular in plan, it measured six feet on a side and was done at the scale of one inch equals one hundred feet. Three years later he expanded on the ideas developed in the Shell Oil model for the Futurama exhibit at the New York World's Fair.[11] This time the model was huge, covering almost 36,000 square feet. Visitors to the Futurama were seated in high-backed chairs that moved over the exhibit on an elevated track. A synchronized audio tape described each part of the model as the visitors glided by. The central design problem addressed by both the Shell Oil and Futurama models was traffic congestion. Drawing on recent research on traffic problems, Geddes separated pedestrian from vehicular traffic, established different types of streets for different types of travel, and threaded limited-access high-speed motorways through his idealized cities of the future. Geddes followed these successes with the publication, in 1940, of *Magic Motorways,* a comprehensive review of the history, present condition, and future possibilities for automotive travel in the United States.[12]

For Toledo Tomorrow, Geddes recruited a team of expert consultants: Alexander De Seversky for aviation matters; the former general manager of the 1939 New York World's Fair, W. Earle Andrews, for highway engineering; Henry Matson Waite, native Toledoan and the engineer responsible for the design of Cincinnati's Union Terminal, for railroad planning; and Geoffrey Noel Lawford and O. Kline Fulmer for housing and community planning questions. Even before these experts completed their preliminary review of conditions in Toledo, Geddes advised Block that the model would cost more than the original contract price. In a letter to Block, dated April 18, 1944, Geddes described his intention to create a model seventy feet in diameter. Negotiations between Block and Geddes continued through the summer and early fall; in November 1944 they signed a new contract,[13] which specified a model fifty-nine feet in diameter and added an additional $26,950 to the original design budget of $50,000. Fabricated of plywood and roughly circular in plan, the model consisted of forty-seven panels, each measuring four by six feet, which could be assembled, like pieces of a puzzle, to create a giant model of Toledo. Ninety percent of the model's surface was left flat and painted like a map; the remaining 10 percent was built up three-dimensionally to show over five thousand buildings, bridges, highways, and transportation facilities in the city's center.

The model was constructed in Geddes's New York office and shipped to Toledo for installation in the Stratford Theater at the zoo. In designing the installation, Geddes applied to great effect his recent experience with the GM Futurama. Visitors were invited to imagine themselves flying over the city in an airplane at an altitude of ten thousand feet as they moved through the exhibit along an elevated walkway. At five points, audio presentations directed the viewers' attention to different features of the model. A special sound system for the exhibit was designed and installed by Sweeney Sound Engineering, a Toledo-based company that had extensive experience with exhibition sound systems and had previously designed special installations for the 1939 New York World's Fair.

Sweeney Sound was not the only Toledo company involved with the Toledo Tomorrow project. To prevent the overlapping of sound from different listening posts, Owens-Corning Fiberglas provided insulating panels for each station. One of the exhibit's most dramatic features consisted of a special nighttime effect. Toward the end of the visitors' "flight," the lights were dimmed to suggest night. At the same time special ultraviolet lamps were turned on, illuminating the network of highways and transportation facilities, which were covered with a special fluorescent paint. Toledo's future literally glowed in the dark!

The *Toledo Blade* Interprets the Exhibit

Following a special preview on July 3, Toledo Tomorrow opened to the public on Independence Day 1945 and remained on view until Columbus Day, October 12. Not surprisingly, since it was the official sponsor, the *Toledo Blade* devoted extensive coverage to the exhibit. Each day during the exhibit's run, the paper featured articles describing various aspects of the model and reporting public reaction. Generally articles about Toledo Tomorrow were carried on page three of the front section, although coverage of special events such as visits by prominent politicians usually made the front page. The depth of coverage is significant; in its enthusiastic support of Toledo Tomorrow, the *Toledo Blade* went beyond simple reportage and actively interpreted the meaning of the exhibit for the reading public.

It is possible to discern three interrelated themes in the *Toledo Blade*'s coverage: cities that failed to change with the times would stagnate, the future would be different from the past, and Toledo should be a model for other cities. In its coverage of Ohio Governor Frank J. Lausche's address at the press preview on July 3, the *Toledo Blade* identified one of the exhibit's central themes: "that cities which fail to plan for their own regeneration after the war are destined for oblivion. . . ."[14] The second theme, the shape of the future, was very much on the minds of the newspaper's writers and editors. Toledo Tomorrow was dedicated to the memory of Toledo's war dead and "to the future happiness of those men and women who will return."[15] Articles on the exhibit provided a

pretext for predictions concerning the changes ahead for those returning men and women. In mid-September, for example, the *Toledo Blade* ran a five-part series labeled "The World of Tomorrow" written by George Ziekle, the newspaper's Washington, D.C., correspondent. "For practically every peacetime pursuit," Ziekle wrote, "there'll be a fancy, novel way to make things easier and more enjoyable."[16] He described dramatic advances in various fields, including travel, energy, communications, food preparation (frozen food!), and new synthetic fabrics that would revolutionize clothing design. In addressing the third theme, the importance of Toledo Tomorrow as a model for other American cities, the *Toledo Blade* reported on visits by planners from other cities, including Detroit, Cleveland, Youngstown, and Rochester, as well as journalists from across the nation.[17] In September, Julius Krug, chairman of the War Production Board, viewed the model. His comments were featured prominently in the *Toledo Blade:* "All of the nation's older industrial cities must be rebuilt and Toledo Tomorrow can provide the inspiration they need to tackle the job of transforming themselves."[18]

Criticisms of the model and the ideas it embodied were not to be found in the pages of the newspaper. Instead, letters to the editor and man-in-the-street interviews projected a uniformly positive response to the exhibit. One visitor was described as having been surprised to realize that her current home was located on the site of the proposed new passenger airport—but she was willing to move. According to the reporter, this public-spirited citizen realized "that the value of such a master plan was immeasurable and she wouldn't mind being one of the persons inconvenienced if she could just see some of the projects realized."[19] One of the most poignant episodes in the *Toledo Blade's* campaign to drum up public support for the Toledo Tomorrow plan occurred in October as the exhibition was drawing to a close. At the newspaper's invitation, an African-American family toured the exhibit. *Toledo Blade* writer William Kitay wrote two articles describing the visit of Alfred Stuart and his family.[20] Like everyone else, Stuart, a city fireman, was suitably impressed by the model and the vision of the city's future it depicted. But his reaction was also one of the few times the *Toledo Blade* hinted at the gap between a vision of the future and the existing social reality of race relations in the city: "It's ironic, said Mr. Stuart as we stood on the ramp looking down on the future, that man can create a wonder as this, and then nullify physical progress because hearts aren't in the right place."[21]

The Role of the Designer

While the *Toledo Blade* was the official sponsor of Toledo Tomorrow, Norman Bel Geddes was the designer, and he demonstrated a proprietorial attitude concerning the project. The original contract specified that Geddes was to be identified as the designer in any

publicity surrounding the project, and Geddes's office jealously protected this credit. When some advance publicity described the Toledo Tomorrow model as "furnished by" Norman Bel Geddes, Sanford Johnson, the managing director in Geddes's New York office, wrote to Daniel Nicoll, associate publisher of the *Toledo Blade,* to complain:

> All publicity that we have read to date has referred to the contribution of Mr. Geddes as furnishing the model. The fact is he is completely responsible for having had the vision to persuade you people to do this thing, to do it the way it has been done, to bring in all of the consultants . . . for the coordination of the diversified contributions of these consultants and those persons in our own organization. The fact that he believed the presentation would be more effective if made into a model, than in a series of drawings, is incidental to the above and should not be featured over the above in reference to his contribution to the Toledo plan.[22]

Norman Bel Geddes's efforts to ensure recognition of his distinctive role in the project reflect more than personal hubris or a businessman's understanding of the value of publicity. Geddes's career spans a critical era in the emergence of the designer as a key figure in the modern industrial culture.

From its beginning as a trade activity practiced by largely anonymous craftsmen, design emerged in the first half of the twentieth century as a recognized profession with explicit claims to specialized skills and expertise (see Heskett, "The Emergence of the Industrial Design Profession"). The history of design in Toledo provides ample evidence of this evolution. Shop-based technicians on the payroll of major Toledo companies contributed to the refinement of particular product lines. Often these early designers worked directly on the factory floor, and their names were seldom if ever acknowledged in company literature or marketing campaigns. In the second quarter of the twentieth century, however, industrial designers like Norman Bel Geddes, Harold Van Doren, Donald Deskey, Freda Diamond, and Raymond Loewy (plate 5), all of whom worked with Toledo companies, began to create independent design offices. Rather than work exclusively for a single company, these designers established consulting relationships with multiple companies and worked on a variety of products (plates 6–14). The lab coat or shop apron gave way to the smartly tailored business suit as designers claimed the status of professionals and companies began to feature the identity of designers in promotional literature (see Taragin, p. 168). Central to the evolution of design from a craft-based activity to a profession was the recognition that design involved distinctive intellectual as well as manual skills. It was his imagination and creativity, not his manual skill at model making, that recommended Norman Bel Geddes to Paul Block, Jr. Toledo Tomorrow, however, was

Plate 5
Raymond Loewy Associates, *Sales Sample for Dune Grass,* 1957
F. Schumacher & Co.
three-color screenprint and silver metallic ink on Fiberglas fabric
37 × 25¼ inches
F. Schumacher & Co., Archives Collection

Raymond Loewy Associates' involvement assured that a product would be stylish and draw media notice. This *Dune Grass* Fiberglas fabric for Schumacher, a maker of fine textiles since the late nineteenth century, was part of the Cosmopolitan line promoted in an appropriately decorated New York suite. The soft, Oriental-inspired pattern, also available in a wallpaper, was featured as a shower curtain. This sales sample originally shimmered with metallic ink. Since Fiberglas threads do not accept dye, manufacturers developed new printing techniques to enhance the material's lustrous qualities.

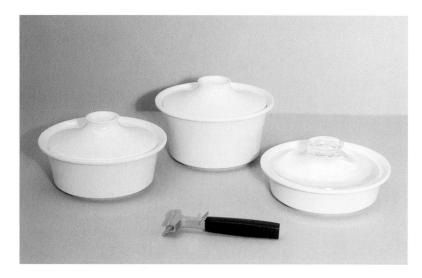

Plate 6
Gerald Gulotta with James Fulton for Raymond Loewy/William Snaith Inc., Prototypical Samples for Libbey Ware, ca. 1963
photo panel

Plate 7
Gerald Gulotta, Patent Drawing no. 197,574: Casserole or Similar Article—Filed July 15, 1963

Gerald Gulotta, Patent Drawing no. 197,575: Cover for a Casserole or Similar Article—Filed July 15, 1963

photo panels

The patent drawing shows the deeply recessed knob formed by the molding of the glass material. The glass lid proved expensive and complex to produce.

Plate 8
Gerald Gulotta with James Fulton for Raymond Loewy/William Snaith, Inc.
Libbey Glass, Division of Owens-Illinois, Inc.

Three-Quart Saucepan, Freeze, Cook, Serve Libbey Ware, 1963
glass-ceramic material
4⅞ × 11 × 9⁷⁄₁₆ inches
Collection of Jim and Linda Tippett

Production Prototype for Libbey Ware, 1963
glass-ceramic material
3⁵⁄₁₆ × dia. 9⁷⁄₁₆ inches
Gerald Gulotta

The Loewy organization designed this two-color applied floral pattern for Libbey cookware after conducting a study of consumer preferences of cookware shapes and decorations. Although Libbey was attempting to compete with Corning's popular freeze, cook, and serve Corning Ware line, it could not match Corning's variety; furthermore, Corning challenged Libbey's glass-ceramic material as a patent infringement to its own versatile Pyroceram. Faced with Corning's market dominance, Libbey abandoned its Libbey Ware line.

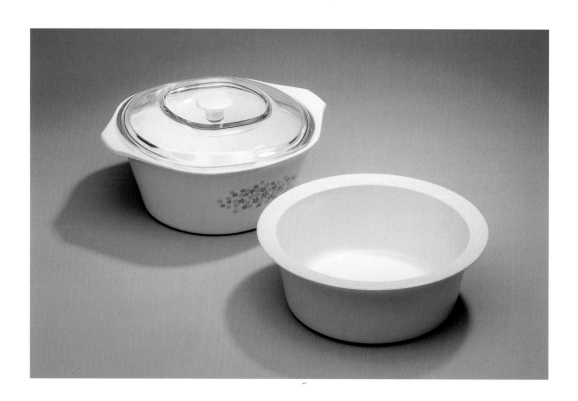

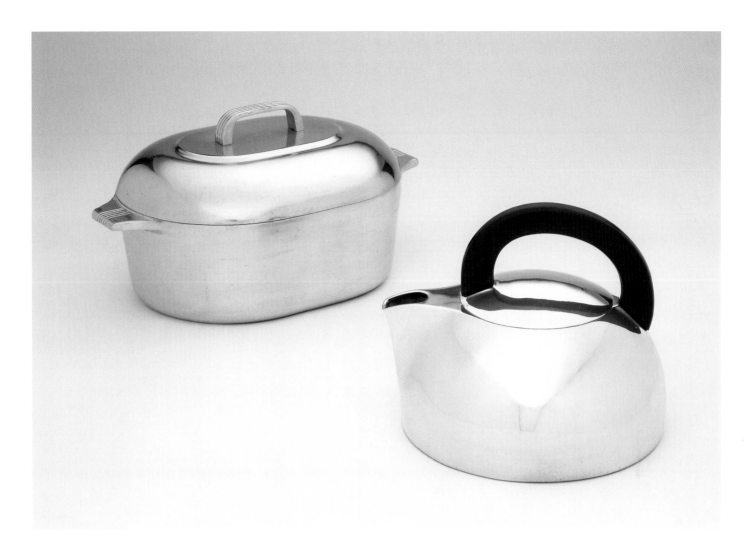

Plate 9
Van Doren and Rideout, *Magnalite Covered Casserole*, ca. 1934
The Wagner Manufacturing Company
aluminum and nickel alloy
8 × 15½ × 8¾ inches
Pamela Heskett

John Gordon Rideout for Van Doren and Rideout, *Magnalite Large Teakettle*, ca. 1933
The Wagner Manufacturing Company
aluminum, nickel alloy, and lacquered wood
8½ × 11 × 10 inches
Toledo Museum of Art, Museum Purchase

The Wagner Manufacturing Company made traditional cast-iron cookware in the nineteenth century and began producing aluminum ware at the beginning of the twentieth. Wagner introduced Magnalite, a patented magnesium/aluminum alloy, in the 1930s. John Gordon Rideout designed a series of cast cook-and-serve saucepans, roasters, and griddles notable for their modern appearance, flameproof handles, improved strainer lips, and vapor-tight covers.

Plate 10
Drawing for Magnalite Teakettle as It Appears in Harold Van Doren, Industrial Design: A Practical Guide *(New York and London: McGraw-Hill, 1940)*
photo panel

In his landmark textbook *Industrial Design*, written in Toledo and published in 1940, Harold Van Doren included drawings to show how geometric solids suggest modern products. Rideout's unusual teakettle was placed beside a coffee urn designed by Eliel Saarinen to demonstrate the elastic variations of the hemisphere and cylinder.

108 INDUSTRIAL DESIGN

HOW SOLIDS SUGGEST MODERN PRODUCTS
The cube and its elastic variations, called in geometry by the incredibly awkward name of "rectangular parallelepipeds,"

b *c*
FIG. 46.

FIG. 47a.

will probably be the most useful. Stoves, refrigerators, kitchen cabinets, even the kitchen sink, are generally variations of these forms. Down in the basement, however, the hot-water heater

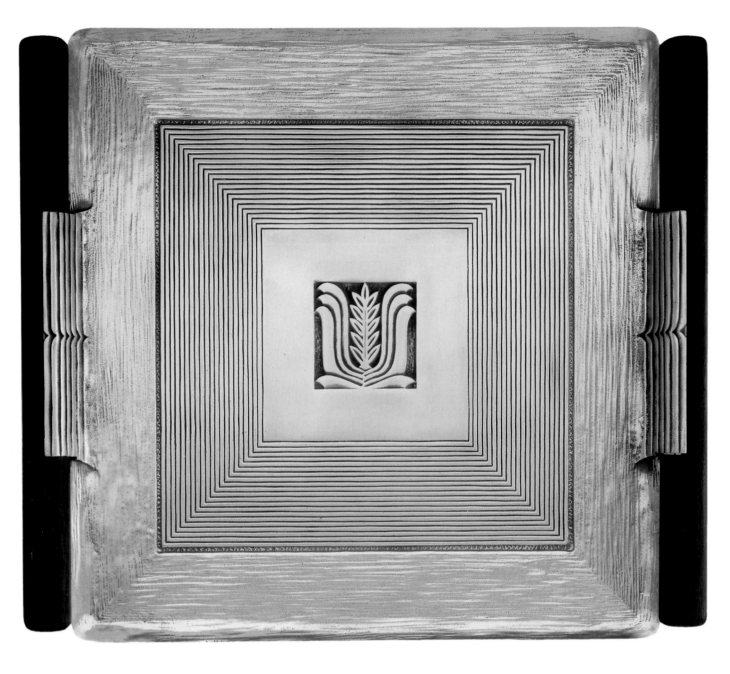

Plate 11
Rideout Giftware, Incorporated, *Prototype for Giftware Tray*,
ca. 1939
The Wagner Manufacturing Company
Lunite and Andes wood
1 × 17 × 15 inches
Alyce Gordon Rideout

John Gordon Rideout designed his giftware line around 1939
in response to other popular 1930s high-style aluminum and
chromium tableware, but the outbreak of World War II prevented
production. Rideout used Lunite, an aluminum alloy that would
cast properly and retain a nontarnishing, nonstaining finish.
These handmade, signed prototypes for mass production bear
the Moderne geometry and stylized floral ornament of the times.
The original models were carved in wood or wax, duplicated in
cast lead, and smoothed by hand-tooling. From the lead "master"
patterns, duplicate metal "working" patterns were made.

Plate 13
John Gordon Rideout, *Rendering for Wheelchair*, ca. 1950
Gendron Wheel Company
gouache and white chalk with graphite on cream paper, and
gray pulp board
21⅞ × 20¹/₁₆ inches
Alyce Gordon Rideout

Plate 12
John Gordon Rideout and Staff, *Drawing for Wheelchair*, 1943
Gendron Wheel Company
graphite on tracing paper
11½ × 10 inches
Alyce Gordon Rideout

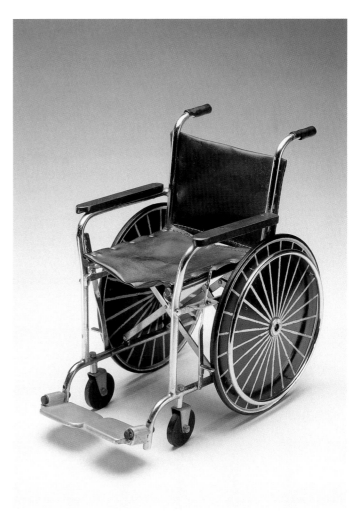

Plate 14
John Gordon Rideout and Staff, *Maquette for Folding Wheelchair*,
ca. 1943
Gendron Wheel Company
wood, rubber, oil cloth, copper, nickel, chrome-plated steel,
and aluminum
9 × 9¼ × 6⅛ inches
Frederic W. Strobel, Gendron, Inc.

After John Gordon Rideout left his partnership with Harold Van
Doren, he opened an independent practice in Cleveland in 1935.
His work with Van Doren in the early 1930s for The American
National Company led to his continued involvement with the
Gendron Wheel Company (its successor) through the 1940s. He
designed a series of disability chairs for Gendron, including mod-
erately priced, collapsible, tubular steel and fabric wheelchairs,
which were lighter than wooden chairs, were more comfortable,
and could fold compactly for storage or transportation.

not a product in the traditional sense of that word, and it demonstrates a further stage in the evolution of modern design.

Early in his career as an industrial designer, Norman Bel Geddes—like his fellow professional designers—applied his skills to the development or redesign of individual products in order to improve product performance and enhance sales. But there was no product for sale in Toledo Tomorrow; instead, Geddes was "selling" an idea: the rejuvenation of an entire urban area through the modernization of the city's transportation infrastructure. This was the same idea Geddes had promoted in the Futurama exhibit at the 1939 New York's World Fair, only now he applied the idea to a specific city—Toledo. Norman Bel Geddes had contributed to the evolution of design from a trade activity to a recognized profession. In addition to his numerous commissions for product design, Geddes's 1932 book *Horizons* did much to introduce the concept of professional design to the general public.[23] He used his considerable energy and imagination to push design beyond product-oriented work and to embrace the idea of design as a form of strategic vision. The creativity and imagination characteristic of designers equipped them, in Geddes's view, to integrate the disparate elements of large, complex problems such as city planning and to provide an integrated, comprehensive vision for the future. Geddes summed up his belief in the following passage from *Magic Motorways:*

> Masses of people can never find a solution to a problem until they are shown the way. Each unit of the mass may have a knowledge of the problem, and each may have his own solution, but until mass opinion is crystallized, brought into focus and made articulate, it amounts to nothing but vague grumbling. One of the best ways to make a solution understandable to everybody is to make it visual, to dramatize it.[24]

Toledo Tomorrow is an exemplary demonstration of Geddes's concept of design as "showing the way" through the dramatic visualization of the future.

Yesterdays' Tomorrow

Since inspiration and unfettered imagination rather than binding legislation and financial realism shaped Geddes's vision of Toledo Tomorrow, assessing the ultimate impact of the plan is difficult. Yesterday's tomorrows seldom live up to their press releases, and predicting the future is riskier than evaluating the past. The model's dominant feature, for example, the proposed giant airfield and tri-terminal serving aviation, rail, and bus travelers, located only five minutes south of the town center between the Anthony Wayne Trail and the river, was never built. Attempts to match Toledo today with the Toledo Tomorrow that Geddes described in 1945 rail line by rail line and overpass by overpass are disappointing. But Toledo Tomorrow was predicated on the idea—the vision—that in the not-so-distant future, American cities would be designed around mobility, advanced technology, and modern environments for living, working, and recreation, and one can argue that this indeed proved to be the animating vision for American planners in the two decades following the end of World War II. An interstate highway system based on limited access and high-speed motorcars was created. Civil aviation did emerge as a significant factor in the nation's economy and lifestyle. Advanced telecommunications have revolutionized the way Americans conduct business. City neighborhoods were transformed—often disastrously—by sustained campaigns of "urban renewal" and "slum clearance."

Norman Bel Geddes applied to his plan of Toledo Tomorrow the same design values—efficiency, economy, and technological sophistication—as he did to many of the products on which he worked during his career. But a city is not a product or a business system, it is a community of human beings; and the quality of life cannot be gauged by the speed with which traffic moves through and around the community. The audio commentary that accompanied the Toledo Tomorrow model assured visitors to the exhibition: "If only a part of this master plan were brought to fruition, your Toledo would be a better city." Ultimately, the future of a city depends upon the commitment of its people and institutions to working together. This was certainly one of the themes of Toledo Tomorrow. As the citizens of Toledo celebrate the centenary of the Toledo Museum of Art and review a century of design in Toledo, they have every right to feel a sense of pride in the city's rich design heritage.

1. "Eyes of the Nation on Toledo Tomorrow," *Toledo Blade Special Edition*, July 3, 1945, p. 1. Official hosts for the Toledo Tomorrow Preview Reception included Hubert Bennett, president, Toledo Scale Company; John D. Biggers, president, Libbey-Owens-Ford Glass Company; Harold Boeschenstein, president, Owens-Corning Fiberglas; Ward M. Canaday, chairman of the board, Willys-Overland Motors, Inc.; William E. Levis, chairman of the board, Owens-Illinois Glass Company; Royce Martin, president, Electric Auto-Lite Company; and Frank D. Stranahan, executive vice president, Champion Spark Plug Company.

2. Transcript of the Audio Program, Toledo Tomorrow, p. 1. Norman Bel Geddes Collection, The Performing Arts Collection, Harry Ransom Humanities Research Center, The University of Texas at Austin.

3. *Toledo Tomorrow: Created by Norman Bel Geddes and Associates* (Toledo: Toledo Blade, 1945), p. 1.

4. Hugh Ferriss, *The Metropolis of Tomorrow* (New York: Washburn, 1929).

5. *This Is Toledo*, 2nd ed. (Toledo: Toledo Blade, 1947). The advertisements reprinted in *This Is Toledo* appeared originally in the following publications: *Advertising Age, Advertising and Selling, Drug Trade News, Editor & Publisher, Food Field Reporter, New York Herald Tribune, New York Times, Printers' Ink, Sales Management, Standard Rate and Data, Tide, Toledo Business News,* and *Women's Wear Daily.*

6. Ibid., p. 33.

7. For more on the career of Norman Bel Geddes, see Jeffrey L. Meikle, *Twentieth Century Limited: Industrial Design in America, 1925–1939* (Philadelphia: Temple University Press, 1979).

8. "What Shows Pulled at the Fair?" *Business Week*, November 4, 1939, pp. 22–28.

9. Contract between Norman Bel Geddes & Company and the *Toledo Blade*, March 20, 1944. Geddes Collection (note 2).

10. For more on the Shell Oil model, see Meikle (note 7), pp. 206–207.

11. For a thorough discussion of the background to the Futurama exhibit, see Roland Marchand, "The Designers Go to the Fair: Norman Bel Geddes, the General Motors Futurama, and the Visit-to-the-Factory Transformed," in Dennis P. Doordan, ed., *Design History: An Anthology* (Cambridge, Massachusetts: The MIT Press, 1995), pp. 103–121.

12. Norman Bel Geddes, *Magic Motorways* (New York: Random House, 1940).

13. Contract between Norman Bel Geddes & Company and the *Toledo Blade*, November 8, 1944. Geddes Collection (note 2).

14. *Toledo Blade Special Edition* (note 1).

15. *Toledo Tomorrow* (note 3).

16. George Ziekle, "Gadget-Loving Americans Are Facing Field Day in the World of Tomorrow," *Toledo Blade*, September 21, 1945, p. 15. The other articles in the series, all by Ziekle, were "Speed to Put Any Place Just Around Corner," September 17, 1945, p. 1; "House You May Have Dreamed About to Be a Reality in the World of Tomorrow," September 18, 1945, p. 5; "Wartime Inventions Will Make Life More Comfortable, Healthful, Safer," September 19, 1945, p. 6; "Radio of Future to Link Far Ends of Earth to Land, Sea, Air Travelers," September 20, 1945, p. 5.

17. "Crowds Flock into Model Despite Weekend Weather," *Toledo Blade*, July 16, 1945, p. 3.

18. "Toledo Model Can Give Inspiration to Cities of Nation, WPB Head Says," *Toledo Blade*, September 17, 1945, p. 3.

19. Dick McGeorge, "Model Visitors Are Enthusiastic over Toledo Tomorrow Projects," *Toledo Blade*, July 13, 1945, p. 3.

20. William Kitay, "Colored Family Sees Benefits to the City in Toledo Tomorrow," *Toledo Blade*, October 1, 1945, p. 3; "Stuart Wonders if His Children Will Be Part of Toledo's Future," *Toledo Blade*, October 2, 1945, p. 3.

21. Kitay (note 20), p. 3.

22. Correspondence, Sanford Johnson to Daniel Nicoll, June 28, 1945. Geddes Collection (note 2).

23. Norman Bel Geddes, *Horizons* (Boston: Little, Brown & Co., 1932).

24. Geddes (note 12), p. 4.

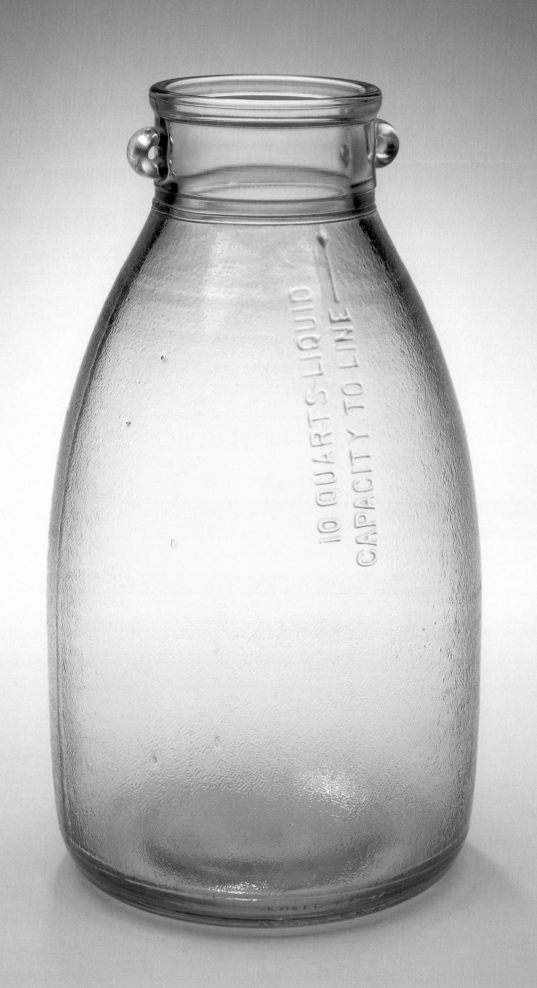

John Heskett

THE EMERGENCE OF THE INDUSTRIAL DESIGN PROFESSION IN THE UNITED STATES

In 1949 an industrial designer, Raymond Loewy, joined the pantheon of acknowledged achievement in American public and business life by being featured on the cover of *Time* magazine. "He streamlines the sales curve," proclaimed the caption. An accompanying article described industrial design as a field "which in less than a quarter-century has mushroomed from a groping, uncertain experiment into a major phenomenon of U.S. business."[1]

After another quarter of a century, however, industrial design, although still widespread as an activity in the business world, lost this prominence. How does one explain this trajectory of rapid ascent? Why was enthusiastic endorsement followed equally rapidly by comparative neglect?

On one level the emergence of industrial design can be seen as part of the process of specialization and division of labor that developed with the Industrial Revolution. Yet design emerged late in the process compared with other specialist practices such as engineering, which clearly surfaced by the early nineteenth century, and advertising, which in a modern sense evolved in the 1870s. So what specific stage of industrial development required the contribution of industrial design, and in what terms?

Earlier work on the question of why industrial design emerged as a specific form of practice has tended to emphasize the influence of the Great Depression that began in 1929 as the decisive factor. Although this undoubtedly accelerated the applications of design, the fact is that some major corporate and consultant design groups predated the Depression, with a clustering of some of the earliest around 1927. The roots of these developments therefore need to be traced back to other sources predating the crash. Two interrelated factors can be suggested as important: the first, a general pattern of development in American industry; and the second, a specific event, an earlier depression in 1920–21.

In the late nineteenth century, industrialization transformed every aspect of American life. Changes in technology—machinery, sources of power, such as coal and oil, and raw materials—were important, but it went much further. There were vast changes in communications, in how goods and people were transported and information transmitted, altering perceptions of space and time. Other changes were in economic organization, business structure and management, and finance and the structure of markets. A swelling flow of goods and services involved complex interrelationships with sweeping patterns of change in society—in the locations in which people aspired to live, the concepts of how they lived, their values, how they organized their homes, and the kind of life considered appropriate for them.

By 1920 a confluence of these changes was occurring. Large business organizations now dominated the American economy, and the technology of mass production and scientific management, based on time and motion studies, was transforming the organization of work. Electrical power was becoming widely available, providing extraordinary flexibility for both business and domestic uses, and the automobile enlarged individual mobility. A noteworthy outcome was a 300 percent increase in the total volume of manufactures in the United States between 1899 and 1929.[2] The proliferation of new products was especially strong in the new field of electrical domestic appliances that began to appear in very substantial quantities by the late 1920s, such as electric irons, refrigerators, washing machines, and radios. Other sectors also saw significant growth and attracted the attention of designers, such as products for industrial and retail use—the Toledo Scale Company is an outstanding example (see Meikle, "Weighing the Difference")—and packaging for a broad spectrum of goods, Toledo examples of which are Champion spark plugs and Libbey-Owens glass products (see Matranga, "Clear as Glass").

Up to this point, a range of people had designed the products of industry: practitioners known as industrial or commercial artists, engineers, draftsmen. Even early usage of the term "industrial design" can be confusing. A translation of a French work that appeared in

America in 1857 used the term as a synonym for engineering drawing.[3] The 1919 prospectus for the New York School of Fine and Applied Art announced: "A new three years' course in Industrial Design is offered this year. It is the result of constant enquiry by students and the various trades for practical decorative design work and for workers in textile, architectural detail, rugs, furniture and in other decorative objects used in everyday life."[4] The course content clearly remained rooted in nineteenth-century artistic training rather than in a new concept of design for industry. An article written in 1911 for the *Toledo Times* by Robert M. Corl similarly illustrates the attitude that in industrial practice at that time, design was essentially considered to be an artistic activity for primarily decorative purposes (see McMaster and Taragin, p. 11).

Significantly different ideas began to emerge, however, from the new competitive conditions facing American businesses after World War I. That conflict brought huge wealth to the United States, accelerating its emergence as a major world power. The end of the war in late 1918 released a pent-up demand for goods of all kinds. In 1920, however, the boom ended and the American economy ran into a serious downturn. Many companies had invested huge sums in mass-production capacity, requiring heavy interest and overhead costs, while overly optimistic production schedules created large inventories with no way of moving them. Many firms went bankrupt or were taken over. It was a sobering blow to confidence, and it was here that the general pattern of development intersected with the specific impact of this economic depression. Economic problems created enormous tensions in the social fabric of cities and industries, nowhere more clearly illustrated than in the industrial unrest that beset Toledo in the 1930s.

Above all, the depression underlined that, as a production system, mass manufacture was highly inflexible. It worked most efficiently and economically when large volumes were produced in constant flows. To fundamentally change products required retooling and physically rebuilding production lines, a disruptive, time-consuming, and costly process. Demand therefore needed to be effectively managed to keep large quantities of basically identical products selling cheaply.

This crisis of 1920–21 was consequently a turning point in the evolution of American corporations. To avoid being caught again in such a trap, many companies began developing techniques to accurately forecast future demand and adjust production flows accordingly. The clear logic was that mass production required mass consumption, and public taste had to be shaped accordingly. The concept of a "consumer society" began to emerge.

Advertising, which had itself emerged in the context of the growth in mass production and a national market, obviously had an important

Plate 1
"Selling in a Large Way" as It Appears in Glass Container Division Owens-Illinois Glass Company, Glass Containers, *n.d.*
photo panel

WHILE affording material for the best all around container which man has been able to devise, glass does not betray nature in that it allows perfect vision of its contents. All the enticement that there is in natural food coloring is visable—all the sparkle and clarity of pure water is apparent. Glass in the form of large bottles makes a most convincing and attractive display.

OWENS—ILLINOIS GLASS COMPANY

Selling In A Large Way

THE great machine that automatically brings large bottles to life dwarfs other ponderous bottle blowing mechanism. There is only one such in existence so that from no other source can be obtained large bottles of like perfection.

Imagine an arm of metal, capable of holding a large bottle mold weighing several hundred pounds, reaching into a huge furnace and extracting enough glass to form the walls and bottom of a big bottle. Then picture six of them steadily rotating, each picking up its charge of molten glass and in almost no time, depositing large bottles of a degree of perfection undreamed of a few years ago.

Anything very large or exceedingly small exerts an unusual pull upon the imagination of the average person. Large bottles therefore, being out of the ordinary themselves, command attention and are ideal for display purposes.

More recently large bottles have come into use for the preservation of foods and their display. Pickles, olives, meats in brine, fruit and vegetable pulp and even fruit itself find their way into large bottles. For many uses they are convenient and attractive because of their size. Their greatest advantages however are the two basic reasons for glass superiority—acid resisting qualities and transparency.

Hundreds of thousands of them are used for the transportation and dispensing of spring and mineral waters and great numbers fill the need for shipping and storing acids of commerce.

When molded into big bottles, speaking in the vernacular of the day, glass is still the ideal container—in a large way

OWENS—ILLINOIS GLASS COMPANY

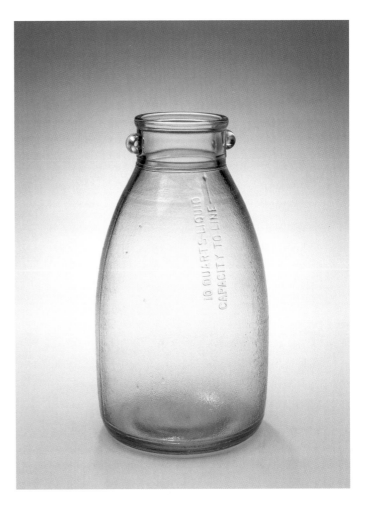

By the 1930s housework used more labor-saving devices and retail merchandising was more powerful than in earlier decades. Owens-Illinois's large, machine-made bottles created a healthful-looking, more colorful and appealing commercial display than canned goods. Seeing fruits and vegetables in clear containers in an era when homemakers still preserved large quantities of food was attractive to shoppers.

part to play in this scheme. By the early 1920s, advertising practitioners were probing new ways to induce the public to buy. The success of wartime propaganda campaigns in manipulating opinion, backed by psychological theories of subconscious, hidden desires revealed in the symbolic language of dreams, underscored the power of visual imagery as a manipulative tool, which implied a new emphasis on visual form in industrial manufacture (plates 1 and 2).

An early manifestation of this tendency was an increasing scale of monies spent on advertising to woo prospective purchasers with extravagant promises, as exemplified by the expenditures of the Willys-Overland automobile company, which was one of the factors encouraging the growth of design consciousness in Toledo (see Messer-Kruse, p. 36). It was then but a short step to refining manufactured forms to present distinctive advertising images—as modern, attractive, glamorous, convenient, hygienic, new, or improved—which could enhance marketing potential. This important early stage in the emergence of industrial design and business for advertising agencies on product improvement is illustrated as early as 1919 in work by West Coast graphic artist Joseph Sinel.

The effectiveness of persuasion waned, however, if products stayed on the market for a long time. The exhortations of advertisements fell on deaf ears if forms were too familiar. Changing product forms at intervals to stimulate interest and clearly differentiate them from competitors' offerings was therefore increasingly seen as a solution to such problems. It was in this context that commissions to design products and packaging rapidly multiplied.

The Growth of In-house Design

If, in general terms, the emergence of industrial design can be seen as part of an attempt by mass-production industries to assert control over new market conditions, the role of industrial management in the evolution of industrial design requires recognition. The commitment and support of leading industrialists for the Toledo Museum of Art is an outstanding example. The number and prestige of those who sat on the museum's board, and the way in which the interests of their companies, through the development of design capabilities, were reconciled with a broader social commitment, suggests that this was not simply a brash commercial appropriation of aesthetic values. It has often been derided or overlooked, however, in accounts that heavily emphasize the role of independent consultant designers as that of some kind of free artistic spirit.

In Europe, indeed, new theories and practice in design emanated from artistic movements, such as de Stijl in the Netherlands or the group in Germany associated with the teaching institution the Bauhaus. These generally sought to impose their views on industry, but with very limited success. In the United States, in contrast, such artistic concepts were not central to the development of design. Although The Museum of Modern Art in New York sought in the 1930s to play a role comparable to that of European artistic movements, with a heavy emphasis on Modernist functionality, the major criterion in American design remained the reconciliation of aesthetic concerns with profitability.

Independent consultants were indeed important figures in this story, and their role will be described later, but the significant difference in contrast to Europe was the scale of change that occurred in industrial companies. Indeed, it can be argued that the need for new design competencies in the United States was first recognized by business managers responding to changing competitive conditions.

It was in the automobile industry that this process of redefinition was most clearly identified. The initial breakthrough in organizing

the mass production of automobiles was, of course, the great achievement of Henry Ford. Of equal importance, however, was the role of Alfred P. Sloan, who redefined the market for mass-produced automobiles and also powerfully influenced concepts of design in corporate contexts.

Ford's immense success lay in producing one basic vehicle, the Model T, which, as far as he was concerned, needed no improvement. All that was required was to continually reduce cost. Whether Ford actually uttered the apocryphal statement attributed to him, "You can have any color you like, as long as it's black," his product philosophy gave it credibility. Ford's approach worked remarkably well for as long as he was the sole mass producer of automobiles and dominated the market—in other words, while he had no effective competition. When other companies built mass-production facilities, however, the situation became more volatile.

General Motors had survived an inventory crisis in 1920, but not without severe problems. Sloan, who was elected president of General Motors in 1923, realized that avoiding a repetition meant managing demand. He was also intent on challenging the leadership of Ford. To achieve both ends implied attempting to understand the market not as one amorphous whole, but as a series of distinctive segments, for which Sloan evolved a strategy of product differentiation as a crucial competitive tool. This seemed to contradict the need for standardization implicit in mass production, but the reconciliation of this contradiction was at the heart of his success. Of plans developed in 1924 for a new Pontiac that shared components with a Chevrolet model, he wrote: "Physical co-ordination in one form or another is, of course, the first principle of mass production, but at that time it was widely supposed, from the example of the Model T, that mass production on a grand scale required a uniform product. The Pontiac, coordinated in part with a car in another price class, was to demonstrate that *mass production of automobiles could be reconciled with variety in product.*"[5]

This was part of a broad strategy emphasizing several elements: installment selling, making purchasing easier; used-car trade-ins, to stimulate market growth and the sale of replacement parts; the closed car body, providing greater comfort than the Model T; and the annual model change, to stimulate demand. This last was the most controversial and became known as "planned obsolescence," but it was at the heart of managing the market. According to Sloan, the GM product-policy program of 1921 stressed "the very great importance of style in selling."[6] While changing external forms created an image of innovation, the underlying continuity of mass production in terms of engines, transmissions, and other engineering components could be maintained. Molds for the presses that produced body panels for the external form were indeed an additional expense, but far cheaper than a wholesale

reconstruction of the production line. There was therefore a trade-off between this extra cost and the benefit of a frequently updated image that Sloan considered worthwhile.

Problems of reorganizing GM prevented this concept from being fully implemented until 1926, when Lawrence J. Fisher, then general manager of Cadillac, met Harley J. Earl, a young designer with a Los Angeles custom car company, and invited him to Detroit to work on a new Cadillac model. The resulting vehicle appeared in March 1927. "The La Salle," wrote Sloan, "was the first stylist's car to achieve success in mass production."[7]

That same year, interestingly, also saw the final collapse of Model T sales, primarily under the impact of GM's new strategy. Henry Ford had stubbornly resisted suggestions that appearance mattered in car sales, but now, in a humiliating retreat, he was forced to totally close his plants and hastily design and retool for a new car. Ford survived, but leadership of the American automobile industry now decisively passed to GM.

The success of the Cadillac La Salle led to Harley Earl's permanent appointment as head of a new Art and Color Section at GM, which became the Styling Section in 1937, growing eventually to 1,400 people by the 1950s. At first, with few precedents for their work, the designers improvised. Gradually, however, as the section grew and Earl's power increased, he imposed his own approach in a uniform process. Initial concepts were developed by two-dimensional renderings, often of a dramatic nature, emphasizing ideas for front and side elevations. Three-dimensional clay models were used to develop ideas in detail as a basis for production specifications. Earl's preoccupation with external form and the use of solid clay models meant that interiors were an afterthought. It was an approach capable of creating a strong visual character, vital for advertising and marketing. Combined with the good engineering quality typical of the early decades of GM, it brought immense initial success. Earl's dictatorial approach and rejection of theory as irrelevant, other than the theory implicit in his approach, excluded any basic reconsideration of these methods. When engineering quality began to decline, an ever more fanciful external appearance proved to be totally inadequate against competitive attacks, particularly when the market opened up to foreign imports from Europe and Japan in the 1950s and 1960s. Nevertheless, the influence of GM on design practice in America was profound. As it was the largest company in the world with an enormous output in its own right, the design methods GM developed dominated not just the automobile industry, but also many other sectors, most notably consumer appliances.

Alexander Kostellow, a pioneering designer and educator who acted as a consultant for GM in the early 1950s, summed up the intimate link between styling and business: "When mass buying became

the very lifeblood and most important element in industry, there was created a demand for the type of artist who could design merchandise, both for mass production and mass consumption."[8] As a concept of design originating in industry, and validated by the most powerful and successful corporation of its time, styling had a powerful and profound influence. The sheer numbers employed at GM meant it was a major training source for a generation of American designers, who frequently went to work for other companies hoping to emulate GM's example. Sloan's widely read autobiography, published in 1963, with a chapter on "Styling," heavily conditioned the thinking of innumerable executives on what constituted design and how it could be applied in a corporate context. Ironically, however, this was precisely the point at which styling was facing a heavy challenge from new approaches to design developed by overseas competitors. In the 1950s, Volkswagen introduced the Beetle and a van that both made substantial inroads into the US market. Such concepts of small, efficient vehicles responded to many people's needs more effectively than the extravagant imagery emerging from Detroit in this period. This was followed by the Japanese invasion that brought standards of quality and convenience to a level at which American companies were hard pressed to compete effectively.

The Growth of Consultant Design

A second strand of development in the 1920s was in the rapid growth of design consultancies, founded by independent designers whose livelihood depended on providing services to businesses and, later, during World War II, to governmental clients. They originally shared many methods, concepts, and approaches with corporate designers, but a divergence began to occur as consultants gained experience and prestige. They began to see their role in terms wider than those encapsulated in the concept of styling.

Exactly how and when the first consultant designer in this sense emerged is almost impossible to establish accurately, but again, 1927 was a year in which several consultancies were founded. What occurred is best described in terms of a clustering of similar events, of companies recognizing a need in the new competitive situation of the time, and practitioners from a wide variety of backgrounds being drawn in to create the forms of industrial products. Within the wide range of experience, a necessary qualification for success was an ability to work in a commercial context. Of the first generation of designers who emerged in the late 1920s, Joseph Sinel, Lurelle Guild, John Vassos, George Sakier, Walter Dorwin Teague, and Raymond Loewy had all worked as commercial illustrators in one form or another. This background also largely explains why designers followed the organizational model of advertising by establishing independent consultancies. Egmont Arens had been a magazine editor, while Norman Bel Geddes and Henry Dreyfuss were well-known theater designers. Despite competing claims by early pioneers to have been the first "true" industrial designer, Arthur Pulos is probably correct in his assessment: "These pioneering industrial designers . . . were the result of this phenomenon, not its originators."[9]

Another source of designers, those from a decorative arts background, specializing in craft-based designs for traditional product areas such as furniture, ceramics, and glass, had more mixed fortunes. They tended to remain specialists, adapting their specific skills to particular manufacturing sectors, as with Gilbert Rohde in furniture and Russel Wright in housewares. Some, however, did respond to the breadth of new opportunities, most notably Donald Deskey.

Many stories of early designers' work, recounted with the benefit of hindsight and, not infrequently, with an eye to publicity value, tell of immediate, dramatic successes. Inevitably, some people unfamiliar by training or temperament were drawn into working on industrial products, and some disasters ensued. Nevertheless, the business world began to take notice. In 1929 an article on "modern art and its relation to business" in *Business Week* referred to radical changes in "our ideas of color and design." It stated that modern art's "advocates are constantly seeking shapes and objects which will lend themselves to the greatest impulse in industry—mass production." The article reflected the decorative arts approach of much work of the time, however, emphasizing products such as textiles and lighting, and noting the use by "the modernistic designer" of engineering and geometric motifs.[10]

Within four months, however, another article in *Business Week* took a diametrically opposite approach: "The burst of modernistic angles and jumbled lines of eight and ten years ago, even the flair for color of two years ago, has passed. Something more subdued, simple, practical is coming." Aggressive manufacturers, it noted, were using "stylizing" as a weapon in meeting competition, and the artist had become a businessman. "He contracts by the year as Style Advisor, or Art Counsellor. The style-conscious manufacturer is coming to depend on him." So many had "caught the new spirit" that to aid harried businessmen in finding "artists who could stylize their products," several organizations were acting as clearinghouses, among them the New York Art Center. New members enrolling in 1929—seven craftsmen, five commercial artists, three interior decorators, and ninety-five "designers of industrial art products"—indicated its effectiveness. Executives were criticized, however, for being conservative in appreciating the potential of design. "What they fail to recognize is that over the last ten years a small group of artists have applied themselves to industrial design, have faced squarely the old prejudices of the practical manufacturer against the creative dreamer; have gone into factories and studied and worked with engineers and chemists; have succeeded in supplanting the old domination of machine over design with a new coordination of effort."[11] The early ventures into design clearly had

enough successes to strike a vital chord, and as the impact of the Great Depression widened from 1929 onward, so greater numbers of desperate manufacturers increasingly looked to design for salvation. Some, such as the Toledo Scale Company from 1929 onward, sent employees to specialized courses at the Toledo Museum of Art in addition to commissioning work from independent consultants.

The connection between design consultancies and advertising meant that much early consultant work also stressed the "styling" of external forms. For example, when the American Gas Machine Company was advised to redesign an unsuccessful heater, N. W. Ayer, the advertising agency responsible for the product account, recommended Walter Dorwin Teague for the work. Introduced in 1933, Teague's redesign was publicized as "a neat example of externals." The new form, with unaltered internal parts, was claimed by the company to have resulted in a 400 percent increase in sales.[12] This language of the bottom line proved to be very effective, although in a situation of economic desperation and widespread ignorance of design, it frequently raised unrealistic expectations of what could be achieved.

In addition to the commercial evolution of styling, there were also hopes, couched more in aesthetic than business terms, that a new national style could evolve from business applications of design. Donald Deskey, who in addition to his early specialization in furniture was beginning at this time to take on work as an industrial designer, including glassware for Libbey, deprecated the American tendency to imitate Europe. In 1933 he strongly criticized the "modernistic" tendency to willfully apply motifs derived from the "hysteria created by the 1925 Paris Exposition" (now better known as Art Deco). This, he wrote, "merely touches the external aspects in surface pattern." In contrast, the work of designers such as Kem Weber, Joseph Sinel, Gilbert Rohde, and Russel Wright, among others, "helped form the new crystallizing modern style in America."[13] In a later draft for an article, Deskey reiterated this hope: "America now has the opportunity to establish a new style based upon American traditions, American methods and American ideals."[14] The public appetite for futuristic designs that would exemplify a new American way of life seemed insatiable, most notably with the New York World's Fair of 1939 (plate 3), but also in Toledo with designs such as the "Kitchen of Tomorrow" developed by Libbey-Owens-Ford in 1942, which achieved national prominence (see Matranga, pp. 187–89).

The influence of commercial applications of design rapidly grew, however, and was highlighted in *Fortune* magazine in early 1934. The author, although not credited, was George Nelson, himself to become a leading industrial designer. His article drew a distinction between traditional industries—the "Art Industries," such as textiles, pottery, and furniture that had long depended upon appearance for sales—and industrial design. The latter "came into being as mass production raised output to where, one after another, industries hitherto without

benefit of other than engineering design found their products matched by other manufacturers, and the market consequently glutted. Furniture and textiles, long taken for granted, had long sold on design. Now it was the turn of washing machines, furnaces, switchboards, and locomotives. Who was to design them?" The Depression was advanced as the cause that finally convinced many businessmen: "The product had to be made to sell itself. The designers were called in." The article pinpointed, however, an important feature of how design was evolving, for the men who "came to redesign the surface of the product, often stayed to suggest practical improvements. . . ."

A feature of the *Fortune* article was a list of ten designers, "chosen arbitrarily as typical and illustrative," showing their age, experience, compensation, staff, typical achievements, and clients or employers. Norman Bel Geddes had the largest staff, of thirty, while George Sakier was next with eleven. Interestingly, people later considered leading pioneers still had small offices: Henry Dreyfuss had a staff of five, Teague four, while Raymond Loewy had only one. Project fees for Geddes ranged from $1,000 to $100,000, but an overall mean figure was more in the range of $10,000–$20,000, with consultation rates ranging from $50 per hour (Dreyfuss) to $100–$200 per day (Lurelle Guild). Interestingly, designers employed by Toledo companies, notably Geddes and Teague, ranked among the highest paid at that time.

Fortune gave a detailed account of the new profession, citing successful projects resulting in sales and profits being increased and factory costs lowered. Concluding that "industrial design is certainly here to stay in a number of industries that knew it not before," a note of caution was also sounded. Because of the range of individual talents and approaches and no common basis of training for designers, ". . . the varying methods by which similar products are being designed raises the question of how this designing is going to be done."[15]

Meeting the growing demand for trained practitioners required an expansion of design education. Toledo again was in the vanguard of this movement, with early design courses adapted to the needs of local manufacturers first being offered at the Museum of Art in 1928. In addition, a considerable number of early designers from Toledo went on to careers in practice and education at the highest levels of the design profession (see McMaster and Taragin, pp. 12–18). Moreover, in what was a male-dominated profession in its early years, the success of Freda Diamond and her work for Libbey Glass was an important example of the potential for women in design, particularly since a very large proportion of designs were in practice intended for use by women (see Taragin, p. 166).

Another center of early design education was the Carnegie Institute of Technology in Pittsburgh, now Carnegie-Mellon University. In 1933–34 it had an optional course in industrial design taught by Alexander Kostellow that covered "special problems in the design of textiles and utensils, rendered drawings, details and execution."[16]

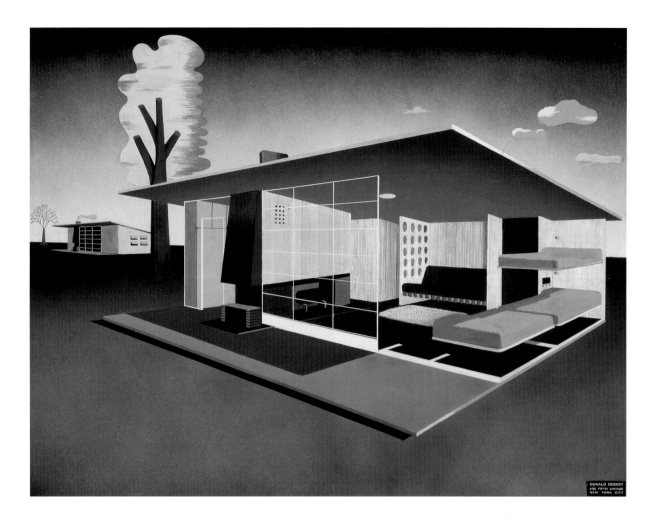

Plate 3
Donald Deskey, *Drawing for Sportshack*, 1940
gouache, partially airbrushed, stenciled, ink, and graphite on
illustration board
21^{15}/$_{16}$ × 29^{15}/$_{16}$ inches
Cooper-Hewitt, National Design Museum, Smithsonian Institution/
Art Resource, New York, Gift of Donald Deskey, 1988–101–1515

In 1940 New York designer Donald Deskey showed his prefabri-
cated weekend cabin Sportshack at the New York World's Fair
and in The Metropolitan Museum of Art's "Contemporary Amer-
ican Industrial Art" exhibition.

This was followed by a degree course in industrial design, believed
to be the first such in the world, established by Robert Lepper in 1934.
A Carnegie teacher, Donald Dohner, left for New York in 1936 to set
up a highly successful industrial design course at the Pratt Institute,
where he was later joined by Kostellow. Many other schools followed
these early examples.

Following this euphoria, by 1936 *Business Week* reflected a more
sober recognition of the role of design. A two-part article headed "Not
a luxury but an economy, not a fine art but a practical business" used
the examples of Dreyfuss' designs for New York Central's train *The
Mercury* and Loewy's streamlined boat for the Virginia Ferry Company
to proclaim that "America has definitely become design conscious."
Hundreds of manufacturers in many different fields, it asserted, were
"being forced to consider product alterations—forced literally into the
increased sales and decreased production costs which good design
guarantees." However, with design now regarded as a valid business
activity, practitioners found it necessary to disabuse manufacturers
"of the prevailing idea that design is something of a cross between
black magic and refined extortion. . . ."

Business Week went into considerable detail to debunk the miracle-
worker reputation and justified designers' fees by the range of their
work—examining production methods, materials, and function, sup-
plemented by marketing research and studies of products in use. Such
approaches were moving industrial design far beyond the corporate

concept of styling. Well-rounded design service, it said, "embraces
virtually every department of a business, even including legal aspects
and labor problems." Moreover, design was "proving its power to sell
not only articles of merchandise but such intangibles as service and
company reputations" (plates 4, 5, and 6). The article concluded: "But
the soundest foundation on which design builds for the future is its
unquestioned ability to determine what the public wants, to build
products to meet those demands, to cut cost in the process."[17]

Such a ringing endorsement was, of course, very gratifying to
designers, and undoubtedly the boom in design consultancy indicated
that the relationship of design to business had clearly moved very far
and fast from its origins in the 1920s. The more honest of them recog-
nized, however, that the period had not simply been a triumphal prog-
ress; gaining full acceptance in industry was still problematic. Harold

Plate 4

Champion Spark Plug Company

Designer unknown, *Champion Minute Spark Plug Cleaner Box with patented 1913 logo*, n.d.
blue and black lithographic printing on cardboard-bearing paper
6¹¹/₁₆ × 2 × 2 inches
Madison Avenue Galleries, Toledo, Ohio

Designer unknown, *Extra Range Spark Plugs 62S Box*, ca. 1936
color screen printing on cardboard-bearing paper
2½ × 6³/₁₆ × 3⅝ inches
Federal-Mogul Corporation

Lippincott & Margulies, *Spark Plug Box Containing Six Utility Line Type J-8 Spark Plugs*, ca. 1959
color screen printing on cardboard-bearing paper
exterior package: 2 × 5⅜ × 3½ inches; individual spark plug boxes: ¾ × 3 × 1 inch
Federal-Mogul Corporation

Designer unknown, *C-4 Champion Spark Plug Box with patented 1913 logo*, ca. 1932
blue and black lithographic printing on cardboard-bearing paper
3¹¹/₁₆ × 1⁵/₁₆ × 1⁵/₁₆ inches
Anonymous loan

Designer unknown, *J-18 Champion Spark Plug Box with patented 1913 logo*, ca. 1932
blue and black lithographic printing on cardboard-bearing paper
3¼ × 1 × 1 inch
Anonymous loan

The Champion Spark Plug Company, which moved to Toledo from Boston in 1910, grew with the young auto and aircraft industries and by 1914 was the world's largest spark plug manufacturer. With plants in several countries making spark plugs for many types of motors, the company's products spanned the globe, as its 1913 trademark indicated; the logo with the word "Champion" encircling the globe was patented in 1917. The logo evolved: for example, the Champion name formed as a "bow-tie" shape (based on the "x" form of a spark plug) was used in 1930s packaging with dense type; later, red accents were added to the blue and white color scheme. Company subsidiaries and divisions altered the logo for various uses and products, diluting the image, and by 1948 a restructuring of the corporate identity was undertaken. Lippincott & Margulies simplified the design, reinforcing the brand's association with dependability through a bold arrangement of the black Champion name inside a white "bow tie" on a black and red background.

Plate 5
Lippincott & Margulies, *Champion/
Pride and Dedication*, ca. 1980
Champion Spark Plug Company
plastic, metal, and wire
51⅞ × 73½ × 5¾ inches
Federal-Mogul Corporation

Plate 6
Lippincott & Margulies, *Dependable Champion Spark
Plugs 1961 Size Chart*, 1961
Champion Spark Plug Company
offset lithography and relief half-tone on paper
1/16 × 11 × 14½ inches
Federal-Mogul Corporation

Van Doren, whose work in Toledo features largely in its design history, when writing in 1940, gave a more skeptical view of how designers were regarded:

> Art, even combined with mechanical ingenuity and merchandising spark, is still suspect with some hard-boiled businessmen. It smacks of afternoon tea and Greenwich Village. Unfortunately there has been just enough slapdash superficiality masquerading as industrial design to give credence to their patently unjust conclusion that the entire brotherhood is a pack of incompetents.
>
> It may be a matter of years before the designer will find his proper level in the kingdom of commerce. To picture him as the savior of industry, the fair-haired boy with the magic wand who can always make sales curves hit the ceiling, is just as false as the opposite extreme. Somewhere between the two he will find his eventual place.[18]

This last point was probably demonstrated to great effect during World War II, when many designers working on war projects made significant contributions. In the period after 1945, however, some designers were to map out a more ambitious scenario for the application of their talents.

Industrial Design after World War II

On April 29, 1952, at Harvard University's Graduate School of Business Administration, a seminar organized jointly with the Society of Industrial Designers took place on the theme "Linking Business and the Consumer: Case Discussions in Industrial Design." Two sessions featured Procter & Gamble, with Donald Deskey, now senior partner of Donald Deskey Associates, and a senior executive from P&G; and Studebaker, with Raymond Loewy similarly partnering corporate executives.[19]

Such events were not unusual in the 1950s, when designers spoke frequently at Harvard and other major business schools. In business organizations and publications, designers regularly argued their role with clarity and conviction. They had established concepts, methods, and a professional style that was appropriate and acceptable in business circles. Neither did their efforts rest there, for ideas about the role of design continued to evolve. In that respect, both Deskey and Loewy provide examples indicative of this new trend.

As a furniture designer, Deskey was regarded as one of the best of his generation, but early on he also displayed a broad versatility. By 1937 he was functioning as a design consultant, later with offices on Madison Avenue in New York and top-drawer clients. Particularly in the realm of packaging for consumer products, his firm shaped many of the most vivid images of the consumer economy. But what is most striking is his thinking about the nature of design as a business and where its future lay.

The artist/designer, who in the early 1930s emphasized the need for a national style, now ran a successful business in a highly professional manner. Deskey clearly had developed into a businessman who understood design processes as involving many disciplines and needing to resolve a complex range of demands to satisfy both the client and the ultimate customer. He not only provided design skills, but was involved in discussions with major clients on future directions affecting their businesses. In addition, he was becoming a spokesman for industrial design at major institutions and events and was writing numerous articles articulating ideas about the contribution of industrial design to business and future directions.

One year after appearing at Harvard, he returned to Boston in 1953 to give a paper on "The Contribution of the Industrial Design Consultant" to a Product Design Seminar at the Massachusetts Institute of Technology. This talk outlined a concept of design going far beyond a concern with form, emphasizing instead the long-term viability of a client's business. Industrial design should not, he stressed, be confused with "styling," which was superficial and "a comparatively unimportant factor in the production process. . . ." Instead, a consultant should be a new pair of eyes for a client, his main function to set up and operate a long-range product design plan. The instability of consumer buying, constantly changing styles, speedier development of better products by competitors, and changing price structures all made such plans necessary. "Continuous change and development are, in fact, the essence of business progress, and no manufacturer can survive unless his product can at least meet current competition measured in terms of consumer acceptance." But every change involves risk, "and it is the function of the industrial design consultant to make recommendations that will reduce these risks to a minimum."

The new kind of designer Deskey had in mind was summed up at the conclusion of his speech:

> He is a kind of catalytic agent through which new creative thinking in management is combined with the latest knowledge of, and insight into, consumer trends to produce the most effective possible designs, production techniques and marketing programs. In short, his function is, or should be, to give his client that comparative edge in the market that can only be achieved through highly coordinated and imaginative planning.[20]

Deskey elaborated this concept on subsequent occasions. Six years later, in a draft document for an unidentified speech, he stated that it was time the ghost of "the impresario concept" of industrial design was laid to rest. He attacked "the false assumption that the industrial designer is an artist practising his art in the manner of a painter working alone and independently in a streamlined penthouse studio and that he personally creates with god-given genius every design to which

his name is attached." Instead, he claimed, "industrial design has been recognized by industry as a highly complex operation and has increasingly been assigned a high-level executive responsibility," with the role of working "with the management as a partner in planning basic long-range strategy."[21] In 1959, when addressing a New Product Seminar in New York, he elaborated on this idea, saying that the role of designers in planning was to evolve new products that met as yet unfulfilled consumer needs. "A product that does this," he emphasized, "automatically builds its own markets."[22]

Yet Deskey was clearly finding that harbingers of change were not altogether welcome in the halls of corporate America. His notes for another speech around the same time included a vehemently critical passage: "Perhaps the greatest frustration for the industrial designer today is the decisions of management based upon expediency, self-interest, fear of new ideas or new methods, and in general, the creation of a climate that inhibits design solutions based upon modern scientific approach through research, and a decision against a course of action merely because it hasn't been done in the past, that competition has not as yet done it, and that for this reason it could not possibly work or be successful."[23]

Deskey's advocacy of design as a high-level activity vital to the competitive future of corporations and his growing apprehension at the lack of competitiveness in many American firms was shared by Raymond Loewy, who similarly advocated "total planning" as a vital necessity in successfully executing design programs.[24] He also criticized a tendency of managers to prefer designs that echoed competitors' products, wryly commenting that "timidity and, even less, following-the-leader are not indicative of transcendental executive ability." Loewy also pointed to a decline in American manufacturing quality, with purchasers disillusioned after being attracted by external designs, only to find products unsatisfactory in use.

The emphasis on planning was also strongly featured in a 1958 review of design in *Business Week:* "The 'airbrush boys' of 20 years ago are now up to their ears in long-term planning for their clients." Industrial designers' work was described as extending to shaping whole corporations, reaching through concept, manufacture, distribution, and point of sale to the customer (plates 7–11). "Many manufacturers," the article continued, "find this breadth the designer's chief asset." The problems of change, however, could not be attributed only to managers. The article noted a degree of confusion in the ranks of designers, particularly those trained and practicing in styling-oriented skills, who were uncomfortable with this potentially enlarged role.[25]

Conclusion

In a New Year's review article for *Printers' Ink* in January 1960, Donald Deskey sounded a prescient warning on another sign of the times. "I believe that 1960 will see an accelerated list of new products on the American scene—but no longer as a near monopoly of American manufacturers. There will be an unprecedented demand on the talents of American industrial designers by foreign manufacturers determined to master techniques that will permit a deeper penetration of the U.S. market." He cited a proposed contract for his firm with a major Japanese corporation. "Requirements are not only for factors of design, product planning, diversification, and packaging, but they go deeper to include information on advertising and merchandising, market potential, mass-production techniques, and even automation." The firm was also prepared to make a major investment in production and distribution facilities. It was a proposal, in fact, that neatly illustrated Deskey's concept of long-range design planning. The answer, he believed, was for American companies to use creative talent, innovative products (plate 12), and knowledge of their home market to compete effectively. He again sounded a warning against the dangers of inertia and opposition to change that stood in the way.[26]

Such warnings went largely unheeded, however, and during the 1960s the role played by design in American corporate thinking waned, becoming widely reduced to a middle level, with the emphasis on executing ideas developed by others. Criticisms of American companies' unwillingness to compete on the basis of a broader understanding of creative ideas at a strategic level subsequently seemed justified as penetration by overseas competitors of the domestic market across a broad spectrum of product categories followed. The consequences of this failure to innovate have been bitter for a number of communities. Toledo, for example, has suffered its share of factory closings and the purchase of local companies as elements of conglomerates headquartered elsewhere.

To explain how and why this occurred is not simple, nor can it be suggested that design could have been some kind of unique economic panacea. In part this decline reflects a sense of complacency arising from the unprecedented success of American industry in World War II and in the boom years of the 1950s that followed. A parochial sense of well-being is not the best stimulus for innovative entrepreneurship. Another possible explanation is the manner in which quantitative methodology, in terms of financial techniques and marketing concepts, came to dominate management thinking and business school curricula. Design, and creative thinking generally, is not easily quantified, which sets it at a disadvantage in how it functions in corporate structures. In his book *The Reckoning,* David Halberstam comments on events at the Ford Company in the 1960s and 1970s, noting that "in most conflicts between the product people and their counterparts in finance, the advantage lay with the finance men. For the product men were arguing taste and instinct, and the finance people were arguing certitudes. It was an unfair match."[27]

The prevalence of the concept of styling also played a part in the loss of competitiveness by many American companies. As long as

Plate 7

Tom Geismar for Chermayeff & Geismar Associates Inc.,
Corporate Logo: Early Concept Sketches, ca. 1971
Owens-Illinois, Inc.
felt-tip marker on blue lined paper
10¹⁵⁄₁₆ × 8⅜ inches
© Chermayeff & Geismar Inc.

The New York firm Chermayeff & Geismar Inc. specializes in graphic design, corporate identification programs, architectural sign systems, and exhibition design for large corporations and organizations. This series of drawings shows the evolution of alternative solutions and a final concept for the Owens-Illinois corporate logo. In 1999 the Toledo Museum of Art commissioned Chermayeff & Geismar to conduct an identification study.

Plate 8

Tom Geismar for Chermayeff & Geismar Associates Inc.,
Corporate Logo: Ideas Being Developed, ca. 1971
Owens-Illinois, Inc.
felt-tip marker with black ink on tracing paper
9¹⁄₁₆ × 11¹⁵⁄₁₆ inches
© Chermayeff & Geismar Inc.

Because of confusion over the similarly named companies Libbey-Owens-Ford and Owens-Corning, and the many different activities and products within the Owens-Illinois organization, research suggested replacing the word "Illinois" with "International" or "Industries" in order to capitalize on the brand equity of the existing O-I symbol. However, a survey of staff and clientele led to the decision to retain the Owens-Illinois name and build the "O-I" symbol into a strong visual image similar to the well-known acronyms of IBM, RCA, and 3M.

Plate 9

Tom Geismar for Chermayeff & Geismar Associates Inc.,
Corporate Logo: Ideas Being Developed, ca. 1971
Owens-Illinois, Inc.
felt-tip marker, black ink, and graphite on tracing paper
8¹⁵⁄₁₆ × 11⅞ inches
© Chermayeff & Geismar Inc.

Since Owens-Illlinois's products are sold to food processing companies and industrial products manufacturers that market their products to consumers, its identity program focused on a "business-to-business" design strategy, emphasizing reliability, quality, and consistency.

Plate 10

Tom Geismar for Chermayeff & Geismar Associates Inc.,
Corporate Logo: Development of Final Logo, ca. 1971
Owens-Illinois, Inc.
felt-tip marker with black ink on tracing paper
8¹⁵/₁₆ × 11¾ inches
© Chermayeff & Geismar Inc.

From 1929 onward, Owens-Illinois used its trademark "O" and "I" in varying ways. In 1954 the J. Walter Thompson advertising agency designed a vertically stretched "O" encircling an "I" along with a style book to guide its use. Nearly two decades later, the corporation updated its emblem once again, using the bold geometry and contrasting colors of red, white, and blue popular in the 1970s.

Plate 11

Usages of Owens-Illinois Corporate Identity Program, n.d.
photo panel

Abramovitz-Harris-Kingsland, architects, Model for Owens-Illinois Headquarters Building (detail), Toledo, Ohio, 1982
photo panel

A corporation's brand identity program encompasses two-dimensional and multidimensional interpretations such as structural packaging, merchandising, transportation vehicles, architectural signage, and interior décor. Owens-Illinois carried this identity to a new world headquarters building in Toledo's downtown riverfront redevelopment district. The program included an "I"-shaped skyscraper beside a low "O"-shaped building housing an auditorium and cafeteria. The material of the thirty-two-story glass-clad International Style building alluded to the company's glass production heritage. The overall plan of the SeaGate project joined the O-I complex to a public plaza, parking structure, hotel, retail buildings, and marina.

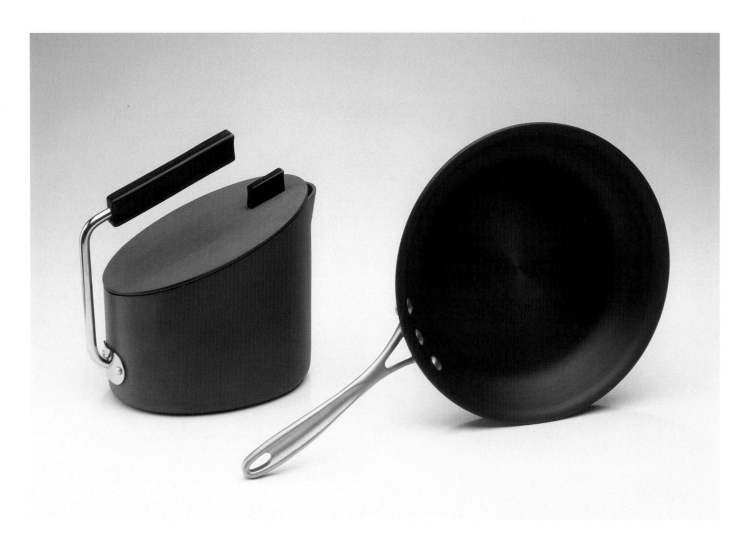

Plate 12

Gary McNatton, *Calphalon Arrondi Kettle,* ca. 1988
Commercial Aluminum Cookware Company
aluminum
9¾ × 9⅛ × 6 inches
Sara Jane and Bill DeHoff

Paul Angelo LoGiudice, *Commercial Hard-Anodized
10″ Omelette Pan,* 1997
Calphalon Corporation
aluminum and stainless steel
3 × 18¹/₁₆ × 10¹¹/₁₆ inches
Calphalon Corporation

In 1963 the Commercial Aluminum Cookware Company intro-duced products for the food service industry made with the hard-anodizing process used in the exteriors of architectural, aircraft, and automotive goods. The cookware's sophisticated design appealed to upscale consumers, and Calphalon entered the re-tail market in the 1970s, pioneering the concept of professional-quality cookware for home use. Task-specific items, such as the omelette pan, broadened the industry view of cookware from a traditional utilitarian item into a fashion brand. The omelette pan retained the vessel's classic shape, but added a modern handle. This patented "Cool-V" handle, a cast-stainless-steel form that replaced the cast-iron handle, is ergonomically improved and remains cool to the touch. In today's highly competitive and cost-sensitive climate, a designer must know the retailers' needs, manufacturing constraints, and consumer preferences to bring a new product to market. Calphalon's director of product design and development, Paul Angelo LoGiudice, came to this position from a culinary and merchandising background, which indicates the company's understanding of its customers in the business of design. The Arrondi tea kettle, introduced in 1988 at Bloom-ingdale's, added a product category to the line and responded to the high-style kitchenware items that appeared in the 1980s. The kettle used Calphalon's traditional method of attaching the handle to the vessel, yet added a comfortable grip. The kettle's unique elliptical shape reflected the designer's interest in simple forms.

General Motors dominated the home market and defined the way vehicles were designed for it, styling seemed a recipe for success— but only as long as every competitor played the game according to the same rules. In the long run, however, mounting competition from overseas changed the rules. In particular, when production quality in America was neglected in favor of what the Japanese call "financial engineering"—the manipulation of cost without regard for quality— no amount of play with surface form could compensate for the lack of a holistic approach to design, in which every detail mattered.

Industrial design's emergence and subsequent development in the United States has been at all stages substantially dependent upon the decisions and attitudes of managers and shareholders and, in the last analysis, in general terms, upon the American public's attitudes toward design. As an activity it is intertwined with the culture of any society and age and can successfully contribute only to the extent to which it is understood and its potential harnessed. In that sense, the final sentence of Nelson's *Fortune* article of 1934 is still profoundly relevant today: "Designers will not cure our industrial ills, for our ills lie deeper than design."[28] The potential of design to contribute to solutions, however, has yet to be fully realized.

1. *Time*, October 31, 1949.

2. Elizabeth Hoyt, *Consumption in Our Society* (New York: McGraw-Hill, 1938), p. 87, based on U.S. Bureau of the Census, Biennial Census of Manufactures, 1935, p. 18.

3. M. Armengaud, Elder; M. Armengaud, Younger; and Amouroux, *The Practical Draughtsman's Book of Industrial Design and Machinist's and Engineer's Drawing Companion: Forming a Complete Course of Mechanical, Engineering, and Architectural Drawing*, trans. William Johnson (New York: Stringer & Townsend, 1857).

4. *Yearly Catalog, 1919–1920* (New York: School of Fine and Applied Art), pp. 5–6.

5. Alfred P. Sloan, Jr., *My Years with General Motors* (New York, Doubleday, 1963), p. 158.

6. Ibid., p. 150.

7. Ibid., p. 269.

8. "Industrial Design at Pratt Institute" (New York: Pratt Institute, 1974), unpag.

9. Arthur J. Pulos, *The American Design Ethic: A History of Industrial Design to 1940* (Cambridge, Massachusetts: The MIT Press, 1983), p. 324.

10. "Modern Art in Business," *Business Week*, September 28, 1929, p. 36.

11. "The Eyes Have It," *Business Week*, January 25, 1930, p. 30.

12. "Design for Dollars," *Business Week*, November 18, 1933, p. 12.

13. Donald Deskey, "The Rise of American Architecture and Design," *The Studio*, April 1933, pp. 266–73, reprinted in David A. Hanks with Jennifer Toher, *Donald Deskey: Decorative Designs and Interiors* (New York: E. P. Dutton, 1987), pp. 157–59.

14. Donald Deskey, Untitled typescript of article for *Crockery and Glass*, in folder of material from 1935–37 in Donald Deskey Archives, The Doris and Henry Dreyfuss Memorial Study Center,

Cooper-Hewitt, National Design Museum, Smithsonian Institution, New York.

15. "Both Fish and Fowl," *Fortune*, February 1934, p. 98.

16. "Bulletin of The Carnegie Institute of Technology, 1933–34" (Pittsburgh), p. 79.

17. *Business Week*, May 1936.

18. Harold Van Doren, *Industrial Design: A Practical Guide* (New York: McGraw-Hill, 1940), p. 16.

19. Typescript announcement in Deskey Archives (note 14).

20. Donald Deskey, "The Contribution of the Industrial Design Consultant," typescript of speech, July 14, 1953, in "Speeches and Writings" folder, in ibid.

21. Donald Deskey, typescript draft of speech titled "Industrial Design," in ibid.

22. Donald Deskey, typescript draft of speech titled "A Definition of Research Is Fact Finding," in ibid.

23. Donald Deskey, transcript of speech, "The New Role of the Industrial Designer in the Planning and Development of New Products," 6th Annual New Product Seminar, sponsored by Kastor, Hilton, Chesley, Clifford and Atherton, Inc., held at the Savoy Hilton, New York, October 13, 1959, in ibid.

24. Raymond Loewy, "Industrial Design Gives More Than a New Look: Knowing What You Need Comes First," *The Iron Age: The National Metalworking Weekly*, May 9, 1957.

25. "Designers: Men Who Sell Change," *Business Week*, April 12, 1958.

26. Donald Deskey, "Foreign Imports Will Buy More U.S. Counsel on U.S. Marketing," *Printers' Ink*, January 1, 1960.

27. David Halberstam, *The Reckoning* (New York: William Morrow and Co. Inc., 1986), p. 210.

28. *Fortune*, p. 98.

Jeffrey L. Meikle

THE MIDWESTERN CITY AND THE AMERICAN INDUSTRIAL DESIGN AESTHETIC

During the years when industrial design was emerging as a means of distinguishing one consumer product from another, the concept of regionalism seemed on the verge of becoming, both literally and figuratively, a thing of the past. With varying degrees of nostalgia and resistance, such writers as William Faulkner and Robert Frost lamented the decline of the South and the withering away of New England tradition. Thomas Hart Benton, whose American Scene paintings depicted the rural folk of Missouri, used his sinuously muscular style to portray railway locomotives, airplanes, power lines, factories, and heroic industrial workers. Across the country during the 1920s and 1930s, regional distinctions weakened and merged into a more homogeneous culture of national retail markets and mass communication. Nationally distributed movies, radio programs, and magazines invited ordinary people of modest means to perceive themselves as urbane citizens of a cosmopolitan machine age. This was especially true for inhabitants of the manufacturing cities of the upper Midwest, the geographic region located south of the Great Lakes and extending from Ohio westward through Indiana and Illinois to Wisconsin and Minnesota. Many recent migrants, whether born on Midwestern farms or in European villages, had abandoned their origins for the bright lights and fast pace of a twentieth-century modernity that seemed almost as exhilarating in Toledo or Fort Wayne as in Chicago or in New York—the ultimate machine-age metropolis.

Nothing embodied this expansive urban spirit so concretely as a new skyscraper towering over the array of miscellaneous four- and five-story commercial buildings in a typical Midwestern business district. No city was too small to aspire to such a beacon of modernity, usually erected by an influential bank as a visible symbol of local power and civic pride. While inhabitants of Cincinnati might boast about the Carew Tower, or those of Columbus about the Le Veque-Lincoln Tower, the citizens of Toledo could look to the Ohio Savings and Trust Building, rising 368 feet above the corner of Madison and St. Clair. Opened in 1930, this visually powerful structure featured an asymmetrical massing of setback elements yielding to a single tower and united vertically by projecting pilasters rising to a crenellated roof line. Its blocky but soaring ziggurat silhouette compared favorably with many of the modernistic skyscrapers completed in New York during the late 1920s. Faced with limestone and elegantly detailed with geometric Art Deco ornament, the Ohio Building and its architectural counterparts in neighboring cities offered convincing evidence that cosmopolitan Manhattanism was flourishing on the prairies and along the lakes and rivers of the Midwest. That the savings bank went out of business in August 1931, as jazz-age optimism yielded to the bleak uncertainties of the Great Depression, only reinforced the impression that Toledo, for better or worse, had been fully integrated into a national economy—and, by extension, a national culture.[1]

Industrial design, which emerged as a business strategy for addressing the problem of underconsumption during the Depression years, drew on the same urbane stylistic vocabulary as had the skyscraper architecture of the previous decade. Often prompted by advice from advertising executives whose bright, full-color illustrations no longer successfully promoted sales of lackluster goods, the more adventurous manufacturers began to employ outside design consultants to rework the appearance of consumer products. These industrial designers, as they soon became known, typically came from backgrounds in advertising illustration, stage design, craft production, or some other form of commercial art. Most of the companies they served, whether located in the Midwest, the Northeast, or elsewhere, produced goods for a national market. Constraints placed on product designers generally involved a factory's technical capabilities and the cost of materials and labor. Any consideration of specialized markets to be addressed by a particular product tended to revolve around issues of economic class—and not geographic region. Just as every city of any size boasted a skyscraper resembling those of mid-Manhattan, so too

did radios and toasters designed or manufactured by Midwesterners seem similar in appearance and function to those produced in New York or elsewhere in the Northeast. For the most part the existence of a national market for consumer goods prevented the emergence of obviously regional modes of expression. Even so, as industrial design evolved in the Midwest during the Depression and over the decades that followed, certain characteristics marked its practice—and its aesthetic—as moderately distinctive. Moderation, in fact, became a recurring theme in the history of Midwestern design, which has tended toward restraint rather than flamboyance, toward an anonymous functional competence as opposed to a flashy stylistic individualism.

The strategy of hiring a design consultant to improve product sales had become a national fad by 1934 as many executives anxiously looked to industrial design as a panacea. In February a major review of the new profession in *Fortune* reported that about twenty-five independent design consultants had established offices in the United States.[2] Out of ten designers profiled by the magazine, most had studios in Manhattan. These included the four acknowledged leaders of the movement—Norman Bel Geddes, Walter Dorwin Teague, Raymond Loewy, and Henry Dreyfuss. While Dreyfuss was born in New York and Loewy arrived there from France shortly after World War I, both Teague and Geddes were Midwesterners, growing up in Indiana and Ohio respectively. But neither remained in the Midwest. Teague went to New York to attend the Art Students' League and then became an advertising illustrator. And Geddes started out in an advertising agency in Detroit, but soon left to become a stage designer on Broadway.

As the four of them drifted into the new profession, they received a significant number of commissions from companies in the upper Midwest. Geddes, for example, was hired to create a sequence of progressively more radical automotive body designs for Graham-Paige, none of which went into production. Teague and Loewy successfully styled elegant luxury automobiles for Marmon and Hupmobile. Other early Midwestern industrial design commissions addressed consumers who were less economically privileged. Among the early converts to the new gospel of design was Sears, Roebuck in Chicago. Seeking to overcome its reputation as a mail-order supplier of cheap goods for rural families and to promote a new chain of urban retail stores, Sears hired Dreyfuss to design the Toperator washing machine, on the market in 1933, and obtained from Loewy a series of annual designs for Coldspot refrigerators, introduced between 1935 and 1938. Trade journals and business publications gave considerable publicity to these consultant-designed Sears appliances and to the impressive increases in sales they stimulated (often omitting such other factors as saturation advertising campaigns and greater opportunities for in-store sales). The Toperator and the Coldspot emphasized clean lines, convenient controls, and gadgets such as the refrigerator's door release, a long

vertical bar that someone with both hands full could operate with the nudge of an elbow. These new Sears models contributed to a design transformation throughout the appliance industry.

Although the New York designers clearly benefited from high-profile commissions in the Midwest, their array of clients came from across the nation, and their work usually involved only the most visible of Midwestern companies, those with national reputations among the general public. Many regional manufacturers of lesser visibility were somewhat slow to accept the concept of consultant design. Or perhaps it is more accurate to say that they lacked clear guidance about how to follow the proselytizing of the business press. Relatively few consultant designers opened up shop in the Midwest during the 1930s. Only one of them, Harold Van Doren, was on the scene early enough to be mentioned by *Fortune* as a founder of the profession along with the New York Four. The magazine described him in 1934 as "working the Middle West out of Toledo and conceded to have the business there sewed up."[3] Two years later Sheldon and Martha Cheney echoed this judgment in their celebratory book *Art and the Machine,* observing that Van Doren was "commonly credited with having introduced industrial design into the mid-West."[4]

Unlike most early practitioners of industrial design, Harold Van Doren did not start out as a commercial illustrator, stage designer, interior designer, or architect. Like most of them, on the other hand, he enjoyed a varied early career and adapted easily to new circumstances. Born in Chicago in 1895, he spent his childhood in New Jersey. Graduating from Williams College in 1917, Van Doren then served in World War I with the US Army ambulance corps in Italy. After the war he worked as an editor at *Survey Graphic* and studied painting at the Art Students League in New York. Traveling to Paris in 1922 to continue his art studies, he supported himself by lecturing at the Louvre, translating French art biographies into English, and playing a lead role in Jean Renoir's film *La Fille de l'eau* (1924). After returning to New York, Van Doren tried out freelance magazine writing for three years before being appointed assistant director of The Minneapolis Institute of Arts in 1927. Three years later, in 1930, he was invited by Hubert D. Bennett, a Williams classmate and president of the Toledo Scale Company, to come to Toledo to serve as a color consultant in devising marketing strategies for Plaskon, a new synthetic plastic, and later to design a plastic housing for a new weighing scale for grocers. Probably without any particular idea at first of what he was getting into, Van Doren was becoming an industrial designer.

Although design at Toledo Scale is discussed elsewhere in this volume (see Meikle, "Weighing the Difference"), it is worth noting here that Bennett had turned to Van Doren, a friend and fellow Midwesterner, only after rejecting Norman Bel Geddes's designs for several weighing scales and his architectural plans for a new manufacturing plant. As opposed to the flamboyant, sometimes visionary

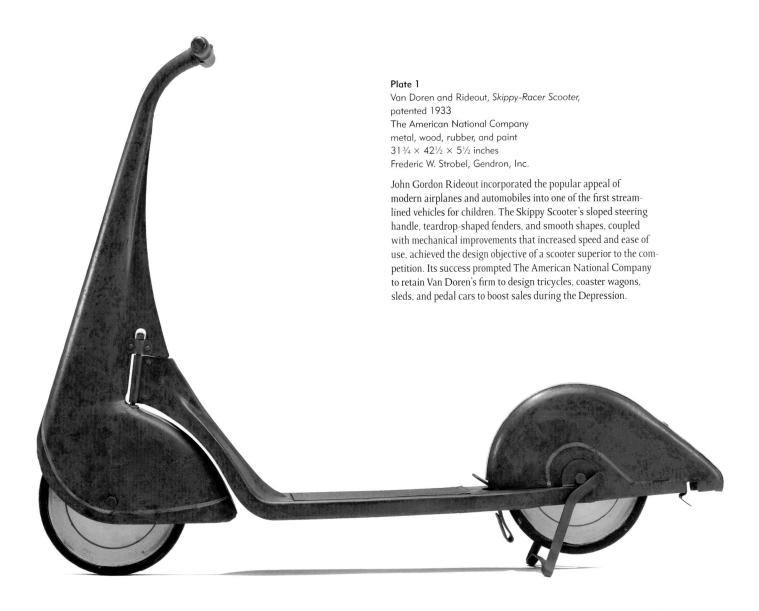

Plate 1
Van Doren and Rideout, *Skippy-Racer Scooter,*
patented 1933
The American National Company
metal, wood, rubber, and paint
31¾ × 42½ × 5½ inches
Frederic W. Strobel, Gendron, Inc.

John Gordon Rideout incorporated the popular appeal of
modern airplanes and automobiles into one of the first stream-
lined vehicles for children. The Skippy Scooter's sloped steering
handle, teardrop-shaped fenders, and smooth shapes, coupled
with mechanical improvements that increased speed and ease of
use, achieved the design objective of a scooter superior to the com-
petition. Its success prompted The American National Company
to retain Van Doren's firm to design tricycles, coaster wagons,
sleds, and pedal cars to boost sales during the Depression.

New Yorker, characterized by *Fortune* as a "bomb-thrower" who
had "cost American industry a billion dollars," Van Doren was more
restrained.[5] His practical, even-tempered approach promised to yield
more than a portfolio of flashy renderings of unproduced designs.
As he later observed, industrial design had to move beyond "eager
prophets" and "spectacular ballyhoo" to a clear understanding of
designing as a "daily job" requiring "persistence" and "industry."[6]
This businesslike approach marked his entire career—and came to
characterize design in the Midwest. Although Van Doren was an out-
side consultant for Toledo Scale, not a regular employee, he confined
his work to Bennett's projects for a couple of years. An officer of the
scale company later recalled that Van Doren's design practice was
"sponsored by Toledo, yes, subsidized by Toledo."[7] In other words,
he and his staff functioned as if they were Toledo Scale's in-house
design department. Twenty years later it had become standard, espe-
cially in the Midwest, for manufacturers to maintain a group of full-
time employees to provide all or most of their design work. In the
meantime, however, Van Doren's career took a different course as he

expanded his independent design office and accepted commissions
from other manufacturing companies.

Business increased so rapidly that in 1931 Van Doren took on
John Gordon Rideout as a partner.[8] In his early thirties, Rideout
had been prevented by the war from training as an architect and had
worked as an illustrator and art director for several advertising agen-
cies. During the four years that the partnership remained in effect, the
younger man seems to have provided a hands-on perspective that Van
Doren initially lacked. Their projects ranged from the simple cylindri-
cal form of the Everhot electric casserole for the Swartzbaugh Manu-
facturing Company in Toledo to the complex modernistic elegance of
a bathroom scale for Holley Carburetor in Detroit. For another Toledo
firm, The American National Company, they designed a series of
streamlined vehicles for children, including a scooter (plate 1), a sled
(plate 2), a coaster wagon (plate 3), and a tricycle with wing-shaped
handlebars and a unified body sweeping back to encompass seat and
teardrop-shaped rear fenders in a two-tone housing of stamped steel
(plate 4). A journalist rationalized this unusual one-piece shell when

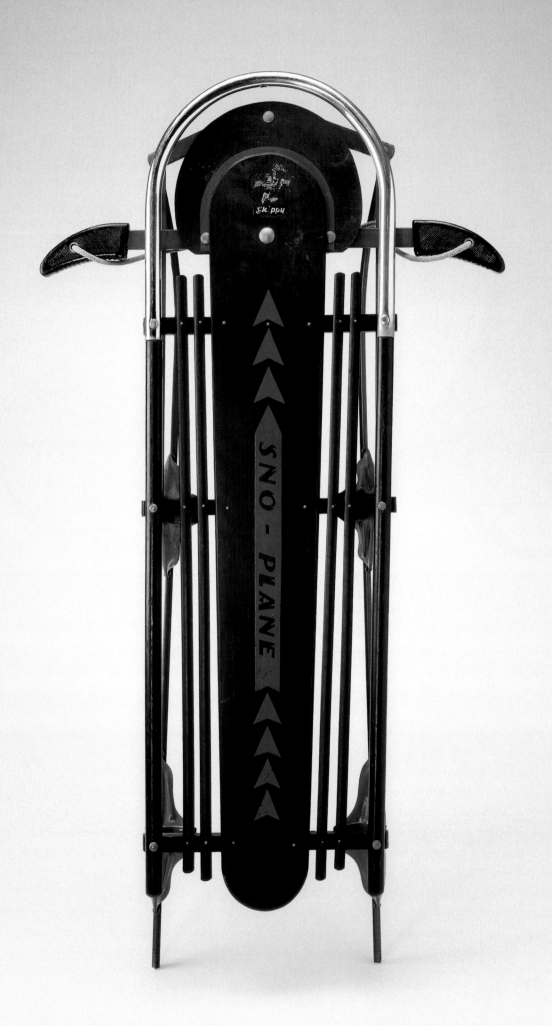

Plate 2
Van Doren and Rideout, *Skippy Sno-Plane Sled*, patented 1934
The American National Company
metal, wood, rubber, chrome plate, and paint
7⅛ × 43 × 25 inches
Frederic W. Strobel, Gendron, Inc.

In light of acute price competition, The American National Company asked Harold Van Doren to devise something entirely new for its line of sleds. The first version of the Sno-Plane sled had slats shaped into a unified form and resembled a toboggan. The rudder and steering mechanisms did not function well, however, and Christmas sales were weak. At the New York Toy Fair the following April, a reworked, deluxe model enjoyed a great reception, becoming a style leader and convincing new clients, such as Sears and Montgomery Ward, to feature American National products in their catalogues.

Plate 3
John Gordon Rideout for Van Doren and Rideout, *Skippy Stream Line Racer*, patented 1934
The American National Company
metal, rubber, nickel plate, and paint
24½ × 40¼ × 16 inches
Frederic W. Strobel, Gendron, Inc.

The smooth, rounded shape of this streamlined wagon, along with its grille effect and battery-powered headlights, echoed sleek 1930s car designs.

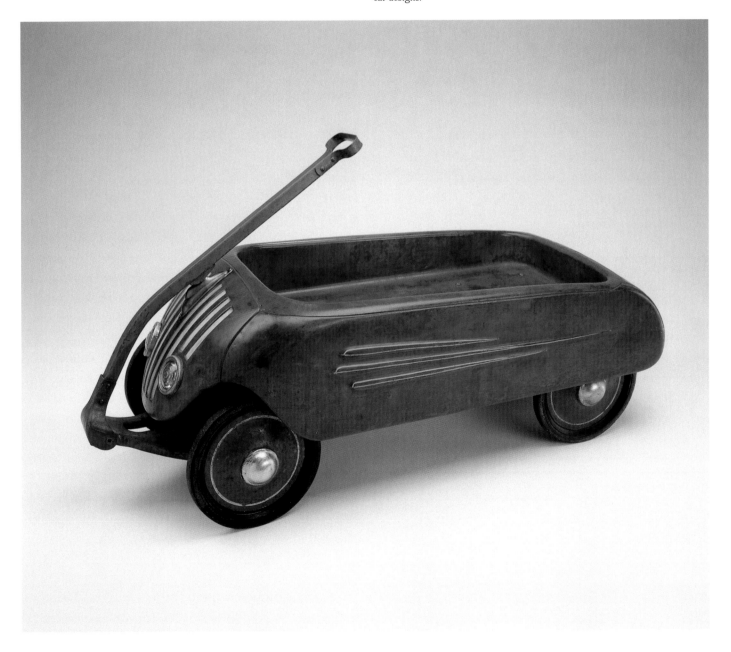

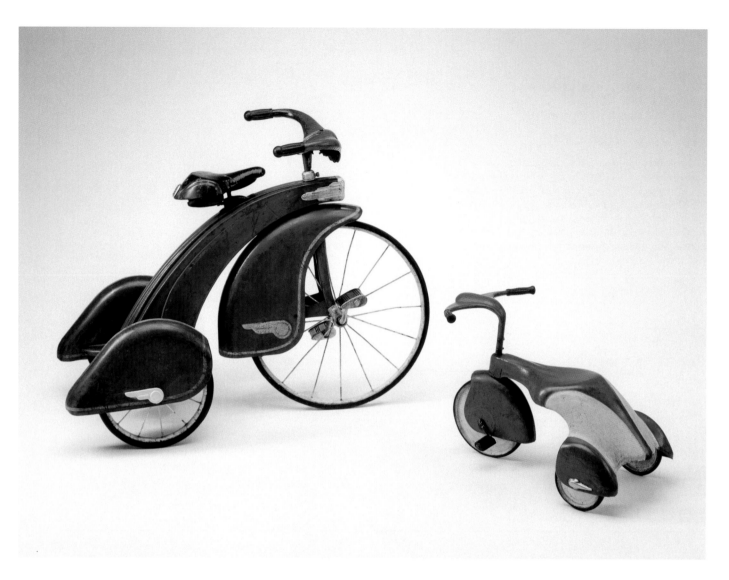

Plate 4
Van Doren and Rideout
The American National Company

Streamline Velocipede, patented 1935
metal, nickel plate, rubber, and paint
29 × 40 × 18½ inches
Steve and Glenda Castelli

Pioneer Streamlined Tot Bike, patented 1935
steel, nickel plate, rubber, and paint
15½ × 21½ × 11 inches
Rick Bugner Collection

These tricycles applied contemporary streamlined automotive styling to children's vehicles. The fluid form of the one-piece, stamped-steel body of the smaller tricycle was a dramatic design departure.

he described the trike as "cleverly designed to prevent the small child from hurting himself." Van Doren, on the other hand, frankly observed that "children like anything that enables them to imitate their elders."[9] Whatever the case, their involvement with a relatively small company that distributed its products nationally but lacked wide name recognition was typical of the second-tier level on which consultant designers in the Midwest tended to operate.

Other consumer designs on which Van Doren and Rideout collaborated during the early 1930s included decorative perfume atomizer bottles (plate 5) and packaging (plate 6) for The DeVilbiss Company of Toledo, handled with a deft understatement as sophisticated as anything coming out of New York. Even more notable in terms of style was the architectonic Air-King radio (plate 7). Nominally designed for an obscure radio company in Brooklyn, the Air-King with its one-piece plastic cabinet was actually a trial run for a much larger one-piece Plaskon housing for Toledo Scale (plate 8). Even so, the radio—with its stepped silhouette, vertical ribbing up the front, and horizontal banding around the base—proved to be the decade's most convincing example of a small consumer product displaying the form of an Art Deco skyscraper, miniaturized and domesticated. In an exuberant expression of local pride that went largely unrecognized outside the

Plate 5

Van Doren and Rideout, *Atomizer*, 1932
The DeVilbiss Company
opaque white glass, metal, enamel, and rubber bulb with textile
3⅞ × 2½ × 1⅛ inches
Alyce Gordon Rideout

Plate 6

Van Doren and Rideout
The DeVilbiss Company

Box for Silver Crackle Glass Ginger Jar with Atomizer, 1932
metallic and color printing on cardboard with paper
5¼ × 4⅜ × 3¹¹⁄₁₆ inches

Perfume Atomizer Box, 1932
metallic and color printing on cardboard with paper
3½ × 2⅜ × 2½ inches

James Fuller

The DeVilbiss Company, which designed its own cardboard
packaging, commissioned this redesign by Harold Van Doren
and John Gordon Rideout, reflecting the simple geometry and
massing that characterize much of the firm's work. The under-
stated DeVilbiss name and stylized flower add subtle touches
to the straightforward organization of the package surface.

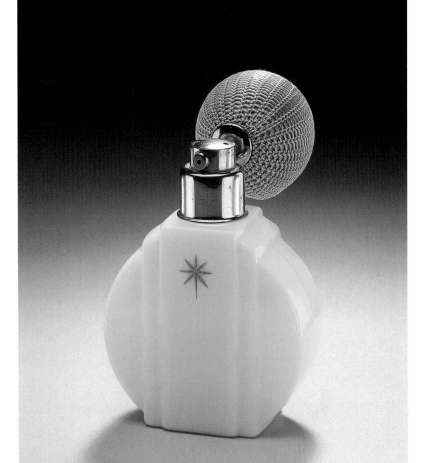

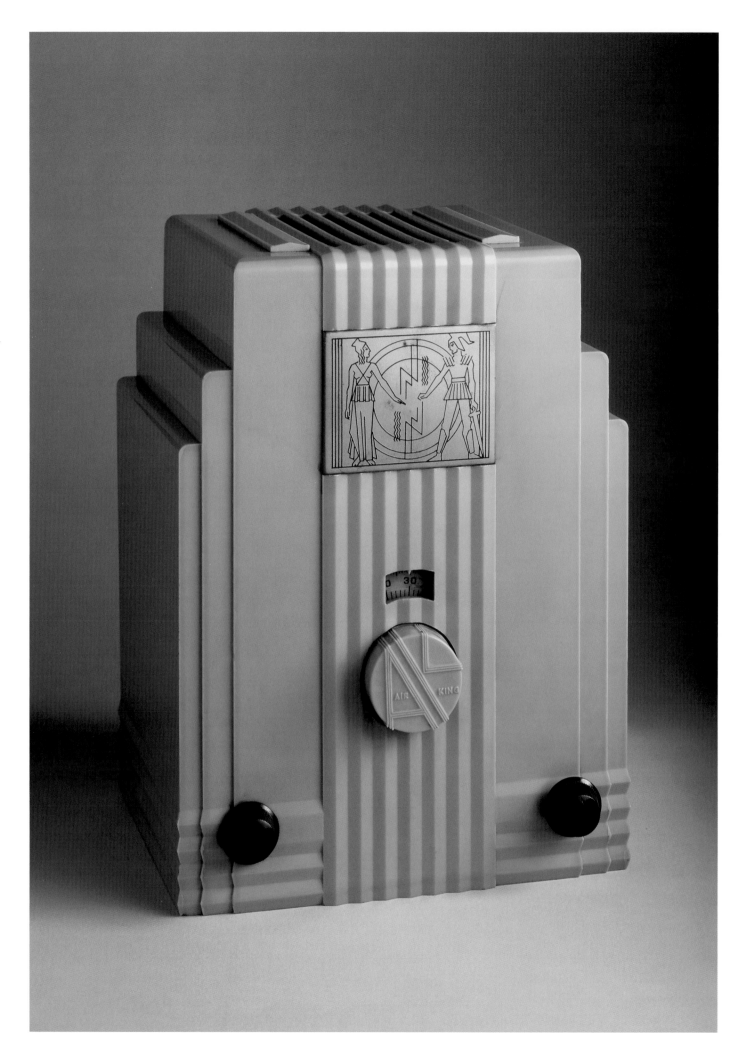

Plate 7
Van Doren and Rideout, *Air-King Midget Radio*, 1933
Air-King Products Company, Inc.
Plaskon, metal, and glass
11¾ × 8⅞ × 7½ inches
Brooklyn Museum of Art, New York, Purchased with funds given by The Walter Foundation, 85.9

By the 1930s the radio was the centerpiece of the American family's living room. Radios transmitted the news and represented the new: the cabinets made of synthetic materials visually embraced the era's design sensibilities, forgoing the Gothic wood shapes of the 1920s. In a promotional brochure, Van Doren and Rideout presented this Air-King radio as "the first completely modern cabinet on the market" and boasted that it increased sales by 320 percent. The radio's inset decoration inspired confidence in the future as antique heroic figures controlled the zigzag radio waves of the present. The one-piece housing reduced manufacturing costs, but the sharp edges were susceptible to damage. Because streamlined shapes were the most economical and took advantage of the sculptural possibilities of fluid plastic, the Air-King's rectangular shape remained a unique example of Plaskon's versatility.

Plate 8
Orwell Reeves, *Engineering Drawing for Sentinel Duplex Scale*, ca. 1934
Toledo Scale Company
pen and black india ink with graphite on linen
35¼ × 62 inches
Collection of Jim Clemens

offices of Van Doren and Rideout, the Air-King's outline clearly echoed that of the Ohio Building, the dominant point on the Toledo skyline.

After Rideout left the partnership in 1934 or 1935 to open his own consultant design office in Cleveland, Van Doren designed several consumer products noteworthy for smooth lines, a lack of egregious ornament, and an air of simple solidity—the last a hallmark of an emerging Midwestern industrial design aesthetic. A wringer washing machine introduced in 1939 by Maytag (plate 9), a company located in Newton, Iowa, exemplified these qualities. Van Doren worked with the company's engineers over a period of several years to ensure that the machine not only looked better, but also operated more cleanly, conveniently, and safely. The ultimate goal was to attract a substantial urban clientele in addition to the firm's traditionally rural customers. As with so many early consumer design projects, Van Doren and his associates brought about a stylistic quantum leap by moving Maytag's washer out of an unconscious, overtly mechanical aesthetic of the late nineteenth century and into a self-consciously streamlined aesthetic of convenience that marked appliance design throughout much of the twentieth century. The previous model featured four spindly, ill-proportioned legs supporting both a lower platform with an exposed electric motor and a utilitarian-looking washtub. The front was marred by a thick black rubber hose looping up from below, and the sheet-metal guard around the drive belt underneath left a gap in which the edge of a female operator's long skirt might just conceivably have become caught. By contrast, Van Doren's design visually

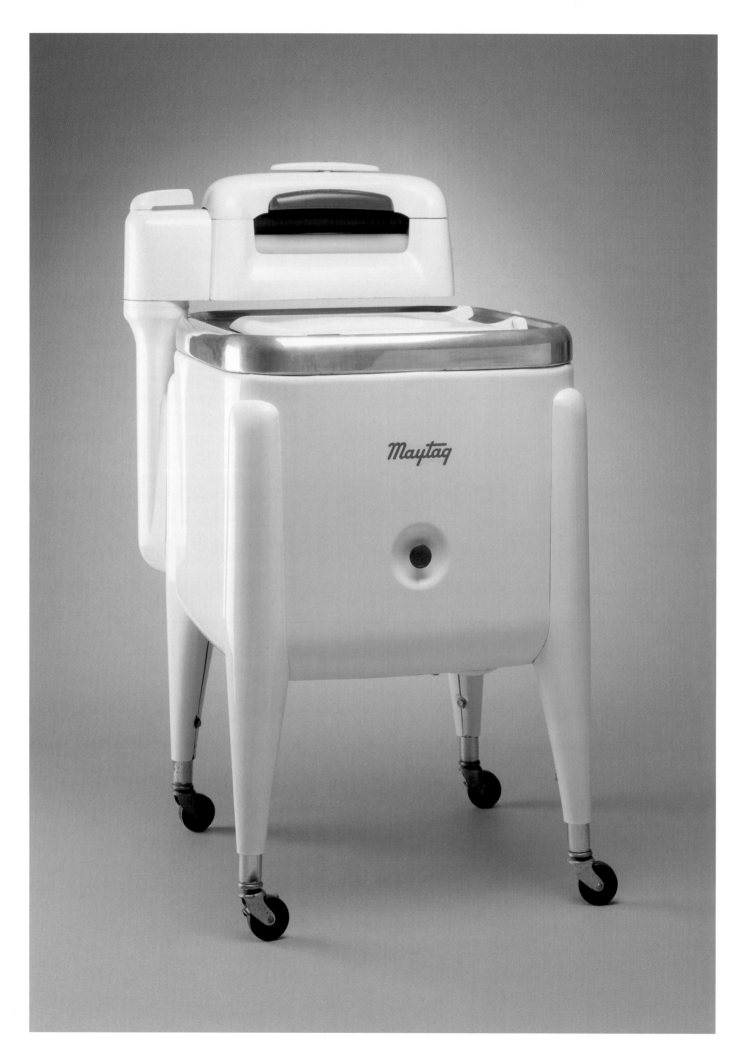

integrated all parts within a smooth-flowing white-enameled casing, with legs articulated by wide, strong-looking vertical elements running to within a few inches of the upper rim of the tub, whose casing extended low enough at the bottom to enclose and conceal the motor. At about the same time, Van Doren was applying a similar aesthetic to a kitchen stove for Westinghouse, whose appliance division was located in Mansfield, Ohio, and to refrigerators for the Philco Company in Philadelphia. Although the results may now appear heavy or bloated, in 1940 the smooth, streamlined forms of these appliances reflected a triumph.[10]

Despite the success of his consumer products, Van Doren tended, like many Midwestern designers who followed him, to specialize in other types of manufactures. He pointed out that "modernization of consumer goods" had made people "conscious of the appearance of equipment they found in retail stores, restaurants, offices, and in public places."[11] It was only common sense for manufacturers of such service equipment to want to make it more visually appealing, more convenient. Shortly before Rideout left the partnership, in 1934 they designed a gas pump for the Wayne Pump Company of Fort Wayne, Indiana (plate 10). Like many other recently introduced objects that we now take for granted, the gasoline pump had not yet achieved a stable form. Early in the twentieth century, a typical device consisted of a cylindrical metal case enclosing a hand-operated pump that moved gasoline into a large glass cylinder above, with graduated markings for measuring the desired amount, which then flowed by gravity through a hose into a car's gas tank. Even when automatic electric pumps and accurately measured flow became available, customers counted on being able to see a specific amount of fuel flowing into their tanks. Abandoning this previously standard design, Van Doren and Rideout specified a tall, four-sided sheet-metal cabinet, curved across the top from front to back. Each side was framed at the vertical edges by projecting lines that rose to end elegantly in a half

circle at the top. Movement of gas was visible, front and back, through a small round window located within the half circle at the top, just above the quantity and price indicators. Without a glass cylinder, without even a lighted advertising globe to substitute for the usual cylinder, their formally integrated design for Wayne Pump set a standard that was eventually followed by the company's major competitors, Bowser and Tokheim, both also located in Fort Wayne.[12]

More than most other consultant designers, Van Doren became involved with designing industrial equipment. He claimed that a heat-treating furnace done in 1934 for the Surface Combustion Corporation of Toledo was "probably the first piece of industrial equipment ever to be designed for appearance."[13] Not only did he strive to make such equipment safer, more convenient to use, and easier to maintain, but he also sought "to evolve some theme of treatment" that could be "carried throughout" all the machines made by a particular company to "act as a trade-mark"—in effect, to create a corporate image.[14] He believed that a company that installed such machinery in its factory would instill pride in the workers who operated it. The designer applied these ideas in 1936 to an integrated line of machine tools for the Ex-Cell-O Corporation of Detroit, and in 1938 to a line of commercial bakery equipment—dough mixer, divider, and rounder—for the Baker Perkins Company of Saginaw. In their solid gravity of form and proportion, the results of both these projects reflected the Midwestern design aesthetic in a state of abstract, anonymous purity. Whatever their size or purpose, all of Ex-Cell-O's machine tools possessed a similar three-part structure: a thin pedestal, a blocky rectangular base, and an overhanging slab supporting work surfaces, working tools, and controls. As Van Doren noted, "Distinctive appearance was obtained by the use of [horizontal] parallel bands" around both base and slab and "chamferred horizontal edges."[15] Similar bands of three parallel lines vertically accented the commercial bakery equipment, whose parts were encased in abstract symmetrical arrangements of architectonic forms that would have been equally appropriate for an office stapler, a shrouded locomotive, or the central pylon of a stream-lined Greyhound bus terminal. Equipment for both Ex-Cell-O and Baker Perkins looked practical and solid, projecting an impressive aura of controlled industrial power. Although a trade journalist referred to Van Doren's work for Ex-Cell-O as a "radical venture," a vice president of the company predicted that "the matched line of products with a common style design will become increasingly popular" for machine tools.[16]

Further evidence of Van Doren's studied practicality came during the late 1930s, when, as *Current Biography* later observed, he "stole a march on fellow designers . . . by walking off with commissions" for the Maytag washer, the Westinghouse stove, and refrigerators for Philco while his major New York competitors were "trying to outdo each other" in creating exhibition buildings for the New York World's

Plate 9
Harold Van Doren & Associates with Thomas R. Smith (engineer),
Washer Model E, patented 1939
The Maytag Company
metal, enamel, plastic, and rubber
44¼ × 38¾ × 26 inches
Anonymous loan

In 1939 The Maytag Company introduced the Master Washer, its first appliance to use white instead of the speckled gray and green finish common at the time. For several years Harold Van Doren & Associates worked alongside Thomas R. Smith, Maytag's director of Research and Development, to design the sleek, unified form that concealed the motor and hoses, increased capacity 50 percent, and featured an insulated tub that kept water hot longer. After the war, demand soared. Although Maytag added functional improvements, the Model E's appearance remained unchanged for forty-four years, establishing this Van Doren–designed washer as one of the most successful household appliances of the century.

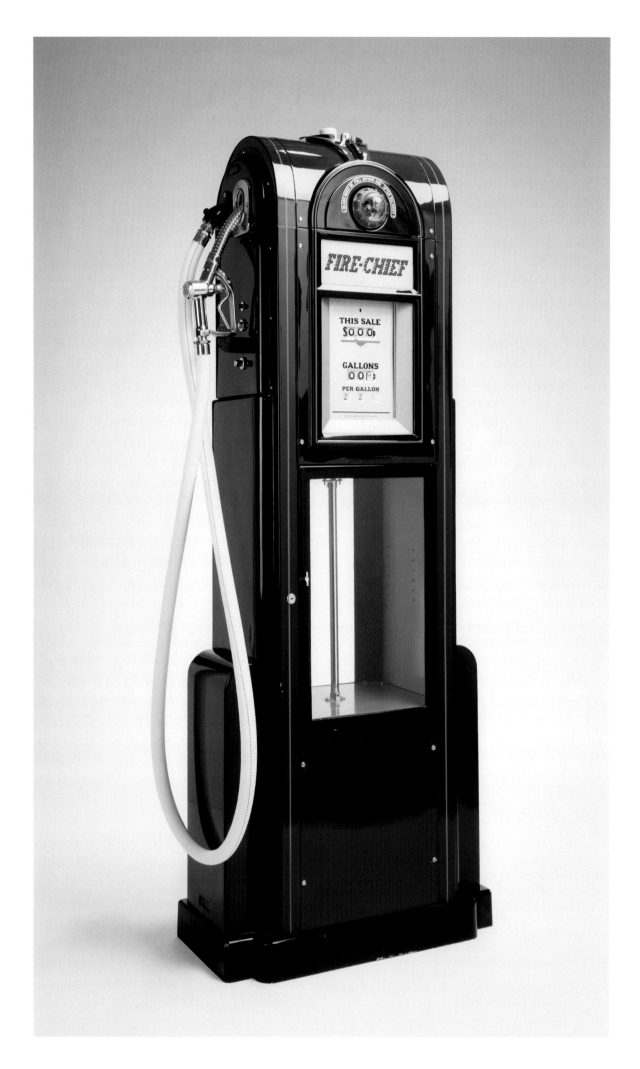

The Wayne Pump Company by 1928 manufactured the most complete line of filling station equipment in the United States. Yet one new product, the mechanical computing pump, saved the company from bankruptcy in 1933. This pump not only measured the gasoline dispensed, but calculated the price, an advantage to supply-sensitive sellers and cost-conscious purchasers alike. Wayne's first professionally designed pump, the Model 60 proved very popular with service stations across the country. The Model 60-S shown here was built only in 1937–38 in a small production run. The center display cabinet held accessories such as oil and polish to spur impulse sales.

Fair. His no-nonsense approach displayed "little of the press-agentry" at which some designers excelled.[17] Norman Bel Geddes, for example, filled his book *Horizons* with illustrations of visionary teardrop-shaped cars, trains, ships, and airplanes. Published in 1932, Geddes's portentous utopian predictions attracted equal attention in corporate boardrooms and Sunday newspaper supplements and propelled awareness of both industrial design and streamlining. Van Doren, on the other hand, wrote the first hands-on manual for industrial designers. Rejecting Geddes's boosterism, the Toledo designer hoped to educate design students to regard their work as "a serious profession that requires persistence, industry, and an unusual variety of technical skills."[18] Published in 1940, *Industrial Design: A Practical Guide* was a thoroughly nuts-and-bolts handbook covering the designer's role in industry; various relationships of consultant to client; market research, materials, and manufacturing processes; the design process of sketches, renderings, models, client presentations, and working drawings; and even contracts and billing options. Unlike *Horizons*, which was ghostwritten, *Industrial Design* was Van Doren's work.

His clear, measured prose conveyed the businesslike efficiency of his designs. Although the whole book radiated an evenhanded approach, his presentation of the design process through sketches and renderings particularly emphasized solid forms, symmetrical massings, and similarity of design solutions along a continuum of objects of various sizes and scales. The resulting aspect of competent anonymity not only reflected Van Doren's own work, which he presented in three revealing case studies, but also defined the essence of the Midwestern design aesthetic.[19]

In 1941, after a decade of advancing the cause of industrial design among Midwestern manufacturers, Van Doren moved from Toledo to Philadelphia so he could interact more productively with Philco, a major client that had become increasingly demanding of his time and energy. Van Doren's long-term influence on Midwestern design continued, however, through the work of former associates he had inspired and encouraged. His onetime partner John Gordon Rideout remained active as a designer near Cleveland until his death in 1951.[20] Another associate, J. McLeod Little, who had come from Minnesota to join Van Doren's office in 1936, stayed behind to manage a branch office in Toledo from 1941 to 1943, when it was finally closed. He then opened his own design practice, J. M. Little and Associates, which remained active in Toledo until 1965. Most of their clients were Midwestern manufacturers of machine tools (plate 11), construction machinery, medical equipment, and what Little referred to as "service" equipment. He inherited and retained such clients as Ex-Cell-O and Toledo Scale (plate 12) from his days with Van Doren. In 1948 Little rationalized the Guardian 70 Duplex grocery counter scale (see Meikle, "Weighing the Difference," pp. 148–49) by reducing from eight to three the number of

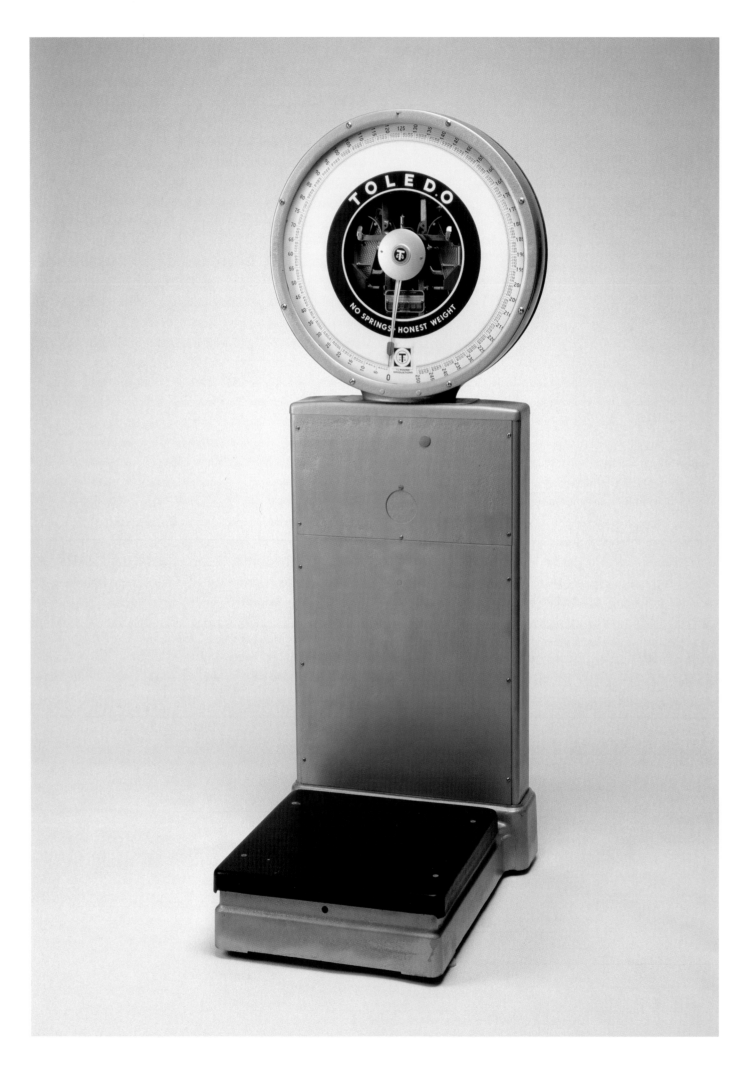

Plate 12
J. M. Little and Associates, *Industrial Dial Scale*, ca. 1960
Toledo Scale Company
painted steel, glass, aluminum, and nonferrous metal
67 × 25 × 29 inches
Peter Kern

Plate 13
J. M. Little and Associates, *Clevite Brush Headphones*, 1961
Clevite Corporation
metal, steel wire, vinyl, polyurethane foam, and Velcro
7½ × 9⅞ × 2¼ inches
Erich Roeck

Plate 14
Donald Dailey for Harold Van Doren & Associates, *Electric Iron*,
ca. 1940
Westinghouse Electric Manufacturing Company
metal and Bakelite
4½ × 9 × 4⅜ inches
Larry and Susann Spilkin

After working with Harold Van Doren in Toledo, Donald Dailey
opened an office for Van Doren in Philadelphia to service Eastern
clients such as Philco and Westinghouse. This iron's design re-
sulted from Van Doren's methods of identifying consumer prefer-
ences. Homemakers were asked to verify which handle was the
most comfortable by grasping and comparing several compet-
ing irons placed in an enclosed box. Dailey later credited the
value of such consumer research in his designs for appliances
and other products.

plastic moldings that were part of its exterior housing. Over the next
fifteen years, he and his associates introduced a greatly revised series of
commercial and industrial scales housed in simple forms of brushed
aluminum. The same practical approach marked a headphone
intended for hard usage in such environments as public-school language
laboratories (plate 13). Introduced around 1961 by the Clevite Cor-
poration of Cleveland, the headphone combined comfort and conve-
nience. Eliminating the tangled wires of its predecessors, Little's
headset boasted a single wire lead, a tough headband of extruded
vinyl enclosing two flexible steel wires, easily sterilized earpieces of
polyurethane foam, and a simple means of adjusting not only for vari-
ous head sizes, but for the presence of what a later generation referred
to as "big hair." Exhibiting an awareness of the human factors of

industrial design, the headphone also retained a certain stolid visual
quality that was typical of postwar Midwestern design—particularly
in objects that did not have to be self-consciously "aesthetic."[21]

Another former Van Doren staffer was Donald Dailey, also from
Minnesota, who moved to Toledo as a teenager and joined the office
after simultaneously studying design at the Toledo Museum of Art
and marketing and engineering at the University of Toledo—a practical
course of study Van Doren had recommended to him (see McMaster
and Taragin, p. 18). While working for his mentor, Dailey designed
a sleek, ergonomically shaped electric iron for Westinghouse around
1940 (plate 14). After working on the East Coast for Van Doren for a
while, Dailey eventually wound up in Evansville, Indiana, first as vice
president in charge of product planning at Servel refrigerators and

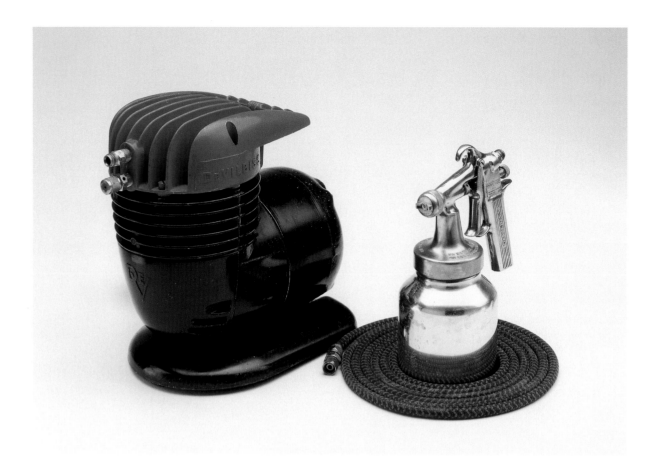

Plate 15
Sundberg-Ferar, Inc.
The DeVilbiss Company

Air Compressor, patented 1948
painted steel and copper wire
12 × 11¼ × 7⅜ inches

Spray Gun with Coil, 1945
spray gun: aluminum, zinc, and chrome plating;
coil: rubber, fiber, and steel
spray gun: 9½ × 6½ × 4 inches

Chuck Crandall

Midwestern manufacturers led the way in designing equipment used by engineers and laborers. Beginning in the 1920s, The DeVilbiss Company produced many varieties of paint sprayers and continually improved the comfort and functionality of its trigger-operated handle. The Detroit firm of Sundberg-Ferar styled many of DeVilbiss' industrial and consumer products. In this "home utility spray outfit" air compressor, sold through the 1950s, the handle is cleanly integrated into the form of the air intake and nozzle head and the shape sits comfortably on its base. The product graphics feature a stylized DeV logo on the front and the full name DeVilbiss on the head. The company's corporate colors of orange and brown were used for the surface decoration and packaging.

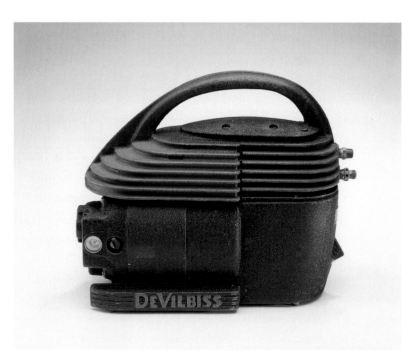

Plate 16
Sundberg-Ferar, Inc., *Air Compressor,* patented 1940
The DeVilbiss Company
painted steel and copper wire
12 × 14 × 8 inches
John C. Waddell

The DeVilbiss Company began making air compressors in 1927. This one-quarter-horsepower 1940 unit was meant for small commercial jobs. A manufacturer's catalogue described this "streamlined" unit as "ruggedly built to give years of trouble-free service under severest conditions, and . . . the highest quality, low-priced spray-painting equipment on the market." Sundberg-Ferar also designed a similarly shaped one-half-horsepower unit. The corporate orange and brown colors unified their identity within the total product line.

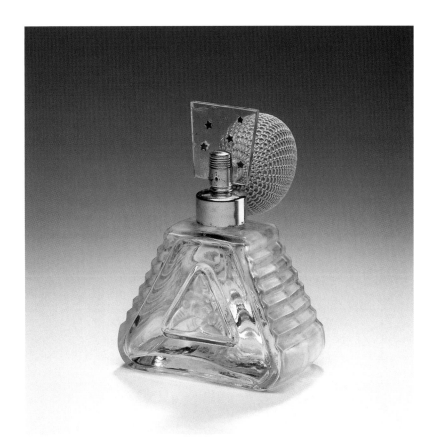

Plate 17
Carl W. Sundberg for Sundberg-Ferar, Inc., *Triangular Crystal Atomizer,* patented 1952
The DeVilbiss Company
glass, enamel, plastic, and rubber bulb with textile
3¾ × 2⅝ × 1½ inches
James Fuller

By the late 1940s Sundberg-Ferar was providing design services to The DeVilbiss Company in several product categories. DeVilbiss purchased glass blanks from American and European factories to use for its perfumizers; Sundberg-Ferar designed the stopper and metal fittings in this atomizer.

then as head of his own consultant design office. His most recognized project was the copper-topped Duracell battery, a "package" that transformed a lackluster product. Even so, like most successful Midwestern designers, Dailey and the others prospered because their work was competently impersonal and thus largely anonymous.[22]

Van Doren and his former associates were not the only industrial designers in the Midwest during the 1930s. Nor was Toledo the only city with design consciousness. As the headquarters of the automobile industry, Detroit was already on its way to becoming a major design center. In 1926 General Motors had discovered Harley J. Earl, a custom auto body designer in Los Angeles, then in his twenties, who became the first director of GM's Art and Color Section (later the Styling Section). Earl was responsible for implementing the automaker's increasing attention to style. The most striking reaction to GM's adoption of design as a marketing tool was Ford's reluctant abandoning of the long-lived Model T in 1927 and its introduction of the more stylish, user-friendly Model A. As design for sales spread during the early 1930s, manufacturers clustering around Detroit's auto industry, such as those making auto accessories and machine tools, gradually became involved, even if they rarely surrendered fully to the ballyhoo that already surrounded automotive design. In 1936, when the Cheneys published *Art and the Machine,* with its favorable review of industrial design, Carl Sundberg and Montgomery Ferar had already been partners for two years in a consultant design office in Detroit. Ferar's prior experience included a degree in architecture from the Massachusetts Institute of Technology and a year of European travel on a fellowship in 1932. Realizing the lack of opportunity for architects

in the depths of the Depression, he had taken a job as a designer at General Motors, where he met Sundberg, who had already gained experience as a body designer at several auto companies. After striking out on their own, they told the Cheneys that industrial design required "a broad and empirical knowledge of engineering and production processes" to satisfy the stringent demands of practical manufacturers.[23] Sundberg-Ferar became one of the leading independent design offices after World War II and thrived for many decades in Detroit's industrial milieu (plates 15–18). Typical of their projects was a series of air compressors and spray guns for The DeVilbiss Company, heavy and solid-looking, with wide curves and horizontal bands of cooling fins echoing the futuristic architecture of science-fiction comic strips. Sundberg-Ferar also pioneered the use of design to create corporate image, coordinating a common look for IBM's early computers and showrooms in the 1950s before Eliot Noyes more famously took over that role.[24]

In 1952 *Business Week* declared that Detroit was "becoming one of the nation's most influential centers in industrial design." Three years later the profession's new journal *Industrial Design* dedicated an entire issue to Detroit as "the design center of the U.S.A." While the editors praised the auto industry for its skill in "using creative people in a vast manufacturing scheme" whose goals were "sales" and "obsolescence," they also congratulated the city more generally for a design-based economic boom that by "changing the face of the city" with "new roads, new buildings, stores and cultural institutions" would serve to "suggest patterns for industries and industrial cities throughout the United States."[25] That this new Detroit later rusted from within

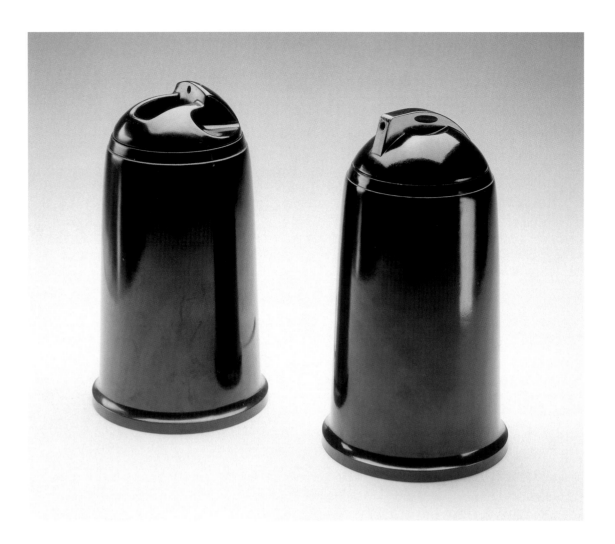

Plate 18
Sundberg-Ferar, Inc., J. B. Schmitt, and Frederic Vuillemenot
The DeVilbiss Company

Electric Steam Vaporizer, 1947
Bakelite
7⅝ × dia. 4 inches

Electric Steam Vaporizer, 1947
Bakelite
8 × dia. 4 inches

Anonymous loan

These personal medical vaporizers, sold through the 1950s, were produced by The DeVilbiss Medical Products Division, which moved to Somerset, Pennsylvania, in 1951. The user placed a ball of cotton soaked with medicine inside the cover and filled the container with hot water. The unit heated the water, which then vaporized the medicine and shut off after the water boiled away. Although altered slightly over time to accommodate different medicine cup shapes, the black plastic bullet form remained basically unchanged. These vaporizers were recognized as an example of well-designed, common household products in the 1947 exhibition "Good Design Is Your Business" at the Buffalo Fine Arts Academy's Albright Art Gallery.

during the 1970s and 1980s, when Americans abandoned Motor City in favor of smaller, more economical, less style-conscious cars from overseas, indicates the ironic accuracy, at least for that moment, of the magazine's observations about obsolescence. Even so, while the boom lasted, the experience of designing for middling consumers in the automotive industry spilled over into the creation of less expensive consumer goods.

In 1955 there were about six hundred designers working in Detroit, with all but a hundred employed as stylists in the automotive industry. About a half-dozen consultant design firms employed the others, working for clients equally distributed between Michigan and the rest of the country. In addition to Sundberg-Ferar, Detroit supported the seven partners of Lawrence H. Wilson Associates, who had taken over the design office of George W. Walker. The latter, an independent consultant since 1929, had often received commissions from the Ford Motor Company and had recently left to become the automaker's head of design. Another firm, the Walter B. Ford Design Corporation, was founded in 1948 by several former GM auto stylists. Even Harley Earl recognized the lucrative prospects for nonautomotive design in the booming postwar economy of Detroit. At the end of the war, though still firmly in control of styling at General Motors, he founded Harley Earl Corporation, a freestanding company that by 1955 employed twenty designers under a management that included Earl himself as

nominal "design counsel." Over the years his staff worked on everything from Wear-Ever aluminum cookware to Bissell carpet sweepers and Clark forklift trucks. Echoing those famous advertising photographs of a typical suburban family posing in the front yard with all their possessions, or with a year's worth of groceries, *Industrial Design* portrayed the leaders of each of these Detroit firms posing on a well-trimmed lawn with an array of recent products they had worked on: lawn mowers, table saws, vacuum cleaners, carpet sweepers, water heaters, washers and dryers, furnaces, water fountains, luggage, air conditioners, televisions, and other mostly utilitarian artifacts—all rendered in a competent but anonymous style composed of boxy shapes, crisp lines, and dull neutral colors. This design aesthetic—typical of the Midwest in the 1950s and 1960s—was not about making an exuberant splash. Instead, it was almost as if Detroit's product designers had chosen to create a neutral backdrop for the flashy automotive display of two-tone pastels, speed lines, tailfins, and baroque chrome bumpers. Even so, *Business Week* concluded that locating a design firm in Detroit "carries with it some of the glamor of the automobile industry."[26]

While consumer product design may have entered Detroit by way of the automobile, that was not true for Chicago, the other great design center of the Midwest. Consumer goods had played a significant role in Chicago's economy since the late nineteenth century, when the city began taking full advantage of its position as the nation's rail hub to supply manufactured products to farm families throughout the central states. Montgomery Ward and Sears, Roebuck prospered by sending out mail-order catalogues offering a cornucopia of all the world's goods—and a veneer of sophistication. By the 1920s, however, both firms faced unprecedented competition as rural folks drove their autos into town to shop in person. Both companies responded by opening retail stores—and by entering aggressively into the design movement of the 1930s. Although Sears initially hired such Easterners as Loewy and Dreyfuss

to consult on appliance design and only later opened an in-house design studio known as Department 817, Ward established a Bureau of Design in 1931. Serving as a de facto educational program for many young artists who later opened their own consultant design offices, the Bureau at Ward shaped the future of industrial design in Chicago.[27]

The Bureau's director was Anne Swainson, a native of Sweden educated at Columbia University in the applied arts. She had taught at Berkeley and was working as a "fashion coordinator" at Chase Copper & Brass when Montgomery Ward recruited her away in an attempt to regain market share they had lost to Sears. Swainson, the most influential woman in American industrial design during the 1930s and 1940s, started out at Ward by redesigning the famous mail-order catalogue, abandoning woodcuts no different from those of the nineteenth century in favor of photographs evoking a stylish modernity. Overcoming resistance from the outside manufacturers who produced Ward's goods, she insisted that the Bureau of Design had ultimate authority to approve or reject all proposed products. By 1935 she was supervising eighteen product designers and fourteen packaging designers who created designs to be manufactured by the company's suppliers. She succeeded so well that by 1936 the annual volume of Ward's sales had risen from 25 percent to 82 percent of that of Sears. Swainson hired most of her staff from among graduates of the Armour Institute of Technology and The School of The Art Institute of Chicago, many of whom had worked as artists or architects at Chicago's Century of Progress Exposition of 1933. She trained them as industrial designers herself. By all accounts she was a tough but humane taskmaster who gave each designer daily assignments with ironclad deadlines. Working under pressure for Swainson taught them to locate quickly the key issues in a project and not to be afraid of making practical compromises. Her employees seem to have appreciated the professional discipline they learned and later warmly recalled their years at Montgomery Ward. One of the first of Swainson's alumni to venture

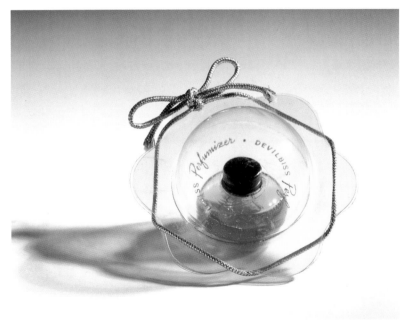

Plate 19
Reinecke Associates, *DeVilbiss Perfumizer,* 1948
The DeVilbiss Company
plastic, glass, and elastic ribbon
2⅜ × 3¾ × 3¾ inches
Connie Cuyler

A pioneer in the use of new plastics, Chicago designer Jean Reinecke promoted the material's versatility in color, form, and manufacturing cost savings. In this transparent display case for a perfume bottle, the words of the label appear to float in space. The package, with soft organic forms typical of the postwar years, declares itself as equal in importance to its contents.

out from the Bureau of Design was Dave Chapman, her head of product design, who established an independent office in Chicago in 1936. A line of durable tube-steel and plywood furniture for school classrooms, designed for Brunswick-Balke-Collender around 1954, proved so successful that the company had to sue a competitor who pirated the designs. Chapman's status in Chicago was confirmed when Ward consulted him in the mid-1950s to assist in reviving the Bureau of Design, which had become moribund.[28]

Many former employees of Swainson remained in Chicago as independent consultants or in-house designers for particular companies, and others relocated throughout the manufacturing cities of the Midwest. In the late 1940s, for example, Richard Latham became a senior partner in Raymond Loewy's Chicago office, which had opened in 1943. There Latham worked on Studebaker automobiles and converted a wartime Hallicrafters shortwave radio for consumer use by simplifying the controls but retaining a utilitarian aesthetic reminiscent of the military. In 1955 he joined with two other former Loewy designers to found Latham, Tyler, Jensen, an independent partnership. Among their first clients was Ekco Products Company, a manufacturer of inexpensive kitchen utensils, whose management required assistance with developing new products—in other words, using design expertise not to improve appearance but to introduce novelty, both entirely new functions and new combinations of functions, into a field that had long remained stagnant. Another designer with experience at Montgomery Ward was James Teague, who opened a consultant office in Chicago in 1950 with David Painter and Victor Petertil. Their projects ranged from the standard wall-mounted hot-air dryer for washrooms, for the National Dryer Corporation in Chicago, to the TR-1 for Texas Instruments, introduced in 1954 as the first shirt-pocket transistor radio and quickly undersold by Japanese competitors in a move that did not bode well for the long-term success of American manufacturing. Some of Swainson's designers, such as Herbert Zeller, chose the corporate route. After working as an in-house designer for three successive companies in the 1940s, Zeller joined Motorola in 1949, became director of design in 1956, and supervised thirteen designers and three model makers in turning out nearly a hundred different radios and televisions annually. In that same year, when *Industrial Design* published a special issue on Chicago, the editors singled out thirty independent consultant practices as worthy of notice. Among them were those of Jean Reinecke (plate 19), formerly in partnership with J. F. Barnes, whose projects included Scotch tape dispensers for Minnesota Mining (later 3M), and Brooks Stevens, whose office in nearby Milwaukee produced work ranging from packaging for Miller High Life beer to the Willys Jeepster station wagon (see Porter, p. 119). For the moment it seemed to the magazine's editors as if Chicago and environs had become the design center not only of the Midwest, but of the entire country. At the very least, as Dave Chapman observed, if New York was the "brains" of

industrial design, then Chicago was the "hands" of the profession.[29]

All the same, not everyone in the national design scene approved of Midwestern commercial design, with its somewhat uninspired aesthetic intended to appeal to ordinary people—either through a blandness that would not obscure functional simplicity or, less often, through a gaudiness that immediately caught the eye. Edgar Kaufmann, Jr., director of the industrial design department of The Museum of Modern Art in New York from 1946 to 1955, criticized much postwar commercial design as unacceptable "borax and chrome" with no redeeming value, no ability to uplift or improve those who came into contact with it.[30] Among the designers he did champion were Eero Saarinen and the husband-and-wife team of Charles and Ray Eames, whose experiments with new materials, such as seating shells of complexly curved plywood or fiberglass-reinforced polyester, were revolutionizing the high-end contract furniture market (plate 20). All three had gained their training in the Midwest at the Cranbrook Academy of Art outside Detroit, which was directed by Eero's Finnish emigré father, Eliel. The Eameses later applied their talents to furniture for The Herman Miller Furniture Company, an exemplar of modern "good design" among the many other firms churning out reproductions of early American furniture in Grand Rapids, Michigan.[31]

Seeking to establish the work of designers like the Eameses and Saarinen among the expanding postwar middle class, Kaufmann organized a series of "Good Design" exhibitions held from 1950 to 1954. His juries selected objects—from textiles and carpets, through tableware and housewares, to furniture and wall storage units—which were installed twice annually, in January and June, at the Merchandise Mart in Chicago, a massive building in which some three thousand manufacturers typically displayed their wares to wholesale buyers representing retail stores throughout the country. Despite a considerable publicity effort and tasteful installations that prompted publicist Alfred Auerbach to describe Kaufmann and his associates as "essentially merchants of environment, not just commodities," the impact of the "Good Design" shows was minimal in the face of such a vast collection of mainstream products.[32] Each year Kaufmann selected the best of the seasonal Chicago displays for an exhibition at The Museum of Modern Art that brought "Good Design" to a cultural class of Manhattanites already primed to receive it enthusiastically. Kaufmann's claim that "a new and crucial audience was gained for progressive modern design" remained dubious on a national scale—with most Americans preferring the more technologically oriented, or more comfortably overstuffed, products of mainstream commercial designers.[33] Only a few of those designs, such as Barnes & Reinecke's Juice-A-Shake, an elongated ovoid Melmac plastic cocktail shaker, ever made it past Kaufmann's selection juries.[34] Harold Van Doren complained bitterly that the first "Good Design" exhibition was "a pitifully inadequate selection." Irritated by "the slight air of Lady Bountiful going

Plate 20
Eero Saarinen for Eero Saarinen and Associates,
Pedestal or Tulip Armless Chair, 1957
Knoll Associates, Inc.
Fiberglas-reinforced plastic, aluminum, and upholstery
32 × 19½ × 21 inches
Cranbrook Art Museum, Bloomfield Hills, Michigan

Influential Finnish-born architect and designer Eero Saarinen experimented with Owens-Corning Fiberglas in his Pedestal chair, also known as the Tulip chair. Like the molded plywood furniture of Charles and Ray Eames, this sculptural Fiberglas shape, manufactured as a series of tables and chairs, expanded the possibilities of new materials and production methods. The molded bases eliminate the clutter of legs and unify the chair's form into an integrated, fluid whole. However, the limitations of Fiberglas at the time required that aluminum be used in the pedestal to support the weight of a person.

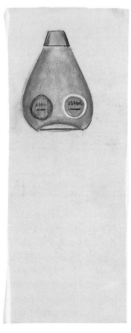

Plate 21

Russel Wright, *Preliminary Sketches for Calvert Reserve Special Gift Decanter*, 1955
Calvert Distillers Corporation
graphite on paper
10 × 8 inches
Department of Special Collections, Syracuse University Library, Syracuse, New York

In February 1955, Russel Wright began planning the design for that year's Christmas promotion of Calvert Reserve Blended Whiskey. This project required the collaboration of Wright's office and the Calvert Distillers office in New York, the liquor ware sales management at the Toledo office of the Owens-Illinois Glass Container Division, O-I's Indiana manufacturing plant, and several outside service providers in the New York area who prepared lettering and materials for the bottle label and gift carton—an example of the multiple issues involved in bringing a product to a retail shelf. After looking at liquor gift containers of competitors, the design team tried a variety of solutions, from a squat, heavy form to a graceful, duckbill decanter with a stopper, each offering challenges in manufacturing, labeling, or packaging. The final selection was a twelve-inch bottle weighing eight ounces with a twenty-four-ounce fluid capacity. This height was believed best for shelf display and packing cases. The cap could be used as a two-ounce jigger. With a production goal of 1.5 million units targeted to a market 70 percent male and 30 percent female, designers worked within strict production cost limits for the bottle, cap, label, and carton.

Plate 22

Russel Wright
Calvert Distillers Corporation

Drawing for Calvert Reserve Special Gift Decanter, 1955
graphite, colored pencil, and chalk on paper
11¾ × 9⅛ inches

Drawing for Calvert Reserve Special Gift Decanter, 1955
graphite, colored pencil, and chalk on paper
11⅞ × 4⅝ inches

Department of Special Collections, Syracuse University Library, Syracuse, New York

The elegant duckbill cruet with a glass stopper and a collar label was thought the most attractive, but its form was the most difficult and expensive to produce; potential spillage from the off-center opening was also a problem. The stopper was a more fragile and less efficient closure than a screw-on cap. The compromise solution took the duckbill form and added a simple top. Other shapes, such as the squat form, presented challenges in attaching a label.

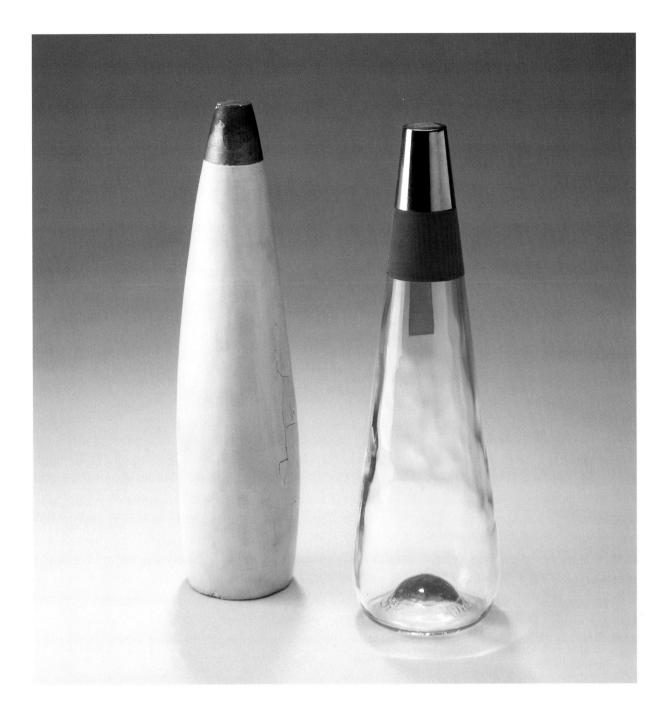

democratic," he wanted to know what it was "about the Museum of Modern Art crowd that makes them seemingly incapable of coming to grips with the realities of design in everyday life?"[35]

Above all else, Midwestern design did concern itself with the realities of everyday life. Midwestern industrial designers engaged in the art of the practical—whether trying to economize manufacturing and marketing processes, simplifying the functional uses of ever more complicated devices, or appealing to the relatively simple tastes of first-generation suburbanites who sought material confirmation of their newly elevated status. Perhaps because they worked in a calculus of the familiar, adding only enough novelty to slightly distinguish each new model from its predecessor, the designers of Toledo, Detroit, Chicago, and other nearby cities worked relatively anonymously. Among those few who achieved popular name recognition were Harley Earl, Eero Saarinen, and Russel Wright (plates 21–24), an Ohio-born

Plate 23
Russel Wright
Calvert Distillers Corporation

Plaster Model for Calvert Reserve Special Gift Decanter, 1955
plaster and paint
12 × dia. 3 inches

Calvert Reserve Special Gift Decanter, 1955
glass, chromed plastic, paper, and textile
11⅞ × dia. 3¾ inches

Department of Special Collections, Syracuse University Library, Syracuse, New York

After considering the optical effects of crackled, colored, or frosted glass alternatives, the design team opted for Owens-Illinois's forte: a whiskey bottle in clear glass; a similar bottle in a frosted finish was made for gin. The gold cap and red velvet labels added a premium touch to the simple yet elegant shape. Although plaster models explored variations of the form, the geometry of the simple, tapered shape proved optimum for manufacturing, labeling, and packaging.

Plate 24
Russel Wright, *Artwork for Labels for Calvert Reserve Special Gift Decanter,* 1955
Calvert Distillers Corporation
colored papers, gelatins, foils, and textiles with ink, gouache, and graphite
various dimensions
Department of Special Collections, Syracuse University Library, Syracuse, New York

Russel Wright contracted an outside firm to execute his final design for the Calvert label's lettering; paper sources recommended alternatives in colored foils, fluorescent, and velvet finishes, as well as methods for adhesives. The red velveteen (now slightly faded) was selected for the encircling label. Russel Wright's name in distinctive script was included in the design of the white, red, and gold gift carton. Such a credit was typical for his work, but unusual for most designers working at the time.

designer of furnishings and housewares whose inexpensive, sensuously organic American Modern dinnerware came from the Steubenville Pottery imprinted with his signature. Those consultant designers who came to prominence in the Midwest during and after World War II—Sundberg-Ferar, Jean Reinecke, Dave Chapman, Brooks Stevens, Richard Latham, and so on—remained leaders of the profession into the 1960s and 1970s. Many served as officers of the Society of Industrial Designers (later the Industrial Designers Society of America), and they all received frequent coverage in the pages of *Industrial Design.* Even so, whatever the nuts-and-bolts workings of American industry, journalists of the design press and of more general publications turned away from the Midwest in tracing the field's most exciting trends. *Industrial Design* never devoted another special issue to the design community in Detroit, Chicago, or any other Midwestern metropolis. Instead, editors looked farther afield for visual stimulation: to the sun-and-surf redwood-and-fiberglass lifestyle of California, to the artificially bright molded plastic furniture and lamps of Italy's *dolce vita,* to the clean white rationalism of Germany's Braun and Krups kitchen machines, and eventually to Japan with its small economy cars and matte-black electronic equipment.[36]

In the meantime, however, designers continued working in the service of traditional industries of the upper Midwest—increasingly not as independent consultants, but as members of in-house design departments at individual companies.[37] Such major Midwestern manufacturers as Sunbeam, Westinghouse, Frigidaire, Hotpoint, and Bell & Howell relied largely on permanent design staffs. As early as 1948 John Gordon Rideout, whose Cleveland-based office had relocated to the aptly named suburb of Chagrin Falls, complained that he was "frankly very discouraged about the situation of the consulting Industrial Designer." He observed a "definite trend toward the employment of staff designers . . . as hundreds of students are graduated from industrial design courses." Manufacturers assumed they were "better off to hire inexpensive staff designers than . . . to use outside design service at studio rates."[38] Both the trend toward in-house design and the increase in numbers of design graduates indicated that industrial design had long since moved beyond the status of business fad it had enjoyed during the 1930s.

Design in fact had become routine by the 1950s and 1960s—merely another of the many variables considered essential to the success of all manufacturing enterprises, especially those that pitched their products to consumers. This sense of routine fostered design anonymity. So too did the accumulated experience of in-house staffers who spent entire careers working on one type of product, whether kitchen appliances or vacuum cleaners or lawn mowers. The introduction to *Industrial Design*'s annual design review for 1964 lamented that "whole categories of entries fell short of the minimum standards"; therefore, no radios or televisions, no cameras or lighting fixtures, and only a few housewares and appliances were illustrated.[39] At best, most American goods reflected a competent aesthetic neutrality that was generally in line with everything else on the market at a given moment. New designs no longer stood out proudly, but instead blended into a general backdrop against which imports from Italy, Germany, or Japan looked strikingly novel, desirable, and highly competitive. In a sense, Midwestern design in the late twentieth century, and indeed American commercial design in general, fell victim to the same false sense of self-assurance that marked the culture of the Cold War and temporarily masked the decline of the upper Midwest, the former industrial foundry of America, into a rust belt of decaying factories and dreams. Designers who succeeded in the Midwest during the 1980s and 1990s did so because they consciously became citizens of a larger, globalizing economic world. Often they symbolically moved their studios and offices out of bleak inner cities and established them in suburban or even rural environments—some even converting abandoned barns into studios. Dedicated to giving shape to the information age, just as the founding designers of the 1930s had given shape to the machine age, they no longer had to be located near their clients, whose enterprises dissolved into a complex web of transnational connections. Though thriving once again, Midwestern design had in effect ceased to exist.

1. On the Ohio Building, designed by Mills, Rhines, Bellman & Nordhoff, Toledo's leading architectural firm, completed in 1930, and renamed the Owens-Illinois Building in 1955, see Eric Johannesen and Allen L. Dickes, *Look Again: Landmark Architecture in Downtown Toledo and Old West End* (Toledo: Landmarks Committee of the Maumee Valley Historical Society, 1973), pp. 202–203.

2. [George Nelson], "Both Fish and Fowl," *Fortune* 9 (February 1934), pp. 40–43, 88, 90, 94, 97–98.

3. Ibid., pp. 43, 88. Biographical data are from an undated one-page typed summary provided to the author in 1986 by Harper Landell, who inherited Van Doren's firm after his death; *Current Biography*, 1940, pp. 823–24; and "Harold Van Doren, Product Designer," *New York Times*, February 4, 1957, p. 19.

4. Sheldon Cheney and Martha Candler Cheney, *Art and the Machine: An Account of Industrial Design in 20th-Century America* (New York: Whittlesey House, 1936), p. 84.

5. [Nelson] (note 2), p. 90.

6. Harold Van Doren, *Industrial Design: A Practical Guide* (New York: McGraw-Hill, 1940), p. xvii.

7. Walter A. Fink, "A History of Toledo Scale Corporation: The First Fifty Years" (1967), p. 122. Fink's unpublished 200-page typescript is in Box 2, Toledo Scale Company Archive, Toledo's Attic-Lucas County/Maumee Valley Historical Society, Maumee, Ohio.

8. Biographical information is from a Rideout public relations handout, ca. 1945, and from Alice Rideout's brief biography of her late husband, April 29, 1999, both courtesy of Victoria K. Matranga. Many of the following commissions are described in *Before and After: A Few Examples of the Recent Work of Van Doren and Rideout* (Toledo: Van Doren and Rideout, ca. 1934); others are in various original client lists provided to the author in 1986 by Harper Landell.

9. "The Industrial Design Consultant," *Art and Industry* 36 (March 1944), p. 77; Van Doren, *Industrial Design* (note 6), p. 148. While Rideout received a design patent for the wagon (93,674), Van Doren and Rideout filed jointly for design patents on the scooter (91,256), tricycle (96,636), and sled (91,796), and for an invention patent on the steering mechanism of the sled (2,041,982).

10. Thomas R. Smith, "Modern Engineering Catches Up with Washing Machine Design," eight-page typed case study provided to the author by Harper Landell in 1986.

11. Van Doren, *Industrial Design* (note 6), p. 350.

12. "The Industrial Design Consultant" (note 9), p. 74.

13. Typed information sheet on Surface Combustion Corporation provided to the author by Harper Landell in 1986.

14. Van Doren, *Industrial Design* (note 6), pp. 355–56.

15. Ibid., pl. 21.

16. P. Huber, "Styled Machines Sell Well," *Electrical Manufacturing* 18 (October 1936), pp. 70–72. Van Doren received a design patent on his work for Ex-Cell-O (106,875). For the Baker Perkins work, he shared a design patent with J. M. Little (118,271). See also Harold Van Doren, "Design for New Living," *Art and Industry* 39 (December 1945), pp. 162–67.

17. *Current Biography* (1940), p. 824.

18. Van Doren, *Industrial Design* (note 6).

19. The book proved so useful that a thorough revision was published fourteen years later: Harold Van Doren, *Industrial Design: A Practical Guide to Product Design and Development*, 2nd ed. (New York: McGraw-Hill, 1954).

20. Alice Rideout manuscript (note 8).

21. J. McLeod Little, "Designer's Case Study," *Industrial Design* 9 (February 1962), pp. 66–71; J. McLeod Little, "Auto Biography in brief of J. McLeod Little," photocopy of thirteen-page manuscript; *J. M. Little and Associates, Inc.: Industrial Designers* (Maumee, Ohio: J. M. Little and Associates, ca. 1960), pamphlet; and photocopied materials from the collection of Linda Braming.

22. Donald Dailey, undated one-page typed biography; Donald Dailey, undated audiotape interview, Department of Special Collections, Syracuse University Library, Syracuse, New York, notes taken by Victoria K. Matranga, November 3, 1998; both courtesy of Victoria K. Matranga.

23. Cheney and Cheney (note 4), p. 87.

24. On Sundberg-Ferar, see "Modern Design = Appearance, Production, Profit," *Industrial Marketing* 31 (March 1946), p. 34; "Brain Center," *Industrial Design* 2 (August 1955), pp. 36–41; and "Dependents and Independents," *Industrial Design* 2 (October 1955), pp. 86–89.

25. "Industrial Designers Find Lush Clover in Detroit," *Business Week*, February 2, 1952, p. 94; "Why Design in Detroit," *Industrial Design* 2 (October 1955), p. 36.

26. "Industrial Designers Find Lush Clover in Detroit" (note 25), p. 96. See also "Arsenal of Design," *Industrial Design* 2 (October 1955), p. 44; and "Dependents and Independents" (note 24), pp. 73–93.

27. The following discussion of the Bureau of Design is based on Jane Fiske Mitarachi, "Dramatis Personae," *Industrial Design* 3 (October 1956), pp. 72–74; Ann Ferebee, "Company at the Crossroads," *Industrial Design* 8 (November 1961), pp. 90–91; and Christian K. Narkiewicz-Laine, *Anne Swainson: Montgomery Ward's Bureau of Design 1931–1955* (Chicago: Chicago Athenaeum, 1994). On Sears, see "Department 817," *Industrial Design* 1 (October 1954), pp. 81–82.

28. "New Equation for the Classroom," *Industrial Design* 1 (April 1954), pp. 52–57. On Chapman in general, see "Four Spokes to the Wheel," *Art and Industry* 51 (December 1951), pp. 196–201; and Barbara Allen, "Dave Chapman, Goldsmith & Yamasaki Inc.," *Industrial Design* 13 (June 1966), pp. 80–85.

29. Dave Chapman as paraphrased by Allen (note 28), p. 84. See also "An American Design Trio" [Painter, Teague, and Petertil], *Art and Industry* 56 (June 1954), pp. 200–205; Mitarachi (note 27), pp. 78–80; "Chicago Design Directory," *Industrial Design* 3 (October 1956), pp. 113–25; Anne Woodhouse, "Industrial Designer Brooks Stevens: Businessman, Engineer, and Stylist," *Wisconsin Academy Review*, Fall 1993, pp. 10–14; and Narkiewicz-Laine (note 27), pp. 11–16.

30. Edgar Kaufmann, Jr., "Borax, or the Chromium-Plated Calf," *Architectural Review* 104 (August 1948), pp. 88–93.

31. For a good contemporary account, see "Herman Miller Furniture," *Industrial Design* 3 (June 1956), pp. 87–89.

32. Alfred Auerbach, speech at Merchants and Manufacturers Club, Chicago, January 16, 1950, as quoted by Terence Riley and Edward Eigen, "Between the Museum and the Marketplace: Selling Good Design," *Studies in Modern Art 4: The Museum of Modern Art at Mid-Century: At Home and Abroad* (New York: The Museum of Modern Art, 1994), p. 166. The entire article, pp. 150–79, is useful.

33. Edgar Kaufmann, Jr., introduction, *Good Design: November 22, 1950 to January 28, 1951: An Exhibition of Home Furnishings Selected by the Museum of Modern Art New York for the Merchandise Mart Chicago* (New York: The Museum of Modern Art, 1950).

34. "Designing to Sell," *Sales Marketing* 48 (March 1948), p. 76; *Good Design: November 22, 1950 to January 28, 1951* (note 33), item 212.

35. Letter from Harold Van Doren to Walter Dorwin Teague, November 27, 1950, in Walter Dorwin Teague Papers, microfilm reel 16.32, Department of Special Collections, Syracuse University Library, Syracuse, New York, photocopy courtesy of Victoria K. Matranga (hereafter cited as "Teague Papers").

36. For early examples of this trend, see *Industrial Design*'s special issues on Europe in July 1957, California in October 1957, and Japan in March 1964.

37. In September 1963 *Industrial Design* dedicated a special issue to the work of in-house design staffs at twenty-four companies. See also "A Conversation with George Nelson," *Industrial Design* 16 (April 1969), p. 76.

38. The first and third quotations are from a letter from John Gordon Rideout to Walter Dorwin Teague, June 2, 1948, Teague Papers (note 35), microfilm reel 16.32; the second is from a copy of a letter from Rideout to Philip McConnell, Society of Industrial Designers, April 16, 1948, Teague Papers, microfilm reel 16.32.

39. "The Eleventh Annual Design Review," *Industrial Design* 11 (December 1964), p. 38.

William Porter

TOLEDO WHEELS
THE DESIGN STORY OF WILLYS-OVERLAND, THE JEEP, AND THE RISE OF THE SUV

A double-page ad in the August 8, 1909, *Toledo Times* announcing "The Overland Company Comes to Toledo"[1] featured pictures of the "mammoth" facility flanked by cameo photographs of founder John North Willys and six of his key management people, among whom is one W. H. Cameron, Designer. This may be the first instance of an American automobile manufacturer having a designer as a member of its management team. The ad copy makes it clear that Cameron's job would be to attend to the "graceful proportions and . . . attractive appearance" of Willys automobiles as well as to their engineering specifications, and "he will devote his time to new ideas and refinements on the Overland." From Cameron's credentials as a designer, it is apparent that Nordyke-Marmon, Packard, and other prestigious automobile companies also employed designers prior to 1910, a fact rarely if ever mentioned outside the industry.[2]

The city of Toledo, Ohio, has been part of the fabric of the American automobile industry from the beginning. Some forty-six makes of automobiles were designed or manufactured in and around Toledo,[3] a proliferation of nameplates that for the most part dates, as with the automobile industry in general, to the early twentieth century. But one company, Willys-Overland, and its successor, Jeep, dominated the Toledo industry since 1909, when Willys[4] brought his Overland Company to Toledo from Indianapolis. The company's turbulent history has run the gamut from enormous success to reorganization in the face of bankruptcy. A great success in its early years, by 1912 Willys-Overland was the second largest selling automobile company in the country, although admittedly a distant second to the indomitable Ford Motor Company. Following a brush with disaster after World War I, it climbed back to third place in the industry. The Great Depression and the death of John North Willys in 1935 drastically reduced the scope of the once great company to a low-volume producer of small cars for the remainder of the decade. Its product orientation was radically altered again with its commitment to the Jeep during and after World War II.

Eventually the all-steel, four-wheel-drive Jeep station wagon evolved into the modern sport utility vehicle (SUV), a new automotive form that dominates the American scene today.

Design Consciousness under John North Willys

The specific executive jobs selected and described in this early announcement ad[5] reveal that Willys's ideas about running an automobile company differed considerably from those of his contemporary Henry Ford. Willys's Toledo home was furnished with fine English antiques, and his frequent, extended trips abroad and intense interest in export business may have contributed to the sophistication of his company's products.[6] A trustee of the Toledo Museum of Art, Willys placed a strong emphasis on marketing and design as well as innovative engineering—a marked contrast with Ford's well-known focus on no-nonsense engineering for production efficiency. Instead of concentrating on one model, as Ford did with his legendary Model T, by 1911 Willys was offering, in addition to trucks, an astonishing eighteen different automobiles, although some were merely different body styles on the same chassis. On the other hand, only one color—"Willys blue" or "Brewster green," usually with black fenders and top[7]—was offered for each body style of a particular model, or in some cases an entire model. Despite this one concession to manufacturing efficiency, however, which was maintained until the late 1920s,[8] Willys was, on the whole, a design-oriented company that tried some very fresh approaches along with its popular mainstream offerings.

A series of models that evidence Willys's early design consciousness were the Opera Coupes (1914–16). In 1914 Willys introduced the exceptionally handsome and innovative Overland Model 79-C (figure 1). It consisted of an erect, beautifully proportioned, carriage-like four-passenger cabin[9] carried well ahead of the rear wheels, on a 114-inch wheelbase chassis. Its height contrasted effectively with low hood and rear trunk volumes, while the flat, more mechanical curves

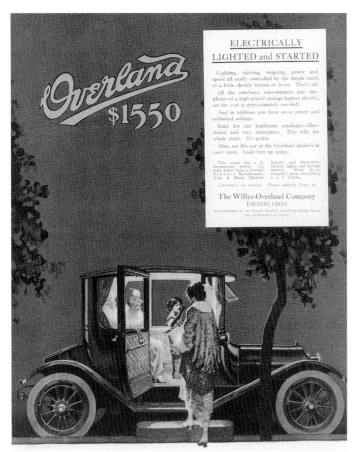

Figure 1. Advertisement for the 1914 Overland Model 79-C
Four Passenger Coupe.

of the fenders and running boards played off against the gently bowed surfaces of the cabin. Its window areas were exceptionally large and gracefully outlined, and its vertical windshield was flanked by two dramatically curved glass corner panels. Thus carried between the wheels with poise and dignity, the glassy coupe cabin was a study in gracious accommodation. The interior was also unique. Electrical switches were conveniently located on the steering column, while the pedestal-mounted front passenger seat could be swiveled to face rearward for conversation with back-seat passengers. Among the amenities were electric lights and a push-button starter.

This relationship between design and comfort was an important and growing consideration. In the early days of the industry, the open car was the dominant body form: the so-called "touring car" configuration, with its bathtublike body containing both front and rear seats; and the "roadster" body for two passengers. Both had canvas tops with side curtains, which could be erected in inclement weather. As the decade progressed, however, a clear trend emerged toward the more comfortable (and more expensive) closed body styles, the sedan and the coupe.

Using design as a tool to resolve the two styles, Willys audaciously sought to have the best of both worlds, offering in 1916 new *detachable* hard tops for both the Overland Model 83 sedan, or "Limousine," as they called it, and the Model 83 coupe. Aware of the potential for awkward design in a hybrid such as this, Willys proclaimed in

its promotional material that these tops were "designed with the car." And indeed they appear to have been, harmonizing surprisingly well with the body lines; full height doors were included in the package. However, any rigid removable top requires a suitable storage space when not in use, and none has ever been truly successful.[10] Nevertheless, Willys was astute in discerning a dilemma inherent in the trend toward closed cars and creative in offering an innovative, well-executed design alternative to deal with it.

In 1917 Willys introduced a sedan body on both the Overland four- and six-cylinder Model 85s[11] that incorporated a couple of surprise innovations. In an effort to provide a sedan for closed car buyers on a limited budget, Willys eliminated the front door on the driver's side, creating, in effect, a three-door sedan. When the side glass was rolled down and the side pillars were folded out of view, there emerged a totally new breed of sedan with a dramatic sweep of open window area. Indeed, this "Touring Sedan" anticipated the so-called hardtop convertibles of the 1950s by some thirty-two years.

Willys kept well abreast of design trends, such as the fusion of the "hood," or engine compartment, with the passenger compartment, or "body." This development progressed incrementally throughout the teen years and continued through the 1920s, culminating at the end of that decade in the so-called "classic car" era.[12] Figure 2 shows John North Willys himself at the wheel of his jaunty new Model 90 Country Club, which, like other Willys models of the time, has an exceptionally clean transition as the body surface wraps from the round hood into the flat front door. The convex "bustle back" visible at the rear of the Country Club, just below the folded top, is also predictive of cars of a much later date.[13] Willys took the big leap, however, with the touring car version of their Willys-Knight Model 20 of 1920, in which, visually, the engine compartment and passenger cabin are contained elements of a single long central body form.

One of the automotive success stories of the 1920s was the Whippet, named after a breed of racing dog: a spirited, inexpensive, light car introduced for 1927 as a stand-alone brand with a full line of body styles. The timing was fortuitous, corresponding with Ford's famous year-long shutdown prior to the introduction of the Model A. Sales generated by the Whippet elevated Willys to third place behind Ford and General Motors. Although the smaller scale of the car and the distinctive taper of the radiator shell were perceived as having English or Continental overtones, the body styling was mainstream American.

Body graphics, or surface treatment, was an important feature in Willys's design: as early as 1924, the Willys Knight Model 64 coupes and roadsters sported a two-tone body paint scheme. The contrasting colors, separated horizontally along a narrow raised body molding and emphasized with a contrasting pinstripe, graphically unified the lower body from front to rear (figure 3). The paint job was an integral

Figure 2. John North Willys, founder of the Overland Company, driving the 1917 Overland Model 90 Country Club.

Figure 3. 1924 Willys-Knight Model 64 Coupe.

feature of this coupe and, as with other Willys automobiles prior to the 1930s, the buyer was not offered a color choice.

The large six-cylinder line of Willys-Knights designated the Model 66 was introduced in 1925.[14] The "Great Sixes," as they were known, were the most prestigious Willys automobiles ever made in Toledo.[15] For the first few years, their designs were attractively mainstream, characterized by Willys's popular body features of double-belt moldings and two-tone paint schemes, but given a new importance by the greater size of these cars. Model 66s also had distinctive, shield-shaped headlamps, the work of designer/draftsman W. Fred Meeks,[16] and a prominent radiator cap ornament in the form of an armored knight, poised with drawn sword pointing forward, oblivious to concerns for pedestrian safety. The knight and shield motifs were very much in tune with the times: the Tudor Revival style, with its attendant heraldic symbolism, was the rage in American residential architecture.

Amos Northup

In early 1928 designer Amos Northup left the Murray Corporation of America to become chief designer for Willys.[17] Better known in the industry than most designers, Northup gave talks to industry groups such as the Society of Automotive Engineers (SAE), which were reported in the trade magazines. On one occasion he delivered a report on differences between American and European design practices as revealed at the Paris Automobile Salon. On another, he set up a number of "body design ideals"—a sort of designer wish list—and predicted the futures of the various types.[18] In one talk, Northup had an associate read his paper while he made large pastel renderings of his body designs—an unusual presentation well reported in the press, with his drawings reproduced. Northup preached and practiced his

aesthetic principles and championed his belief in a central role for the artistically talented designer:

> Much of the lack of unity and beauty in automobile design of the past can be attributed to the unfortunate interference in body designing activities by executives not qualified by experience, training or talents to dictate the form a given body should take. They do not realize that there is a wide gap between the possession of good taste and real artistic ability. The two are easily confused. . . . Experience seems to demonstrate that the most attractive motor bodies are the product of experienced designers working without interference from well-meaning executives who hope to assist with their criticisms.[19]

This remarkably candid observation was delivered to the SAE in 1927, *before* Willys hired Northup.

Willys evidently had great admiration for Northup's talents. In October 1929, at a Paris banquet on the occasion of the European announcement of the new product line designed by Northup, Willys introduced him as "the biggest little man in this room."[20] The timing of Northup's arrival at Willys in early 1928 allowed him to make only minor, last-minute changes to the Model 66A, successor to the first of the Great Sixes. However, his dramatically redesigned Model 66B arrived in dealer showrooms in mid-1929 (figure 4).

Northup's new radiator shell design resembled the exotic European Hispano-Suiza more than the American Packard. He eliminated the shield-shaped lamps and stretched the fender lines into powerful yet graceful curves. Twin spare tires mounted in the elongated front fenders replaced the single spare on the rear deck. The closed body styles—sedan, Victoria Coupe, and coupe with rumble seat[21]—carried a daring two-tone paint scheme. From behind the

new "knight in a ring" hood ornament, this graphic treatment unfurled rearward toward the windshield. Its outline plunged down on either side of the cowl, then swung rearward across the lower door and back up again over the rear fender.[22] Most dramatic of all were Northup's Great Six Sport Roadster (plate 1), a hit at the Chicago Auto Salon, and its four-door counterpart, the Sport Phaeton. Nicknamed the "Plaidsides," these cars had an extravagant paint and molding treatment that isolated the doors within a graphic panel consisting of a pinstripe grid.[23]

The Market Crash and Its Aftermath

In late 1929, only a short time before the market crash, Willys, always deeply involved in international commerce, sold the company to a group of investors and embarked on a career change as ambassador to Poland, although he retained his title as chairman of the board and

Figure 4. 1930 Willys-Knight Model 66B Great Six Coupe with rumble seat, designed by Amos Northup.

$5 million in company stock. A short time later, Northup also left Willys, returning to Murray Corporation of America as chief designer. Murray was a major supplier of automobile bodies to the industry, and Northup's design services were available to Murray's clients. Northup remained at Murray for the remainder of his career, designing automobiles for "independent" automakers, including Willys.

In spite of Northup's designs, Willys's new owners suffered severe setbacks in the early stages of the Depression: sales plummeted, its dealer organization fell apart, and model lines were dropped; 23,000 workers were unemployed. The year 1933 saw the last of Willys-Knight and its Great Six line.

Starting Over: New Design for the Depression Era

At President Herbert Hoover's request,[24] Willys returned to Toledo in 1932 in an effort to save the failing company; he was named co-receiver. Discontinuing all past models, Willys had Northup

design a Depression-bred small car for 1933, the Model 77. One of Northup's most controversial designs, it had a European-style downward curving front joined to an American-style body—a formula that, handled more conventionally, had been quite successful on the Whippet in 1927. The Model 77's small size and low price of $395 (a four-cylinder 1933 Ford was $510) were well suited to the severely depressed market. It seems unlikely, however, that the more extreme design of the Model 77[25] would have appealed to many of its intended buyers, but the question is academic. Willys was unable to secure a crucial bank loan, production was halted, and the US Bankruptcy Court allowed only limited numbers of the Model 77 to be built during the next three years of receivership.

In May 1935 Willys suffered a heart attack at the Kentucky Derby. Further incapacitated by a stroke, he died a few months later. Ward Canaday, Harvard graduate and successful advertising executive, became chairman of the board of Willys-Overland; David Wilson was named president.

Design changes were in the air. The term "streamlining" had been used in the industry since the 1920s to describe any design with rounded corners and perhaps a slanted windshield, but in the early 1930s it became widely accepted that the ideal streamlined form was the convex teardrop shape. Reinforcing this style trend were new developments in sheet-metal forming, which favored more rounded forms. Hence, the boxy, angular, and concave shapes so popular in consumer products of the jazzy 1920s gave way to convex rounded forms in the streamlined 1930s. Aiding the Willys organization's efforts to struggle out of its receivership was one of Amos Northup's most memorable—and successful—designs for Willys, the Model 37 of 1937 (plate 2). A bold and original statement about streamlining, it brought to American production-automobile design a chunky, densely packed expression of the convex streamlined teardrop form[26] not unlike the most famous American racing airplanes of the decade, the Gee Bees.[27] The chubby, spirited forms of the 1937 Willys spoke convincingly to the diminutive scale of the car. Its nose, packed with contained energy, was blunted like the nose of a teardrop and "leaned into the wind."[28] Any tendency to dive was offset by insistently horizontal louvers extending back on both sides. The headlamp pods sprouted from the front fenders in a fresh and appropriate way. Each pod's three small embossed horizontal louvers echoed those of the grille.[29]

Amos Northup died in February 1937 as a result of a head injury sustained in a fall on an icy walk outside his home. His obituary in the

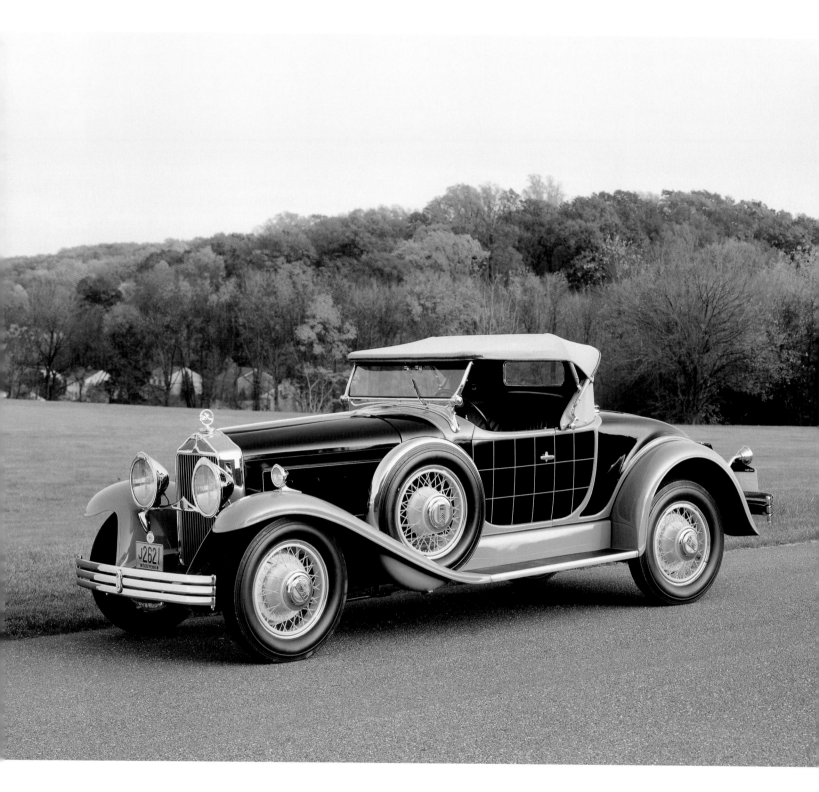

Plate 1
Amos Northup and Willys-Overland Company design staff,
Willys-Knight Model 66B, Plaidside Roadster, 1930
Willys-Overland Company with Griswold Motor and Body
Company
Joe and Rose Marie Lucks

Willys-Overland, Toledo's most renowned automobile manufac-
turer, offered models in a wide price range. Although strikingly
novel, Amos Northup's Plaidside body design, like most cars of
its era, was constructed of a box-shaped wood framework with
a metal skin wrapped over it, mounted atop a steel chassis.

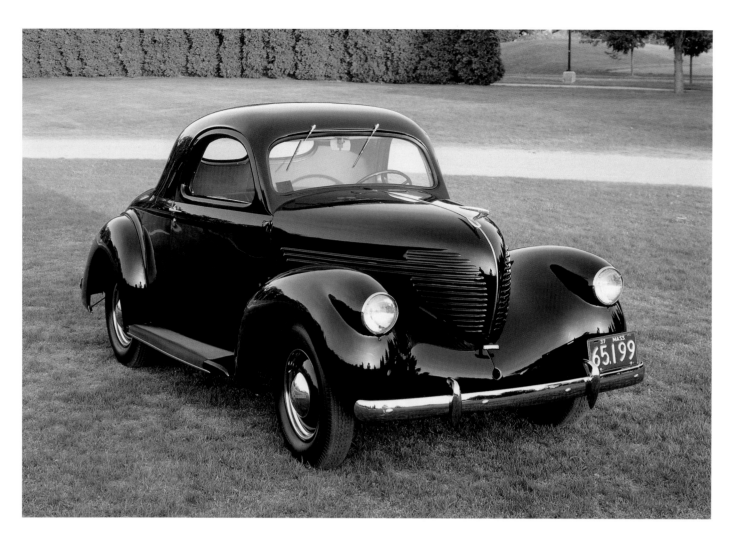

Plate 2
Amos Northup and Murray Corporation of America design staff,
Willys Model 37 Coupe, 1937
Willys-Overland Motors, Inc.
Mike O'Connor

Figure 5. 1941 Willys Americar.

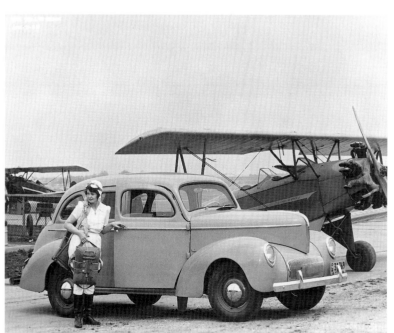

Toledo Blade revealed another aspect of his character: "Mr. Northup played a large part in the reorganization of the Willys-Overland company by designing the new [1937] car. President David Wilson of Willys-Overland Motors, Inc., explained at the time that Mr. Northup, desiring to help in the situation, designed the car and did not accept a cent of pay for his work."

Delmar (Barney) Roos took over as chief engineer at Willys in 1938. Although he was not a designer, it is reasonably certain that Roos directed the design process at Willys in these last prewar years—there is no doubt that he did so during and after the war.[30] Northup's facelifted front end of 1939 was again facelifted in 1940 to have a low grille and more than a hint of Studebaker, where Roos had worked prior to Willys. In 1941 a new body, still utilizing the 1937 cowl, windshield, and front doors, was introduced and renamed the Americar (figure 5). Its overall shape with the integrated trunk was a tamer version of the so-called "torpedo" sedan bodies introduced a year earlier by Studebaker. Likewise, the front end continued the clean, low grille look of the Loewy Studebakers.[31]

The Jeep: Fame and Affection

Simply put, the Jeep is a great American icon. It earned its legendary status in World War II. General George C. Marshall called it "America's greatest contribution to modern warfare." Presidents, generals, and even European royalty were photographed riding in it. And its remarkable performance in all types of military situations endeared it in the hearts of the rank and file in every branch of the service and every theater of operation (figure 6).

From a design standpoint, the Jeep is a complete rejection of the Streamline Style, which completely dominated American automobile design by the late 1930s. It is instead a pure expression of the Functionalist ethic prevalent among automotive engineers throughout the industry's history. Yet it is enormously appealing aesthetically. It was included in curator of architecture Arthur Drexler's 1951 landmark design exhibition "Eight Automobiles" at New York's Museum of Modern Art. Drexler commented upon its design character: "The admirable Jeep seems to have the combined appeal of an intelligent dog and a perfect gadget. . . . The Jeep looks like a . . . sturdy sardine can on wheels. Part of the top appears to have been cut open and folded up, to serve as a windshield. . . . Large wheels dominate the design, and insist rather than suggest that the Jeep's primary purpose is transportation. . . . It is one of the few genuine expressions of machine art."[32]

Three separate automobile companies as well as the US Army had a hand in the design of the Jeep. Its fundamental form was conceived by the Army Quartermaster Corps[33] in response to a long-standing need for an agile reconnaissance vehicle, light weapons carrier, and all-around replacement for the horse. In June 1940 an Army committee including William F. Beasley, chief of engineering for the Quartermaster Corps at Fort Holabird, Maryland, drew up a list of specifications for a "¼ ton truck, 4 by 4" (able to carry five hundred pounds and with four wheels and four-wheel drive). Beasley sketched a rough drawing embodying its basic parameters (figure 7), which was probably included as a supplement to the written specifications.[34]

The call for bids was sent out to 135 automobile manufacturers on June 20, 1940, with the promise of a $175,000 contract for seventy vehicles to the winner. However, because of the Army's insistence on an extremely short response time (one month for bids and vehicle plans and the first operating vehicle to be delivered only three months later, on September 23), only two companies responded: the American Bantam Car Company of Butler, Pennsylvania, and Willys-Overland Motors, Inc., of Toledo, Ohio.

Bantam, a Depression-era manufacturer of midget cars derived from the English Austin, was in dire financial straits and desperately needed the Army contract. Bantam enlisted Karl K. Probst,[35] a Detroit-based consulting engineer with previous small car experience, to take on the formidable task. He put together a workable set of plans and

Figure 6. Bill Mauldin, World War II Cartoon: *Cavalry Sergeant Putting His Broken Jeep to Rest*, 1944.

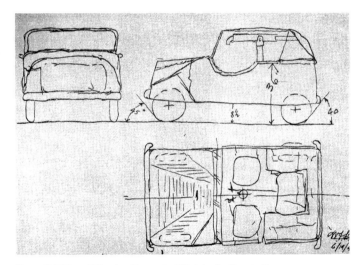

Figure 7. William F. Beasley, *Conceptual Sketch of a Quarter-Ton Truck, 4 × 4*, June 19, 1940.

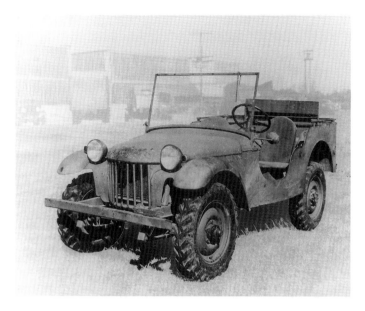

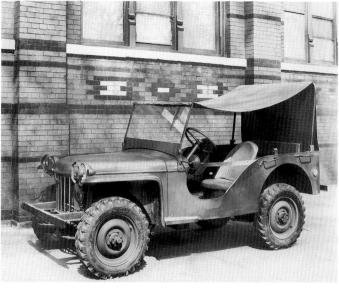

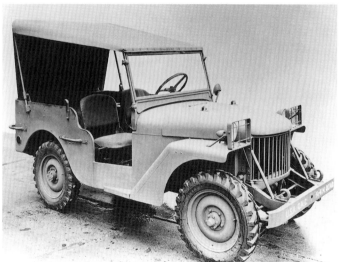

Figure 8. Bantam 4 × 4 prototype No. 1001.

Figure 9. Bantam 4 × 4 prototype No. 1007.

Figure 10. Willys Quad prototype, 1940.

Plate 3
Delmar Roos (engineer) and Willys-Overland Motors, Inc.,
engineering staff, *Jeep Military, Model MB*, 1941
Willys-Overland Motors, Inc.
Walter P. Chrysler Museum, Auburn Hills, Michigan

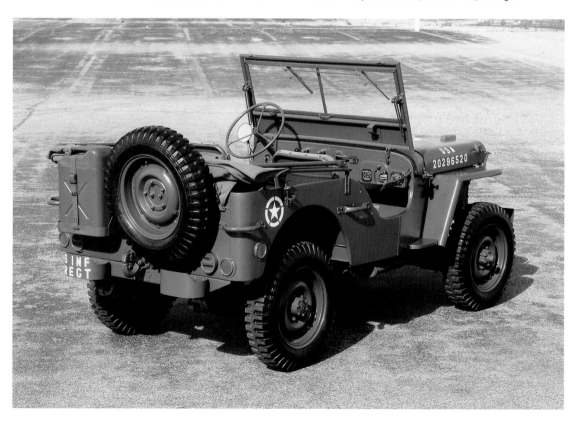

submitted them to the Army on time. At 1,850 pounds, his design was well over the Army's unrealistically low limit of 1,300 pounds (the actual Bantam prototype weighed in at 2,030). Barney Roos, Willys's chief engineer, submitted relatively sketchy plans and, understandably, argued for more time. The Willys design, which incorporated its more powerful engine, exceeded the Army's weight limit by an even greater amount than Bantam's, but eventually the Army raised the limit to 2,160, which enabled Roos's Willys MB to qualify.

On the strength of Probst's more complete proposal, Bantam was awarded the initial contract and completed its first running prototype, Bantam No. 1001 (figure 8). Probst and plant manager Harold Crist drove the 250 miles from Butler, Pennsylvania, to Fort Holabird, in Baltimore, Maryland, arriving one-half hour before the 5:00 PM deadline, September 23, 1940. The remainder of Bantam's seventy-vehicle order, of slightly more advanced design, was delivered on December 17, 1940 (figure 9).[36]

As war clouds gathered, both the Army and the federal government were concerned that the tiny Bantam organization was not capable of volume production and, in any event, they were anxious to have more than one supplier of the vehicle as a precautionary measure.[37] There was also considerable interest in having a manufacturing giant such as Ford taking part in the program. Hence, both Willys and Ford were encouraged to submit entries, even though they would be late. To expedite matters—and much to Bantam's chagrin—the Army allowed both Willys and Ford access to Bantam's plans and prototype vehicle. On November 13, 1940, Willys submitted two of its so-called Quad prototypes (figure 10). Ford, in turn, submitted on November 23 two Pygmy prototypes, one built by the Briggs Body Company and the other by Ford, which was the one that interested the Army.

Although all three bodies resembled that of the original Bantam, significant differences existed among the prototypes from their windshields forward. For example, the Willys had more angular, skirted front fenders. Both Bantam and Willys had headlamps mounted on their front fenders, while Ford's more innovative approach integrated the lamps into a broad, flat grille plane, tucked under a wider hood.

Encouraged by favorable results from its rigorous testing of these early prototypes, the Army asked the three companies to build a second round of 1,500 improved vehicles for further evaluation. Contracts were awarded in March 1941 for the new Bantam BRC-40, the Willys MA, and the Ford GP. Intensified testing revealed the capabilities of this new vehicle, and there was a clear call to produce it in very large numbers. On June 8, 1941, the Army decreed that production should be standardized on one model produced by two or more vendors, as a safeguard against work stoppage or sabotage.

The Willys design was selected, but with the Ford hood and grille arrangement as well as Ford's shift lever and handbrake. Willys had

outperformed its rivals because of its superior Go-Devil engine.[38] Ford was asked to be the alternate supplier, building its vehicles to Willys designs in order to achieve the Army's goal of complete interchangeability of parts (although they did not have to be identical), including the engine, among all Jeeps. Willys's Roos and Ford chief engineer Dale Roeder developed a cooperative working arrangement during the subsequent engineering design and manufacture of both companies' vehicles.[39] The resulting mature design produced by Willys was called the MB (plate 3). Ford's almost identical version was called the GPW.[40]

Squeezed out of the final volume manufacturing by the superior production capabilities of its larger competitors, Bantam did eventually receive contracts for some 2,643 BRC-40s, most of which saw

Figure 11. Ford Model GPW Jeep, in its crate.

service with US allies Canada, Great Britain, and Russia. Willys and Ford production volumes were far greater: 362,841 and 281,448, respectively, for a total of 644,289.[41]

There are good reasons why, as Arthur Drexler observed, the Jeep's proportions resemble those of a sardine can. Its thin, flattened body form resulted from the Army's insistence on high ground clearance for traversing rough terrain, yet low overall height to provide a poor target for enemy fire. As a consequence, the driver sits *on* his Jeep rather than *in* it, a position that contributes substantially to his ability to control the vehicle and his perception of its agile responsiveness. Its compact form also lent itself to a variety of shipping and stacking arrangements (figure 11), greatly increasing its effectiveness in reaching far-flung combat operations.

In the absence of a stylist, the design aspect of producing the Jeep in large quantities boiled down to the classic balancing act between the requirements of design engineering—the need for the vehicle to function as well as possible—versus the realities of manufacturing

engineering—the need to build it as efficiently as possible. The ideal engineering solution is a design that achieves both goals at minimal cost. For example, the final front-end design, a Ford contribution, which initially had a grille consisting of an open "cage" of steel straps and tubes, was replaced by a one-piece stamped-steel panel with the necessary vertical slots and headlamp openings punched into it. The stamped design was much simpler to manufacture and furthermore added structural rigidity to the front of the vehicle. This was an altogether desirable solution, whose vertical slots have become sacred: most modern Jeep derivatives have them.[42]

The question of who deserves credit for the design of the Jeep has long been of interest to many. In 1941 the Truman Committee inquired into why Bantam had been left out of the Army's award of Jeep contracts.[43] The question came into much sharper focus in April 1942, when Willys mounted a national advertising campaign that proclaimed: "It was the great Willys civilian engineering staff fresh from their triumphs in the Willys-American and Go-Devil engine, who collaborated with the Quartermaster Corps of the US Army to create and perfect the jubilant Jeep."[44] Reacting to this and similar ads, the Federal Trade Commission issued a complaint against Willys for misrepresentation in advertising, ultimately ordering the company to cease advertising that it took part in the invention of the Jeep, although it was allowed to advertise its role in improving and manufacturing the vehicle.

In 1991 the American Society of Mechanical Engineers proclaimed the Jeep "An International Historic Mechanical Engineering Landmark." Their conclusion regarding its authorship stated, "The general design and bodywork were largely from Bantam; the front end, Ford; the power unit, Willys."[45] It is worth noting that ASME, an industry-oriented organization, did not mention the initiative role of the US Army Quartermaster Corps or the major contribution of the original specifications committee, which included William F. Beasley and his seminal sketch. Also, from the outset, the Army's relentless and absolutely merciless testing of prototypes and resulting feedback to the industry engineers undoubtedly played a crucial role in identifying design issues and validating their resolutions.

Beyond ASME's general statement, the design origins of several other parts of the Jeep can be deduced from the prototypes.[46] The angular, two-piece front fenders derived from the Willys MA, while the windshield framing and two-piece glass configuration originated with the Ford Pygmy. Like the first Bantam prototype, both the Willys Quad and Ford Pygmy carried their spare tire in the center of the rear-end panel. It is not clear who acted first, but all three soon moved it off center to the right to make way for the center-mounted towing pintle. All three second-phase prototypes appear to have only one top bow (figures 9 and 10). In all likelihood the second bow, which provided additional headroom for the driver and front passenger, was developed by Willys and/or Ford for their final production models.

The wonderful nickname "Jeep," snappy and memorable, apparently became attached to the quarter-ton truck sometime in late 1941 or early 1942, although the term "Peep" was used early in the war, "Jeep" being reserved for the larger half-ton truck. One plausible source for the name was cartoonist E. C. Segar's popular comic strip "Popeye," which introduced a mythical little creature with magical powers, "Eugene the Jeep," in the late 1930s. Near the end of World War II, Willys-Overland president Joseph Frazer applied for a copyright on the name Jeep, thus ensuring its identification with Willys-Overland. Ironically, the parent company has undergone profound changes over the years and its own name is largely forgotten—but Jeep lives on. Appropriately, the organization exists today as the Jeep Division, part of DaimlerChrysler.

Postwar Evolution

Early in the war Willys-Overland management anticipated possible postwar uses of the Jeep. A test was staged at an agricultural experiment station near Auburn, Alabama, and Jeeps were inspected on the production line by representatives of *The Farm Journal* in March 1942. An optimistic feature article appeared in the June 1942 *Country Gentleman* magazine, and it was even suggested that the versatile Jeep could pull a plow and replace the tractor. Within the corporation, Barney Roos oversaw an Agrijeep project in 1944 and early 1945. At war's end Willys-Overland was ready with a wide array of farm attachments for the new CJ (Civilian Jeep) series.

But the Jeep's civilian appeal proved to extend far beyond agriculture-related applications.[47] Its rugged, go-anywhere character appealed to a great many people who enjoyed the outdoor life. In succeeding decades civilian and military jeeps evolved more or less in sync, both growing progressively larger and more powerful. The military M38A1 of 1951, followed by the civilian CJ-5 series of 1955, ushered in the "on steroids" look that still characterizes contemporary Jeep front ends. Prominent molded wheel flares debuted on the Renegade model in 1972, and the CJ nomenclature was phased out with the introduction of the Wrangler in 1987. But the role of the Jeep in the military began to wane with changing requirements: other vehicles, such as the Ford M151 in the 1960s and the Humvee beginning in the 1980s, have filled the void.

Unlike the major manufacturers whose goal was to pick up where they left off before World War II, Willys had in the Jeep a new product born of the war that was more successful than anything it had produced since its glory days prior to the Great Depression. The Willys management all believed in aggressively pursuing applications and variants of the Jeep, but views on tactics differed sharply. Board chairman Ward Canaday was interested in entering the low-priced field with a new car, larger than the prewar Americar. President Joseph Frazer, a widely respected salesman with a background at Chrysler, believed that there

Plate 4

Esther Trattner, *Rendering for a Sportscar Proposal Based upon the Jeep Chassis,* ca. 1946
Willys-Overland Motors, Inc.
colored crayon with graphite on tracing paper and tape
8¼ × 10½ inches
Shelly Hirsch Schaefer and Lynne Hirsch Gaines

Esther Trattner, the first woman draftsperson to be employed at Willys-Overland, prepared sketches, renderings, and presentation drawings that illustrated design proposals for interiors, exterior details, and complete vehicles. Her sense of color and organic form helped designers visualize and define concepts for military Jeeps and postwar automobiles. She was also invited to develop designs, such as this proposal for a sports car on a Jeep chassis.

was greater potential in the ultra-low-priced field the American had inhabited before the war.[48] The new president, as of June 1944, former Ford executive Charles ("Cast-Iron Charlie") Sorensen, thought that Willys could not compete with the "big three" (General Motors' Chevrolet, Ford's Ford, and Chrysler's Plymouth) and Studebaker in the low-priced field, primarily because it lacked the facilities to stamp the sheet metal for passenger car bodies, and Murray and the other body companies would be working to capacity to satisfy the pent-up demand caused by the wartime interruption of all civilian car production.[49]

Chief engineer Roos, in spite of his low opinion of designers,[50] managed to have an assortment of design resources at his command. As early as 1943, he brought in Milwaukee-based designer Brooks Stevens[51] to generate ideas for postwar vehicles. Stevens remained Willys's dominant styling consultant, with interruptions, until 1980. Independent designer Alexis de Sakhnoffsky was called upon for alternate proposals. Toward the end of the war and for several years afterward, Roos had a talented renderer and designer on his staff in the person of Esther Trattner, who had been the first woman draftsperson ever hired by Willys-Overland. Among her numerous design proposals during this period is one for a sports car based on the Jeep chassis (plate 4). By at least 1945, ex–Hudson Motor Car Company designers Arthur Kibiger, Robert Andrews, and Dale Lewton, as well as chief body engineer Eric Shoote, had joined Willys as full-time employees. Andrews recalled going to work for Roos "in engineering, where the so-called styling was done."[52]

One offspring of the Jeep-based product thinking was the highly original Jeepster,[53] offered from 1948 through 1951 (plate 5). Brooks Stevens invented the concept, a hybrid somewhere between a Jeep and a sports car. A distinctive open car with a fold-down canvas top, it was a remarkably economical design to manufacture: it shared its entire front-end sheet metal with the all-metal Jeep station wagon introduced two years earlier; its rear fenders came from the Jeep truck, somewhat disguised by the addition of a partial fender skirt. The grille wore a decorative chrome center panel. The most popular colors, yellow and red, were offered with a well-placed two-tone paint application that visually lowered the height of the body—black paint extended all around the belt line, including the windshield frame. The open windows had only side curtains as protection against the weather.

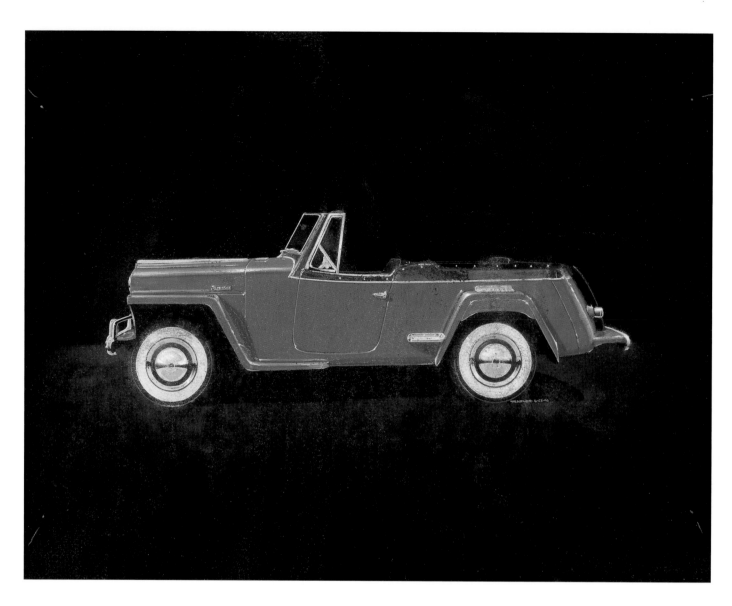

Plate 5
Esther Trattner, *Rendering of 1948 Jeepster Designed by Brooks Stevens,* ca. 1946
Willys-Overland Motors, Inc.
gouache on black medium-weight paper
9⁹/₁₆ × 14³/₈ inches
Shelly Hirsch Schaefer and Lynne Hirsch Gaines

The Evolution of the SUV

The 1949 all-steel, four-wheel-drive Jeep Station Wagon (plate 6) appears to be an unlikely source for the most profound product shift in the American automotive scene since World War II, but its vehicular characteristics and absolutely on-target 1984 redesign treatment triggered a landslide. Today, the sport utility vehicle (SUV) rules.

The ancestor of the SUV body was designed several years earlier and first appeared as a two-wheel-drive, 1946 model. Considerably larger than the Jeep, it has a certain awkward appeal that is hard to define. The flat sides[54] and rear of the generous passenger and cargo compartment consist of shallow embossed panels painted to resemble a conventional "woodie" wagon[55] Willys-Overland president James D. Mooney declared, "the safe, all-steel body permits the user to avoid the cost of varnish upkeep on the costly wooden construction of the traditional station wagon."[56] Still, designer Brooks Stevens later felt obligated to justify the counterfeit paint job, explaining, "Now that was, you might say, a dishonest thing to do. But . . . this is what the station wagon means to the consumer, at least in their mind, and therefore it shall look like that."[57] In contrast to the flat body sides, the roof is gently puffed. Details like the rounded rear wheel openings and the related

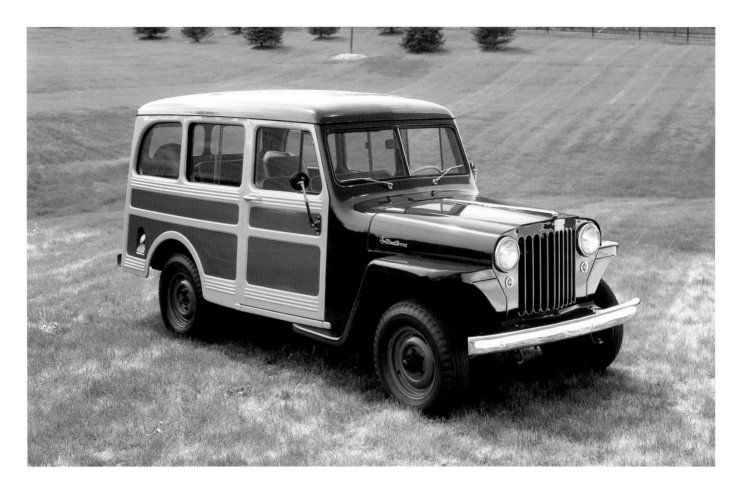

curve of the upper rear side windows help to harmonize these dispa-
rate body elements. Somehow it all works, perhaps because its parts
are so clearly defined and its straightforwardness is so convincing.

The interior is similarly appealing in its unpretentiousness. Plain
Masonite door panels are secured with visible screws; the tubular
framed seats are sensibly upholstered in vinyl. All but the driver's seat
can be removed to clear the full-length load floor, ribbed like the bed
of a truck. The stamped instrument panel has the appearance of simple
bent sheet metal. The effect speaks convincingly of a vehicle that
would be very much at home in any camp or rural setting.

Brooks Stevens has always been credited with the design of this
original Jeep Station Wagon,[58] but according to Robert Andrews, both
he and Arthur Kibiger were also involved. Andrews declared, "What
is not commonly known is that Art Kibiger and myself did the produc-
tion version of the Jeepster and the Wagon. . . . The initial thinking
on the Jeepster was definitely Brooks Stevens . . . I give him credit
for that. The polished-up station wagon, that was [the work of] Art
Kibiger and myself."[59]

In any event, a full-size mockup of the production wagon, includ-
ing the final version of the front end, was finished by February 5, 1945.
Introduced as a 1946 model, the Jeep Station Wagon proved to be a
profitable product for more than two decades. It was offered, with
countless grille and two-tone side variations, until 1965 in the US
market, and on into the 1970s in Brazil.

Plate 6
Robert Andrews, Arthur Kibiger under Delmar Roos (engineer),
and Brooks Stevens, *Jeep Station Wagon, 4WD*, 1949
Willys-Overland Motors, Inc.
Walter P. Chrysler Museum, Auburn Hills, Michigan

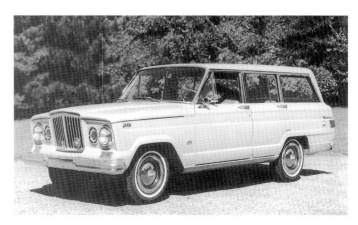

Figure 12. Jeep Wagoneer, 1963.

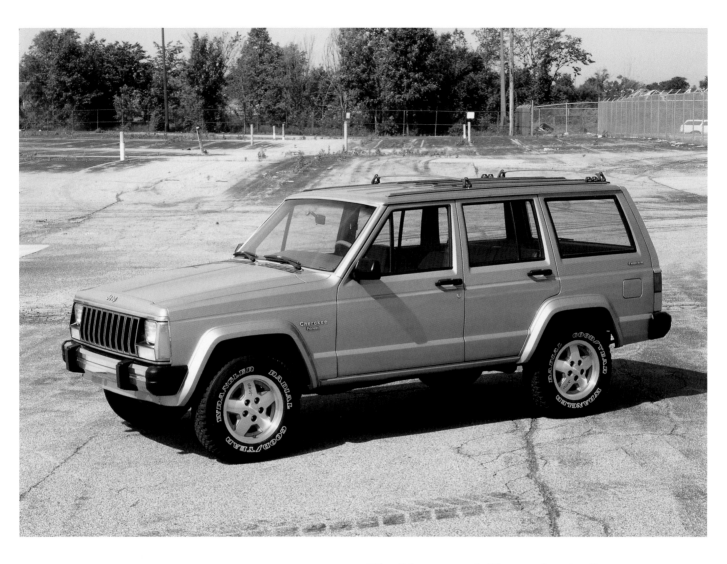

The Wagoneer: A Change for the Bigger

There is no doubt that the Brooks Stevens design organization was responsible for the styling of the 1963 four-wheel-drive Jeep Wagoneer (figure 12). A product of the new Kaiser Jeep Corporation (the name change took place in March 1963), the Wagoneer was completely new in every way. Offered in both two- and four-door configurations, it was a substantially larger and more complex vehicle, with a curb weight of 3,700 pounds as compared with less than 2,900 pounds for the Jeep Station Wagon.[60] While moving much closer to the automotive mainstream in both its amenities and its styling, the Wagoneer maintained a unique position relative to other body types in the market.[61] Most significantly for the future, it was the first four-wheel-drive vehicle to offer an automatic transmission.

Far more style-conscious than the Jeep Station Wagon, the Wagoneer was also less distinctive overall, although it did begin its long life with a unique front-end design that was toned down considerably after two years. Despite this lack of design distinctiveness, or perhaps because of it, the Wagoneer was highly successful for twenty-nine years because of its unique marriage of brawn and tractability—its four-wheel-drive capability and its comfortable automotive interior and automatic transmission. In the words of one automotive historian, it

Plate 7
Robert Nixon (exterior), Vincent Geraci (interior), and American Motors Corporation design staff under Richard Teague, *Jeep Cherokee XJ, 4 Door Sport Utility Vehicle*, 1984
American Motors Corporation
Walter P. Chrysler Museum, Auburn Hills, Michigan

"would define the four-wheel-drive utility market until the end of its life-time."[62] Its success spawned competing large-size four-wheel-drive, or 4 × 4, vehicles: the Chevrolet Blazer and GMC Jimmy, Ford Bronco, and Dodge Ramcharger. Thus the sport utility vehicle market was born.

Unexpected Jackpot: Landing the Mass Market

Many corporate changes took place during the life of the Wagoneer body. In 1969 American Motors Corporation (AMC) purchased Kaiser Jeep and soon formed a new entity, AM General, to handle all military contracts.[63] At the same time its counterpart, the Jeep Corporation, was formed to consolidate all civilian products. AMC later sold off AM General. However, in 1980 the French firm Renault gained controlling interest in AMC, thus acquiring Jeep Corporation as well. The styling of all AMC vehicles, including Jeeps, then came under the direction of AMC design vice president Richard A. (Dick) Teague.

Work on an all-new, updated Wagoneer was begun in the late 1970s, during a time of profound product reevaluation throughout the industry. The "second oil crisis" prompted manufacturers to rethink the size of their offerings, especially in light of rumors of increased government regulation and mandatory gasoline mileage requirements. The replacement vehicle, referred to as the XJ, ended up as a much smaller, lighter seating and engineering package, now targeted at 2,900 pounds,[64] very close to the original Jeep Station Wagon and considerably less than the Wagoneer, now at 4,000 pounds. This mass saving was partly accomplished by adopting unibody rather than chassis or frame-mounted construction. Designer Robert Nixon was in charge of exteriors while Vincent Geraci directed interior design, both reporting to Richard Teague. The new, smaller body made its debut in October 1983 as a 1984 model in both two- and four-door versions and in both Cherokee[65] and Wagoneer trim levels (plate 7).

Unlike the Wagoneer, the XJ's roof and lower body shapes are visually unified into one volume by means of a single long vertical plane running the length of the lower body, through the door handle area, which continues uninterrupted up the pillars to the roof, thus capturing the plane of the side windows. The slightly different angle between this key unifying plane and that of the side glass plane is resolved by means of a chamfer along the base of the windows, which turns upward at each pillar and tapers to nothing at the roof line. This chamfer extends forward along the tops of the front fenders as a beveled transition between fender and hood surfaces, inconspicuously providing the link between all the upper-body design elements. It also lends a certain appearance of thickness, or substance, to the doors and pillars as well, a very desirable impression in an SUV—whose body should look sturdy.[66]

The base of the vehicle is conceived as its visual structural foundation: a boxed-out section through the lower doors appears to connect yet penetrate the chamfered wheel openings and emerge at either end to hold the bumpers. On sportier Cherokee models, this ensemble was a contrasting color, often black, thereby emphasizing the girderlike implied structure and the importance of the wheels as fundamental to the design. Several wheel options were available, varying in graphic assertiveness but all strongly mechanical in character. The front and rear views appear to be logical outcomes of the main body forms. A broad graphic band containing the wall-to-wall grille, traditional in the Wagoneer by now, wraps onto the fenders at the corners just far enough to enclose amber turn signal lamps. The grille between the headlamps is segmented into ten vertical boxes, recalling the vertical slots of the original Jeep. This row of boxes gains some added penetration by being folded horizontally in profile, with the fold indexing across the bottoms of the headlamp bezels. Similarly thoughtful graphic placement of elements characterizes the tailgate. Its lamps also wrap around the corners—thereby satisfying federal requirements for side lamps—then extend vertically up from the bumper toward the little "shelf," which defines the lower edge of the unifying upper side plane. This shelf bridges horizontally across the tailgate, unifying the rear of the vehicle with its sides and top.[67]

The interior continues the architectonic vocabulary of the exterior, a bit softened in deference to its human occupants. One overriding attribute of this vehicle is that its elements contribute to the design but remain subordinate to the overall effect. The 1984 Cherokee/Wagoneer body comes across as a thoroughly capable, handsomely packaged piece of machinery.

The XJ was initially marketed in a standard range of color and trim levels in three general categories: base level with relatively straightforward paint and trim; "traditional luxury" with imitation wood grain side panels and whitewall tires; or "sporty" with blacked-out chrome, dark side cladding, and decals. But in 1985, when a Cherokee Limited series was offered in solid black with gold pinstriping, laced cast alloy wheels, and a luxurious coordinated black leather interior, its sales success surprised everyone.[68] Evidently the new "forest ranger in a tuxedo" look, so fresh after decades of simulated wood grain and whitewalls, was the wake-up call. The black was soon followed with suitable earth-tone fashion colors. Marilyn White, color expert for PPG, paint supplier to AMC at the time, recalls brainstorming this new palette with AMC interior chief Vincent Geraci and color coordinator Thelma Sibley. White believes this was the turning point, when the public first perceived the SUV as a luxury vehicle, eventually prompting upscale makers such as Mercedes and Lexus to enter this market.[69]

During this same period, the mid-1980s, the newly invented front-wheel-drive "minivan" was breaking sales records as a dramatic improvement over the conventional family sedan or station wagon.

But the minivan remained identified—negatively—with mundane everyday chores and the suburban "hockey mom" image. By contrast, the perceived athleticism of the XJ (whose off-road capabilities would never be used by 98 percent of its buyers) projected a rugged outdoor image—identified with physical health, leisure, and, certainly, affluence—although at some sacrifice in packaging efficiency. In a short time the Cherokee became a style-motivated aspirational vehicle for a great many Americans. By the early 1990s the SUV was mainstream.

Afterthoughts

This history of the products of Willys-Overland and its successor organizations reveals two distinctly different design approaches: that of the Jeep, which was designed with no thought of the consumer market; and that of the remainder of the vehicles, which were designed to compete in the consumer market. Either approach can have an aesthetically satisfying outcome. The military required of the Jeep only that it be functional and practical. Its appearance was, in effect, a rejection of the existing Streamline Style, but in the civilian market, it became a kind of chic Functionalist statement among those unsatisfied with mainstream automotive products. The Jeep became stylish in spite of itself.

Author's Note: The author wishes to express his gratitude to numerous individuals and organizations for their generous assistance with this essay. Particular thanks go to Ron Szymanski and the late Dave Holls.

1. Willys had acquired this impressive new plant in Toledo at a great bargain upon the collapse of the Pope-Toledo Company, makers of prestige automobiles. He subsequently moved his Overland Company from Indianapolis to Toledo and renamed it the Willys-Overland Company.

2. William H. Cameron may not have remained with the Willys organization very long. His name appeared in the *Toledo Directory* (a city directory listing Toledo residents by name, address, and occupation) only from 1909 through 1912. Little is known about his subsequent design career, but in the 1930s he appears in the press as a proponent of improved automotive safety. No other Willys designer is mentioned by name until Amos Northup appears on the scene in the late 1920s.

3. According to an undated, typewritten list of all the cars ever manufactured in Toledo, compiled by Ron Szymanski, curator, Jeep House, Toledo, Ohio, and shared with the author, June 1999.

4. The family's preferred pronunciation, "Willis," was used in radio and television advertising, according to Jeffrey Godshall and David Horton, in conversation with the author, June 2000. Most Americans, however, pronounced the name "Willies."

5. Three slightly larger cameos pictured John North Willys, president and general manager; Will B. Brown, vice president and assistant general manager; and F. A. Barker, sales manager. Four smaller cameos pictured W. H. Cameron, designer; M. G. Fitch, secretary to the president; E. F. Blue, purchasing agent; and A. J. Dutton, advertising manager.

6. In conversation with the author, April 1999, design historian John Haskins observed that during the first half of the twentieth century, design tended to be more integrated with all aspects of company activity. Heads of automobile companies considered design to be of absolutely top importance and dealt with it on an everyday basis. However, beginning in the 1970s, when business school graduates began to enter the ranks of top management, this personal involvement with design waned. Design and engineering have become the province of specialized departments which in turn report to management. Today it is noteworthy when a top manager exhibits a strong level of product involvement or connoisseurship.

7. The fenders were part of the chassis, not the body, and hence were painted (black) with the former.

8. Henry Ford's oft-quoted statement, "They can have any color so long as it's black," succinctly sums up his color policy with regard to the Model T.

9. The body may have been designed and/or built by an outside supplier. It is not known if it was used exclusively by Willys.

10. The advent of relatively lightweight fiberglass-reinforced plastics enabled "removable hardtops" to enjoy a brief popularity in the 1950s. Offered on sporty two-passenger cars such as the Corvette and Thunderbird because of the relatively small size of the tops required, they waned in popularity before the end of the decade.

11. According to automotive historian Leroy Cole, the Springfield Body Company of Springfield, Massachusetts, patented "pillarless" bodies of this type, which they supplied to several manufacturers. See "Open Sedans," *Motor Age* 31, 1 (January 4, 1917). It is possible that Springfield made these Willys bodies.

12. A starting point for reference might be the Ford Model T of 1909–1912 whose engine compartment was a low box butted directly against its broader, flat dashboard, thus providing absolutely no visual connection other than proximity.

13. Notably the so-called "torpedo body" style introduced on Studebaker and GM sedans in 1940 and Willys-Overland cars in 1941.

14. For a more complete account of this model series, see Bill McGuire's two-part article, "The Great Sixes of Willys-Knight," *The Knight-Overland STARTER* 78 (December 1981), pp. 11–12; and 79

(March 1982), pp. 8–13. The *STARTER* article is reprinted from *Cars & Parts* 23, 9 (September 1980), pp. 38–40; and 23, 10 (October 1980), pp. 38–42.

15. In 1925 Willys acquired the F. B. Stearns Company of Cleveland, Ohio, whose ultra-prestige automobile line, the Stearns-Knight, also succumbed to the Great Depression. Stearns-Knight had used a figure of a knight with sword and shield as a hood ornament since 1913.

16. William Fred Meeks, who had been with Willys-Overland since Pope-Toledo days (see note 1) also laid out the unusual lamps on the 1933 Model 77. See the untitled article on William Fred Meeks by his son, Ralph Meeks, in *The Knight-Overland STARTER* 64 (June 1978), p. 4.

17. Amos Northup first gained recognition for his designs of Wills Ste. Claire automobiles from 1924. At Murray Corporation of America, he designed production car bodies, which Murray supplied to various automobile manufacturers. Northup assisted Edsel Ford in the design of the famous Ford Model A, introduced in 1928, and is also credited with the smart-looking 1928 Hupmobile Century prior to his stint as chief designer for Willys. Among his most notable later achievements were the 1931 Reo Royale, 1932 Graham Blue Streak, and 1938 Sharknose Graham. For a concise biography of Amos Northup, see Michael Lamm and Dave Holls, *A Century of Automotive Style* (Stockton, California: Lamm-Morada Publishing, 1996), pp. 76–77.

18. "Beauty Rather Than Style in Modern Body Design," *Automotive Industries* 59, 21 (November 24, 1928), pp. 770–71.

19. Norman G. Shidle, "S.A.E. Summer Meeting, Body Design," *Automotive Industries* 56, 22 (June 4, 1927), p. 866.

20. Willys's remark was no doubt well intentioned, but hardly sensitive. Northup was a very short man with a large head, due to acromegaly, according to friend and fellow designer Hugo Pfau. See Hugo Pfau, "Amos Northup, Unsung Hero," *Cars & Parts* 21, 2 (January 1978).

21. In the days before seat belts, rumble seat passengers were often injured or killed in accidents. Rumble seats, located under the rear decklid, went out of use in the late 1930s as designers developed coupes and convertibles in which all four passengers were accommodated inside.

22. This particular paint break theme had been shown by Northup, in an SAE presentation before he took over Willys's design, to demonstrate how "cheat lines" (optical illusion devices) could be used to create the appearance of a longer, sleeker vehicle. However, this paint scheme does visually separate the body from the hood form, running counter to one of the most powerful industry trends at the time. These cars did not sell as well as their more conservative predecessors, although the onset of the Depression makes objective evaluation impossible.

23. About this same time, another automobile designer, Al Leamy, was also using free-form moldings on some of his Auburn automobile designs. This aspect of both Leamy's and Northup's work during this period appears to draw inspiration from the European Art Nouveau style in architecture and decorative arts of an earlier decade.

24. President Hoover evidently told Willys that it was his "patriotic duty" to give up the ambassadorship, return to Toledo, and save his former company. See Boyden Sparkes, "Down and Up," *Saturday Evening Post*, March 25, 1933, pp. 15, 72–74.

25. Jeffrey Godshall believes that Northup's design intent with this front end was to take advantage of the increased formability of sheet steel to integrate the headlamps into the front fenders and thereby improve vehicle aerodynamics, a significant consideration in an economy car. Conversation with the author, June 2000.

26. America's first successful car in the Streamline Style, the 1936 Lincoln Zephyr, by John Tjaarda, Edsel Ford, and E. T. Gregorie, was considerably more slender and graceful by comparison.

27. Gee Bee is an acronym for the Granville Brothers, of Springfield, Massachusetts, whose racing airplanes were known for their

record-breaking speed, impossible bumblebee shapes, and reputation for being extremely dangerous to fly; they were the sensation of their day.

28. Northup was enamored of this effect in his late work. The front end of the Willys-Overland model for 1939, possibly begun by Northup before his death, was a continuation of this exaggerated dynamism. Northup also initiated, but did not complete, the exaggeratedly forward-leaning body design of the Sharknose Graham of 1938.

29. The following year Edsel Ford and E. T. Gregorie used a very similar nose and grille configuration on their 1938 Ford, which was more gracefully executed but not as clearly or forcefully stated as Northup's front end on the Willys. Northup had been making design proposals to Ford and Gregorie in his efforts to get Ford business for Murray. See Henry Dominguez, "Edsel Ford and E. T. Gregorie," *SAE*, 1999, pp. 148, 176.

30. For a vivid account of Roos's high-handed methods in directing the design process at Willys, see "Interview with Brooks Stevens," *Collectible Automobile* 7, 4 (February 1991), pp. 42–47.

31. The two schools of thought at the time with respect to four-door sedans were the "fast back" and the "torpedo" ("bustle-back" or "notch-back"). Willys opted for the latter, as did Studebaker. GM offered both, but favored the torpedo style. Designer Raymond Loewy stationed talented automobile designer Virgil Exner in South Bend, Indiana, to service the Studebaker account.

32. New York, The Museum of Modern Art, *Eight Automobiles*, text by Arthur Drexler (New York, 1951), no. 5, The Jeep.

33. Stimulated, at least in part, by a dialogue with the American Bantam Car Company of Butler, Pennsylvania, which had supplied the Army with examples of their tiny automobiles for evaluation. After using them from July 23 through August 6, 1938, the Army was pleased with their performance and economy, suggesting only that heavier springs and larger doors would be useful.

34. "A miniature sketch of what the proposed vehicle might look like was the only guide that any of the companies had in the initial stages beyond general specifications as to weight and load capacity." Interview with Willys chief engineer Barney Roos, *American Hardware Record*, September 1942. Note the air-cooled machine gun mounted between the front seats. In addition to a boxy shape, Beasley also indicated vertical body dimensions and ramp angles at both ends, both important aspects of the Jeep's final appearance.

35. For an account of Probst's important contribution as the designer of the first prototype, see Michael Lamm, "Father of the Jeep," *Special-Interest Automobiles* 31 (November/December 1975), p. 25. Lamm relates this poignant event: "At age 79 in 1963, he [Probst] spread out the original Jeep blueprints at his bedside and then took an overdose of sleeping pills. That's the way they found him, with his Jeep for a shroud."

36. Bantam historian George Domer states that the shapely hood and front fenders of the original prototype (figure 8) were hand-formed from parts found at a local junkyard by Bantam's German "panel-beater." In general, however, elements of the Streamline Style of the late 1930s were systematically eliminated during the Jeep's early development process. Domer also points out that hard-caked mud or ice buildup under the fender—which could interfere with both steering and traction—was the probable reason for changing to a more open, squarish fender design. (Compare front fenders in figures 8 and 9.) E-mail correspondence with the author, August 2000.

37. This policy was intended to guard against work stoppage and sabotage. Yet by November 1941, one source, the American Central Manufacturing Company, of Auburn, Indiana (where Auburn automobiles had been built before the war), was contracted to supply all Jeep bodies for both Willys and Ford.

38. The Go-Devil engine, tracing its ancestry to the original 1927 Whippet poppet valve four-cylinder engine, was rigorously tested and improved by Barney Roos when he became chief engineer in 1938. It had also been thoroughly proven in the prewar Willys Americar.

39. For an account of Ford's participation in the design of the Jeep, see volume two of the two-volume, typewritten manuscript "The Reminiscences of Mr. Dale Roeder," Henry Ford Museum & Greenfield Village Research Center, Dearborn, Michigan.

40. Inconspicuous details distinguish the two: for example, the front cross member below the radiator is tubular on the Willys, a "U" section on the Ford.

41. Arch Brown et al., "Jeep, The Unstoppable Legend," *Consumer Guide* (Publications International, Ltd.), 1997, p. 34.

42. The number of vertical slots in Jeep grilles has varied over the years. The World War II Jeeps had nine, contemporary Jeeps have seven. Many postwar derivatives of the Jeep, such as the Jeep Station Wagon and its successors, have had vertical slotlike grilles, but a number have not. The Jeep Wagoneer, for instance, had various horizontal and checked grilles.

43. For the testimony of Army and company officials, see the typed manuscript "The Jeep/Its Development & Procurement Under the Quartermaster Corps, 1940/1942," by Herbert R. Rifkind, Historical Section, General Service Branch, General Administrative Services, Office of the Quartermaster General, Washington, DC, 1943. Collection of National Automotive History, Detroit Public Library.

44. Willys-Overland advertisement in *Collier's Magazine* 100, 15 (April 11, 1942), p. 10. The ad copy states: "The Quartermaster Corps of the U.S. Army and the Civilian Engineers of Willys-Overland . . . gave birth to the amazing Jeep of today."

45. See the American Society of Mechanical Engineers' pamphlet "The Jeep MB, An International Historic Mechanical Engineering Landmark," July 23, 1991, Collection of Jeep House, Toledo, Ohio.

46. The skirted portion of the three-piece Willys fender was no doubt sacrificed when Roos relentlessly reduced the weight of the Quad in order to meet the Army's limit of 2,160 pounds. A folding windshield was part of the original Army specifications, but the early Bantam design's one large piece of glass was subject to stress and breakage. For its very first Pygmy prototype, Ford developed a tubular fabricated outer frame with a split windshield carried in its own inner frame— a design immediately adopted by Bantam and Willys. While more complex, this concept relieved stress on the glass and also allowed the windshield to be opened for ventilation. See "The Reminiscences of Mr. Dale Roeder" (note 39).

47. For example, the Dispatcher, a ubiquitous two-wheel-drive mail carrier series introduced for 1956 and continued as a variant on succeeding Jeep series until 1988. For a concise account of the Jeep's postwar evolution, see John Sgalia, "The Rich American Heritage of the Jeep," *Innovation* 17, 1 (Spring 1998), pp. 28–34.

48. Based on research by William Tilden and David Horton. Conversations with the author, June 2000. Frazer ultimately left to pursue his own interests.

49. Conversation between Sorensen and designer Brooks Stevens recounted in ibid.

50. Roos's arrogant treatment of Brooks Stevens has already been mentioned (note 30). Robert Andrews also mentions Roos' expressed exasperation with designers. See David Crippen, Interview with Robert F. Andrews, 1985, in The Design Oral History Project, Henry Ford Museum & Greenfield Village Research Center, Dearborn, Michigan. Also, referring to another well-known designer, Roos declared, "Walter [Dorwin] Teague and associates are well known to me—he is one of the high-pressure designers who . . . have only their personal welfare in mind." D. G. Roos, Letter to W. A. MacDonald, July 19, 1943. DaimlerChrysler Corporate Historical Collection, Detroit.

51. Brooks Stevens had delivered an SAE paper in early 1942 citing possible postwar uses for the Jeep. Renderings were published in Brooks Stevens, "Your Victory Car," *Popular Mechanics* 78, 6 (December 1942), pp. 82–85. Stevens showed "how a civilian jeep can be given grace and style" by simply jacketing the chassis in a modern automotive envelope. Roos contacted Stevens as a result.

52. Crippen (note 50).

53. According to Brooks Stevens, the Jeepster name was coined by former Willys-Overland president Joseph Frazer, as a combination of Jeep and roadster. Conversation with William Tilden (note 48).

54. The flat side panels were an engineering requirement to keep die tooling costs down and allow Willys-Overland to obtain the panels from suppliers who did not have the ability to make deep-drawn panels. Sorensen evidently laid down these rules early in the design process. William Tilden, unpublished manuscript for talk to W-O-K Registry gathering, 1999, shared with the author in June 2000.

55. A publicity announcement entitled "Lead—Station Wagon," asserting that simulated framing strips are "painted to represent clear maple while broader areas are a replica of dark mahogany" was sent out by Neil T. Regan, Steve Hannagan Associates, Willys-Overland Motors, Inc., Toledo 1, Ohio, for release on July 24, 1945. DaimlerChrysler Collection (note 50). Elsewhere Roos stated that the colors were arrived at by carefully matching spinning pieces of maple and mahogany. (Rapid spinning of the wood samples blurs variations in grain color into one tone.)

56. Regan, publicity release, in ibid.

57. "Interview with Brooks Stevens, Industrial Designer" (note 30), p. 47.

58. Virtually all published accounts over the years have reinforced this attribution. In ibid., p. 46, Stevens describes sitting down and personally making sketches and layouts of the Jeep Station Wagon. This would have been in June or July 1944, shortly after Sorensen took over Willys-Overland as president. A number of renderings showing alternative front-end designs on the production wagon body, bearing Brooks Stevens's studio signature and dated June 9, 1945, are now in the DaimlerChrysler Collection (note 50). However, these may have been face-lift proposals for a later year, since they were done four months after the full-size production mockup was finished.

59. Crippen (note 50).

60. Barney Roos, who strongly opposed the industry trend toward ever larger vehicles, had left the organization in 1953, the same year that Kaiser bought Willys. Roos died in 1957.

61. Kaiser Jeep publicity also proclaimed, "[The Wagoneer] is not a converted passenger car with a tailgate thrown in, nor a modified truck with windows . . . the all new 'Jeep' was conceived and designed as a wagon from its wheels to its reinforced roof." R. C. Ackerman, *The Standard Catalog of 4 x 4's* (Motorbooks International, 1993), p. 460.

62. Brown (note 41), p. 120.

63. AM General developed the Hummer, which eventually replaced the military Jeep after AM General was sold off by AMC. While AM General was still part of AMC, designer Richard Teague insisted that Hummer use the vertical-slot Jeep grille theme, according to Michael Lamm. Conversation with the author, June 2000.

64. Interior chief designer Vincent Geraci recalls product planner Timothy D. Leuliette arguing in favor of the smaller package to Gerald C. (Jerry) Meyers, head of product planning for AMC. AMC president Jose J. Dedeurwaerder made the ultimate decision to go with the more compact XJ package. Author's interview of Vincent Geraci, December 1999, corroborated in interview of exterior chief designer Robert Nixon, July 2000.

65. The name Cherokee first appeared when the old two-door Wagoneer was resurrected as a new lower-trim-level model in 1974 to compete with two popular 4 x 4 newcomers from GM, the Blazer and Jimmy. In time, however, the name Cherokee became identified with the sportier trim options while the Wagoneer name connoted more traditional, luxurious appointments. The marketing device of offering any given model in both sportier and more formal trim versions had become widespread practice by 1970.

66. "A Jeep should look like a brick on wheels," declared exterior studio chief Robert Nixon (note 64).

67. In later years the tailgate and grille were face-lifted in an effort to soften the overall design in line with the then current trend toward more rounded shapes. This horizontal step in the tailgate and the low horizontal fold in the grille were eliminated, somewhat compromising the overall unity of design. The basic body, however, continued in production through model year 2001.

68. According to vice president of engineering and product planning François Castaing. See Rachel Konrad, "An Interview with François Castaing, *Detroit Free Press*, March 5, 1998, p. 1, E. See also another interview with Castaing: "France's Visionary," *Automotive News* 5847 (November 8, 1999). Castaing dates the rise of the SUV to its current mass-market status from this Cherokee Limited model.

69. Telephone interview of Marilyn White, July 2000.

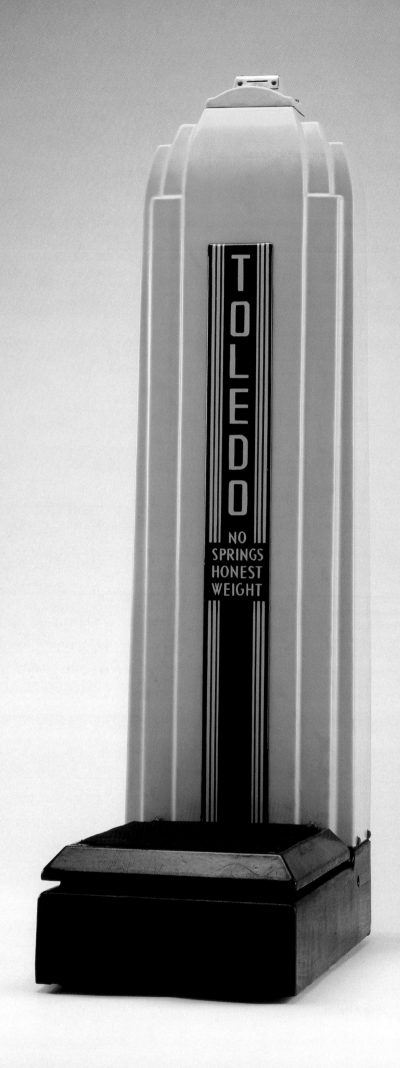

Jeffrey L. Meikle

WEIGHING THE DIFFERENCE
INDUSTRIAL DESIGN AT THE
TOLEDO SCALE COMPANY, 1925–50

When Hubert D. Bennett assumed the presidency of the Toledo Scale Company in 1926, he knew he had a big job ahead of him, but he did not realize the endeavor would involve the design process at all levels—from such obvious concerns as product form and function to such general matters as long-term strategy and corporate culture. Although Bennett had grown up in Toledo, he was relatively unknown when he bought a controlling interest in the Toledo Scale Company. In his early thirties, he had graduated from Williams College in 1917, fought with the French Foreign Legion and as a US Navy pilot during World War I, and then worked briefly with Willys-Overland, of which his father was general manager, before making his way up through a succession of advertising and sales positions with Studebaker in Boston, South Bend, and New York. He soon made it clear, despite his youthful appearance, that he intended to take command and forge "a well-trained, thoroughly-coordinated, well-disciplined, . . . keen, hard fighting organization."[1] An innovator unwilling to pursue business as usual, Bennett became an early patron of design as a means of creating and maintaining a competitive edge within a particular industry. His story—and that of Toledo Scale—offers an exemplary narrative of industrial design's emergence during the years between the World Wars as a point of convergence of entrepreneurship, aesthetics, engineering, marketing, and shifting social realities.

At the time of Bennett's takeover, Toledo Scale was a stagnant company that exploited one fundamental invention, depended on old-fashioned boosterism to promote sales, and faced a debt of close to a million dollars. Henry Theobald, formerly general manager of the National Cash Register Company, had founded the Toledo Scale & Cash Register Company in 1901 to develop patents issued to Allen DeVilbiss, Jr., for the so-called pendulum computing scale. DeVilbiss' invention replaced the centuries-old balance scale, with which a merchant balanced a commodity in one pan against metal counters of specific weights in another pan. Customers depended not only on the accuracy of the weights, but also on a merchant's honesty and mathematical skill as he figured the cost of a specific amount of a given commodity at so much per unit of weight. DeVilbiss eliminated both of these uncertainties by employing a single pan which, when depressed by the commodity being weighed, offset a counterbalanced pendulum. The pendulum moved a long pointer across a graduated dial, visible to both merchant and customer, that indicated a full range of weights and the computed prices associated with each weight at a wide array of different unit costs. DeVilbiss' original scale employed a fan-shaped dial extending above the base and weighing pan. Later innovations included a double-pendulum mechanism and, in 1906, a so-called cylinder scale whose much larger dial was printed on a cylinder revolving on a horizontal axis above the weighing pan. Supplied initially in a blue lacquer finish and later in a deep gold, the cylinder scale, owing to its large size and increased computing capacity, appealed especially to grocers and butchers. Although several other companies also marketed fan and cylinder scales to grocers, butchers, bakers, confectioners, and druggists, most competing devices relied on spring mechanisms rather than on Toledo's patented pendulum system. Claiming that springs yielded inaccurate measurements because they were sensitive to temperature changes and became deformed under the stress of repeated use, the company dramatized its alternative mechanism by equipping cylinder scales with glass windows through which shoppers could view the pendulum in operation. A slogan boasted that a Toledo scale offered "No Springs—Honest Weight" (plates 1 and 2).[2]

In the years leading up to Bennett's takeover, the prospects for Toledo Scale seemed increasingly bleak. An adverse patent judgment in 1918 nearly doubled the company's debt. Unable to absorb the shock, Henry Theobald fell ill and died in July 1924, leaving his widow in financial control and his son Robert in executive control as vice president. Robert Theobald paid little attention to the company's fortunes,

however, because he had been suffering from depression since his wife's death more than a year earlier. His suicide in December 1925 left the way open for Bennett to purchase controlling interest in the company in January 1926 and for his election as president on February 1.[3] The new president was not pleased with the company's standard operating procedures, promising instead "some very radical changes in policy" intended to bring about "a fifty per cent increase in business."[4] More than anything else, he emphasized the importance of shaping the company's products to fit the realities of the marketplace. Until then Toledo Scale had relied for promotion of sales on the enthusiasm of its traveling agents, whose in-house broadsheet exhorted them in boosterist rhetoric to compete for entry into the elite ranks of the "One Hundred Per-Centers." For the most part, salesmen were on their own in this effort. As one of them recalled, his attention was confined "almost exclusively to my own little territory." He received "little if any factory assistance" and had "very little" knowledge of "what was going on" with the company "generally."[5] As a result Toledo Scale received little feedback regarding its customers' needs and desires other than through raw sales figures. Recognizing as early as 1926 the advent of a highly competitive buyer's market, Bennett promised his sales managers that "it will be the endeavor of this factory to make what you can sell and not ask you to sell what the factory can make." Rather than trying "to sell the output of an engineering department," no matter what it might be, he would "try to have the engineers make what you want." In other words, by paying attention to their customers—in effect, by adopting a business philosophy soon to be expressed by the emerging profession of industrial design—they would be able to satisfy Bennett's prediction that "the next depression is going to put the Toledo Scale Company on the map."[6]

The new president's "can-do" attitude resolved some chronic problems. He recruited new investors to absorb the tremendous debt and negotiated patent disputes with the Dayton Scale Company. However, the task of adjusting the company's products to the marketplace proved difficult. Bennett became familiar with the most serious problem while accompanying Toledo sales agents on their rounds. From the beginning the standard sales approach depended on bringing in a demonstrator for on-site comparison tests with a customer's old scale. A new Toledo usually proved more accurate in measuring certified test weights than did a worn-out spring-operated scale from some other

Plate 1
Halvor O. Hem, *Engineering Drawing for the Person Weigher Model 8300*, 1928
Toledo Scale Company
pen and black india ink with graphite on linen
80 × 35½ inches
Collection of Jim Clemens

Plate 2
Orwell Reeves and George Frye, *Toledo Official Athletic Scale, Coin-Operated*, 1930
Toledo Scale Company
enameled steel, glass, nickel plate, cement, and brass
71 × 16¾ × 31 inches
The Christopher K. Steele American Coin-Operated
Weighing Machine Collection

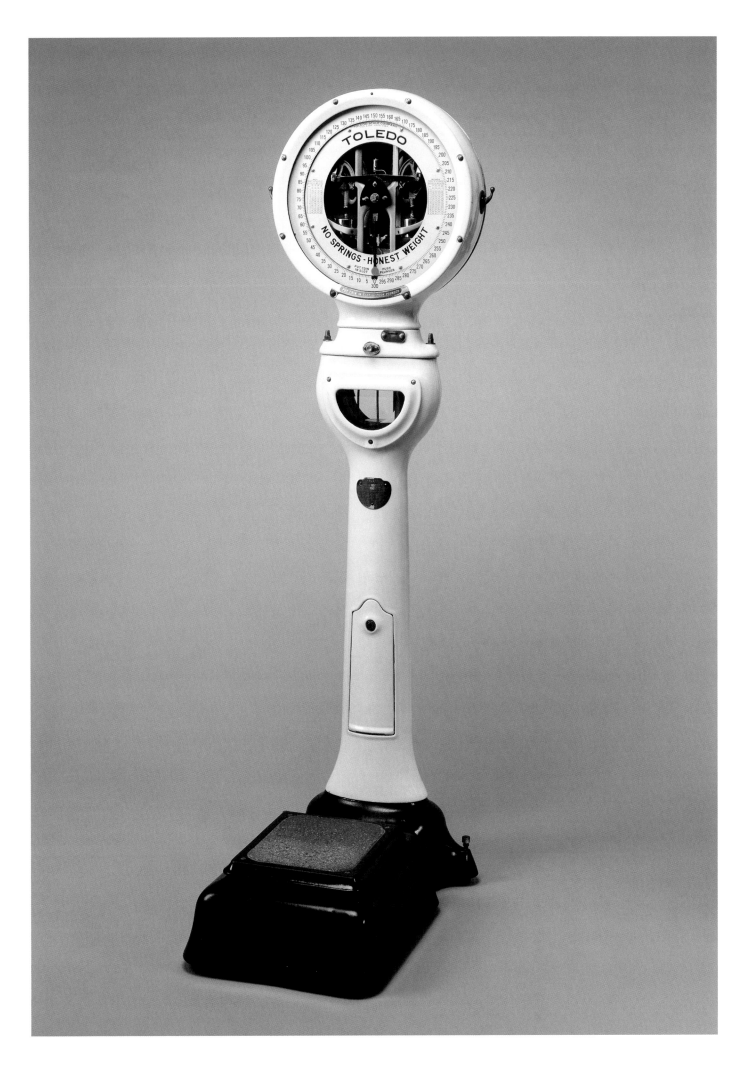

Plate 3
Designer unknown, *Cylinder Scale*, 1928
Toledo Scale Company
cast iron, porcelain enamel, aluminum, nickel-plated steel,
copper alloys, and glass
24¾ × 18 × 22¾ inches
Mettler-Toledo, Inc.

manufacturer. In addition, the Toledo's dial yielded a more accurate reading. Most other scales introduced reading errors depending on the varying angles from which short and tall clerks viewed a fixed horizontal line against the moving cylinder with its printed lines of prices. Toledo engineers had solved that problem with a system of double lines, one above the other, which had to be visually lined up to yield a more precise reading. Sales prospects usually melted under the double-barreled assault of these so-called "scale audits," but Bennett found that most agents were unable to perform these comparison tests because the cylinder scale was too heavy to carry into stores. Three years earlier, in 1923, faced with unexpected competition from a company that finished its otherwise inferior spring-operated cylinder scales in porcelain enamel instead of lacquer, Toledo had followed the rest of the industry in switching to porcelain. The resulting scale (plate 3)—with its cast iron ribbed and strengthened to withstand the 1,300-degree heat required for fusing porcelain enamel—weighed in at 165 pounds compared to the 70 pounds of an older lacquered scale. Saddled with such a heavy scale, grocers and butchers could no longer easily rearrange the layouts of their stores with the frequency that modern retail handbooks demanded. Even more problematic, sales agents suffered hernias, refused to transport the new scale, and reduced the company to feeble exhortations that they take along a small, lightweight fan scale for on-site demonstrations: "Carry a scale—not photographs."[7] Clearly something had to be done.

The search for a lighter scale involved Bennett directly with the emerging profession of industrial design, whose earliest practitioners focused mostly on endowing consumer goods with stylishly attractive exteriors in order to differentiate them from competing products. Engaged in making equipment for retail stores, Toledo Scale was already superficially aware of style. In 1925, for example, an in-house magazine described a new supermarket in Kansas City as a "great achievement in general design" and observed that its "beautifully fashioned and porcelain finished" Toledo scales provided not only the usual "guaranty of a square deal," but also "an adornment to the market."[8] Although a typical cylinder scale from 1925 may now appear to us as an ungainly assemblage of poorly integrated parts—base, weighing pan, pendulum housing, portholes, side struts, and cylinder—the company stressed its "new artistic design," especially its "curved surfaces, molded corners and flowing lines which, with lustrous white porcelain finish, reflect the lights and shades."[9] Even so, as Bennett sought new materials to replace porcelain enamel fused onto cast iron, he realized that such innovations might yield entirely new aesthetic forms or shapes and thus transform the grocery-counter cylinder scale. This quest led him to become one of the first American executives to employ outside design consultants in the redesign of a formerly standard, engineer-designed product. His experiences with two quite different industrial designers—Norman Bel Geddes and

Harold Van Doren—exemplified a shift from the Barnumesque showman to the pragmatic business consultant that defined the early evolution of the industrial design profession during the 1920s and 1930s.

Like most early patrons of industrial design, Bennett probably learned about it by word of mouth. The designer he first hired, Norman Bel Geddes, already had a considerable reputation in New York theater circles as an avant-garde stage designer, and he was beginning to redesign products for a few clients of the J. Walter Thompson advertising agency.[10] Although Toledo Scale was a Thompson client during the late 1920s, Geddes, who grew up in eastern Ohio, also had close personal ties to the city of Toledo. Left fatherless in his teens, he had received encouragement as an art student from his uncle Frederick L. Geddes, a wealthy lawyer who was both a trustee of the Toledo Museum of Art and a member of the board of the Toledo Scale Company. It was Uncle Fred who arranged for George W. Stevens, director of the museum, to recommend Norman as a student to The School of The Art Institute of Chicago.[11] Geddes first met Bennett in Toledo, while playing tennis with a cousin who was a classmate of Bennett's at Williams College.[12] Although the two men were reintroduced under the auspices of the Thompson agency, Bennett presumably knew about the younger Geddes's stage design career through conversations with Fred Geddes. Whatever the precise details of their association, they found themselves sitting across a conference table at the Thompson agency in New York on November 13, 1928, as Bennett explained Toledo Scale's need for a new cylinder scale and Geddes explained how he could help out.[13]

Bennett was a prime target for Geddes's utopian gospel of social regeneration through art and industry because he himself was already involved with the arts, having just commissioned fourteen paintings by Georges LaChance celebrating individual craftsmen at various stages in the manufacture of scales.[14] That same year Bennett had also become a trustee of the Toledo Museum, with its long-standing mission of establishing "a vital and valuable relation to our manufacturing interests."[15] Within a month of signing a contract with Geddes, on December 18, 1928, he demonstrated the depth of his commitment to design by enrolling nine Toledo Scale employees in a course on design and "dynamic symmetry" taught by Idene McAleese (later Ayers) of the museum's School of Design.[16] Bennett's contract called for ten new scale designs by the end of 1929. In addition to two cylinder scales, one for grocery counters and the other to be mounted in a specially designed cabinet, their agreement specified several fan scales, a coin-operated personal weighing scale for public places, a small bathroom scale, and a built-in bathroom scale with a platform recessed into the floor and a dial built into the wall. Recognizing, despite the designer's considerable personal flair, that he was hiring a design studio and not an individual fine artist, Bennett agreed that Geddes did not "personally" have to "create the said designs," but could "employ draftsmen, assistants and artists" to do the work so

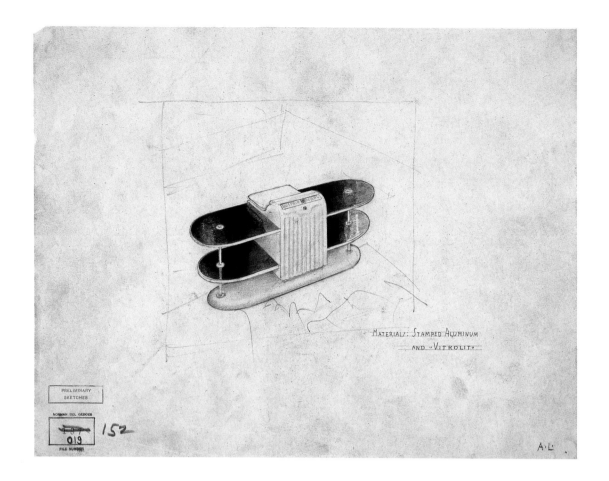

Plate 4
Norman Bel Geddes with Al Leidenfrost, *Rendering for Island Scale,*
1929
Toledo Scale Company
graphite on paper
8⅜ × 10¾ inches
The Norman Bel Geddes Collection, The Performing Arts Collection,
Harry Ransom Humanities Research Center, The University of Texas
at Austin, by permission of Edith Lutyens Bel Geddes, Executrix

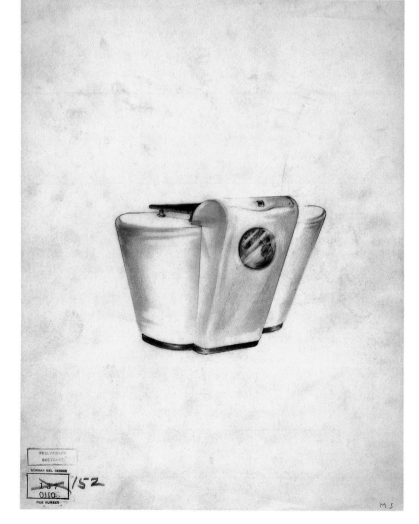

Plate 5
Norman Bel Geddes, *Rendering for Scale,* 1929
Toledo Scale Company
graphite on paper
10⅞ × 8⅜ inches
The Norman Bel Geddes Collection, The Performing
Arts Collection, Harry Ransom Humanities Research
Center, The University of Texas at Austin, by permission
of Edith Lutyens Bel Geddes, Executrix

long as they remained "under his direction."[17] In exchange for a flat fee of $15,000 plus overhead, he clearly expected the designer to live up to his expansive rhetoric.

As the designer's notes reveal, the aggressive Bennett was "most interested in perfecting entirely new ideas, so he can have them patented."[18] Fortunately, Geddes was bursting with ideas, though his reach sometimes exceeded his grasp. Fascinated by the window through which shoppers could view the mechanism of a typical cylinder scale, he proposed making an entire scale housing of transparent glass instead of cast iron. When told that was impossible, he suggested that a housing of Bakelite plastic might contribute a glasslike transparency while solving the problem of weight.[19] This idea unfortunately exposed Geddes's relative ignorance about new synthetic materials. Bakelite was a dark, brittle substance whose transparency lay only in his imagination. It was hardly appropriate for molding the large housing of a scale. Nor could black substitute for the gleaming hygienic whiteness of porcelain enamel, as Bennett discovered when he tested black porcelain scales at ten locations around the country and found that shoppers "refused to buy food weighed" on them.[20] Even so, it was probably Geddes's brainstorm that provoked Bennett to fund research in organic chemistry at the Mellon Institute in Pittsburgh for the express purpose of developing a synthetic resin that could be colored white. Although such a resin might serve as a molding material, Bennett thought of it initially as a synthetic substitute for lacquer or porcelain—a thin, light, durable coating for a lightweight sheet-metal scale housing. In January 1929, less than a month after funding an industrial fellowship for Arthur M. Howald at the Mellon Institute, he told Geddes to concentrate on scales to be fabricated from sheet metal rather than cast in iron. As the project progressed, the metal of choice shifted from steel to aluminum.[21]

Designer and patron eventually focused on only two scale types, not ten—a stand-alone cylinder scale and another of Bennett's ideas, a so-called "island" scale built into a freestanding counter (plates 4 and 5) that could be wheeled wherever it was needed in a store.[22] Geddes's staff worked on variant designs throughout March and April 1929, eventually producing both working drawings and several presentation renderings in watercolor by Al Leidenfrost. These luminous, architectonic, machine-age forms were clearly inspired by the iconic, airbrushed photographs of Midwestern grain elevators that had appeared only two years earlier in the English translation of Le Corbusier's Modernist manifesto, *Towards a New Architecture*, of which Geddes possessed a well-thumbed copy.[23] Glowing with auras of reflected light along their sculptural forms, these masterful renderings shrouded the complex mechanisms of a traditional cylinder scale. In one variant (plate 6), published by *Fortune* as an exemplar of Geddes's work, a tall, white monolith with a thin, vertical gauge reminiscent of a thermometer rose from the back of a rectangular

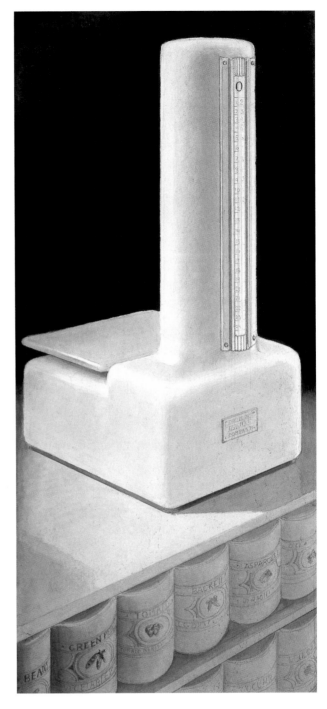

Plate 6
Norman Bel Geddes with Al Leidenfrost, *Rendering for Counter Scale*, 1929
Toledo Scale Company
ink and watercolor on board
10 × 4⅝ inches
The Norman Bel Geddes Collection, The Performing Arts Collection, Harry Ransom Humanities Research Center, The University of Texas at Austin, by permission of Edith Lutyens Bel Geddes, Executrix

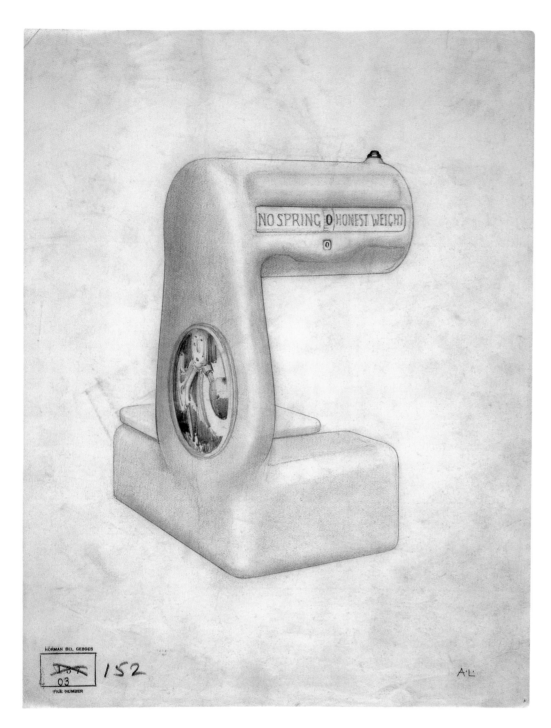

NORMAN BEL GEDDES

152

03
FILE NUMBER

A·L·

NO SPRING 0 HONEST WEIGHT

Plate 7
Norman Bel Geddes with Al Leidenfrost, *Rendering for Counter Scale*, 1929
Toledo Scale Company
graphite on paper
10¾ × 8⅜ inches
The Norman Bel Geddes Collection, The Performing Arts Collection, Harry Ransom Humanities Research Center, The University of Texas at Austin, by permission of Edith Lutyens Bel Geddes, Executrix

base and weighing pan, with all edges and corners given a soft-focus, streamlined blur.[24] Another of Leidenfrost's renderings became Geddes's favorite, appearing in his book *Horizons* in 1932 and frequently in magazine articles (plate 7).[25] Clearly developed from a traditional cylinder arrangement, this design featured the same rectangular base, with a wide, heavy, slightly tapering vertical support, offset to one corner, which enclosed the pendulum mechanism (visible through a porthole rimmed with gleaming aluminum) and supported a cantilevered cylinder housing. Although these renderings earned considerable free publicity for both designer and client as progressive champions of industrial design, the scales they represented never went into production.

Oddly enough, a more conservative design, for which there are no surviving drawings or renderings, definitely reached the next design stage of being embodied in a realistic, full-scale model. Photographs of this model reveal a prototype much closer to a traditional cylinder scale, though all aspects were highly abstracted or modernized. Unlike the earlier renderings, this model was symmetrical, possessing a rounded base and platter flowing smoothly into a tapering vertical housing that opened out to support fully the cylinder housing on top. The ungainly struts of the original scale disappeared into a vertical pedestal, but retained visual presence as the frame of an elongated porthole for viewing the mechanism. Solid, clean-lined, and capable of fabrication from die-stamped and die-cast aluminum, this model achieved a simple, up-to-date enclosing of the clutter of elements of a traditional cylinder scale without expressing radically new forms or making reference to Modernist architecture. Prophetic of the route taken by designers of all sorts of appliances and machinery from the late 1930s into the early 1950s, this model provoked none of the extravagant publicity of the Leidenfrost renderings. Several working prototypes seem to have been built, which may account for an intriguing notice in a trade journal: *Better Enameling* reported in June 1933 that a scale designed by Norman Bel Geddes had been displayed by Toledo Scale at the Porcelain Enamel Parade trade fair. However, nothing came of the test models, which were probably fabricated in aluminum. Bennett seems instead to have been anxiously awaiting the results of the chemical research he had funded at the Mellon Institute.[26]

Although Toledo Scale was never to sell a single scale designed by Geddes and his staff, Bennett was clearly impressed by a largeness of vision similar to his own. Early in their association, in the middle of January 1929 before Geddes had really set to work, Bennett raised the possibility of his designing not just a series of scales, but a whole new factory complex in which to manufacture them.[27] At the time the company's facilities were scattered over four buildings at different sites, and its plant relied on obsolete belt drives from overhead shafts to run the machinery. Harvey Wiley Corbett, a leading Modernist architect, had already completed plans for a new plant to be located on land purchased by the company back in 1916. But Bennett, desirous of making a statement with something "entirely different, even weird looking," removed Corbett from the project, acquired an eighty-acre tract of land (three times as large as the other site), and on April 10 signed a contract with Geddes for "the preliminary study of the problem as a whole."[28] Corporate leaks led the *Toledo News-Bee* to predict a "modernistic style . . . in line with the [company's] policy of introducing beauty in industry."[29]

As finally delivered, down to working drawings "complete and ready for the contractor," the plans for this ambitious complex encompassed a circular machine shop connected to a rectangular laboratory; a large, shedlike assembly building; an adminstration building with

a central tower flanked by two diagonal wings; a covered parking garage; and such amenities as a landing strip for executives, tennis courts, a baseball diamond, a swimming pool, and a wooded picnic ground (plates 8 and 9).[30] In August 1929, shortly before the stock market crashed, Bennett reported being "very anxious to get this construction started up as quickly as possible."[31] Despite the quick work of Geddes's office, however, the $1.5 million project was delayed by disputes between county and state governments over road construction near the site.[32] Even so, Geddes's daring plans garnered considerable publicity for the company in 1930, with *Industrial Engineering* describing the complex as "so modern that it properly may be termed 'modernistic,'" and *American Machinist* referring to it in December as "now under construction."[33] Two months earlier the Toledo Museum of Art had exhibited drawings of the project along with photographs of existing examples of "recent Toledo architecture." The curator, Nina Stevens Rivière, who admired Geddes as a "genius," was "thrilled" that the new complex he had designed "is in Toledo and is going to put us on the map."[34] That never happened, however. The bureaucratic impasse went unresolved until June 1931, at which point the deepening Depression halted any thought of expansion. In 1939, when recovery finally made it possible to construct a new plant, Bennett abandoned Geddes's extravagant vision in favor of a more modest plan by Albert Kahn, the nation's leading industrial architect.[35]

There is no evidence that Bennett ever regretted his involvement with his company's first industrial designer.[36] Geddes's expansive spirit, flair for publicity, and visibility and notoriety as an avant-garde New Yorker appealed to this aggressive executive, who was himself involved with the arts. And Geddes's grandiose vision for the new factory flattered Bennett's conception of himself as an empire builder.[37] More practically, it was the designer who had inspired the decision to fund research at the Mellon Institute. No one could blame Geddes for the fact that both the new cylinder scale and the new factory were delayed—the one by the search for a new synthetic material, the other by the economy's general collapse. Bennett had much for which to be grateful to Geddes—not least a clear demonstration that an independent design consultant might have valuable ideas to contribute. Nevertheless, when Toledo Scale resumed the cylinder scale redesign project, Bennett turned not to Norman Bel Geddes, but to Harold Van Doren, a fellow 1917 graduate of Williams, someone he knew to be solid and practical rather than flamboyant and visionary. In 1930 Bennett invited Van Doren, the assistant director of the Minneapolis Institute of Arts and a formally trained painter, to come to Toledo as a color consultant. He was about to become an industrial designer.

Bennett had just formed a subsidiary, the Toledo Synthetic Products Company, headed by James L. Rodgers, Jr., another 1917 Williams graduate, to exploit Howald's research at the Mellon Institute.[38] Initially seeking a protective coating, the chemist had developed

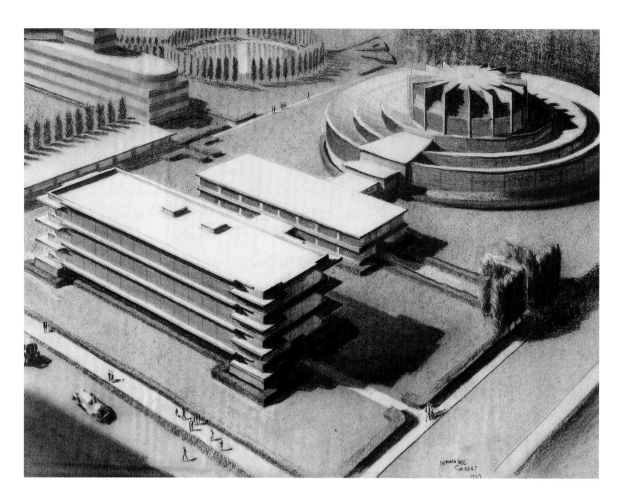

Plate 8
Norman Bel Geddes, *Rendering for the Factory: Precision Devices Group*, 1929
Toledo Scale Company
charcoal on paper
16 × 21 inches
The Norman Bel Geddes Collection, The Performing Arts Collection, Harry Ransom Humanities Research Center, The University of Texas at Austin, by permission of Edith Lutyens Bel Geddes, Executrix

While designing products for the Toledo Scale Company, Norman Bel Geddes also planned the company's new factory and administrative headquarters. Although never built, the striking assemblage of well-proportioned, geometrically shaped buildings, recreational facilities, and transportation functions set in a grand landscape was meant to inspire the worker and enhance the manufacturer's public image. The three-part Precision Devices Group included a round machine shop connected to the shipping/receiving/storage building and the laboratory. The circular building proposed production efficiencies with new mechanical operations as well as innovations in artificial and natural lighting. The laboratory's glass-walled, cantilevered construction allowed for flexible, open floor plans for the chemistry, engineering, and testing functions.

opposite
Plate 9
Norman Bel Geddes, *Rendering for the Main Entrance to the Factory*, 1929
Toledo Scale Company
charcoal on paper
16½ × 25½ inches
The Norman Bel Geddes Collection, The Performing Arts Collection, Harry Ransom Humanities Research Center, The University of Texas at Austin, by permission of Edith Lutyens Bel Geddes, Executrix

a synthetic urea formaldehyde resin that could be used as a plastic molding compound. Unlike Bakelite, previously the only truly durable plastic, this new Plaskon, as it was called, could be made in delicate pastels and a bright, hygienic-looking white similar to porcelain enamel. Van Doren was brought in as a painter and art expert to work "elbow to elbow" with Toledo's chemists as they tested hundreds of pigments and thousands of batches of resin before arriving at a full array of color samples.[39] With plastics widely promoted as one of the few growth industries of the Great Depression, Bennett intended to market Plaskon for use in a wide range of products (plates 10 and 11). Promoted as "molded color," Plaskon went on sale early in 1931.[40] Before long, Van Doren's duties expanded as the company promoted the new material by offering potential manufacturing customers his services as a product designer. He took on a partner, John Gordon Rideout, who remained with him into the mid-1930s.[41] Within a couple of years, they had designed hundreds of Plaskon products for other companies, including Bisquick cutters and other premiums, lids for cosmetic jars, desk sets, cigarette boxes, automotive knobs and accessories, electrical fixtures, and lighting globes. Their designs ranged from inexpensive Bonny Ware salt and pepper sets and spice shakers designed for Reynolds Spring, a Michigan molding company, to elegant stemware of Plaskon and plated metal for The National Silver Company (plate 12). The most technically impressive result of this effort was the Air-King radio of 1933, which boasted an unprecedented one-piece cabinet molded from Plaskon. Its stylish Art Deco form,

echoing the zigzag skyscraper silhouettes of the era, attracted considerable attention among those who were tracking contemporary design.[42] Throughout this process Van Doren was learning both the material possibilities and limits of Plaskon and the general processes of industrial design. The time had come to move toward Bennett's ultimate goal of a lightweight plastic scale housing.

So far as Toledo Scale was concerned, Van Doren and Rideout had already proven their ability to cooperate with mechanical engineers on a major project. In addition to designing novelties for molding in Plaskon, they had contributed to the complete redesign of the so-called Public Health Scale, known more familiarly within the industry as a "person weigher," the sort of scale, often coin-operated, on which people could check their weight in a pharmacy, dime store, or other public place. The older model, as marketed in 1930, had remained mostly unchanged since 1916. Nearly six feet tall, it was a massive instrument surmounted by a round dial housing at least eighteen inches in diameter—large enough to telegraph one's weight to curious bystanders. Van Doren and Rideout's replacement was announced in December 1931. Less than four feet tall, it took up considerably less floor space and rose smoothly as a single pylon, complete with refined skyscraper setbacks, to end in a discreet indicator visible only to the person standing on its platform (plates 13 and 14).[43] Finished in a new shade of tan porcelain enamel and "trimmed in lustrous black" for a "really beautiful duotone effect,"[44] the new scale complemented the modernized Vitrolite glass and chrome exteriors

of downtown stores and appealed to women shoppers over heavy-duty scales that looked more appropriate for weighing in prizefighters. As a newly design-sensitized, in-house publication proclaimed, "of two products, equal in merit, the buying public favors the better looking." And so did the National Alliance of Art and Industry, which in 1932 awarded the scale its "first prize for fitness of purpose and beauty of design." Even so, it was also true that although engineers had "compromised to benefit appearance," Van Doren and Rideout had "amended in favor of production." No mere stylists, these consultant members of the company's new Division of Design had proven they could "work in conjunction with the principles of engineering and with the engineers themselves."[45] They were ready for the project that had brought Van Doren to Toledo in the first place.

A contemporary observer commented that the new Plaskon Duplex model (plate 15), introduced in 1935 and soon renamed the Sentinel, looked about "as different from the scale made of cast iron as the modern automobile does from the buggy it replaced."[46] Such evolutionary mutations were common during the 1930s as industrial designers devised often radically new innovations. In this case the project involved Van Doren and his associates in collaboration not only with Toledo's engineers, but also with those from Alcoa, Bausch & Lomb, and General Electric. Company engineers made the mechanism more compact, collapsing its parts around the cylinder to eliminate the standard separate housings for base, pendulum, and cylinder—thereby reducing the total height to fifteen inches. While the cast-iron housings

Plate 10

Edwin W. Fuerst, *Cocktail Shaker*, patented 1935, *with Tumblers*, ca. 1936

Owens-Illinois Glass Company

shaker: glass and Plaskon; tumblers: glass and enamel

shaker: 32¼ × dia. 3½ inches; tumblers: 3½ × dia. 2⅛ inches

Larry and Susann Spilkin

After the repeal of Prohibition in late 1933, a highly competitive market catered to America's cosmopolitan cocktail culture. Cocktail shakers, in ceramic, glass, metals, and plastics, took on novelty shapes or streamlined sophistication. In this moderate-priced, Depression-era set, designer Edwin W. Fuerst applied his knowledge of glass design to Plaskon, the new urea formaldehyde resin material developed in Toledo. The shaker included a strainer molded into the cap and was available in several colors, along with matching glass tumblers.

Plate 11
Edward Hoffman, *SWINGLINE® Electro-Pointer Pencil Sharpener*, 1941
Triple "E" Products Company
Plaskon and Bakelite
9 × 8 × 3⅝ inches
Rick Bugner Collection

This extraordinary streamlined shape, made possible by the fluid properties of molded resin, brought modern style to an ordinary office product. Triple "E" Products Company's automatic pencil sharpener won an award in 1941 sponsored by *Modern Plastics* magazine and was featured in advertisements for the Plaskon Company of Toledo. Promoted as "Molded Color," Plaskon resisted cracking and chipping, allowed little shrinkage or expansion, and insulated against noise. Replacing traditional heavy, die-cast metal housings, it reduced manufacturing costs and enhanced sales appeal.

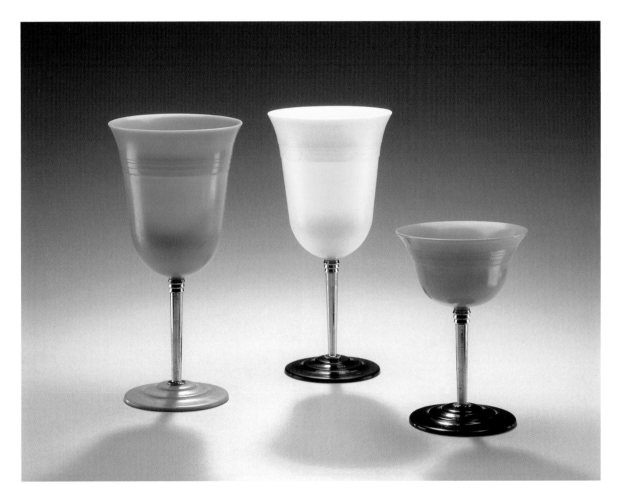

Plate 12
Van Doren and Rideout, *Stemware*, ca. 1933
The National Silver Company
Plaskon and plated metal
two water: 6¾ × dia. 3¼ inches; wine: 4⅜ × dia. 3⅛ inches
Larry and Susann Spilkin

Harold Van Doren and John Gordon Rideout designed many small consumer products for different manufacturers using Plaskon. This graceful stemware for The National Silver Company joins stylishly colorful Plaskon with metal, demonstrating the contrast of shapes and textures possible with modern materials. Van Doren and Rideout's promotional brochure included these goblets along with other products made of Plaskon.

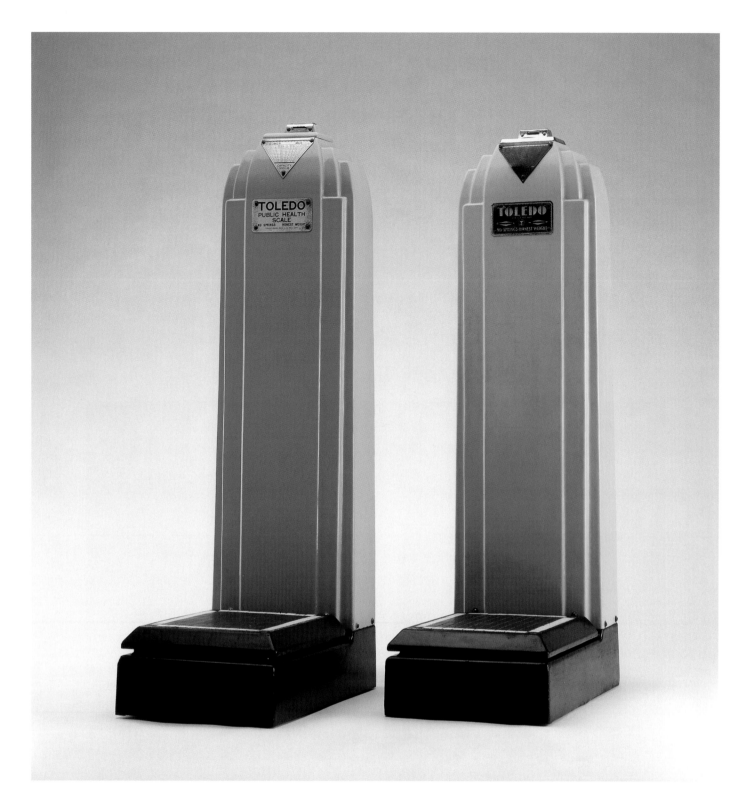

Plate 13
Van Doren and Rideout
Toledo Scale Company

Toledo Public Health Scale, Coin-Operated, 1931
chromium plate, iron, porcelain enamel on steel, paint,
tile, and glass
42½ × 12½ × 22¾ inches

Toledo Public Health Scale, Coin-Operated, 1931
chromium plate, iron, porcelain enamel on steel, paint,
tile, and glass
42½ × 12½ × 22¾ inches

The Christopher K. Steele American Coin-Operated Weighing
Machine Collection

Toledo Scale promoted this beautiful "person weigher" scale as a
profitable traffic builder for retail merchants. The scale appealed
to women because the weight indicator was visible only to the
person standing on the platform. Recognizing current color fash-
ions in automobiles and interiors, the company offered this scale
in standard porcelain finishes—tan, green, black, blue, ivory,
and light brown—as well as custom colors at an additional price.
Sales of the new scale exceeded expectations—equaling in one
year the total sales of the previous model's ten years.

Plate 14

Van Doren and Rideout, *Toledo Public Health Scale, Coin-Operated,* 1931
Toledo Scale Company
iron, porcelain enamel on steel, paint, concrete, and glass
42½ × 12½ × 22¾ inches
The Christopher K. Steele American Coin-Operated
Weighing Machine Collection

The skyscraper form appeared very bold when accentuated by the vertical graphic treatment of this model of the Public Health Scale. Reinforcing established brand loyalty and uniting the Toledo name with "honest weight," the company persuaded retailers that women confident of Toledo's accuracy would patronize shops that provided this scale as an extra customer service.

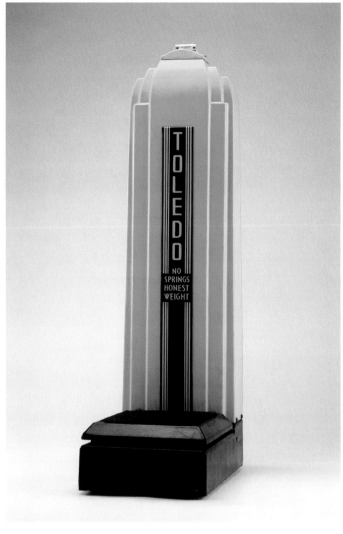

Plate 15

Van Doren and Rideout, *Sentinel Duplex Scale,* patented 1934
Toledo Scale Company
Plaskon, aluminum, glass, enameled steel, and Bakelite
15½ × 17¹⁵/₁₆ × 14⅝ inches
The Mitchell Wolfson, Jr. Collection, The Wolfsonian-Florida
International University, Miami Beach

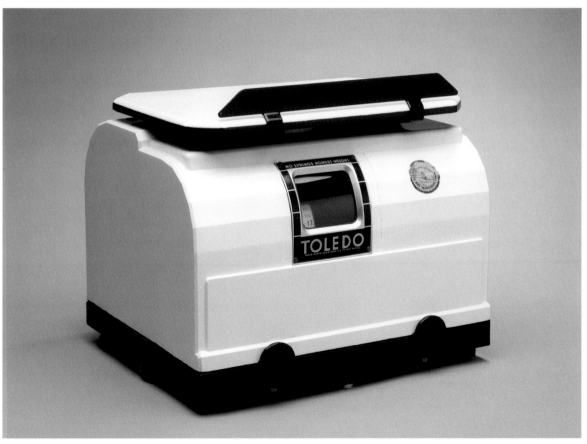

of the old scale had supported the works, the Sentinel rested entirely on a one-piece, cast-aluminum base. Most other working parts were also fabricated from aluminum, "the same type of strong, light weight material used in airplane construction," as the company informed the sales force.[47] The chart of weights and prices was printed directly on the cylinder's thin sheet aluminum, so dimensionally stable (unlike paper, which expanded with changes in humidity) that the glass lens (specially designed by Bausch & Lomb to magnify more than twice as many prices as before) could be placed almost up against it—thereby eliminating any need for the former double-line sighting method.

Throughout the process of engineering the scale, the industrial designers contributed perspective sketches indicating how various mechanical decisions would affect exterior shape. Once the working elements were finally set, the designers began modeling the housing or cabinet that would enclose the mechanism. After making a so-called clearance model of wood, which indicated the spatial allowances required for all moving parts, they packed modeling wax over it and began shaping the dimensions of the Plaskon cover. As Van Doren recalled, Bennett had insisted "that the design *express the new material in which it was to be made.*" In practice, this could be interpreted as a negative—that he "did not wish it to have the curves and radii that would have been appropriate, in fact necessary, in stamped steel or in a casting." But this interpretation left them in a quandary because a "cylindrical shape," according to the rule of functional expression, would naturally be "suggested by a large-radius curve on the outside." They finally hit on "the idea of breaking up this curve into clear-cut faces, like those of a jewel, extending the full length of the scale and preserving the suggestion of the cylinder within."[48] Van Doren might have added that these facets or bevels, receding from the front toward the top, also gave the housing a precise machined look, in keeping with its birth in a polished steel mold. They also served to strengthen the plastic shell.

The new design, for which Van Doren and Rideout jointly filed a patent application on April 13, 1934,[49] was simplicity itself—an exemplar of modernity. A publicist for the company later caught something of the genuine excitement surrounding this new scale by observing that because its self-contained mechanism provided its own internal frame and thus supported itself, the external Plaskon housing seemed to float, "much as the curtain walls of a modern building."[50] Beyond all the rhetoric, however justified, the Sentinel was, most of all, compact and lightweight. At half the height of an old cast-iron scale, a Sentinel permitted grocer and customer to see each other as a purchase was weighed; two inches narrower and five inches less deep, it took up less counter space. Above all, it weighed only fifty-five pounds, a full two-thirds less than the cast-iron behemoth that had given hernias to salesmen and grocers. The lighter weight also permitted the company to pack the Sentinel in a cardboard carton instead of a wooden crate,

with considerable additional savings in shipping charges. The fundamental problem that had bedeviled Bennett for nine years, ever since he took over the Toledo Scale Company—that is, what to do about the heavy, clunky, clumsy-looking cast-iron cylinder scale in an era of increasingly streamlined, image-conscious grocery marketing—was finally resolved in a striking manner that left seasoned sales agents gushing over "the most beautiful thing . . . [ever] seen in a scale."[51]

Publicity surrounding the Sentinel's introduction emphasized the high-tech innovations surrounding the molding of its Plaskon housing, particularly the fact that it was purported to be "the largest plastic molding ever made in the United States" up to that time.[52] Entrusted to the fast-growing plastics division of General Electric, the job required construction of the world's largest hydraulic compression-molding press by the French Oil Mill Machinery Company of Piqua, Ohio. Eventually installed in a safe room at GE's plant at Fort Wayne, Indiana, the press stood twenty-two feet high, encompassed two stories, weighed nearly forty-five tons, and possessed nine hydraulic rams exerting fifteen tons of pressure on a mold that had been machined from a seven-ton block of steel. The press room was air-conditioned and pressurized to keep out dust that would have contaminated the smooth, unblemished surface of the moldings. During the molding process, white-garbed technicians loaded the mold with carefully measured amounts of Plaskon urea formaldehyde plastic resin powder, activated the massive plunger that drove the male half of the mold into its female receptacle, stood by for twelve minutes as the plastic resin melted, flowed, hardened, and cured into permanent form, retracted the plunger, and then released and removed the huge molding as tourists watched through a large plate glass window. The gleaming white housing, created out of nothing as if by some uncanny magic, weighed less than nine pounds.

The Sentinel was a phenomenal success from the moment it was introduced. In its first six months, sales exceeded those of its predecessor for a similar period by 300 percent as grocers hurried to discard cast-iron reminders of a rapidly vanishing past. Higher sales volume, lower assembly costs, and lower shipping costs more than offset the higher cost of the Sentinel's plastic and aluminum materials. Although the sales increase followed a major publicity effort that reportedly placed articles about the new scale in some six hundred publications, Bennett recognized that Van Doren's design efforts were largely responsible for Toledo Scale's recovery from the economic depression. He lost no time commissioning Van Doren to create designs in Plaskon for a retail meat chopper and coffee grinder that were distributed by Toledo Scale sales agents under exclusive license from the Enterprise Manufacturing Company of Philadelphia. On the market in 1936, these new pieces of equipment created an ensemble with the Sentinel scale and appealed to grocers who recognized that, as an advertisement phrased it, "new lighter, brighter stores, with clean-looking,

sanitary fixtures have proved repeatedly their customer-winning appeal." So attractive was the Plaskon meat grinder to shoppers that it would "tempt them to order chopped meat."[53] The Sentinel also distinguished itself in the first annual competition held by *Modern Plastics,* a trade journal, which awarded it first place in the Industrial Applications Division, as selected by a panel of judges including, among others, architect Harvey Wiley Corbett and industrial designer Raymond Loewy.[54] In combining aesthetics, functional performance, and marketing considerations, the Sentinel was a clear hit.

With the Sentinel, Bennett not only succeeded in solving a problem that had vexed his own company for many years; he also extended the place of plastics in manufacturing in general, demonstrated the efficacy of industrial design as a marketing tool even in nonretail industries, and gave Van Doren an opportunity to invent himself as an industrial designer and to become an early success among the consultants who were part of the new profession. But there was more to it than that, as Toledo engineer H. Warren Hem recognized as early as January 1936. Although Hem acknowledged the "impressive transformation" in the new scale's appearance, he thought that its "genuine significance" lay "in the design methods, in the application of new materials, and in bringing to the foreground the possibilities of cooperative research of a number of specialized organizations toward the development of a single product." He hoped that Toledo Scale's own experience would "suggest a formula for the successful redesign of many other products."[55] Although for Hem to voice the logical conclusion would have seemed obvious flattery, the key to this formula was Hubert Bennett, who had orchestrated the assault on the company's overriding problem almost from the day he took control in 1926. From this larger perspective, it was Bennett who was the supreme designer, devising strategies, attracting personnel, allocating resources, and making it all happen. At the very least, industrial design in its earliest phase owed much to such flexible, innovative, risk-taking entrepreneurs.

As time passed, however, industrial design, whether at Toledo Scale or in general, became more routine. Even designs that had seemed revolutionary needed tinkering with. The Sentinel had problems almost from the start. The Plaskon case, for example, sometimes developed a crack radiating down from the customer's viewing window. In addition, tiny gaps between the housing and the base permitted cockroaches to enter, potentially disturbing the scale's accuracy and creating the possibility of a distinctly unpleasant experience with an instrument designed to appear especially hygienic. Most important, grocers who installed scales in recessed wells or on counters behind display cases found the Sentinel too short for shoppers to read. Their complaints compelled the company to offer extension legs and eventually full stands that could add three or five inches to a scale's height.[56] Within a few years Van Doren was commissioned to design a new

Guardian Duplex scale (plate 16), taller than the Sentinel and enclosed not by a one-piece molding, but by a housing assembled from eight molded pieces of Plaskon (plate 18). Although the Sentinel remained in Toledo's catalogue (as did traditional porcelain enamel models), the company emphasized the new Guardian. In fact, the official promotion of the Guardian smacked of disingenuousness. By juxtaposing photographs of an old cast-iron scale and a new plastic Guardian, the company implied that no such radical development as the Sentinel had ever occurred. This misrepresentation was compounded by talk about amazing height and weight reductions and a somewhat tired observation that the Guardian offered "a perfect example of what Plaskon and redesign can do for a product."[57] Even Van Doren entered into this historical revisionism, permitting a series of publicity photographs to be made in his office tracing the design process involved in creating the Guardian, from sketches to renderings to models, as if the old cast-iron behemoth was its only predecessor. And when he did obliquely refer to the Sentinel, it was to observe that the Guardian was "newsworthy chiefly because no attempt was made to devise a one-piece housing," as if there were something slightly distasteful about such an endeavor.[58]

Although Van Doren's reputation as an industrial designer continued to rise, his visibility within the Toledo Scale hierarchy was already diminishing. Not that there was any break in relations between the designer and the company or its president. For at least seven years after the Guardian was introduced in 1938, Van Doren continued to provide numerous designs for scales (plate 17), both retail and industrial, including even the bottom-of-the-line Defiance, a sheet-metal version of the Guardian with a cheap spring-operated mechanism.[59] In 1940 the Toledo Museum of Art displayed Van Doren's work for the company in an exhibition of product design in Toledo, and Bennett led the discussion when the designer addressed the local chapter of the Society for the Advancement of Management.[60] The two men remained on such good terms personally that when Bennett died in 1951 following a long illness, many years after the designer had moved his office to Philadelphia (and later New York) and had stopped working as a consultant to the company, Van Doren was asked to serve as honorary pallbearer.[61] Even so, Van Doren the designer no longer received significant attention within the company. When the Guardian appeared in 1938, the company's sales agents were warned not to "permit the beauty" of the scale to detract from the all-important "comparative reading test" that could alone close a difficult sale.[62] The company's promotional materials, especially those addressed to the sales force and to customers, no longer emphasized Van Doren's involvement. The so-called Division of Design, quite prominent during the mid-1930s, disappeared from organizational charts. Design for appearance and functionality, coordinated with the basic engineering of a scale, had become part of the ordinary manufacturing process.

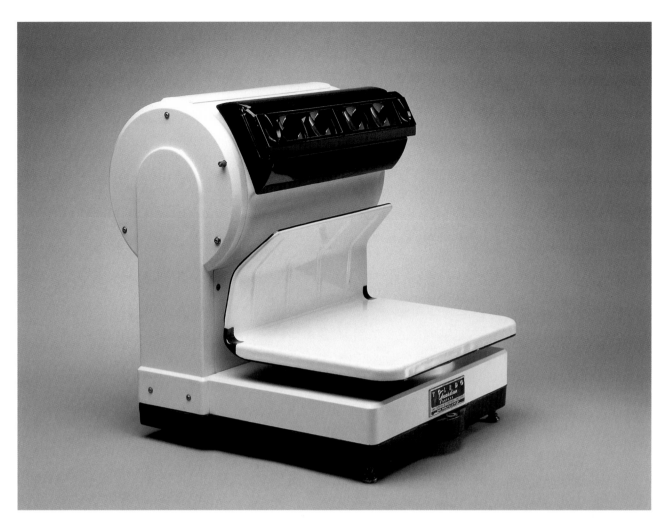

Plate 16
Harold Van Doren & Associates, *Guardian Duplex Scale,* 1938
Toledo Scale Company
Plaskon, aluminum, enameled steel, and glass
20¾ × 17½ × 22 inches
The Mitchell Wolfson, Jr. Collection, The Wolfsonian-Florida
International University, Miami Beach

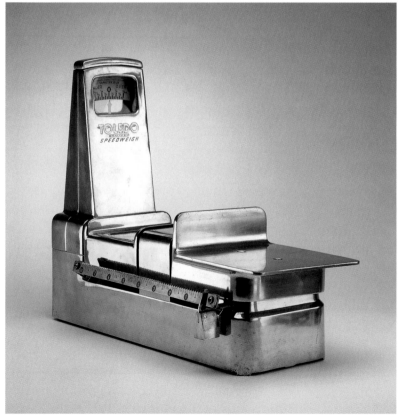

Plate 17
Harold Van Doren & Associates, *Speedweigh Scale,*
ca. 1939
Toledo Scale Company
polished aluminum and glass
15¹³⁄₁₆ × 6⅞ × 19½ inches
Anonymous loan

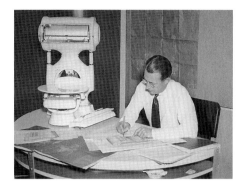

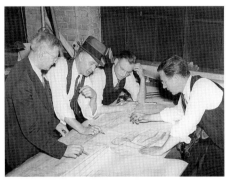

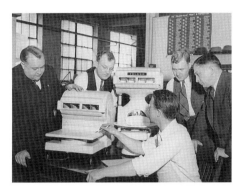

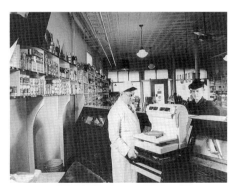

Plate 18

"Eleven Stages in the Development of a Cylinder Scale for Retail Store," Plates 16 and 17, in Harold Van Doren, Industrial Design: A Practical Guide *(New York and London: McGraw-Hill, 1940)* photo panel

In his book *Industrial Design: A Practical Guide*, Harold Van Doren presented "Eleven Stages in the Development of a Cylinder Scale for Retail Store" as a glimpse of the design process that developed the Guardian Duplex for Toledo Scale. Beginning with a preliminary investigation of the current product in a store setting (1), the designer assesses the needs of the user. Van Doren then meets with the company executives to discuss the project requirements (2), and works with his staff to sketch alternatives (3, 4). Artists and sculptors prepare clay models (5) and presentation drawings (6), followed by a wooden mock-up (7). Factory workers form the eight Plaskon component parts (8, 9) and assemble the scale (10). The final product, a sleek, easy-to-operate scale, is shown placed in a butcher shop (11).

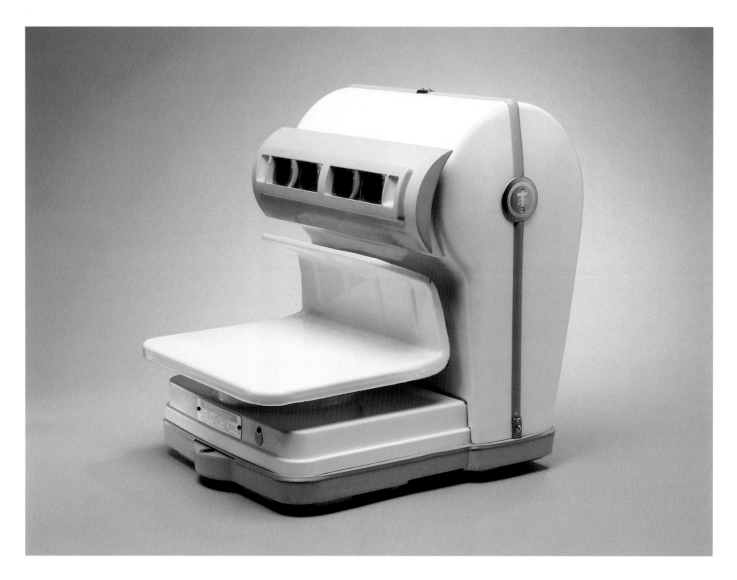

Plate 19
J. M. Little and Associates, *Toledo Guardian 70*
Duplex Scale, 1948
Toledo Scale Company
Plaskon, aluminum, glass, and rubber
20¾ × 17¾ × 22 inches
Shorling's Market/Robert Anteau

Plate 20
F. E. Huss for J. M. Little and Associates, *Drawing for Medallion for Plastic Duplex Scale*, 1946
Toledo Scale Company
pen and black ink, white correcting fluid, blue crayon on rag card, and paper
9⅛ × 12¼ inches
Larry Markin

The corporate trademark of Toledo Scale, composed of a highly readable "T" combined with a classic image of a balance scale, was a familiar insignia beginning in the early 1930s. When J. M. Little and Associates redesigned the Guardian, the new product appearance included an update of the trademark—a triple ring instead of a simple circle enclosed the "T" form.

When it was finally time to revamp the Guardian, around 1946, the job went to J. McLeod Little, a veteran of Van Doren's staff who had opened his own office in Toledo in 1943. The new Guardian 70 (plates 19 and 20), introduced in 1948, differed visually from the original mostly in exhibiting the bulbous swelling that was typical of automotive and appliance styling during the immediate postwar era. In addition, however, Little corrected a number of problems. He reduced the eight Plaskon moldings to three, one for the base and two for the upright section, thus cutting down assembly time and the number of required fasteners. Instead of permitting plastic edges to meet, as Van Doren had done at several points, Little employed rubber gaskets that kept the edges from binding or cracking. Even parts that were not perfectly shaped would fit tightly, thereby excluding cockroaches and other vermin that had remained a problem with the original. The solution seemed so effective that *Modern Plastics* awarded the Guardian 70 first place in the Store and Business Equipment category of its 1948 competition.[63] The considerations behind the new scale's design and credit for Little as industrial designer were both featured in trade journal articles addressed to product engineers.[64] However, Toledo Scale's own publications mentioned little about the Guardian 70's appearance and virtually nothing about its designer. Even a presentation for sales agents in "Toledovision" (the company's name for multimedia productions in film strip and phonograph record) made no mention of J. McLeod Little or industrial design.[65]

Back in 1931, when a magazine like *Fortune* could devote many admiring pages to the mostly unrealized work of Norman Bel Geddes, industrial design had seemed not only a process essential to the survival of the American economy, but also an avant-garde expression of the culture of the machine age. By 1948 design was no less essential to the marketing of products and thus the survival of individual companies, but it had become an invisible process. More and more companies were organizing in-house design departments staffed with graduates of recently established university design programs. As corporate reliance on design increased, independent consultants like those who had founded the profession received an ever-smaller percentage of the available work. An entrepreneur such as Bennett, taking over a floundering company in 1926 on the eve of the Great Depression, had required a certain breadth of vision and a willingness to take risks in order to effect this new union of art and industry. As the economic renewal of Toledo Scale proceeded, however, industrial design, as reflected in the progression from Geddes to Harold Van Doren to J. McLeod Little, gradually became nothing more—nor less—than an operative part of business as usual. No longer a corporate art verging on the avant-garde, it had become part of the normal routine.

1. Bennett as quoted in the transcript of "Toledo Scale Company District Managers' Conference," March 22, 1926, p. 569, Box E, Toledo Scale Company Archive, Toledo's Attic-Lucas County/Maumee Valley Historical Society, Maumee, Ohio (hereafter referred to as "Scale Archive"). Biographical data are from "Hubert D. Bennett Stressed Research in Industry," *Toledo Blade*, September 9, 1951; and Walter A. Fink, "A History of Toledo Scale Corporation: The First Fifty Years" (1967), p. 1. Fink's 200-page typescript is in Box 2, Scale Archive.

2. Information from "Facts About the Company and Its History," Toledo Scale Company, *Abridged Course of Instruction*, October 1929, Scale Archive (note 1); and Fink (note 1), *passim*. I have relied throughout on Fink's disorganized but invaluable history.

3. "Robert R. Theobald Ends Life Facing Mirror," *Toledo Blade*, December 19, 1925.

4. Bennett (note 1), p. 5.

5. Letter from D. H. McGhee to Stanley W. Bennett, May 31, 1938, Box C, Scale Archive (note 1).

6. Bennett (note 1), pp. 6, 569.

7. A. A. Smith, "Demonstrate the New Fan Line," *Toledo System* 24 (January 22, 1930). See also *Abridged Course of Instruction for Salesmen* (Toledo: Toledo Scale Company, 1926); H. D. Bennett, "Are You a Counter Scale Salesman or Just a Cylinder Scale Salesman?," *Toledo System* 21 (December 3, 1927); "Toledo-Built Scales Are Toledo Finished," *Toledo System* 18 (October 11, 1924), pp. 1–7; "Toledo Porcelain Enamel," *Toledo System, Jr.* 1 (June 11, 1928); "Outline—Background Sales History Leading to Presentation of the Guardian-70," typescript, ca. 1947, pp. 2–3, Box B, Scale Archive (note 1); and Fink (note 1), pp. 184–85.

8. "Stop and Shop Food Market," *Toledo System* 19 (July 18, 1925), pp. 1, 10.

9. "Toledo No. 3125," *Toledo System* 19 (February 28, 1925), pp. 10–11. See also "A Dozen Features of the New Toledo Scale," *National Grocers Bulletin*, May 1927, p. 14, advertising tearsheet, Scrapbook 5, Box 5, Scale Archive (note 1).

10. On Geddes's connection with J. Walter Thompson, see Jeffrey L. Meikle, *Twentieth Century Limited: Industrial Design in America, 1925–1939* (Philadelphia: Temple University Press, 1979), pp. 51–53.

11. On Geddes's Toledo connection, see Norman Bel Geddes, *Miracle in the Evening: An Autobiography*, ed. William Kelley (Garden City, New York: Doubleday, 1960), pp. 98, 115, 118, 120, 124, 142–44, 154. Frederick L. Geddes's classical revival mansion, designed by Thomas F. Huber for Clarence Leeper and completed in 1903, is illustrated by Eric Johannesen and Allen L. Dickes, *Look Again: Landmark Architecture in Downtown Toledo and Old West End* (Toledo: Landmarks Committee of the Maumee Valley Historical Society, 1973), pp. 168–69.

12. Norman Bel Geddes, "The Horse Race Game," typed autobiographical fragment, December 2, 1951, in Autobiography ms., chapter 47, Norman Bel Geddes Collection, The Performing Arts Library, Harry Ransom Humanities Research Center, The University of Texas at Austin.

13. Typed job record, p. 1, File 152, 16.TSF3a, Geddes Collection (note 12).

14. Social regeneration suffused Geddes's major work of design promotion, *Horizons* (Boston: Little, Brown, 1932), especially pp. 3–23, 273–93. On Toledo Scale's use of LaChance's works, see "Craftsmanship of Toledo Builders a Factor in Weighing Service," *Toledo System, Jr.*, June 25, 1930. The Toledo Museum of Art exhibited the paintings in 1929.

15. For the museum's mission, see *The Toledo Museum of Art: Its Plans and Purposes with Reference to the New Museum Building* (Toledo: Toledo Museum of Art, ca. 1912).

16. See Blake-More Godwin, *Director's Report for 1929* (Toledo: Toledo Museum of Art); and "Dynamic Symmetry Declared Adapted to Present Day Art," *Toledo Blade*, February 14, 1929. Many early industrial designers, in particular Walter Dorwin Teague, borrowed from Jay Hambidge, *The Elements of Dynamic Symmetry* (New York: Brentano's, 1926), a draftsman's quasi-mystical presentation of the classical golden mean as a basis of modern composition. See Meikle (note 10), pp. 44–47.

17. Contract between Toledo Scale Company and Norman Bel Geddes, December 18, 1928, File 152, Geddes Collection (note 12).

18. Typed job record, p. 2, File 152, 2.TS2b, Geddes Collection (note 12).

19. Geddes, "The Horse Race Game," typed autobiographical fragment, December 2, 1951, in Autobiography ms., chapter 47, Geddes Collection (note 12); and typed transcript of a telephone conversation of Geddes with a Mr. Edgerter, August 27, 1954, in Autobiography ms., chapter 40, Geddes Collection.

20. Edward R. Weidlein and William A. Hamor, *Glances at Industrial Research: During Walks and Talks in Mellon Institute* (New York: Reinhold, 1936), p. 63.

21. Ibid., pp. 63–64; typed job record, p. 2, File 152, 2.TS2b, Geddes Collection (note 12). The idea that Bennett had initially sought a synthetic finish as a substitute for porcelain enamel, rather than a wholly new synthetic fabricating material, was volunteered by Bud Kasch in an interview with the author on July 22, 1985. Kasch, son of a founder of Kurz-Kasch, Inc., a plastics molding firm in Dayton, Ohio, participated in early tests of the molding material, Plaskon, that Howald subsequently developed.

22. Geddes (note 14), p. 225.

23. The book is among hundreds of volumes of his personal and professional library in the Geddes Collection (note 12).

24. "Bel Geddes," *Fortune* 2 (July 1930), p. 56.

25. Geddes (note 14), p. 230.

26. Clipping from *Better Enameling*, June 1933, p. 10, Geddes Collection (note 12). A thorough search of product catalogues in the Scale Archive reveals no hint of this design in commercial production, though Weidlein and Hamor (note 20), p. 70, note that several aluminum test models were constructed at about this time. Attribution of the design to Geddes is conjectural. Four photographs of the model—from the front (grocer's view), the rear (customer's view), the side, and an angle shot of the front—can be found in File 152, Folder 152.2, Geddes Collection. In 1986 I discovered lone copies of the angle view, identical to that in the Geddes Collection, in two small collections of materials originally belonging to Harold Van Doren, who succeeded Geddes at Toledo Scale. One was then in the possession of Harper Landell, who inherited Van Doren's design practice after his death; the other was in the possession of Peter W. Bressler, who bought Landell's practice when he retired. In the absence of other documentation, I regard as suggestive the existence of the four images in the Geddes Collection, as opposed to only one in the Van Doren materials. It also makes sense that Van Doren, who came later, would have been given a copy of his predecessor's final proposed cylinder scale. It is not likely that Geddes would have acquired four different photographic views of a model produced by his successor several years after he himself had moved on to other clients and projects.

27. In a letter dated January 12, 1929. See typed job record, p. 2, File 152, 2.TS2b, Geddes Collection (note 12).

28. Notes on a phone conversation between Bennett and Geddes, February 20, 1929, in typed job record, File 153.1, Geddes Collection (note 12); and contract between Toledo Scale and Geddes, April 10, 1929, p. 1, File 153.1, 14.TSF1, Geddes Collection. See also Fink (note 1), pp. 99–102.

29. "Toledo Scale Buys 80-Acre Tract for Centralized Plant," *Toledo News-Bee*, April 8, 1929.

30. Undated typed notes, 1 p., File 153.1, Geddes Collection (note 12). See also undated typed notes, 2 pp., File 153.1, 18.TSF5a&b, Geddes Collection; and Geddes (note 14), pp. 205–21.

31. Letter from Bennett to Geddes, August 1, 1929, Folder 153.1, Geddes Collection (note 12).

32. "Toledo Scale Co. to Build $1,500,000 Plant Near City," *Toledo Blade*, June 25, 1930; and "County to Buy Right of Way for New Road," *Toledo Times*, June 12, 1931.

33. *Industrial Engineering* 88 (July 1930), cover story; and "All Windows," *American Machinist*, December 11, 1930, p. 918; both clippings in File 153.5, Geddes Collection (note 12).

34. Quotations from two letters from Mme. [Nina] Georges Henri [Stevens] Rivière to Geddes: August 20, 1930, File 152, Folder 152.4; and September 24, 1930, File 153, Folder 153.1; both Geddes Collection (note 12). See also *Catalogue: Viennese Architecture and Some Recent Toledo Architecture* (Toledo: Toledo Museum of Art, 1930).

35. See "Design for Mass Production," *Architectural Record* 87 (February 1940), pp. 86–90.

36. For Bennett's support of Geddes's unsuccessful attempt to gain an architectural license in New York State, see a carbon copy of Bennett to Herbert J. Hamilton, State Education Department, University of the State of New York, February 6, 1931, File 314, Geddes Collection (note 12).

37. Bennett was continually forming spin-off companies (Toledo Porcelain Enamel Products Company, Toledo Synthetic Products Company, Toledo Precision Devices, Inc.), forming relationships with others (Enterprise Manufacturing Company), and acquiring still others (Defiance Machine Works).

38. "J. L. Rodgers Jr., Plastics Leader," *New York Times*, February 26, 1955, p. 15.

39. *Before and After: A Few Examples of the Recent Work of Van Doren and Rideout* (Toledo: Van Doren and Rideout, ca. 1934).

40. The quotation is from *Plaskon Molded Color* (Toledo: Toledo Synthetic Products Company, 1934), a stylish twenty-page promotional booklet printed in luminous colors on black paper. See also A. M. Howald, "Systematic Study Develops New Resin Molding Compound," *Chemical & Metallurgical Engineering* 38 (October 1931), p. 583; James L. Rodgers, "Plaskon, a New Molding Compound the Result of Planned Research," *Plastics & Molded Products* 7 (December 1931), p. 664; and "New Developments: Plaskon, A New Synthetic Product," *Toledo System* 26 (February 1932), p. 10. On the promotion and development of plastics during this period, see Jeffrey L. Meikle, *American Plastic: A Cultural History* (New Brunswick: Rutgers University Press, 1995), pp. 63–124.

41. The company described the design services of Van Doren and Rideout as part of its "complete technical and service department" in *Plaskon: Technical Data* (Toledo: Toledo Synthetic Products Company, 1933), p. 2.

42. On the Air-King radio, see "Plastics in Pictures," *Plastic Products*, March 1933, between pp. 22 and 23; "A Product of Toledo Research—'Plaskon Molded Color,'" *Toledo System* 29 (March 1935); and Fink (note 1), p. 122.

43. Details of each scale, before and after, are on pages dated August 11, 1930, and January 1932, respectively, inserted in a handbook of scale models and prices, Box B, Scale Archive (note 1).

44. Mimeographed memo to all sales agents, 2 pp., December 10, 1931, Scale Archive (note 1).

45. "Toledo Research Division of Design Creates New Sales Appeal in 8400," *The Toledo Scaleman*, November 25, 1932, 2 pp., Box 8, Scale Archive (note 1). Organizational charts of Toledo Scale Research from 1932 and 1938 gave prominent position to design

consultants along with mechanical, optical, electrical, chemical, and metallurgical divisions.

46. Weidlein and Hamor (note 20), p. 68. Unless otherwise noted, my account of the Sentinel is based on the following: "Redesigned Scale, with Molded Plastic Housing, Is Tribute to Research," *Steel* 97 (August 5, 1935), p. 75; "Research—on a New Scale," *Business Week,* August 10, 1935, pp. 9–10; "Giant Plastic Molding Produces Large Weighing Scale Housings," *The Iron Age* 136 (August 29, 1935), pp. 13–14; H. D. Bennett, "Pushing Back Frontiers," *Modern Plastics* 13 (September 1935), pp. 25–27, 30–32; S. A. Maxom, "Hail to the Scale," *Du Pont Magazine* 29 (October 1935), pp. 8–9; N. S. Stoddard, "Molding the Toledo Scale Housing," *Modern Plastics* 13 (October 1935), pp. 11–13, 56–57; "Plaskon: A New Plastic Material," *Machinery* 42 (November 1935), pp. 169–74; H. W. Hem, "Weight, Size Down—Utility, Sales Up," *Machine Design,* January 1936, pp. 19–22; Weidlein and Hamor (note 20), pp. 59–82; and Fink (note 1), pp. 122–23.

47. Attachment to General Letter No. 36-37, April 30, 1936, in "General Letters, 1/1/36 to 12/29/36," Box G, Scale Archive (note 1).

48. H. L. Van Doren, "Design for Selling," *Toledo System* 29 (August 1935), p. 6.

49. They received design patent 93,953 on November 27, 1934.

50. From anonymous, undated, typed manuscript, "Today . . . New Dimensions for Toledo Scale Corporation," Box G, Scale Archive (note 1).

51. W. R. Crowley of Los Angeles as quoted in "The Plaskon Duplex Parade Is On!," *Toledo System* 29 (September 1935), p. 3. For comparative dimensions and weights, see "It's a Marvelous 'Weigher'—Here's Why," *Toledo System* 29 (August 1935), p. 7.

52. Weidlein and Hamor (note 20), p. 78.

53. Advertising tearsheet, Enterprise Manufacturing Company, in binder "Obsolete Literature of Old Toledo Scales," Box I, Scale Archive (note 1). See also "Modernized Chopper," *Business Week,* August 8, 1936, p. 16; a clipping from *Sales Management,* August 15, 1936, in scrapbook, Box A, Scale Archive; "One Good Molding Deserves Another," *Modern Plastics* 14 (September 1936), p. 26; "Modern Trend Is Toward Plastics for Food Store Equipment," *California Retail Grocers' Advocate,* September 11, 1936, p. 23; "Modern Beauty—an Important Sales Asset," *Toledo System* 32 (December 1938), p. 12; and Fink (note 1), pp. 73, 124. On p. 124, Fink correctly identifies Harold Van Doren & Associates as the designer; on p. 73, he incorrectly identifies J. M. Little and Associates, who only later assumed responsibility for consultant design at Toledo Scale.

54. "Plaskon Duplex Accorded New Honor," *Toledo System* 30 (November 1936), p. 1.

55. Hem (note 46), p. 22.

56. On cracking, see General Letter No. 36-4, January 17, 1936; and General Letter No. 36-32, April 16, 1936. On cockroaches, see General Letter No. 36-71, July 14, 1936. On height extenders, see General Letter No. 36-5 with two-page attachment, January 20, 1936. All are in "General Letters, 1/1/36 to 12/29/36," Box G, Scale Archive (note 1).

57. Advertising tearsheet from *Modern Plastics,* May 1938, in a scrapbook in Box A, Scale Archive (note 1). See also *The Long and the Short of It* (Toledo: Toledo Scale Company, ca. 1938), brochure, Box C, Scale Archive.

58. Van Doren as quoted in *Modern Plastics* 15 (April 1938), p. 80, clipping in a scrapbook in Box A, Scale Archive (note 1). The series of design process photographs was published by the *Toledo Times,* July 16, 1939. I located a complete set of original prints in 1986 in Peter W. Bressler's office in Philadelphia.

59. Form 1295-b, bound with booklet *For Modern Foodstores: Toledo Scales* (Toledo: Toledo Scale Company, n.d.), Box 29, Scale Archive (note 1). See also undated, typed manuscript, "Today . . . New Dimensions for Toledo Scale Corporation," Box G, Scale

Archive. The Defiance scale appears as job number P-218-1 on Harold Van Doren's three-page, typed "Complete List of Philadelphia Jobs," October 3, 1945, provided in 1986 by Harper Landell.

60. "Museum Plans Design Display," *Toledo Blade,* April 3, 1940; "Toledo Consultant to Address Society," *Toledo Times,* January 7, 1940.

61. "Hubert Bennett Stressed Research in Industry," *Toledo Blade,* September 9, 1951. Serving in the same capacity was James L. Rodgers, Jr., former president of Toledo Synthetic Products (and of its successor, Plaskon Company). A typed, undated, seven-page list, "Clients—Harold Van Doren," provided by Harper Landell in 1986, indicates that Van Doren designed a "House" for "H. D. Bennett." No other information about this intriguing project is available.

62. "To All Toledomen," *Toledo System* 32 (April 1938), p. 2.

63. "Store and Business Equipment Award: To Toledo Scale Company," *Modern Plastics* 26 (September 1948), pp. 173–75.

64. See, for example, "How to Scale Down Maintenance Time," *Modern Industry,* September 15, 1948, pp. 41–42.

65. Marshall Templeton, Inc., "Toledovision Presents 'The Winners,'" a twenty-page typed manuscript, November 11, 1948, with revisions from December 20, 1948, Box F, Scale Archive (note 1).

Davira S. Taragin

BREAKING PATTERNS
LIBBEY GLASS IN THE TWENTIETH CENTURY

The story of the designer at Toledo's Libbey Glass parallels in many ways the evolution of design in America from largely a trade to a professional activity.[1] Libbey's renowned Rich Cut glass of the late nineteenth and early twentieth centuries was primarily a product of its skilled craftsmen. The declining popularity of this type of glass during the second decade of the twentieth century led the company to supplement its luxury, handmade objects for the home with low-cost machine-made wares for the institutional market, mainly during the 1920s. By the 1930s competitive pressures forced Libbey to adopt some of the most progressive measures for that time to create well-designed products for American consumers. However, Libbey's most distinguishing role in the history of the design profession was its forty-seven-year relationship with the New York–based industrial designer and home-furnishings consultant Freda Diamond. Beginning in 1941, Diamond led Libbey into a clearly defined program of well-designed machine-made tableware for middle-class America, placing Libbey in the enviable position of defining the look of modern America and helping establish the role of women in industrial design.

Libbey Glass, today America's leading manufacturer of machine-made glassware, was founded in 1818 as the New England Glass Company of East Cambridge, Massachusetts. Known during its early years for high-quality blown, pressed, and engraved wares for the home, W. L. Libbey and Son Company, New England Glass Works moved to Toledo, Ohio, in 1888, after declining sales, the high cost of fuel, and labor difficulties forced its proprietor, Edward Drummond Libbey, to visit several American cities in search of natural gas (a less expensive fuel), labor, and good transportation facilities. The renamed (1892) Libbey Glass Company achieved international recognition for its cut glass through promotional schemes at the Chicago 1893 Columbian Exposition and the 1904 Louisiana Purchase Exposition, St. Louis (plates 1, 2, and 22). At the former, for instance, the firm received particular commendation for its cut-glass clocks, banquet lamps, candelabra, and pedestals, all of which were cited for "the great boldness and elaboration of design and high-class execution."[2]

The technological revolution in glassmaking that Libbey plant superintendent Michael J. Owens began in the 1890s with the financial backing of Edward Drummond Libbey led to a number of significant inventions.[3] Among them was the automatic tumbler machine, which in the late 1920s and early 1930s paved the way for the company to begin to reposition itself as a supplier of well-designed, inexpensive glassware to the restaurant industry.[4] However, the company's inability to establish its niche in the housewares market in the period between the wars resulted in a loss of a substantial percentage of Libbey's assets in 1935 to Owens-Illinois Glass Company (O-I), then the largest bottle maker in the world. Libbey became a subsidiary and later an operating division of O-I until 1987, when the latter was acquired by Kohlberg Kravis Roberts & Company. In 1993 Owens-Illinois, Inc., sold Libbey to the public in an initial public offering and Libbey became a publicly traded company in its own right. Today its substantially expanded offerings include glassware, ceramic dinnerware, and flatware, primarily for the institutional market.

Until now, many historians of glass have followed Albert Christian Revi's lead in attributing most of the company's cut-glass patterns from the late 1880s, 1890s, and 1900s to in-house designers such as Joseph Locke (until 1889), William C. Anderson, and William Marrett, because their names figured on company patents.[5] This raises intriguing questions about the role of workers like Robert M. Corl, who in 1911 described himself as a "staff designer," but whose name never appears in these patents.[6] One possible explanation for this could be that not all designs were patented. Today the decision to patent a design is dependent upon various business and commercial considerations in addition to the uniqueness of the design. Since company records no longer exist that would provide sufficient information about the employees during the Rich Cut glass period or the company's early

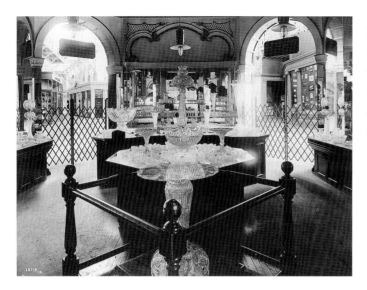

Plate 1
*Libbey Glass Company Display, 1904 Louisiana Purchase Exposition,
St. Louis*
photo panel

Before the days of radio and television, world's fairs were oppor-
tunities for public entertainment and global communication, and
commercial vehicles for cities and companies to enhance their rep-
utations and promote their wares. The Libbey Glass Company's
elaborate exhibits took full advantage of these occasions.

policies towards patent submission, the exact composition and nature
of Libbey's design staff during this era remain open to conjecture.[7]

As the company was establishing its reputation in cut glass dur-
ing the last decade of the nineteenth century and into the first years
of the twentieth century, Edward Drummond Libbey, encouraged by
Michael Owens, realized that the future of glassmaking lay in automa-
tion. When Libbey became part of Owens-Illinois in 1935, its principal
business was the manufacture and sale to institutional, container, and
premium markets of machine-made tumblers under the trade name
of Libbey Safedge. Designs for the first Libbey Safedge and No-Nik
glassware were developed by the company's Engineering Department
in the mid-1920s. In fact, the Safedge concept can be ascribed to these
engineers. By burning off the moil, the overblown portion of the tum-
bler left on it when it was detached from the automatic press-blow
machine, the engineers accidentally produced a tiny beaded lip along
the tumbler's edge, which was extremely resistant to chipping, giving
rise to the patented trade name (plate 3).[8]

By 1930 No-Nik Safedge glass was the only glass sold nationally
under an unconditional guarantee against chipping on the edges;
however, the institutional trade was initially skeptical about purchas-
ing the lightweight Safedge glasses, doubting their longevity with
heavy usage.[9] In addition, Libbey could not ignore the "noticeable"
climate of the city of Toledo, where, under the auspices of the museum,
art was "making itself felt in industry." Recognizing that domestic
glassware was "into a sort of hum-drum" ultimately impacting sales,[10]

Libbey felt even further threatened when it realized that the automatic
tumbler machines were being sold to Japanese manufacturers who
were reproducing Libbey's wares for sale in the United States at
cheaper prices.[11] One consequence of these developments was that
design became a significant factor in company marketing, with adver-
tisements like the following appearing regularly in the early 1930s:

> *Glassware* and the Modern Soda Fountain
> Soda fountains are dressing up. They are becoming particu-
> lar about style in glassware to go with their new decorative
> schemes. That is why more and more of these smart, profit-
> making soda fountains are installing Libbey Safedge Glass-
> ware. Libbey designs have the modern feeling that people
> like in their clean-cut lines, and sweeping curves.[12]

These words were intended to remind prospective clients—in this
case, druggists—about design's capacity to attract audiences.

Realizing as early as 1928 that it needed to do more about the de-
sign of its products, Libbey instituted the first of several broad-minded
approaches. Turning to the Toledo Museum of Art, it enrolled its engi-
neers in the School of Design's Dynamic Symmetry classes, which
were open to employees of any industry in the city. One of the main
subjects addressed in this class was proportion, which was of particu-
lar interest to those in the glass industry, who saw the need for lines
of glassware in which the variously sized glasses were in harmonious
proportion to one another.[13] Several significant designs for inexpen-
sive, machine-made tableware resulted, including the Governor Clin-
ton line of tumblers, which was selected by Richard Bach, director of
Industrial Relations of The Metropolitan Museum of Art, for inclusion
in its critically acclaimed 1931 "Twelfth Exhibition of Contemporary
American Industrial Art." Following its introduction in 1930, the com-
pany claimed that the corrugated shape made the Governor Clinton
one of the strongest drinking glasses ever produced.[14]

In 1930 Libbey began discussions with Simon DeVaulchier,
"a famous New York supervisor of design," to develop "new art

Plate 2
Designer unknown, *Table*, 1902
Libbey Glass Company
glass
31⅜ × dia. 27⅝ inches
Toledo Museum of Art, Gift of Owens-Illinois Glass Company

This elaborate, one-of-a-kind cut-glass table impressed visitors
at the 1904 Louisiana Purchase Exposition, St. Louis. It was
made in three handcrafted pieces, joined together with no metal
fittings. As in early window glassmaking, the table's top was
first formed as a globe, then reheated, opened, flattened by rota-
tion, and cracked off an iron rod (pontil). The blanks for the base
and standard were mold-blown. After the parts had been formed,
artisans cut the patterns into the glass, using three distinct types
of grinding and polishing wheels, water, and various abrasives.

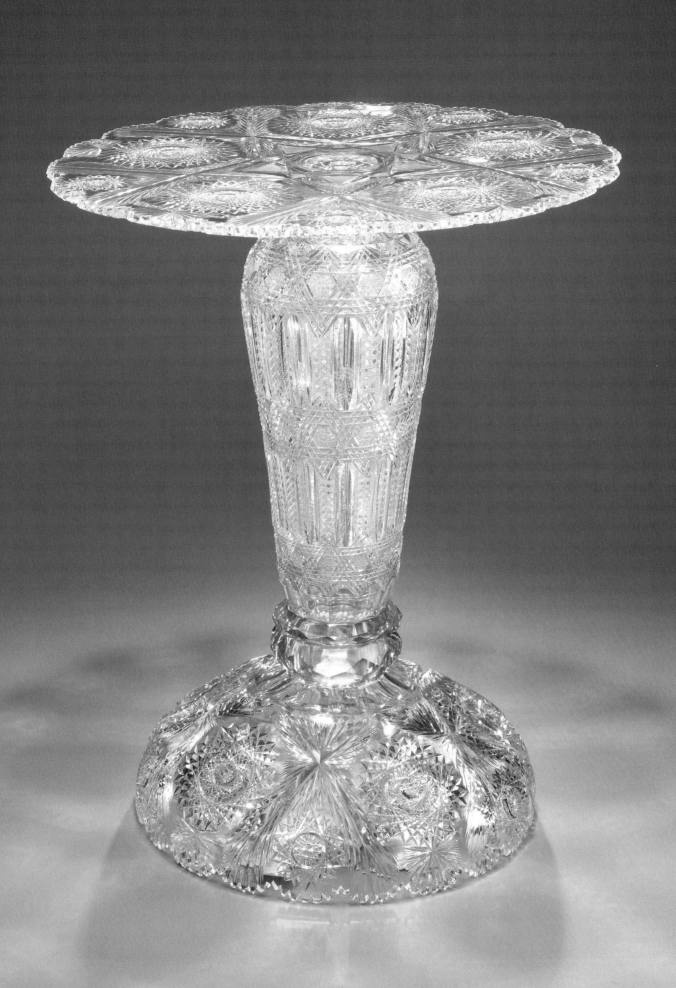

features for domestic glassware," although his contribution remains undocumented.[15] In the meantime, with the demise of Prohibition, company management saw a niche opening for luxury, handcrafted wares for wine, beer, and liquor.[16] A. Douglas Nash, promotional director and head of his own firm, the A. Douglas Nash Corporation, which operated the Tiffany Furnaces in Long Island, New York, was hired in 1931 to develop handcrafted as well as machine-made products for institutional and domestic use. Employing skilled craftsmen such as Frederic Vuillemenot,[17] the new Libbey Studios division was established and a line of exquisitely cut and copper wheel–engraved stemware and tableware was developed (plates 4, 5, and 6). Marketed for "modest income" consumers as "The New Era in Glass," it was extolled as "the highest point that has yet been attained in the glassmaker's art. . . ."[18] Unfortunately, as soon as the designs premiered in a limited number of stores, the company realized that they were priced too high to sell during the Depression, especially since formal dining was rapidly becoming outmoded.[19] They were essentially too difficult and costly to fabricate to meet the increased demand for such glassware that resulted with the repeal of Prohibition in 1933.[20]

In an effort to cope with this disaster, Libbey's advertising agency convinced the company to turn to the emerging industrial design profession. Around 1933–34 company president Joseph W. Robinson placed New York industrial designer Donald Deskey on retainer,[21] inviting him to come to Toledo to develop not only products, but an entire product design plan for the faltering company. By that time Deskey was well known as an industrial designer, having just won the prestigious competition for New York's Radio City Music Hall.

Deskey's response involved a review of existing products, the addition of several new designs, and suggestions for technological modifications as well as identification of new markets. After carefully analyzing company records, the designer recommended that only two Libbey Studios designs be continued. Deskey then proposed several stemware (plate 7) and tumbler lines utilizing Libbey's new automated color application technology. However, his most significant accomplishment was persuading Libbey to become a leading manufacturer of well-designed premium products. In 1933 Libbey had entered into an agreement with Owens-Illinois Glass Company to produce as premium wares reusable tumblers in which a variety of foods could be packaged.[22] These premium products generally served as an incentive to the retail trade and resulted in large orders for their manufacturers.[23] Convinced that it could distinguish itself from its competitors, who usually used the premium scheme to dispose of their least desirable

merchandise, Libbey selected Deskey's central-banded glass tumbler design to produce in rose or clear glass with the option of applied color on the band. Although Libbey chose not to adopt Deskey's recommendation that it conduct a consumer test of the product, it emphatically advertised the tumblers' modern appearance, noting that "their unique shape was created by one of America's foremost designers and the contours of the glass are in accord with the trend in modern designs and modern interiors."[24] Although premium sales of specially created products would ultimately help the company survive the Depression years,[25] Deskey's plan did not prevent the merger with Owens-Illinois in 1935.

Owens-Illinois's takeover of Libbey placed the new subsidiary in a design-conscious environment that was strongly nurtured by O-I president William E. Levis and vice president Harold Boeschenstein, among others.[26] Levis's attitude toward design was shaped by his close friend Blake-More Godwin, director of the Toledo Museum of Art, who believed strongly in well-designed manufactured goods.[27] Shortly after the takeover, upon the recommendation of the editor of one of the local newspapers, Levis started discussions with New York industrial designer Walter Dorwin Teague to do contractual work for two of O-I's divisions: bottling and packaging, and structural, which produced

Plate 3

Designer unknown, *Safedge Bell Fountain Pattern*, ca. 1928
The Libbey Glass Manufacturing Company
glass
soda: 5⅛ × dia. 3 inches; tumbler: 3⅞ × dia. 2⅝ inches
Libbey Glass Inc.

Toledo Museum School of Design, *Governor Clinton Pattern*, ca. 1930
The Libbey Glass Manufacturing Company
glass
largest tumbler: 5¼ × dia. 2¾ inches; juice (smallest):
3¾ × dia. 2¹/₁₆ inches
Libbey Glass Inc.

Libbey's soda fountain glass, along with the Coca-Cola bottle, makes up a pair of shapes in glass that have identified a brand for generations worldwide. Selected in 1955 for the permanent collection of The Museum of Modern Art, the design was produced by Libbey for Coca-Cola for many years. The ubiquitous Governor Clinton tumbler, originally developed for restaurant use, gained a new life in the consumer retail trade of the 1940s after Libbey added heat-resistant qualities to its glassware lines.

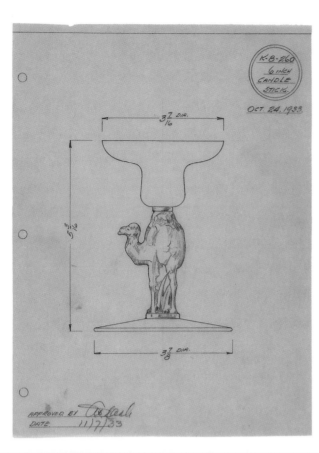

Plate 4
Libbey Studios, *Shape Drawing for Six-Inch Candle Stick*, 1933
The Libbey Glass Manufacturing Company
graphite on tracing paper
11 × 8¼ inches
Libbey Glass Inc.

Plate 5
Libbey Studios, *Silhouette Pattern*, 1933
The Libbey Glass Manufacturing Company
glass
candlesticks: 5¼ × dia. 3¾ inches; claret: 5⁵⁄₁₆ × dia. 2⅛ inches;
compote: 7 × dia. 5⅞ inches; cocktail: 6 × dia. 2⅝ inches
Ruth and Bill Stewart

The design of this unusual animal stemware has been attributed
to Frederic Vuillemenot. The red glass was done as an experimen-
tal sample; the black and moonstone versions went into limited
production.

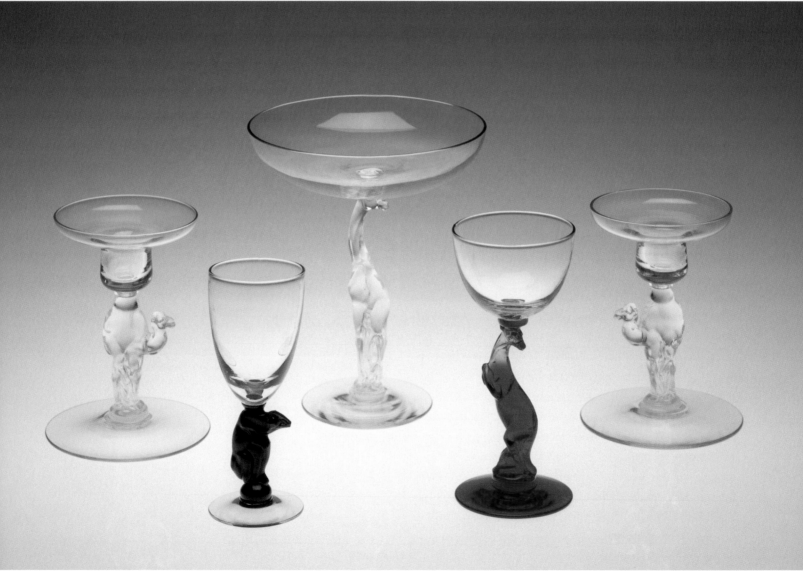

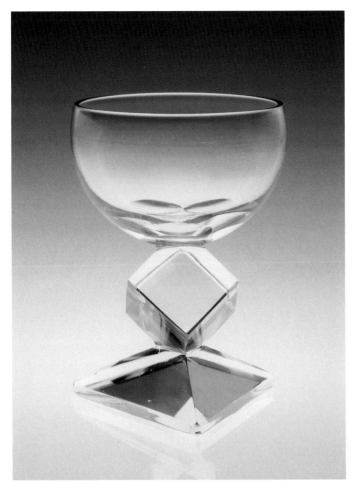

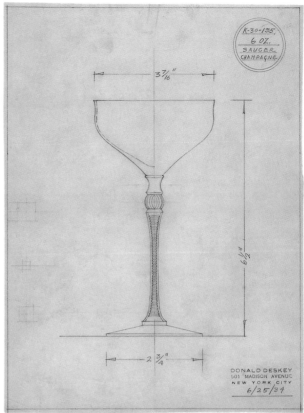

Plate 6
Libbey Studios, *Syncopation Pattern*, patented 1932
The Libbey Glass Manufacturing Company
glass
cocktail: 3¹³/₁₆ × 2¾ × 2⅜ inches
Toledo Museum of Art, Purchased with funds from the Libbey
Endowment, Gift of Edward Drummond Libbey

Plate 7
Donald Deskey, *Shape Drawing for 6 oz. Saucer Champagne*, 1934
The Libbey Glass Manufacturing Company
graphite on paper
11³/₁₆ × 8½ inches
Libbey Glass Inc.

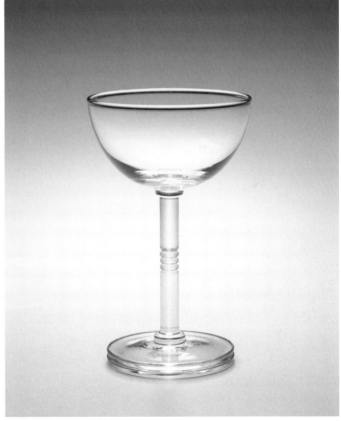

Plate 8
Edwin W. Fuerst, *Greenbrier Pattern*, ca. 1938
Libbey Glass Company, subsidiary of Owens-Illinois Glass Company
glass
wine: 4½ × dia. 2⅞ inches
Karen S. Laborde

glass bricks and, at the time, insulating materials.[28] Until that time most of O-I's bottles were being designed by art students from the Toledo Museum's School of Design under the direction of Edwin W. Fuerst, who had been a student at the museum from 1927 to 1932, assuming the position of stylist and designer at the bottle maker's design studio in 1930.

Realizing around 1936 the need for outside design talent, but concerned that his associates would feel coerced into accepting it, Levis first established strong design departments at the various subsidiaries of Owens-Illinois, utilizing the best of Toledo talent. Dwight Fuerst, Edwin W. Fuerst's brother, was selected to head the design area for bottling and packaging. In 1938 Edwin W. Fuerst was brought to Libbey to head Design Development, where he designed several lines

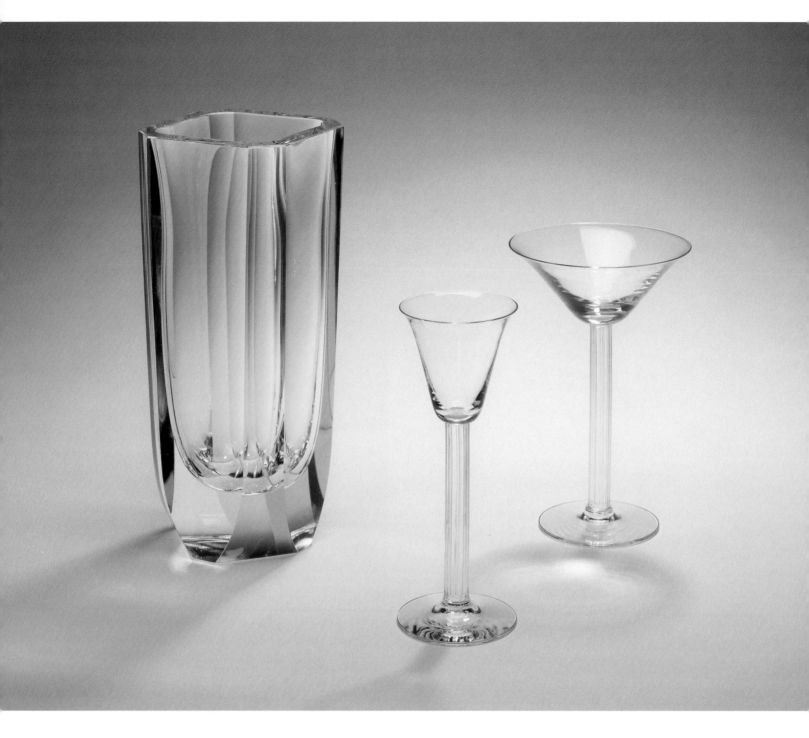

Plate 9

Edwin W. Fuerst, *Vase*, patented 1940
Libbey Glass Company, subsidiary of Owens-Illinois Glass Company
glass
10 × 5 inches
Toledo Museum of Art, Gift of Libbey Glass Company

Walter Dorwin Teague and Edwin W. Fuerst, *Monticello Pattern*, 1940
Libbey Glass Company, subsidiary of Owens-Illinois Glass Company
glass
wine: 7¹⁄₁₆ × dia. 2¹¹⁄₁₆ inches; cocktail: 7¹⁄₁₆ × dia. 4⁹⁄₁₆ inches
Toledo Museum of Art, Gift of Libbey Glass Company

Libbey Studios, *Knickerbocker Pattern*, ca. 1932
The Libbey Glass Manufacturing Company
glass
sherbet: 2½ × dia. 4⅜ inches
Toledo Museum of Art, Gift of Libbey Glass Company

Edwin W. Fuerst, *Cordial Decanter*, 1940
Libbey Glass Company, subsidiary of Owens-Illinois Glass Company
glass
11⅜ × dia. 4 inches
Toledo Museum of Art, Gift of Libbey Glass Company

Libbey Studios, *Knickerbocker Pattern*, ca. 1932
The Libbey Glass Manufacturing Company
glass
cordial: 2⁵⁄₁₆ × dia. 2 inches; tumbler: 4⅞ × dia. 3¹⁄₁₆ inches
Toledo Museum of Art, Gift of Libbey Glass Company

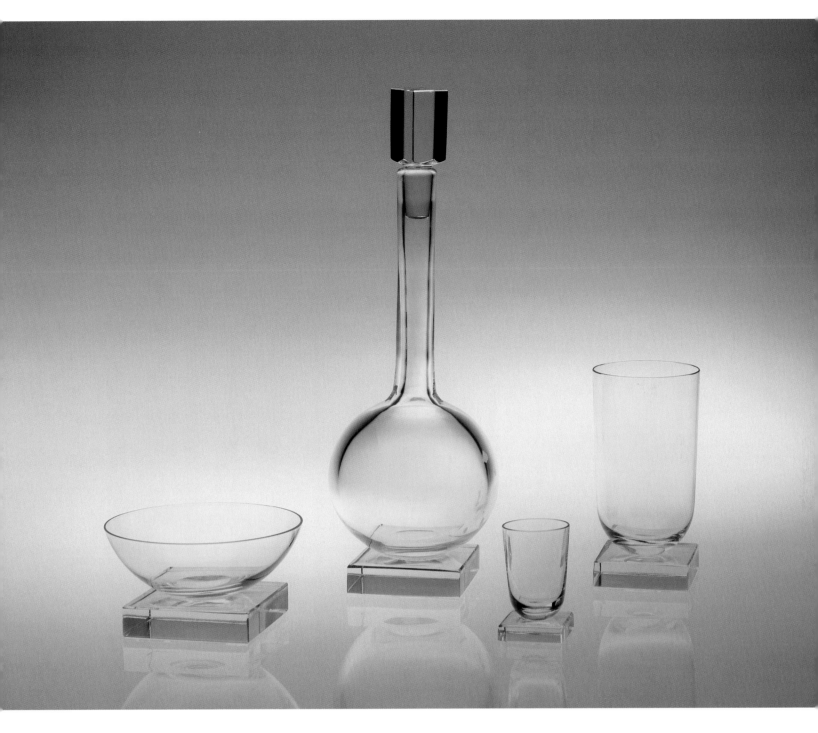

of stemware (plate 8) and machine-made tumblers, including souvenir glasses for the exhibitors of the 1939 New York World's Fair. He is best known for the handcrafted Modern American line (plate 9), created to compete in the developing market for American crystal that resulted as political turmoil in Europe curtailed supplies of European fine glass.[29] Marketed as "moderately priced for crystal,"[30] the line continued the Knickerbocker pattern introduced under Nash. The other items largely were reminiscent of the elegant, clear glass Scandinavian designs of the period and of wares that Teague and Frederick Carder had designed in the early 1930s for the Steuben Division of Corning Glass Works. Upon the introduction of the line, Fuerst was appointed retail sales manager so that he could set up stores and outlets for the line, analyze consumer reaction to it, and then apply his research to future

work for the company. He held this position until World War II broke out and Libbey facilities were turned over to wartime production. Rather than remain inactive, he left the company in 1944 to open his own industrial design office in Toledo.

Teague's services were enlisted on a piecemeal basis at Owens-Illinois and its Libbey Glass subsidiary. He first designed glass bricks for Owens-Illinois's structural division (plates 10 and 11) and then was asked to redesign the division's offices in the Chrysler Building in New York. At the same time he began preparing designs for the Libbey glassware to be used in the State Dining Room at the 1939 World's Fair. For this project Teague prepared a number of proposals that included a footed tumbler with a fluted, rectangular-shaped stem, inspired by the Ionic columns on the front of the fair's Federal

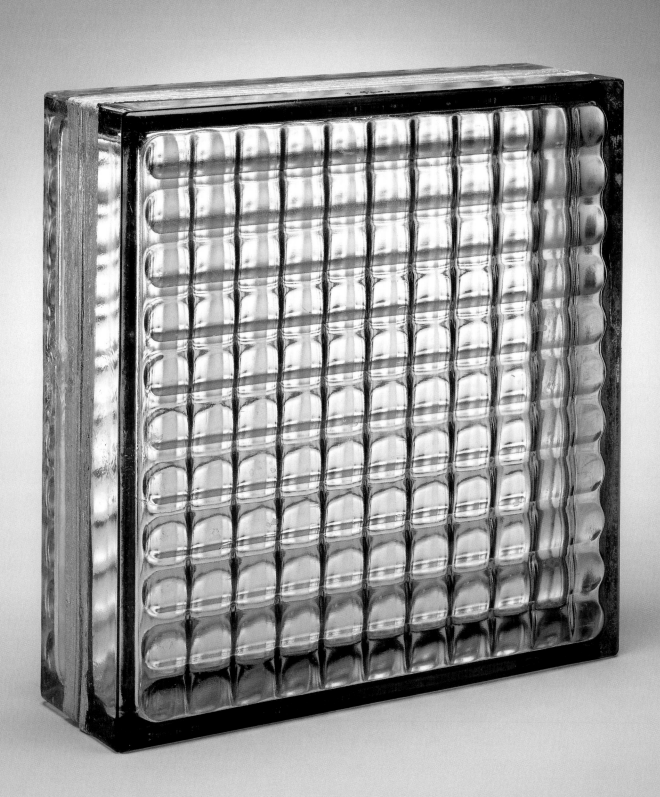

Plate 10
Insulux Products Division design staff, *Insulux Glass Block,*
1937
Owens-Illinois Glass Company
glass and metal
11¾ × 11¾ × 3⅞ inches
From the Collection of Derek Trelstad

Owens-Illinois began mass producing glass blocks in 1935 and
continued to improve sealing and mortar materials as well as its
glass production methods. This block was used in Chicago's Kitty
Kelly building. Its two halves were separately pressed, then joined
under pressure with a metal sealant to enclose a partial vacuum.
Laid in mortar by a bricklayer, the blocks combined the brilliance
of glass with the stability of masonry, transmitted light but ob-
scured vision, and provided sound and heat insulation. Insulux
blocks were available in sizes, shapes, and decorative surfaces
that offered varying light diffusion effects and design flexibility.

Plate 11
Attributed to Walter Dorwin Teague, *Circon Pattern Insulux Glass
Block Used in the Coral Court Motel, St. Louis,* ca. 1939
Owens-Illinois Glass Company
glass
7¾ × 7¾ × 3⅞ inches
Museum of Transportation, St. Louis, 95.10

In 1938 Walter Dorwin Teague designed a glass block for the
Owens-Illinois Glass Company. The following year, while de-
signing glassware for the Federal Building of the New York
World's Fair for Libbey Glass, a division of Owens-Illinois,
Teague was asked by Owens-Illinois to design two new glass
blocks. He used this block in the décor of his Los Angeles
office, which O-I publicized in its 1947 Insulux advertisements
in architecture magazines.

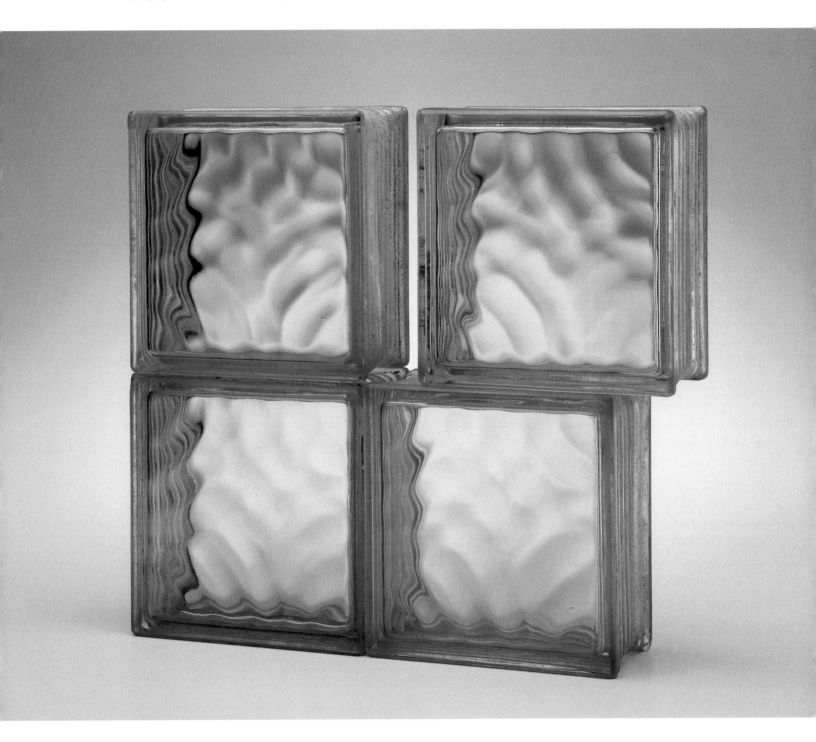

Plate 12
Walter Dorwin Teague, *Drawing for Tumbler and Stemware,*
ca. 1939
Libbey Glass Company, subsidiary of Owens-Illinois Glass Company
graphite on tissue
16¹³/₁₆ × 13¾ inches
Department of Special Collections, Syracuse University Library,
Syracuse, New York

Building, and stemware with a rounded, fluted stem and cylindrical bowl (plate 12). However, like many schemes involving the first generation of industrial designers, who were not always knowledgeable about technology, Teague found that his initial proposals presented serious manufacturing difficulties.

Although Teague's fluted, rectangular stem was selected, his concept required the production of new molds for both the stem and the bowl. Faced with severe time constraints, Edwin W. Fuerst, who was responsible for their implementation, concluded that they would have to substitute stock stemware bowl molds for Teague's concept and use a traditional Libbey foot. Similarly, since there was not sufficient time to make a stem mold sized for each bowl shape, Fuerst made a single, pressed stem mold (plate 13) for the entire line, breaking from the principles of Dynamic Symmetry that he had learned at the Toledo Museum's School of Design, which dictated that the size of the stem had to be in proportion to the bowl. One hundred and twenty place settings were produced consisting of ten different styles of glasses and finger bowls for the State Dining Room. Libbey then issued this pattern without the etched crest of a spread-winged American eagle surrounded by thirteen stars as the stock item Embassy in the 1940 Modern American

line. A variation on Teague's idea for stemware with fluted, rounded stems was introduced into the Modern American line as Monticello (plate 9).

Teague was furious. Upset with the garbled form of Embassy, he was even more incensed that it was being publicized as a collaborative effort, since he saw the stem as its primary feature. While the company apologized to Teague and merchandised the line, like its other products, without designer attribution, this was the last line of glassware that Teague developed for Libbey. Nevertheless, his involvement with the company did have one significant long-term effect: Teague helped convince Libbey that the changing role of women as consumers necessitated the employment of a woman designer.[31] In 1941, upon the advice of its advertising agency, Libbey finally did hire, on a contractual basis, the New York–based designer and home-furnishings consultant Freda Diamond. More than a designer of glassware, she proved to be a strategic planner who was able to position Libbey as a tastemaker in post–World War II America.

Libbey was one of Diamond's earliest clients;[32] by the time she retired in 1988, her client list included such companies as Sears, Roebuck; Lightolier; General Electric; Herman Miller; G. Fox & Company of Hartford; and Los Angeles's May Company. Better at adapting existing designs than inventing new forms, Diamond became one of the few designers in the profession who also served as an interior decorator and style and merchandising consultant to department stores, using her extensive knowledge of contemporary furnishings to establish trends in decorating for middle-class America.

Diamond was a visionary, with definite ideas about changing the entire home-furnishings industry. Above all an advocate for the consumer, she was constantly crusading for affordable, well-designed products, and she frequently adapted high-priced designs so that they could be produced for mass taste. Since she believed that good design encouraged sales, she felt that the manufacturer and the designer had a responsibility to work with the retailer to develop products that the consumer needed. Diamond interpreted demand as consumer preference for styling and color over price. She called for manufacturers and designers to assess consumer demand by instituting marketing surveys ranging from formal interviews with department store managers and buyers to informal observations of consumer buying habits. Moreover, she recognized the necessity of involving in this process marketing departments and advertising agencies with knowledge of trends in the marketplace, noting at the end of her life that "being involved as

Plate 13
Walter Dorwin Teague and Edwin W. Fuerst, *The Embassy Pattern,*
1939
Libbey Glass Company, subsidiary of Owens-Illinois Glass Company
glass
parfait: 8⅜ × dia. 2⅝ inches; cocktail: 6⅞ × dia. 2¹¹/₁₆ inches
Toledo Museum of Art, Gift of Owens-Illinois, Inc.

a consultant with people in advertising and publicity both at the retail and wholesale level gave me a chance to help SHAPE DEMAND."[33] Essentially, she cautioned that once the market had been satisfactorily analyzed, designers had the responsibility to respond with products reflecting consumer preference.

Diamond also felt that the manufacturer and the designer needed to work with the retailer to merchandise products; this meant training salespeople to become knowledgeable about their products and instituting dramatic changes in store design so that the merchandise would be displayed with related color- and style-coordinated products, helping the consumer to create a harmonious but affordable living environment. An advocate for producing limited quantities of one design, she lectured and wrote vehemently against the common practice in the ceramic and glass industry of open stock, which forced stores to carry a large inventory of all the products they had ever sold. Instead, she suggested that merchandisers develop products to which they were committed, test these designs with consumers, and then institute progressive merchandising, as in the automobile industry, giving products a substantial but finite shelf life.

Like her male counterparts, Diamond realized that self-promotion was critical to her success in the emerging design profession. A frequent lecturer, she was also a prolific writer. In 1953, for instance, she published *The Story of Glass,* which, by outlining the material's enormous potential, garnered publicity for the country's glass industries in general. Keenly aware that the industrial design profession "was predominantly male" and that "it was an uphill battle all the way,"[34] she underscored the unique contribution that she was able to make as a woman, encouraging other women to explore the career potential of the home-furnishings industry.

> Women are welcome in the home-furnishings industry. Our reputed sixth sense for color style, our other lives as homemakers are to our advantage. Probably most to our advantage, as I have observed from my own quarter-century experience in the field, is our instinctive concern with people, for, after all, what is a consumer but a person, and what are consumer buying habits but personal behavior? . . . In helping them make their homes more comfortable, more efficient, more beautiful so that they can live the way they would like to live, you are performing a social and profitable service.[35]

Above all, she realized the role her own physical appearance played in achieving her goals. A tall woman whose hallmark was her hats, she became "easily identifiable [as a] designer . . . always wearing a handsome outfit . . . usually an unusual color . . . a mammoth handsome ring . . . a giant-size magnificent bracelet . . . conversation pieces."[36]

Having established her reputation as a designer by the time she was hired at Libbey, Diamond found that her new position provided an opportunity to put her ideas into practice. She immediately convinced Libbey officials of the need for her and another New York home-furnishings expert, Virginia Hamill, to conduct an unprecedented, several-years-long survey of Libbey's clients throughout the United States. Visiting more than eighty department, chain, and drug stores; premium users; and mail-order houses in fourteen cities, they studied the social and economic trends affecting sales in the glassware market, the pricing structures and popularity of the products of Libbey's competitors, and the display and merchandising of glassware in retail establishments.

Diamond's report to Libbey in 1942 recommended that the company enter the retail glassware market, offering products at every price range. She felt that the subsidiary's emphasis should, however, be placed upon developing for daily use, prepackaged matching tumbler sets. There should be at least three different sizes with salad plates and a limited number of machine-made stemware lines,[37] all of which were to be color-coordinated with the lower-priced, most popular china patterns on the market by Russel Wright and Susie Cooper, among others. Finally, she suggested that the company produce its "Coke" soda fountain glass for the retail market (plate 3).[38]

Diamond's affiliation with Libbey came at the particularly fortuitous time when the New York advertising agency J. Walter Thompson assumed the entire Owens-Illinois account. Confirming Diamond's analysis of the trend toward a more casual lifestyle, the agency, along with Diamond and Libbey's in-house "ad man" Carl U. Fauster, was able to convince the glassware manufacturer to adopt some of the home-furnishings consultant's recommendations.[39] In 1945 Libbey's Design Development Department, which had been restructured a year earlier to include both Diamond and marketing staff,[40] introduced an innovative two-step postwar product design program that reflected the needs of a country embracing a more style-conscious, "servant-less" existence. First, it opened in major cities like Philadelphia, Chicago, and New York, model showrooms designed to present to retailers the best design, lighting, colors, and installation methods for glass.[41] Next it introduced seven silkscreen-decorated tumbler lines designed by Diamond and Hamill, which were intended for casual entertaining in the new middle-class, single-family homes of the postwar period; they were packaged in units of eight as Libbey Hostess Glassware Sets. Edwin W. Fuerst and Diamond designed the boxes so that either open or closed, they enhanced the glassware for store display, ensured its safe delivery, and provided attractive and suitable storage in the home.[42]

Believing that most women of the postwar period wanted brightly colored, patterned, less formal glassware, Diamond and Hamill began a series of decorated lines depicting popular themes.[43] However, convinced that by the early 1950s trends for elegance and refinement would emerge, Diamond began to focus on form, designing Stardust in 1947, Classic in 1948, and Flair, introduced in 1952 (plate 14).

These designs resulted in Diamond's close association with Libbey's engineers,[44] leading to the introduction of colored glass; following trends in the larger home-furnishings market, Libbey became known for its colored glassware lines, Emerald Glass and Aqua Ripple in the 1950s and Tawny in the 1960s.[45]

While decorated lines constituted much of Diamond's later work for Libbey, form continued to be of interest to her. In the 1963 design Nob Hill (plate 15), Diamond worked with Libbey engineers to use a technological breakthrough to produce a thick, hobnailed base.[46] The simple yet elegant silhouette of Nob Hill emphasizes the translucency of the glass base as light is refracted off these circular elements. Generally, Diamond's designs that emphasized form rather than decoration were well received by the design establishment.[47] Emerald Glass and Flair, for instance, were chosen because of their "good looks and low price" for inclusion respectively in the 1950 and 1952 "Good Design" exhibitions organized under the auspices of New York's Museum of Modern Art for the Merchandise Mart in Chicago. Libbey took advantage of this imprimatur in marketing Emerald Glass, establishing a link between consumer taste and MoMA approval (plate 16).

Plate 14
Freda Diamond
Libbey Glass, Division of Owens-Illinois Glass Company

Stardust Pattern, ca. 1947
glass
cocktail: 6 × dia. 4⅛ inches

Classic Emerald Pattern, ca. 1948
glass
toddler: 3⅜ × dia. 3¼ inches; juice: 3½ × dia. 2⅝ inches

Libbey Glass Inc.

Belle Kogan, *Victoria Pattern Sample*, patented 1958
Libbey Safedge, Division of Owens-Illinois, Inc.
glass
ice bucket: 6 × dia. 6 inches
Libbey Glass Inc.

Retained by Libbey Glass for more than four decades, New York–based consultant Freda Diamond had the simplicity of her Classic beverage ware recognized in 1950 by The Museum of Modern Art in its annual "Good Design" exhibition. Another of the first independent women designers, New York–based Belle Kogan created a single design for Libbey, called Victoria. The cuts on the base of this unusual block-molded, pressed pattern were dictated by the production process. Block molds are solid and do not open. A "push-up valve" releases the glass from the bottom of the mold. To facilitate this process, the cut designs of the mold must be carefully drafted at specific angles.

To increase sales of her designs, Libbey began in 1946 to capitalize on Diamond as a persona, merchandising her as well as her products. Expanding upon the "testimonial" approach that J. Walter Thompson had instituted in 1944, whereby in a series of advertisements, noted society women endorsed Modern American,[48] Libbey over the next fifteen years attached Diamond's name and frequently her image to the announcement of each of its new lines. For instance, in its first advertisement for machine-made stemware, Libbey included both a drawing of Diamond and a statement giving her imprimatur as home-furnishings consultant. "We made 'Stardust' elegant but also *serviceable* . . . so that you could have the fun of using it every meal! Note that each glass serves a double purpose, saves storage space. . ." (plate 17). In 1951 Libbey even went so far as to name a line after Diamond.

By 1954 Libbey unequivocally dominated the tumbler market in America with its greatest sales taking place in the East and Midwest. Such success indicated that during the 1950s, 1960s, and 1970s, Freda Diamond *was* the design department at Libbey, even though most of her work initially was done in her New York studio and her visits to the Toledo plant were limited to several days a month. During these years other contractual designers were occasionally brought to Toledo

Plate 15
Freda Diamond, *Nob Hill Pattern*, 1963
Libbey Glass, Division of Owens-Illinois, Inc.
glass
highballs: 5 × dia. 2¾ inches; 4⅛ × dia. 2⅜ inches
Libbey Glass Inc.

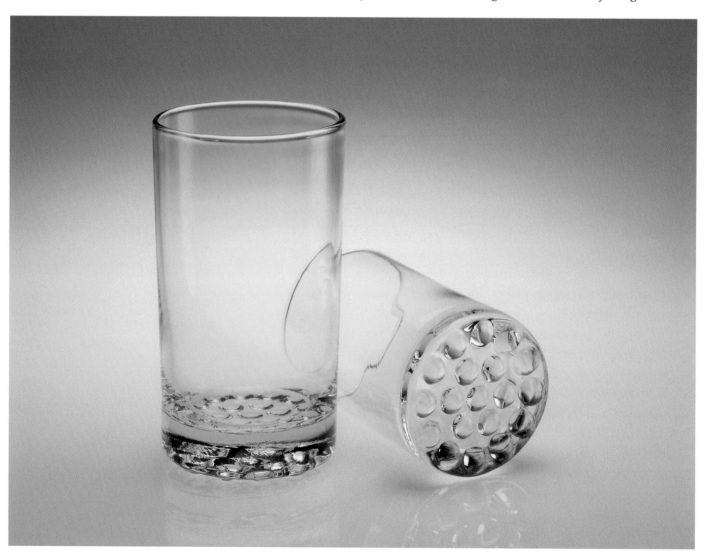

Plate 16
Advertisement for Libbey Emerald Glass, Life, June 26, 1950
offset printing
Anonymous loan

Libbey Glass promoted both glassware products and its own good taste with advertisements in *Life* magazine. Images of diamonds (allusions to the designer, Freda Diamond), with text heralding The Museum of Modern Art's recognition of the Classic line, enhanced Libbey's profile in the eyes of consumers.

to boost faltering sales in the household trade area. However, when this outside assistance was solicited, it frequently resulted in specific assignments and finite employment.[49]

Diamond's greatest triumph for Libbey was, however, the development around 1956 of the Golden Foliage pattern (plate 18), which upheld her unfailing conviction that the American consumer wanted decorated housewares. She began with the immensely popular Classic shape, to which thin layers of gold were screened on alternating areas of satin-etched white and clear glass to create both matte and shiny gold leaf patterns that were reminiscent of the foliage from oak, maple, and poplar trees (plate 19).[50] Diamond was generally uninterested in the technological aspects of manufacturing, essentially expecting engineering to realize her design concepts.[51] However, the fact that Golden Foliage, initially called Golden Leaves, was easy and inexpensive to manufacture, since the leaves fell in loose registration on the clear and etched backgrounds, added to its overall success (plate 20).[52] For Diamond, it epitomized the desires of the consumer of the day, providing a "dressed up effect . . . yet . . . completely practical for the average home."[53]

Diamond's decorated wares dominated Libbey's aesthetic of the 1960s and 1970s, even though her position underwent some modifications in those years. After being assigned to the division's marketing

Plate 17
Advertisement for Stardust Stemware, House Beautiful, December 1949
offset printing
Anonymous loan

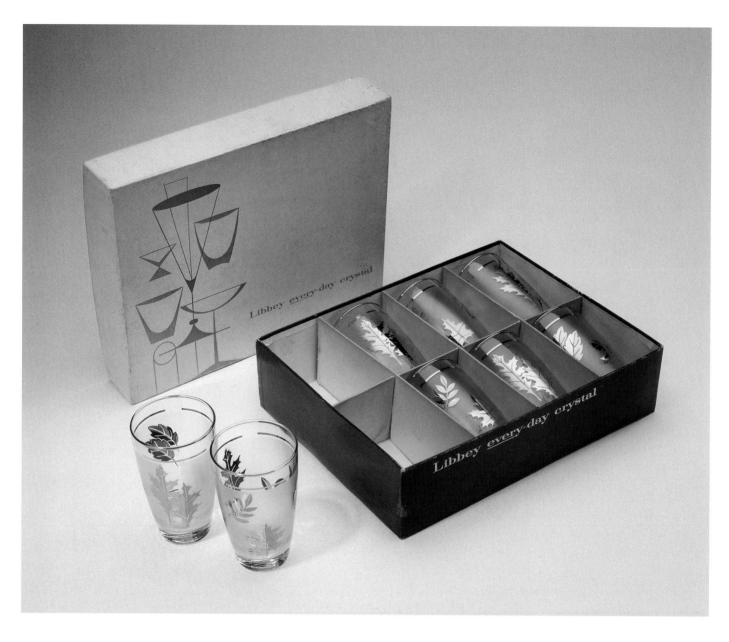

Plate 18
Freda Diamond, *Libbey Every-Day Crystal Hostess Set Box,*
ca. 1955, *with Eight Golden Foliage Pattern Beverage Tumblers,*
ca. 1956–57
Libbey Glass, Division of Owens-Illinois, Inc.
box: green and gold printing on coated paper over cardboard;
eight tumblers: glass and enamel
box, closed: 3⅛ × 12¾ × 10 inches; tumblers: 4¾ ×
dia. 3 inches
Anonymous loan

Golden Foliage, the Libbey Glass Company's most successful
decorated pattern, sold for twenty-one years. Its casual elegance
fit the entertaining styles of the times. The twenty-two-carat gold
applied to the Safedge glass used for this popular ware added
fashion to function. Packaged in various sizes and Hostess Set
assortments, more than thirty million units sold. A companion
pattern, Silver Foliage, was also produced.

section, she became a member of the New Product Development Group,
headed by a longtime employee with sales background. A slump in
retail sales in the early 1960s led the company to admit what other
manufacturers of the time were recognizing: home-furnishings con-
sultants were not always attuned to consumer taste. Moreover, they
realized that Diamond's name did not have the same cachet among con-
sumers and store buyers as did that of male designers like Raymond
Loewy and Russel Wright. Consequently, it began to figure less prom-
inently in their advertising campaigns. Nevertheless, the company
continued to value its long-term relationship with Diamond.[54]

As the designer grew more elderly, other changes began to occur.
Artists initially hired into the New Product Development Group to
ready Diamond's rough sketches and renderings for production began
to translate her ideas into sketches for initial review. More significantly,
increasingly they were divided into smaller design groups focusing
individually on shape, decoration, and packaging. By the early 1980s,
established designers including Allen Samuels, Betty Baugh, and Irene
Pazinski were placed on extended contracts to develop new kinds of

"Golden Leaves" for D148

SATIN
BREAK

GOLD
BREAK

Two operation-
 Satin etch
 Gold (overprint)
 Gold safedge

Note: Gold will become dull where it overprints the satin etch
 as on present sample of E8956 - AX18213 "Golden Leaves".

D 148

2 July 1957

Designed by
FREDA DIAMOND

Plate 19
Freda Diamond, *Golden Leaves Pattern*, July 2, 1957
Libbey Glass, Division of Owens-Illinois, Inc.
black felt-tip pen, black ink stamp, gouache on acetate, mounted
on tracing paper
acetate: 4⅝ × 10⅝ inches; tracing paper: 8¾ × 11 inches
Libbey Glass Inc.

Few examples remain to reveal how designers communicated
visually with a client. This presentation drawing, however, illus-
trates one approach that Freda Diamond took to suggest pattern
development to Libbey Glass. The acetate was meant to wrap
around the beverage-size Classic form.

Plate 20
*Worker Applying Satin Etch Background to Golden Foliage
Tumbler, n.d.*
photo panel

glass housewares. Diamond gradually decreased the length of her stays
in Toledo; however, she continued to mentor the design staff, includ-
ing them on her trips to housewares and home-furnishings shows both
within the country and abroad, and bringing back well-designed, ex-
pensive products for all to consider. The noteworthy design Gibraltar
(plate 21), for example, is reminiscent of a six-paneled Baccarat tum-
bler that Diamond saw on one of her trips.[55]

Diamond died in 1998, but her influence shaped the new Libbey
that has emerged over the last decade. Today Libbey has a corporate
creative director, Robert Zollweg, who oversees design work for all its
products. In a recent interview, Libbey chairman and chief executive
officer John Meier cautioned, "Be open to the constructive criticism
that your customers give to you. And then go out and do something
about it." He then discussed, in a voice strongly reminiscent of Dia-
mond's, the influence of fashion trends in housewares on his company:

Our designers travel the world. We monitor the color schemes that are constantly changing in American households. . . . It's very much a fashion business. Colors come and go. Certain colors will drive sales. We spend a lot of time . . . staying on top of the trends. We watch to see what trends are emanating from other parts of the world—principally from Europe.

A primary influence is the fact that American lifestyles have become more and more casual. Our assortments must reflect that casual trend, to mirror the way people eat, drink and dine. It's an overriding theme that we all try to express in our products.[56]

Until today, within the history of glass, the name Libbey has engendered visions of magnificent Rich Cut glass executed in the late nineteenth and early twentieth centuries (plate 22). Now its role in recognizing the highly significant relationship between manufacturer, merchandiser, designer, and consumer should be included as part of its legacy to the twentieth century. Even more significantly, as further details about the rise of the industrial designer in twentieth-century America come to light, the role of Libbey Glass should figure prominently in this story, thanks to its patronage of both the men and women of this new profession.

Plate 21
New Products Development Group, *Gibraltar Pattern*, 1977
Libbey Glass, Division of Owens-Illinois, Inc.
wood and enamel paint model; Lucite acrylic model; glass
wood model: 5 × dia. 3¼ inches; Lucite acrylic model:
4⅜ × dia. 3 inches; rocks glass: 4⅛ × dia. 3¹¹⁄₁₆ inches
Libbey Glass Inc.

opposite
Plate 22
Designer unknown, *Floor Lamp*, 1904
Libbey Glass Company
glass and metal
57¾ × dia. 16¾ inches
Toledo Museum of Art, Gift of Owens-Illinois Glass Company

Beginning with the 1851 "Crystal Palace" exhibition in London, universal fairs were considered prime marketing opportunities. This dramatic floor lamp was displayed at the 1904 Louisiana Purchase Exposition, St. Louis, in the "Golden Pavilion" of the jewelry firm Mermod and Jaccard, Libbey's agent in St. Louis. Shown alongside magnificent jewelry and watches, such glass objects advertised the artistic and technical talents of Libbey's craftsmen.

Author's Note: I would like to thank Robert Zollweg, Libbey, Inc., Kenneth M. Wilson, Erin Appleby, and Anne Morris and Sandra E. Knudsen of the Toledo Museum of Art for their generous assistance in the preparation of this essay.

1. The most comprehensive studies on Libbey Glass are Carl U. Fauster, *Libbey Glass Since 1818: Pictorial History & Collector's Guide* (Ohio: Len Beach Press, 1970) and Kenneth M. Wilson, *American Glass 1760–1930* (Toledo: Toledo Museum of Art, 1994), vol. II, pp. 639–51, 655–744, 825–37.

2. *Award to the Libbey Cut Glass Company from The World's Columbian Commission*, 1893, Libbey Glass Company Papers, Toledo Museum of Art Archives.

3. For an excellent discussion of the technological advances made in glassmaking in Toledo during the 1890s and the first decades of the twentieth century, see Warren C. Scoville, *Revolution in Glassmaking: Entrepreneurship and Technological Change in the American Industry 1880–1920* (Cambridge, Massachusetts: Harvard University Press, 1948).

4. During the second and third decades of the twentieth century, Libbey was recognized for its production of industrial glassware, which included such products as medical tubing, railway signage wares, and gauge glasses.

5. See Albert Christian Revi, *American Cut and Engraved Glass* (New York: Thomas Nelson & Sons, 1965), pp. 19–39.

6. Robert Corl, *Toledo Times*, February 17, 1911.

7. Conversation with Arthur H. Smith, vice president, general counsel and secretary, Libbey, Inc., and Wendy Daudelin, June 2001.

8. A good account of the history and manufacture of Libbey Safedge can be found in Libbey Glass Company, *The Story of Libbey Safedge Glassware*, n.d., Libbey Glass Company Papers, Toledo Museum of Art Archives.

9. George H. Meeker, "Libbey History 1818–1968," unpublished manuscript, 1968, Collection of Ted Harbough, Toledo, Ohio, p. 51.

10. *Toledo Times*, January 25, 1931.

11. Interview between Donald Deskey and J. Stewart Johnson, September 6, 1975, Donald Deskey Archives, The Doris and Henry Dreyfuss Memorial Study Center, Cooper-Hewitt, National Design Museum, Smithsonian Institution, New York, pp. 31–32.

12. "Libbey Glass Magazine Advertisement, Job No. 4560-A," *H. A. Crow Volume 1931–1932*, Corporate Archives, Owens-Illinois, Inc., Toledo, Ohio.

13. *Toledo Times*, May 12, 1929.

14. "Libbey Glass Issues Illustrated Folder on Governor Clinton Line of Tumblers," File F-13, 173, microfiche number 0007 0009 1530, Libbey Glass Company, Owens-Illinois Glass Company, Toledo, Ohio; 1888–1973 Papers, J. Stanley Brothers Collection of Papers About American Glass Companies, The Juliette K. and Leonard S. Rakow Research Library, The Corning Museum of Glass, Corning, New York.

15. *Toledo Times* (note 10).

16. Deskey interview (note 11), p. 30.

17. Frederic Vuillemenot figures most prominently in Toledo's history as chief designer of DeVilbiss' atomizer division. However, he periodically worked for Libbey, first during the second decade of the century and then again during the Depression. Alastair Duncan, *American Art Deco* (New York: Harry N. Abrams, Inc., 1986), p. 126. See Cullowhee, North Carolina, Western Carolina University, The Art Department, *DeVilbiss Perfumizers & Perfume Lights: The Harvey K. Littleton Collection* (Cullowhee, 1985).

18. Advertisement in *House Beautiful*, October 1933, File F-13,101, microfiche 0007 0009 0733; "Foreword," *The New Era in Glass*, 1933, File F-13,101, microfiche 0007 0009 0726-0730, 0732, Libbey Glass Company Papers, Brothers Collection (note 14).

19. For a discussion of the changing attitudes toward dining in twentieth-century middle-class America, see Regina Lee Blaszczyk, *Imagining Consumers* (Baltimore and London: The Johns Hopkins University Press, 2000), p. 146.

20. Meeker (note 9), p. 60.

21. This discussion of Donald Deskey's involvement with Libbey is well documented in Deskey interview (note 11), pp. 30–35.

22. Meeker (note 9), p. 67.

23. See Blaszczyk (note 19), pp. 96–100, for a good discussion of the beginnings of the scheme-ware business in the United States.

24. "Tumbler Division," *Glass Containers—Owens-Illinois Glass Company* (Toledo, n.d.), T 10.

25. See Carl U. Fauster, "Learning from the Libbey Ads—Part VII: The Modern American Series, 1940–45," *The Antique Trader*, November 27, 1985, p. 80.

26. The discussion of Teague's involvement with Libbey is based largely upon the Walter Dorwin Teague Papers, Department of Special Collections, Syracuse University Library, Syracuse, New York. See also Carl U. Fauster, "Libbey Crystal for New York 1939 World's Fair," *Hobbies—The Magazine for Collectors* (October 1972), 98K-N; and F. A. Mercer, *The Industrial Design Consultant: Who He Is and What He Does* (London: The Studio, 1947), p. 91.

27. Philip Williams in conversation with the author, June 2000.

28. Teague was no stranger to Toledo's glass companies, having designed advertising for Libbey-Owens sheet glass in 1928.

29. "American 'Crystal' Returning," File F-13, 101, microfiche 0007 0009 1461, Libbey Glass Company Papers, Brothers Collection (note 14). The information on the career of Edwin W. Fuerst is largely drawn from the designer's scrapbooks in the holdings of Mrs. Carolyn Swanson, Florida.

30. Advertisement in *House and Garden*, September 1940, *Owens-Illinois Advertisements 1940 Prepared by D'Arcy Advertising Company*, Corporate Archives, Owens-Illinois (note 12); *Toledo Sunday Times*, September 28, 1941.

31. Owens-Illinois did not act upon Teague's recommendation that industrial designer Helen Dryden be hired, even though Dryden had been retained by Toledo's Dura Corporation in 1930–31 to design several lines of automotive hardware.

32. Unless otherwise noted, the discussion of Freda Diamond is extracted from the holdings of the Smithsonian Institution, National Museum of American History, Washington, DC, The Archives Center, Freda Diamond Collection; from Susan Myers in conversation with the author, February 1999; and from Regina Lee Blaszczyk in conversation with the author, March 2000.

33. Blaszczyk (note 19), p. 250.

34. Josephine DiLorenzo, "Clever Gal Has Design to Thank for Her Living," *Sunday News*, February 25, 1951, National Museum of American History, Freda Diamond Collection (note 32).

35. Freda Diamond, "Fashion Careers in Home Furnishings," in Olive P. Gately, *Your Future in the Fashion World* (New York: Richards Rosen Press, Inc., 1960), p. 61.

36. Betty Barrett, "This Diamond Is a Girl's Best Friend," *Hartford Courant*, August 9, 1964, National Museum of American History, Freda Diamond Collection (note 32).

37. By 1938 Libbey had introduced the first machine-made stemware.

38. The author would like to acknowledge the use in the preparation of this discussion of the exhibition proposal "Designing Demand: Industrial Design and Consumer Demand in the Tableware Market," prepared in 1998 at the National Museum of American History by Susan Myers, Bonnie Lilienfeld, and Charles Taragin. Freda Diamond, "Report of Survey Made for Libbey Glass Company," unpublished manuscript, 1942, Curatorial Archives, Division of Ceramics and Glass, National Museum of American History, Smithsonian Institution, Washington, DC.

39. See Regina Lee Blaszczyk, "'We Must Create Demand by Advertising': Carl U. Fauster, Libbey Glass, and Postwar America," *The Glass Club Bulletin*, Spring/Summer 1993, pp. 3–8.

40. "Libbey Studies Post War Designs," *Crockery & Glass Journal*, November 1944, File F-13, 173, microfiche number 0007 0009 1486, Libbey Glass Company Papers, Brothers Collection (note 14).

41. Crystal, "The Last Word in Glass Display," *China and Glass*, August 1945, pp. 18, 20, 24, File F-13,173, microfiche 0007 0009 1499, Libbey Glass Company Papers, Brothers Collection (note 14).

42. "Libbey Introduces Seven New Decorated Tumbler Sets," *Retailing*, August 9, 1945, File F-13, 173, microfiche 0007 0009 1503, in ibid.

43. Carl U. Fauster, "Libbey Glass and Glass Art—An American Tradition," *Consumer and Technical Products Division of Owens-Illinois*, 30, 2, p. 2.

44. According to Robert Miner, a key member of the company's manufacturing staff during the Diamond years, Stardust was a technological feat to create by machine. Robert Miner in conversation with the author, December 1999.

45. Fauster, "Libbey Glass and Glass Art—An American Tradition" (note 43), p. 2.

46. Daniel J. Obendorfer in conversation with the author, October 1999.

47. *Industrial Design* magazine cited Nob Hill in its annual design review for 1963. "Tenth Annual Design Review," *Industrial Design* 10 (December 1963), pp. 72–73.

48. Fauster, "Learning from the Libbey Ads—Part VII" (note 25), p. 81.

49. In 1956 Libbey introduced the New Dimensions line developed by designers affiliated with the Art Center School of Los Angeles; a year later New York industrial designer Belle Kogan was invited to develop proposals for a new venture into pressed wares, resulting in Victoria. Advertisement in *Post Exchange*, September 1956, in *Kimble, Owens-Illinois Inter-America Corporation Advertisements 1956 Prepared by J. Walter Thompson*, Corporate Archives, Owens-Illinois (note 12); Belle Kogan in conversation with the author, May 1998.

50. Meeker (note 9), p. 95.

51. Robert Zollweg in conversation with the author, October 1999.

52. Miner (note 44).

53. "Designs for Living in America," *Crockery and Glass Journal*, February 1958, p. 43.

54. Robert Chernoff, letter to Ted Harbaugh, April 11, 1961; John P. Kearney, letter to Freda Diamond, May 12, 1965; T. H. Harbaugh, letter to Freda Diamond, April 4, 1967; T. H. Harbaugh, letter to Freda Diamond, February 8, 1963, Corporate Archives, Libbey, Inc., Toledo, Ohio.

55. Zollweg (note 51); Robert Zollweg in conversation with Deborah Miller, September 1998.

56. Jay L. Johnson, "Face to Face . . . with John F. Meier," *Discount Merchandiser*, November 1997, p. 11.

Victoria K. Matranga

CLEAR AS GLASS
THE LIBBEY-OWENS-FORD WINDOW TO BETTER LIVING

The story of design at the Libbey-Owens-Ford Glass Company in Toledo—L-O-F—is the story of America in the middle of the twentieth century: a tale of postwar prosperity marked by a surge in housing and automobile production. The Libbey-Owens-Ford Glass Company, a corporation formed from the 1930 merger of The Libbey-Owens Sheet Glass Company and the Edward Ford Plate Glass Company, pioneered the development and mass production of flat and curved glass products for the automotive, architectural, aircraft, and specialized industrial markets. L-O-F used design to focus attention on a generic product that virtually defined America—the steel-and-glass skyscrapers that remade cities, the wrap-around automobile windshield, the suburban ranch house with a picture window, and Main Street modernizations that moved storefront retailers into a new era. How the company generated excitement and sales for what essentially was an indistinguishable commodity demonstrates the use of design as a strategy to create demand for a product made possible by technical achievements.

Shortly after Edward Drummond Libbey relocated his glass-making enterprise to Toledo in 1888, he hired Michael J. Owens. In 1916 they incorporated The Libbey-Owens Sheet Glass Company as a partnership—by 1925 claiming 40 percent of the glass manufactured in the United States.[1] The company grew during the 1920s and 1930s through acquisitions, licensing, and purchasing patents for new technologies. After 1930 it formed an engineering department and invested heavily in research, developing laminated safety glass for automobiles and distortion-free plate glass, a product finer and more expensive than window (or sheet) glass.

L-O-F did not just supply markets but began using design and advertising to create markets. Modern public relations began in the period 1919–29, and in the years between 1929 and 1941 it became an accepted part of business management in many industries.[2] Beginning in the 1930s, design at L-O-F became integral in the public relations

and sales efforts. George P. MacNichol, Jr., L-O-F's vice president and director of sales and, later, president, stated in 1936, "Selling is a business of making people want things, because they are made of better materials and better designed for specific uses. Making people want things because they are more attractive in appearance—because they better fulfill a specific and understood need, bring greater convenience, greater satisfaction and greater profits to business."[3] For example, L-O-F's national advertising campaign to consumers and its public relations efforts to auto dealers beginning in 1930 affected legislation. The company promoted the use of safety glass in all autos,[4] and eventually in all car windows, not just the windshields, citing safety for the whole family. By 1937, with laws in thirty states, auto manufacturers generally adopted laminated safety glass.[5]

The company also added its influence to design promotion outside its own industry. After the success of its 1934 "Machine Art" exhibition, New York's Museum of Modern Art proposed to establish an industrial art department. The management of the Libbey-Owens-Ford Glass Company, because of its relationships with the Toledo Museum of Art and other city companies, strongly supported this initiative. In MoMA's 1938 report outlining its plan, L-O-F president John Biggers and Harold Alexander, head of the Architectural Service Department, along with the Owens-Illinois director of advertising, were the only actual manufacturers included along with six retailers on the list of nine supportive "Manufacturers." The Toledo Museum of Art was among the eighteen museums in favor of the project.[6]

After World War II, demographics favored the company's fortunes—a growing population and more than a decade of unmet desires fueled a huge demand for autos and houses. In May 1955, *Fortune* stated, "Last year in the U.S. some seven million tons of [glass] were formed into products worth about $1.60 billion. Glass products outweighed everything made from plastics, synthetic rubber, aluminum, copper and lead combined. Corning Glass Works and four other

major glass companies—Owens-Illinois, Libbey-Owens-Ford, Pittsburgh Plate Glass and Owens-Corning Fiberglas" were expected to run up new sales records that year.[7]

The Automotive Market

The expanding automobile market prompted great changes in the glass industry. In 1928 Henry Ford had introduced his Model A, with a windshield of laminated safety glass. In order to produce enough automotive glass to meet this opportunity, Libbey-Owens in 1930 effected a merger with another Toledo company, Edward Ford Plate Glass, founded in 1899. In 1931 the company, now called Libbey-Owens-Ford Glass Company (L-O-F), acquired the National Plate Glass Company, a division of General Motors, and contracted to furnish all GM's automotive glass. This exclusive relationship continued until 1961, when Pittsburgh Plate Glass was able to capture a portion of this market. L-O-F also supplied safety glass to independent car makers, such as Studebaker and Packard.

After the end of World War II, most automakers resumed production with 1946 models that were slightly updated versions of their prewar, 1942 models. But as the peacetime economy picked up speed, more radical design directions appeared. In 1947 Studebaker introduced a one-piece L-O-F windshield in an all-new postwar model designed by Virgil Exner under Raymond Loewy. At General Motors, legendary design vice president Harley Earl, head of Styling (formerly Art and Color) since 1927, launched a new era of flamboyant automobile design that captured the spirit of the times. Earl's staff, working with L-O-F engineers, created the one-piece "wrap-around," or panoramic, windshield, which premiered in 1950 on the stunning LeSabre show car, a design that forecast styling motifs for the next decade. The LeSabre was strongly influenced by aircraft shapes, particularly World War II fighter planes with their bubble cockpits and tailfins. A production version of the wrap-around windshield soon appeared on the top-of-the-line Cadillac Eldorado convertible. By 1954 the panoramic windshield, a great technical achievement, was incorporated into the full line of General Motors production cars. The new windshield promised increased visibility for driver and passengers as it redefined their experience of the road. Each year introduced provocative new models, and in the 1950s US auto sales reached record heights. In 1955 the president of General Motors credited the new windshields for what he called "the greatest forward surge by all manufacturers in the entire history of our industry."[8] Subsequent improvements included windshields with tinted safety laminates, built-in radio antennas, and backlights with defroster heating elements. In addition to the curves made possible by L-O-F's windshields, collaboration with Owens-Corning and the application of its exciting new material, Fiberglas, allowed GM stylists to create the fluid form of the 1953 Corvette, America's first modern sports car and first

production automobile body constructed of Fiberglas-reinforced plastic (plate 1).

Many of the innovations in automotive styling that involved window design required L-O-F to invent, design, and construct new machinery and methods for glassmaking, often at great speed and expense to meet project deadlines. This challenging relationship was recognized by L-O-F president George P. MacNichol, Jr., who stated in a speech to employees in 1954 that "the design of the cars is so important to each one of us in this industry. Design has been responsible for jobs in our plants."[9] This teamwork continued into the 1980s as L-O-F engineers perfected high-performance glass for cars ranging from the Corvette to the Jeep.

The Architectural Market
The Early Years: Walter Dorwin Teague, Donald Deskey, Bruce Goff, Harold Van Doren

From nineteenth-century city arcades to cases at the small-town grocer's, the growth of plate glass in retail settings accompanied the evolution of merchandising display, and competition for this market grew more heated. Libbey-Owens doubled its two-man sales department in 1921 by adding two district offices, in New York and Chicago, to build its distributor network.[10] It initiated the industry's first national advertising campaign, in the *Saturday Evening Post*, in September 1927, and was the first glass manufacturer to label its product with trademarked packaging. Salesmen stressed the advantages of L-O's design as well as the quality of its glass, promoting consumer awareness of the brand and the space-saving box that shipped and stored efficiently. This new approach to marketing led to the company's first relationship with a noted designer, Walter Dorwin Teague. Known for his glamorous advertising illustrations, in 1928 Teague designed L-O's ads for the *Saturday Evening Post* with the MacManus advertising agency (see Messer-Kruse, pp. 36–37 and Harris, p. 45). The sophisticated series presented L-O glass as the quality material for quality residences. Although Teague seemingly did not continue designing for L-O-F, he did continue relationships with other Toledo companies:[11] in 1938–39 he designed glass blocks for Owens-Illinois and tableware for Libbey; in the 1950s he designed products for Owens-Corning Fiberglas.

The L-O-F Company initiated numerous campaigns in which design became the pivotal point between technology and advertising. One sales brochure, titled "Decade of Design, 1930–1940," recognized that architectural demands had resulted in new L-O-F products.[12] L-O-F designers encouraged outside designers to experiment with new uses of glass—a promotional approach also undertaken by the aluminum industry in the 1930s and 1950s.[13] Glass appeared in fashionable contemporary furniture, for example, as in the line of occasional tables designed by Gilbert Rohde in 1939 for The Herman Miller Furniture Company of Zeeland, Michigan (plate 2), featuring tops made of

L-O-F's thick polished plate glass. Rohde, along with other noted designers of the time, also added dramatic effects to interiors by using mirrors and glass for walls and room partitions.

 With its dominance in the automotive market contractually assured, L-O-F sought to build market share in architectural glass, where the Pittsburgh Plate Glass Company was the leader. The company introduced major projects at the great events of the Depression decade: the Century of Progress in Chicago of 1933–34, the New York World's Fair in 1939–40, and the Golden Gate International Exposition in San Francisco in 1939. In Chicago especially, L-O-F allied itself with vanguard architects who relied on glass for wondrous effects. An exhibition of houses at the Century of Progress featured window glass by L-O-F. Two remarkable houses, the Crystal House and the House of Tomorrow, designed by architect George Fred Keck, captivated

Plate 1
Harley Earl and General Motors design staff, *Chevrolet Corvette,* 1953
Chevrolet Motor Division, General Motors Corporation
White Family Companies, Inc.

America's first modern sports car, the 1953 Chevrolet Corvette, introduced the Fiberglas-reinforced plastic body to production cars. Its fluid, nearly seamless body shell—echoed in the curved glass windshield by the Libbey-Owens-Ford Glass Company— evolved from the innovative material as well as the design vision of Harley Earl, GM's head of styling. Toledo's Owens-Corning Fiberglas Corporation developed Fiberglas for automotive use.

Plate 2
Gilbert Rohde, *Coffee Table*, 1939
The Herman Miller Furniture Company
plate glass, brass, Lucite acrylic, and plating
15⁷⁄₁₆ × dia. 33¹⁵⁄₁₆ inches
William H. Straus

The Herman Miller Furniture Company of Zeeland, Michigan, commissioned architects and designers to devise trend-setting lines for modern interiors. In 1939 New York–based designer Gilbert Rohde's occasional tables presented innovative applications of Libbey-Owens-Ford's three-quarter-inch plate glass and Lucite acrylic, an exciting new material. The glass top, available in various shapes and sizes, was machine cut and polished. Unusual for its time, the table was shipped "knock-down," and the Lucite acrylic tubular legs, of varying lengths, could be attached without using tools. Major department stores carried the tables for several years.

imaginations for decades to come. Until these houses were built, architects believed that large glass areas meant large heat losses; yet 90 percent of the wall areas in the House of Tomorrow were of clear, single-thickness glass, and internal temperatures were warm in winter. What Keck learned here about solar heat influenced his entire career[14] and encouraged L-O-F research in insulating glass; in 1934 the company acquired the manufacturer of Thermopane glass. Toledo's other company producing architectural glass, Owens-Illinois, constructed a glass block building at the same fair (plate 3), thus establishing Toledo as a center for innovative building materials (plate 4).

At the 1939–40 New York World's Fair, Corning Glass Works, Pittsburgh Plate Glass, and Owens-Illinois built pavilions demonstrating their products. Libbey-Owens-Ford Glass supplied glass to the sponsors of many buildings at the fair, including the General Motors Building designed by Norman Bel Geddes. For GM's Futurama display, L-O-F produced virtuosities: the largest single glass installation at the fair (22,000 square feet) of cylindrical showrooms formed of bent glass fourteen feet in diameter and twelve feet high and huge bent glass

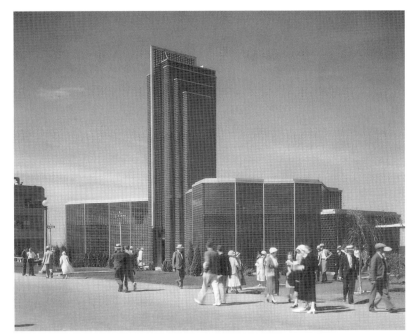

Plate 3
Owens-Illinois Building at "A Century of Progress Exposition,"
1933–34
photo panel

Owens-Illinois began experimenting with glass block production in 1930 and although the blocks did not become commercially available until 1935, this "novelty" building introduced the new material at the 1933 Chicago exposition. Constructed of an early type of block coated on five sides with a colored cement paint and with the sixth, untreated, surface exposed to the weather, the building's apparent dimensions and shadow effects varied in daylight, at night, and with exterior and interior illumination. Light reflected from the paint gave the effect of tinted glass, offering architects new freedom to design with color and light. This building, 100 feet long and 60 feet wide, with a 50-foot-high tower, made dramatic use of the modern material, creating a simple, unified shape with shimmering surfaces. It served as the landscape pavilion for the James W. Owen Nurseries and housed a display of garden equipment and furniture, flowers, and a display about the Owens-Illinois Glass Company.

Plate 4
Alfred S. Alschuler, Inc., for R. N. Friedman-E. A. Renwick Associates, *Alterations to Building for Kitty Kelly Shoes, Chicago, Illinois, Front Elevation and Section Through Front*, 1937
ink and graphite on linen
26 × 41¼ inches
Chicago Historical Society, 1980.311

Alfred Alschuler remodeled this 1870s building with modern materials in order to compete with the new stores along State Street, Chicago's primary retail location. Alschuler updated the glazed terra-cotta façade with a highly effective, vertical expanse of Owens-Illinois glass block to bring excitement to the streetscape. O-I featured this building in trade magazine advertisements to encourage architects to use its Insulux translucent masonry for modernizations or new structures.

Libbey-Owens-Ford Glass Company hired Bruce Goff in
Chicago to develop concepts for architectural uses of new glass
materials. Shortly before he moved to Toledo to work at L-O-F's
headquarters, Goff proposed this striking, multilevel residence
with ground-level garage and roof deck. Set in a stylized land-
scape, the cubelike structure organized spaces and surfaces with
geometric order.

letters twenty feet high.[15] Riders on the Highways and Horizons tour
viewed the "world of tomorrow" through the curved plate glass that
L-O-F developed after much experimentation. Also at the New York
Fair, designer Donald Deskey displayed a stunning new idea for a
mass-produced house in which glass played a major role.

Deskey, a New Yorker who had designed tumblers and stem-
ware for Libbey in the 1930s and was recognized for his furniture and
interiors, created the Sportshack, a weekend cabin. Its openness and
innovative floating planes were made possible by L-O-F's AKLO, a
bluish green glass that eliminated glare and withheld the sun's heat
to maintain an even temperature; it was used in a sliding window
wall that joined the interior with the outdoors. The cabin was also
included in The Metropolitan Museum of Art's "Contemporary Amer-
ican Industrial Art, 1940: Fifteenth Exhibition." This experiment in
prefabricated housing inspired Deskey's postwar projects joining
modern design with economical mass production.[16]

For the Golden Gate International Exposition in San Francisco
in 1939, Libbey-Owens-Ford Glass constructed an 85-by-32-foot build-
ing with an exhibit organized by H. Creston Doner, head of L-O-F's
Design Department.[17] The display included modern storefronts, a

grand glass staircase and mirrored walls, a fun house section featuring distorting glass, and a spectacular all-glass bathroom with a glass-enclosed tub and shower area that presaged the home spas of the 1990s. An employee newsletter revealed a key point in L-O-F's agenda with this exhibition: "Our company has operated on the principle that women are always a fundamental factor in our selling."[18] This approach became increasingly important in the company's promotion of bathrooms, mirrors, and picture windows.

An important element of much of the new design was Vitrolite, the trade name for an opaque structural glass, which first became popular in the 1920s as an inexpensive, durable alternative to marble. Its easy-maintenance surface was promoted to hospitals, public restrooms, and restaurants, and its polished finish and variety of available colors made it an exciting material for modern fashions.

In 1935, when L-O-F production was limited to plate, window, and safety glass, the company established a New Uses Department to create new applications.[19] Later that year, L-O-F purchased the Vitrolite Company (founded in West Virginia in 1907) and the L-O-F sales office merged with Vitrolite's Chicago office. The following year, L-O-F hired Bruce Goff, an architect working in Chicago for the Vitrolite Company, to experiment with this material, perhaps in response to Pittsburgh Plate Glass' engagement of designer Walter Dorwin Teague to promote its Carrara structural glass.[20] When L-O-F relocated the Vitrolite division to Toledo, Goff moved as well and lived in an apartment across the street from the Toledo Museum of Art.

Charged with designing interiors and exteriors showing the possibilities of glass, Goff initially used Owens-Illinois glass blocks, Vitrolite, and Vitrolux (its transparent version) to effect Modernist design (plates 5–7). He explored the play of light in interwoven bands of colored glass in concepts for the homes of Toledo businessmen: a bathroom for David H. Goodwillie, executive vice president at L-O-F, and the Taproom, a bar in the home of R. A. Stranahan, president of the Champion Spark Plug Company. Variations of the bathroom design were installed in several Toledo homes owned by L-O-F executives (plates 8 and 9).

Goff also redesigned the L-O-F showroom in Chicago's Merchandise Mart, creating a series of spaces highlighting forms composed of curved, colored, ridged, clear, and opaque types of glass. Despite his success, however, Goff was uncomfortable within a corporate structure,[21] and returned to Chicago in 1937 to establish an independent architectural practice. Ironically, that same year L-O-F had already turned to a designer established in Toledo, Harold Van Doren, whom the company hired to work with Vitrolite as a color consultant.[22] This position contributed to Van Doren's growing reputation as a consultant and no doubt informed his knowledge of glass that he could then apply to other projects.

The Golden Years: H. Creston Doner

By the end of 1937, L-O-F had hired H. Creston Doner, who was to head the company's design department until his retirement in 1967. Doner was a self-made man with no formal education in design. A colorful and dapper personality, Doner impressed everyone with his flair. A handsome man, he posed (anonymously) in sales brochures and narrated and produced L-O-F's promotional films.[23] Remembered as a man of "very little education but of great talent" who could "pick up an idea and promote it,"[24] "Cres" Doner was more a manager than a designer. His showman's enthusiasm established L-O-F's name in the architectural segment of the company's business.

After Doner joined the company, the New Uses Department, headed by H. M. Alexander, was renamed the Architectural Service Department and acted as a development department for new specialty products. During these years design was integral to the sales, public relations, and advertising departments in the corporate structure; extraordinary programs brought design to the forefront. Doner redesigned the showroom display and the furniture for the executive offices in the Nicholas Building headquarters. In a reorganization of the Design and Drafting Department, Doner was named manager of the Department of Design, which would "cooperate with North Wright's sales promotion department in designing exhibits, etc., and with the sales division in any field work that is necessary." Franz Wagner served as Doner's assistant manager and Frank Sohn headed Architectural Service.[25]

Located under the direction of L-O-F's vice president of sales in the 1930s, the design department shifted position in the 1940s. In 1941 Doner's department and the Sales Promotion Department under North Wright apparently were on the same level, but in 1945 Wright was named public relations manager in charge of sales promotion, advertising, and design.[26] Upon Wright's death in 1946, James Ashley became vice president of public relations and oversaw the design department until Doner's retirement in 1967.

Despite the corporate positioning, Doner was given broad freedom.[27] Although the architectural and automotive divisions were somewhat separate, Doner often visited Detroit to meet with GM personnel.[28] He courted furniture companies in North Carolina to expand the use of glass for tabletops and mirrors.[29] Doner approved and distributed work to his staff, served as primary client contact, and cooperated with outside designers. Among the architects and designers he hired for his small office was Margaret Pilliod, a recent graduate of the University of Michigan School of Architecture and Design. She specialized in graphic design, but also handled many other tasks and ran the office during Doner's frequent travels.[30] Although the only woman in the Design Department, she felt she was treated equally and enjoyed the respect of her colleagues.[31]

Interiors

TO HARMONIZE WITH MODERN TASTES

Brilliant in gay, festive colors—or restrained, if you prefer, in colors of lower key—a clean-looking modern interior of Vitrolite Structural Glass will help you to *build* and to *hold* patronage.

There is a wide variety of Vitrolite colors—plain and agate. Also, borders, monograms or decorative spots in colors and inlays are available.

You'll find Vitrolite an ideal material for wainscotings or wall facings—also for soda fountains, lunch counters and bars. Vitrolite is particularly effective in combination with mirrored sections which give an illusion of doubled area to the room. This effect is now very popular in the restaurants of Paris, France.

You'll find, too, that maintenance cost is reduced to a minimum where Vitrolite is used. Occasional attention with a damp cloth, or with soap and water in extreme cases, will keep it looking *like new,* for years. Redecorating will *never* be needed.

RESTAURANT INTERIOR WITH VITROLITE WALLS, COUNTERS AND TABLE TOPS AND VITROLUX ILLUMINATED PANELS.

VITROLITE WALLS FORUM CAFETERIA, CLEVELAND, OHIO GEORGE B. FRANKLIN, ARCHITECT KANSAS CITY, MO.

SHORECREST TEA ROOM, MILWAUKEE, WIS. HERBERT W. TULLGREN, ARCHITECT

COCKTAIL ROOM, CHICAGO ATHLETIC ASSOCIATION, CHICAGO, ILL.

GREENFIELD'S RESTAURANT, DETROIT, MICH.

Plate 6
Bruce Alonzo Goff, *Ice Cream Parlor Alterations: Vitrolite Design,* 1937
Libbey-Owens-Ford Glass Company
colored pencil, ink, watercolor, gouache, and graphite on paper
22⅝ × 37⅛ inches
The Art Institute of Chicago, Gift of Shin'enKan, Inc., 1990.905

Plate 7
Designer unknown, *Restaurants That Win! Brochure,* ca. 1937–38
Libbey-Owens-Ford Glass Company
color printing with black and white photos on paper
11 × 8½ inches
Ward M. Canaday Center for Special Collections, University of Toledo, Toledo, Ohio

Plate 8
Bruce Alonzo Goff, *R. A. Stranahan Taproom Alterations: Vitrolite Design*, 1937
Libbey-Owens-Ford Glass Company
colored pencil, pastel or chalk, ink and/or watercolor, gouache, and graphite on lineprint paper
20 × 29¼ inches
The Art Institute of Chicago, Gift of Shin'enKan, Inc., 1990.906

Plate 9
Bruce Alonzo Goff, *D. H. Goodwillie Bathroom Alterations: Vitrolite Design*, 1937
Libbey-Owens-Ford Glass Company
colored pencil, pastel or chalk, ink, watercolor, gouache, and graphite on lineprint paper
25½ × 33⅝ inches
The Art Institute of Chicago, Gift of Shin'enKan, Inc., 1990.904

● This design for a men's store combines a Visual Front with a partial show window without sacrificing the advantages of an open front.

The bulkhead, pilaster and trim are indicated as being Glastone or Vitrolite structural glass. Tuf-flex tempered plate glass doors play an important role in making the entire interior of the store visible to sidewalk and street traffic.

Mirrors on the inside wall reflect portions of the merchandise and help create an illusion of a wider storeroom.

The partition at the back of the showroom could be decorative as well as utilitarian by glazing it with Blue Ridge patterned glass in either clear or satinol finish.

10

Plate 10
Libbey-Owens-Ford Glass Company Department of Design,
Visual Fronts Brochure, 1945
Libbey-Owens-Ford Glass Company
black and white printing on paper with paper cover
8¾ × 11½ inches
Ward M. Canaday Center for Special Collections, University
of Toledo, Toledo, Ohio

Developed during the war years, the Visual Fronts program encouraged merchants to remodel stores and enliven city Main Streets by using several types of L-O-F glass to put an entire store on display rather than just a small part, thus increasing sales potential. The Libbey-Owens-Ford Department of Design prepared exciting drawings of pharmacies, auto showrooms, and clothing stores to promote the benefits of Polished Plate Glass, Tuf-Flex Tempered Plate Glass, Thermopane, L-O-F Heat Absorbing Glass, Vitrolite, Glastone, Blue Ridge Glass, and Bent Glass.

Doner was especially interested in color. He formulated L-O-F's corporate color scheme for buildings and interiors and lectured frequently about color to professional organizations and potential clients. Responding to consumer preferences, he reorganized the available colors of Vitrolite to allow more versatility in contemporary interior decorating.[32] Ever the salesman, he approached color pragmatically, as indicated in a memo he wrote to his supervisors and staff reporting on a lecture by noted designer Egmont Arens: "The industrial designer is concerned with the effect color has on human beings, and how it can be used to affect their moods and behavior, especially their purchases. . . . The artist is interested in his own reactions . . . but the designer must study mass reactions. . . . The best criteria are sales records." Doner added in capital letters: "THE DEPARTMENT OF DESIGN SHOULD ALWAYS TAKE THE DESIGNER APPROACH RATHER THAN THE ARTIST APPROACH TO THE PROBLEMS AT HAND."[33]

Doner also understood the value of relationships between designers and architects. He coordinated design competitions and promotions with architects to bring the L-O-F name to new and broader audiences. His Department of Design embarked on ambitious programs such as the 1939 Visual Fronts, 1940 Design for Happiness, 1942–45 Kitchen of Tomorrow, 1940s Daylight Color, 1947 Solar House, 1956 Decorama, and 1960s Open World. These programs were all supported by targeted merchandising plans that would help distributors sell glass. L-O-F expanded its reach in consumer and trade publications, radio, films, and then television; partnered with retailers, manufacturers, and government agencies in special events; and devised inventive methods to make windows and doors exciting.

Visual Fronts

In 1939 L-O-F, along with *Architectural Record* magazine, sponsored an architectural competition for retail store improvements. Among the seven architects on the jury were Louis Kahn, William Lescaze, and John W. Root. The book presenting the entries, *52 Designs to Modernize Main Street with Glass,* described the program, which was supported by the Federal Housing Authority. The FHA insured loans up to $50,000 and extended credit to lending institutions to encourage them to release funds for modernization.[34] Reinvigorated after the war under the title "Visual Fronts" (plate 10), this program lasted from 1945 until around 1955. Creston Doner went on the lecture circuit and the L-O-F Department of Design produced a booklet emphasizing that see-through visibility and proper lighting could turn an entire store into a dramatic display even after closing time.[35] As America's downtown merchants faced competition from new suburban shopping centers, this approach encouraged remodeling and helped new stores as well.

Design for Happiness

In 1940 the "Design for Happiness" homes program was the copy-righted name of the nationwide development effort sponsored by L-O-F and intended to increase the amount of glass used in mass housing. Ten low-cost model homes were constructed in Toledo to showcase L-O-F products. FHA-approved and insured, the homes were sold with 50-by-100-foot landscaped lots. Ingenious promotion included advertising and events targeted to professional and consumer markets: one Toledo department store furnished a house and opened it to tours, receiving six thousand visitors in two weeks.[36] Trade magazine advertisements encouraged architects to propose schemes for mass housing.[37] L-O-F sponsored a national half-hour Sunday afternoon radio show that featured conductor Izler Solomon leading the Chicago Women's Symphony—a direct pitch to women consumers.[38] The show premiered at the Toledo Museum of Art and then was broadcast from Chicago's Civic Theatre. The FHA produced a short film, *Design for Happiness,* about how a young couple solved their yearning for a home; it was shown to twelve million people in five thousand theaters.

Demonstrating that greater utilization of glass made houses more appealing and was surprisingly inexpensive, the L-O-F sales department put together a "glass package" of interior items, to be sold to builders for about $75 in lots of ten or more. Terminated by World War II, this program served as an important foundation for the postwar building boom. The "picture window," a term that L-O-F pioneered in 1932,[39] would characterize houses in suburbia in the following decade.

Kitchen of Tomorrow

Creston Doner is best known for his visionary "Kitchen of Tomorrow." Challenged in 1942 by *National Geographic* magazine to create a kitchen, Doner invented a scheme that not only showcased glass products, but proposed appliances and furniture for a new, servantless mode of American family life (plate 11). A "design for better living" promised a "peacetime revolution of convenience and comfort."[40] Preparation and dining areas were joined into an open space (plate 12), made possible by a dining table that flipped up to attach to a wall, a pass-through counter area, and a refrigerator accessible from both kitchen and dining alcove. A cabinet attached to the refrigerator took advantage of waste heat to dry kitchen towels. The glass-fronted refrigerator and cabinets brought food and dinnerware into clear view (plate 13). The sink and food preparation areas were placed at a height comfortable for the housewife to work seated. Foot pedals in the floor activated the water faucet in the durable Vitrolite sink, which connected to a disposal unit; a cover could be used to make the sink flush with the counter. A dishwasher was installed beside the sink. Doner replaced the traditional stove top with a unified wall unit that included a glass-walled oven/rotisserie/griddle, built-in toaster, mixer/juicer/meat grinder, waffle maker, and digital clock/thermometer as well as recessed cooking/baking vessels (plate 14). A "serving wagon" for storing dishes could be wheeled to the table (plate 15). With the smooth, unified appearance of the appliance wall and the suspended cabinets lit from the top and bottom, the room appeared open, airy, and light.

Again, the promotional campaign was astonishing. Paramount Pictures produced a short feature for movie theaters. *Life, Better Homes & Gardens, National Geographic,* and other consumer and trade magazines featured the parade of kitchens in 1943. Three full-sized models toured nationally for two years. A woman lecturer, an employee of the L-O-F Advertising Department, accompanied each display to present a twenty-minute program and answer questions. Visitors received a folder explaining the room's features, a postcard to send to a friend, and a mail-in ballot on which to register preferences. Favorites were the picture window, easy-clean Vitrolite walls, and glass-hooded oven. By mid-1945, 1.6 million people had seen the displays in forty-five stores around the country.[41]

Typical of utopian "Tomorrows" that appeared during the 1930s and 1940s, this project included impractical features[42] that were evident to women users of the kitchen when it was installed in a few Toledo homes, such as hard-to-clean, built-in appliances. Nonetheless, Doner's vision of the kitchen as a multifunction family room did anticipate trends in lifestyle and in residential architecture. His glass-doored cabinets inspired manufacturers in the late 1940s to produce similar cabinets and appliance makers to add windows to ovens. Glass-faced refrigerators and cabinets appeared in gourmet kitchens of the 1980s and 1990s. Doner's kitchen was revived in 1984 for an exhibition at the Smithsonian Institution, "Yesterday's Tomorrows," and periodically recalled in publications.[43]

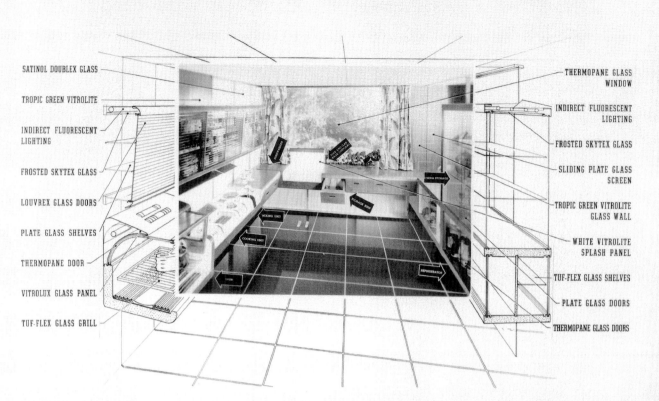

SATINOL DOUBLEX GLASS

TROPIC GREEN VITROLITE

INDIRECT FLUORESCENT
LIGHTING

FROSTED SKYTEX GLASS

LOUVREX GLASS DOORS

PLATE GLASS SHELVES

THERMOPANE DOOR

VITROLUX GLASS PANEL

TUF-FLEX GLASS GRILL

THERMOPANE GLASS
WINDOW

INDIRECT FLUORESCENT
LIGHTING

FROSTED SKYTEX GLASS

SLIDING PLATE GLASS
SCREEN

TROPIC GREEN VITROLITE
GLASS WALL

WHITE VITROLITE
SPLASH PANEL

TUF-FLEX GLASS SHELVES

PLATE GLASS DOORS

THERMOPANE GLASS DOORS

SECTIONAL VIEW OF KITCHEN OF TOMORROW

Plate 11
H. Creston Doner and Libbey-Owens-Ford Glass Company Department of Design, The Kitchen of Tomorrow, 1942
photo panel

Plate 12
H. Creston Doner and Libbey-Owens-Ford Glass Company Department of Design, The Kitchen of Tomorrow, 1942
photo panel

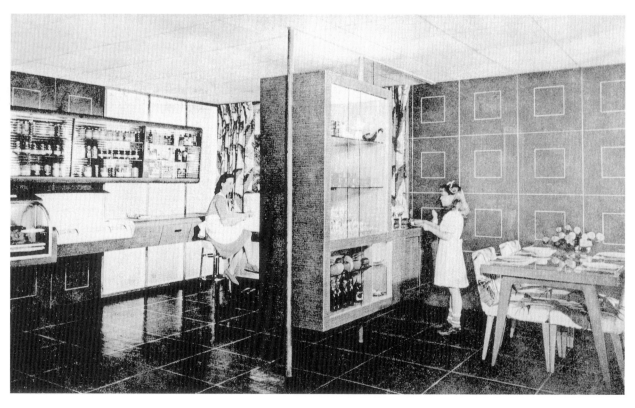

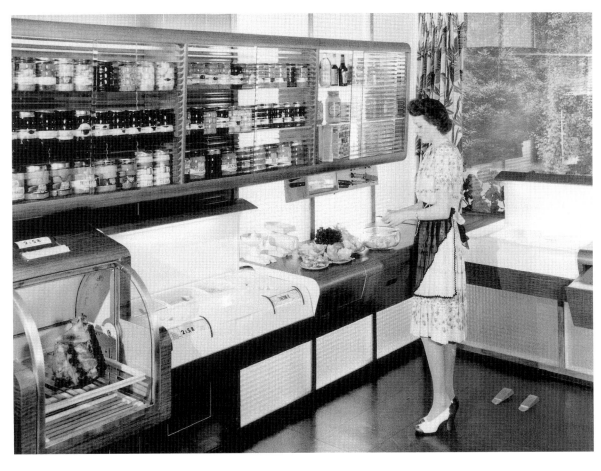

Plate 13
H. Creston Doner and Libbey-Owens-Ford Glass Company Department of Design, The Kitchen of Tomorrow, 1942
photo panel

Plate 14
H. Creston Doner and Libbey-Owens-Ford Glass Company Department of Design, The Kitchen of Tomorrow, 1942
photo panel

Plate 15
H. Creston Doner and Libbey-Owens-Ford Glass Company Department of Design, The Kitchen of Tomorrow, 1942
photo panel

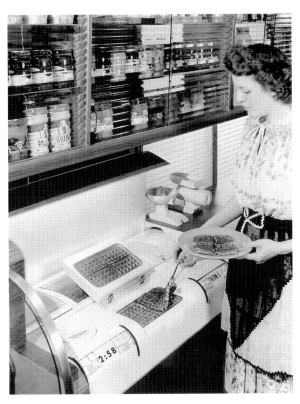

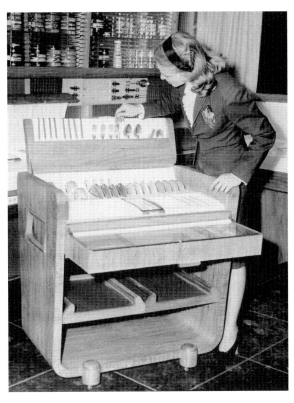

Daylight Color

The "Daylight" campaign began in the early 1940s and was reformulated after World War II. At first the program studied the effects of natural daylight and "man-made daylight" on the performance of factory workers, determining that daylight reduced eyestrain and improved working conditions.[44] The postwar program responded to the promotional efforts of the masonry industry. L-O-F sponsored university engineering research that showed how daylight made for a safer and more comfortable environment.[45] Studies demonstrated how windows reduced operating costs for air-conditioning and lighting and were much safer in times of fire because firefighters could rescue people faster. L-O-F carried its message to architects, school administrators, and civic officials from the late 1940s into the 1960s, the years of greatest US school construction.[46]

Solar House, 1944–48

More than ten years of research into producing effective sealants to sandwich two panes of glass around an air layer finally resulted in reliable insulating glass, Thermopane. Combined with southern exposures and overhanging roofs, Thermopane allowed great expanses of glass in any climate, reducing costs for illumination, air conditioning and heating, and exterior maintenance. To trumpet this achievement, L-O-F launched the "Solar House" program, once again relying

on its proven promotional methods. The company sponsored scientific studies, an architectural competition, a solar house giveaway contest advertised on popular radio shows and in major magazines, films in movie theaters, and a barrage of newspaper stories describing the pleasures of natural light streaming through picture windows.[47] The architectural component of the campaign yielded innovative home designs published in 1947 by Simon and Schuster. L-O-F commissioned leading architects nationwide to design $15,000 homes suitable to the climate and living standards of their states (plate 16). The book, *Your Solar House,* which included George Fred Keck's house for Illinois, explained seasonal solar patterns along with technical details about windows. It was distributed to 7,300 registered architects and prominent banks in key cities[48] and offered for sale to consumers.

The interest generated by this Solar House campaign took several more decades to reach common understanding and popularity, but the long, low silhouette of these houses fit well with modern taste in ranch houses. Perfecting AKLO glass types since the 1930s, L-O-F continued

Plate 16
Designer unknown, *Your Solar House Booklet,* 1947
Libbey-Owens-Ford Glass Company
color-printed paper covers and black and white printing
for text and illustrations on paper
13⅛ × 9¾ inches
Anonymous loan

to develop glass that absorbed the sun's rays, along with tinted glass to shade building interiors, which became important to glass-walled skyscrapers of the 1960s. Cultural changes in the 1970s encouraged America to seek alternative energy sources and living styles and moved glass manufacturers toward the development of solar collection panels.

Decorama

Building on the 1946 trade-directed mirror promotion featuring interior decorator Dorothy Draper,[49] the 1956 "Decorama" mirror campaign was framed as a public service educational program. The L-O-F Department of Design commissioned Paul MacAlister, a Chicago furniture designer, to create miniature rooms depicting a history of interior decorating styles. Complete with furniture, floral arrangements, wallpaper, and carpets, these rooms presented a short course in home decoration in which mirrors played an important part.[50] Demonstrated on television and in personal appearances by "home stylist" June Cabot, Decorama was intended to attract media attention. MacAlister and his associates built two sets of these Lilliputian homes that could be packed as airplane luggage. Department stores and women's clubs responded enthusiastically. When Cabot had a schedule conflict, Creston Doner substituted. The course educated seventeen thousand people, mostly women, in twenty-six locations from Los Angeles to Boston in 1956.[51] Not only did it contribute to increased sales of mirrors, but retailers reported increased sales of home furnishings as well.

Open World

The "Open World" program of the 1960s addressed the giant buildings reshaping city skylines by promoting ever-larger panes of glass, as in the 1968 milestone of one-and-one-half-ton panels nearly thirty feet high for the New York General Motors headquarters. L-O-F challenged architects to design buildings that took advantage of its tinted, insulated, and patterned glass varieties. L-O-F advertisements emphasized how noted architects used its products in New York's Lincoln Center and the Chicago Civic Center.

Appropriately, in 1960 L-O-F established its new corporate image with its own new steel-and-glass building in downtown Toledo, designed by New York architects Skidmore, Owings & Merrill. This building, the first major office construction in downtown Toledo in thirty years, indicated the company's commitment to the city (plate 17).

Plate 17
Skidmore, Owings & Merrill, New York, architects, Libbey-Owens-Ford Glass Company Corporate Headquarters, 1960
photo panel

The fifteen-story corporate headquarters building, which brought together L-O-F offices that had been scattered in several locations, was a showcase for a variety of L-O-F products, such as Thermopane insulating glass, Vitrolux, and Parallel-O-Grey plate glass. Construction was announced in May 1958 and employees occupied the new space in February 1960. The firm of Skidmore, Owings & Merrill frequently used L-O-F products in its signature architectural style.

Changing Times

The surge in large buildings came at a time when other conditions in the business environment were moving in directions that would prove unfortunate for L-O-F. The first alarms about foreign imports were sounded by L-O-F management in the early 1950s. The effects of the 1958 steel strike plus the impact of this competition resulted in major layoffs in 1960.[52] L-O-F's automotive glass, which since 1930 had dominated the company's revenue, began to lose market share, and automakers began producing smaller cars that required less glass. In 1967 L-O-F brought in an outsider, an executive from an automotive equipment manufacturer, to head the company. This was the first time a non–family member or career "glassman" occupied the presidency of a company filled with multigenerational families of employees.[53]

Creston Doner retired on January 1, 1968, and opened an independent consultancy in Toledo. Peter Orser, appointed to the newly created position of director of advertising and sales promotion, assumed responsibility for the Department of Design under James Ashley, vice president of public relations. Orser had worked with Doner for many years while regional sales promotion manager. The Department of Design was split into two parts, with Doner's staffers Margaret Pilliod rising to chief of graphic design and Ralph Sherwin heading architectural design.[54] Within months design lost much of its autonomy; market-based, not product-based, sales teams were established in a sweeping corporate reorganization.[55]

In 1968 the word "glass" was removed from the corporation's trademark shield to indicate the company's new diversification program. Soon L-O-F owned companies that produced fluid power hoses, molded plastic boats, appliance parts, furniture, and picture frames. The 1970s energy crisis and recession, growing labor demands, higher taxes, and international competition combined pressures on one of Toledo's flagship companies. By 1981 less than 50 percent of the company's revenues came from glass products. In 1986 the Pilkington Brothers p.l.c., a British glassmaker since 1826, purchased 100 percent of the glass division of the L-O-F Company and the Libbey-Owens-Ford name. Pilkington, a major multinational manufacturer of glass and glazing products for the building, automotive, and technical markets, maintains its North American headquarters in the same Toledo building.[57]

Creston Doner's freewheeling nature had fit the expansionism and optimism of the 1930s–60s. During these decades of growth in American business, design was a driving force in the quest for new products and creation of new markets for the company. The story of how subsequent economic instability and management adjustments to global competition affected design at L-O-F mirrors similar situations at US corporations in other industries in the following years.

1. E. William Fairfield, *Fire & Sand . . . the History of the Libbey-Owens Sheet Glass Company* (Cleveland: The Lezius-Hiles Company, 1960), p. 113.

2. F. Rhodes Henderer, *A Comparative Study of the Public Relations Practices in Six Industrial Corporations: United States Steel Corporation, Aluminum Company of America, The Westinghouse Corporation, Pittsburgh Plate Glass Company, Koppers Company, Dravo Corporation* (Pittsburgh: University of Pittsburgh Press, 1956).

3. George P. MacNichol, Jr., published text of speech, May 1936, File F-13, 171, microfiche 0007 0009 0255, Libbey-Owens-Ford Glass Company, Toledo, Ohio Papers, J. Stanley Brothers Collection of Papers about American Glass Companies, The Juliette K. and Leonard S. Rakow Research Library, The Corning Museum of Glass, Corning, New York (hereafter cited as "Brothers Collection").

4. *The Batch*, February 1939, folder 1, box 11, Libbey-Owens-Ford Glass Company Records, 1851–1991, collection no. 066, Ward M. Canaday Center for Special Collections at the William S. Carlson Library, University of Toledo, Toledo, Ohio (hereafter cited as "Canaday Collection").

5. *Fifty Years of Safety Glass*, n.d., folder 26, box 46, in ibid.

6. *A Report Covering a Proposed Industrial Art Project of The Museum of Modern Art*, prepared by Monroe Wheeler, June 1938, Ryerson and Burnham Libraries, The Art Institute of Chicago. MoMA proposed to show beauty in manufactured articles that would affect the purchasing power toward artistic products, and "to aid in the enlargement of the artist's part in modern manufacture, particularly by stimulating his interest in the special modern problem of industrial design as distinct from the traditions of handicraft, and by keeping him informed of the particular requirements of industry. Also, to help the industrialist recognize the best creative talent, and to encourage him to prefer it, and to give him such information and counsel as may be helpful in raising the aesthetic level of manufactured products."

7. Francis Bello, "Greatest Year for Glass," *Fortune*, May 1955, p. 134.

8. Ibid.

9. George P. MacNichol, Jr., "Ottawa Service Award Dinner" speech, October 6, 1954, folder 11, box 19, Canaday Collection (note 4).

10. Fairfield (note 1), pp. 119–21.

11. Letter from Martin Dodge (representing Walter Dorwin Teague) to Mr. Levis, Owens-Illinois Glass Company, May 13, 1936, Walter Dorwin Teague Papers, Department of Special Collections, Syracuse University Library, Syracuse, New York: "Mr. Teague and I have given serious thought to the project which I discussed with you in Toledo and we have finally had to conclude that because of our obligations to Pittsburgh Plate Glass it would be better to drop our negotiations for the present. We have not discussed this with Pittsburgh and are not at all sure that Pittsburgh would object to our entering into an arrangement with you, particularly as our work for you would be on products which they do not manufacture, but it seems to us wise to avoid any possibility of embarrassment that might result from working on an intimate basis with two companies that are in some respects competitive. . . . It should be said in explanation of our position that since my recent telephone conversation with you our Pittsburgh contract has been extended on a somewhat broader basis and that this has influenced our decision."

12. *Out of the Design Decade Comes the Age of Glass: Libbey-Owens-Ford Glass Company, Toledo, Ohio*, folder 25, box 17, Canaday Collection (note 4), stated: "Ten new flat-glass and related products in ten years. Ten products that were born because Architect, Designer and Decorator demanded them. The success that these design elements have achieved during the Design Decade can be attributed largely to the skillful interpretation given them by the Architectural profession. For our part, it has been the professional interest and encouragement t hat has kept us constantly searching out new uses and new products of Glass."

13. See *Aluminum by Design* (Pittsburgh: Carnegie Museum of Art, 2000), particularly the work of Lurelle Guild described on p. 228. Also Dennis Doordan, "Promoting Aluminum: Designers and the American Aluminum Industry," in *Design Issues* 9, 2 (Fall 1993). Also see comments by Frank L. Magee, president, and Samuel L. Fahnestock, chief industrial designer, in *Design Forecast 1* (Pittsburgh: Aluminum Company of America,1959).

14. Ralph Wallace, "The Proven Merit of a Solar House," condensed from *The Baltimore Sunday Sun, in Reader's Digest*, January 1944, folder 20, box 18, Canaday Collection (note 4).

15. *The Batch*, July–August 1939, folder 1, box 11, in ibid.

16. Jeffrey L. Meikle, "Donald Deskey Associates: The Evolution of an Industrial Design Firm," in David A. Hanks with Jennifer Toher, *Donald Deskey: Decorative Designs and Interiors* (New York: E. P. Dutton, 1987), pp. 124–26, also see p. 7.

17. "Found: Place Where Rainbows Are Born. Location: L-O-F Exhibit on Treasure Island," *The Batch*, May 1939, pp. 7–10, folder 1, box 11, in Canaday Collection (note 4).

18. Ibid.

19. "Creating Glass Business," *The Batch*, March 1939, p. 2, in ibid. In 1939 Harold M. Alexander recalled, "It was known in print as the 'New Uses Department,' but it assumed many easier names like 'New Useless Department,' 'New Abuses Department' and 'New Excuses Department.' Like the name, the program of the department covered an unknown field: to develop new uses of glass, to offer new designs of glass products, to stimulate glass in architecture. . . ."

20. Jeffrey L. Meikle, *Twentieth Century Limited, Industrial Design in America, 1925–1939* (Philadelphia: Temple University Press, 1979), pp. 117–21.

21. For personal reminiscences about Goff's bathroom designs, see Davira S. Taragin, interview with Carol Orser, March 1999. For more information on Goff, see David G. DeLong, *Bruce Goff: Toward an Absolute Architecture* (New York and Cambridge, Massachusetts: Architectural History Foundation and The MIT Press, 1988), p. 57. DeLong cites a letter written by Goff to L-O-F officials expressing his dissatisfaction at his lack of control over the project and asking to be excused from "further connection or responsibility with the [design for the] L-O-F Chicago Showroom."

22. "Van Doren with LOF," January 11, 1937, news clipping (no source indicated), File F-13, 171, microfiche 0007 0009 0690, Brothers Collection (note 3), stated: "Harold Van Doren is appointed Color Consultant to Libbey-Owens-Ford. His activities for L-O-F will be directed towards the solution of color problems associated with Vitrolite. Mr. Van Doren has had wide experience in the color field. He directed the color research and standardization of Plaskon, leading urea resin, which was recently carried out at The Mellon Institute for Industrial Research in Pittsburgh."

23. See *Practical Glass Ideas for Today's Homes*, June 1942, folder 5, box 11, Canaday Collection (note 4). The film *Glass and the Future*, narrated and produced by Creston Doner, was mentioned in *Home Furnishings Daily*, April 30, 1962, File F-13, 171, microfiche 0007 0009 0534, Brothers Collection (note 3).

24. Obituary: "LOF Design Director a Pioneer with Color," *Toledo Blade*, September 17, 1991.

25. "Their Job Is to Help You—Look 'Em Over," *The L-O-F Glassic*, January 1941, folder 5, box 11, Canaday Collection (note 4).

26. "L-O-F Appoints Wright," *Retailing*, September 24, 1945, File F-13, 171, microfiche 0007 0009 0325, Brothers Collection (note 3), and *L-O-F News and Views*, November 1945, folder 5, box 12, Canaday Collection (note 4).

27. Telephone interview with Peter Orser, October 5, 2000.

28. Davira S. Taragin, interview with Margaret Pilliod, March 1999.

29. Orser interview (note 27).

30. Ibid.

31. Taragin, Pilliod interview (note 28).

32. *American Glass Review*, April 2, 1949, File F-13, 171, microfiche 0007 0009 0706, Brothers Collection (note 3). While speaking to a convention of the American Institute of Architects, Doner said: "Mrs. Housewife will be able to walk into home furnishings stores throughout the country and find matching, harmonizing or contrasting colors in practically every known decorating material, which will allow her to blend the colors of her Vitrolite bathroom with all the other colors of her home."

33. Memo from Doner to fifteen individuals, April 26, 1950, folder 26, box 46, Canaday Collection (note 4).

34. "52 Designs to Modernize Main Street with Glass," folder 11, box 19, in ibid.

35. *Visual Fronts* (Toledo, Ohio: Libbey-Owens-Ford Glass Company, 1945).

36. The Design for Happiness campaign is extensively described in materials found in folder 17, box 17, and in "Design for Happiness," *The Batch*, October 1940, folder 1, box 11, Canaday Collection (note 4). Also see George P. MacNichol, Jr., "Comments," Sales and Promotion, Distributor/Dealer Training and Meeting Pamphlets, folder 19, box 16.

37. *Architectural Forum* 74, 1 (January 1941), pp. 49–52; 74, 2 (February 1941), pp. 64, 142–44; 74, 3 (March 1941), p. 52.

38. "Libbey-Owens-Ford 'On the Air,'" *The Batch*, September 1940, pp. 4–5, folder 1, box 11, Canaday Collection (note 4).

39. George P. MacNichol, Jr., talk to the New York Society of Security Analysts, February 9, 1954, p. 8, folder 11, box 19, in ibid.

40. Quoted from an undated press release issued by Carl Byoir and Associates, headlined "L-O-F Demonstrates Functional Kitchen for Post-War Homes." The Kitchen of Tomorrow is described in folder 31, box 17, in ibid., and *The L-O-F Glassic* issues of April 1944, June 1944, April 1945, and July 1945. See also *Better Homes and Gardens*, July 1943.

41. *The L-O-F Glassic*, July 1945, folder 6, box 11, Canaday Collection (note 4).

42. Davira S. Taragin, interview with Susan Coss, daughter of James Ashley, March 11, 1999.

43. *Design Perspectives*, February 1986 (Industrial Designers Society of America members newsletter).

44. *L-O-F News and Views*, June 1947.

45. *The L-O-F Glassic*, September 1962, folder 10, box 11, Canaday Collection (note 4).

46. "Controversy over Windowless Buildings Met Head-On by Educators, Architects," *The L-O-F Glassic*, December 1961, and "LOF Continues to Lead Fight Against Windowless Schools," *The L-O-F Glassic*, April 1963, in ibid.

47. Solar House file, folder 20, box 18, and Earl Aiken, "Glass in Future Building Construction," reprinted from *New Architecture and City Planning*, ed. Paul Zucker (New York: Philosophical Library, n.d.), pp. 233–36, folder 5, box 17, in ibid.

48. *The L-O-F Glassic*, November 1947, folder 6, box 11, in ibid.

49. Folder 23, box 17, in ibid.

50. *The L-O-F Glassic*, May 1954, folder 8, box 20; Press Releases, January–June 1954, folder 5, box 11; folder 8, box 11; and *The L-O-F Glassic*, March 1957, folder 8, box 11, in ibid.

51. "Decorama Presentations in 1956," folder 15, box 17, in ibid.

52. "Libbey-Owens-Ford Plans to Lay Off Over 800 in Illinois," *Wall Street Journal*, June 10, 1960.

53. During most of the period discussed in this essay, George P. MacNichol, Jr., a grandson of L-O-F founder Edward Ford, was a key manager who directly influenced design. Of the original founders, Edward Drummond Libbey left no children and Michael J. Owens's only son did not join the company.

54. "LOF Appoints Peter R. Orser Director of Advertising and Sales Promotion," *The L-O-F Glassic*, December 1967, folder 13, box 11, in Canaday Collection (note 4).

55. *The L-O-F Glassic* issues of February, March, April, June, and July 1968 featured diagrams of the new management structure and articles about the rationale and individuals in the new marketing approach.

56. These facts and interpretations are gleaned from annual reports dating from 1964 to 1982.

57. www.pilkington.com.

BIOGRAPHIES OF THE DESIGNERS

Robert F. Andrews
Howell, Michigan 1923–1991 Toledo, Ohio

Robert Andrews grew up in Monroe, Michigan, and graduated from Monroe High School in 1941. Ineligible for military service because of a medical condition, he began his automotive career that year at the Monroe Auto Equipment Company, teaching himself on the job. Also on his own, he pursued a lifelong interest in aerodynamics and aviation. In 1945 he joined the Hudson Motor Car Company where he worked under Frank Spring and Arthur Kibiger on the styling of the innovative 1948 "Step-down" Hudson. Upon completion of this project in 1946, he and Kibiger left Hudson and became staff designers for Delmar (Barney) Roos, chief engineer at Willys-Overland in Toledo. During this period Andrews worked on the design of the Jeep Station Wagon and the Jeepster. He joined Raymond Loewy in 1949 and contributed to various projects in that organization during the 1950s. For a time he assisted automotive illustrator Art Fitzpatrick with Buick ads. In 1960 Loewy invited him to be a member of the team that designed the 1963 Studebaker Avanti during a two-week period in Palm Springs. Andrews did the original scale clay model from which the final design was developed. During his career, Andrews held many patents, was a contributing editor to *Automotive Quarterly* and *Classic Car* magazines, and was a frequent speaker at automotive conferences. He was a consultant to Saab and Mercedes-Benz, designed an experimental BMW automobile, and participated in the interior design of the French Caravelle aircraft. He was an advisor to the Henry Ford Museum & Greenfield Village and the International Women's Air and Space Museum in Centerville, Ohio. He retired in 1985 to Monroe, Michigan, where he devoted himself to sculpture and painting.

Donald Earl Dailey
Minneapolis 1914–1997 Evansville, Indiana

Donald Dailey attended art classes at The Minneapolis Institute of Arts as a youngster. His family moved to Cleveland when he was in his teens, and just after high school, Dailey took a job drawing retail advertising. At an advertising club luncheon, he was inspired by Harold Van Doren's speech about industrial design's contribution to the business of new product introduction. Van Doren encouraged Deskey to study at the Toledo Museum School of Design and to take classes in marketing and engineering at the University of Toledo, where he studied from 1934 to 1936. In 1937 Dailey went to work for Van Doren in Toledo, assisting in the preparation of Van Doren's textbook, *Industrial Design,* and serving clients such as Toledo Scale and Miles Laboratories. In 1940 Dailey relocated to head the firm's second office, in Philadelphia, which served Philco, Westinghouse, and other East Coast clients. During World War II, Dailey worked on numerous Philco military projects. In 1946 he began an independent practice and continued to design for Philco products such as refrigerators, as well as small appliances for Proctor Electric Company. In 1950 he followed Philco's manager of refrigerator products to Servel, a maker of appliances in Evansville, Indiana. For five years as vice president of product planning at Servel, Dailey pioneered a new corporate approach to integrating design at top management levels. In 1955 he opened Don Dailey and Associates in Evansville, which he operated for forty years. His firm designed consumer and medical products, corporate identity and packaging, industrial equipment and vehicles, architectural and aircraft interiors, and furniture. His best-known designs include the 1945 manual Boston Pencil Sharpener that sold for fifty years, the 1969 Mallory Duracell CopperTop battery, and the twin-wheeled furniture

caster for Faultless Caster Company. Dailey was awarded eighty-seven US and foreign patents, was a guest lecturer at many universities, and contributed to many publications. His products earned him awards and exhibitions. Dailey joined the Society of Industrial Designers in 1946 and was instrumental in drafting the original Code of Ethics for the profession. He served on the board of the American Society of Industrial Designers and was elected a Fellow of the Industrial Designers Society of America in 1967.

Donald Deskey
Blue Earth, Minnesota 1894–1989 Vero Beach, Florida

Donald Deskey studied architecture at the University of California, Berkeley, and painting at the California School of Design, The School of The Art Institute of Chicago, and the Art Students' League in New York. After service in World War I, he worked in advertising and pursued a career as a painter. He studied painting in Paris and visited the influential 1925 Paris Exposition and the Bauhaus in Dessau, Germany. Upon his return to New York, he worked as an interior designer and retail display artist. An entrepreneur, he formed companies to manufacture and market his designed products. With partner Phillip Vollmer, he established Deskey-Vollmer (1927–31) to specialize in furniture and lighting, and in 1946 he started Shelter Industries, Inc., a short-lived attempt to manufacture and distribute prefabricated houses. Noted for his 1930s interiors, Deskey designed luxury apartments for prominent New Yorkers and interiors for the famed Radio City Music Hall (1932). His painted screens, textiles, and aluminum and tubular steel furniture are considered landmarks of American Modernism. In the 1920s and 1930s, Deskey experimented with synthetic and unconventional materials, such as laminated plastics and woods, asbestos, cork, and aluminum, and was hired by makers of plastic resins and aluminum foil to apply research to new uses. He designed glassware lines for Libbey in the 1930s. A pioneer in the industrial design profession, in 1928 Deskey was one of the founders of the American Union of Decorative Artists and Craftsmen (AUDAC), a group that promoted the work of allied designers with exhibitions and publications. He participated in major museum exhibitions and world's fairs and helped create the industrial design department at New York University in 1940. He formed Donald Deskey Associates in the mid-1940s, and within a decade the firm grew to be one of the country's largest industrial design firms and maintained international offices. Staff included Robert Vuillemenot, vice president in charge of packaging, who was the son of Toledo designer Frederic Vuillemenot. The firm designed packaging for Procter & Gamble for thirty years,

as well as commercial architecture, corporate identities, restaurant and hotel interiors, gasoline stations, and recreation facilities, with a philosophy that united product, packaging, and point-of-sale presentation as environmental packaging. Deskey continued his firm's work until the 1970s.

Freda Diamond
New York 1905–1998 New York

Raised by her widowed mother, costume designer Ida Diamond, Freda Diamond was influenced toward design in her childhood. After graduating in decorative design from the Women's Art School at the Cooper Union in New York, she taught there while working as a designer in an exclusive furniture store. She then entered the mass-market arena by designing window displays at Stern Brothers and soon rose to become the country's first female furniture buyer at a major department store. A home-fashions advisor to retailers, manufacturers, and trade associations, she promoted affordable, good design for the typical American. Diamond and her husband, industrial engineer Alfred Baruch, maintained their individual offices in their New York home. As a consultant to Libbey Glass for more than forty years, Diamond initiated top-selling glassware products and innovative merchandising programs. She authored *The Story of Glass* (1953) and wrote articles for the china and glass trade about styles as well as business issues such as pricing, brand identity, international competition, and inventory management. She coordinated color programs for organizations such as the Institute of Carpet Manufacturers and served as home-furnishings consultant to national stores in the Associated Merchandising Corporation, Hess', and May Company organizations. She designed interiors, furniture showrooms, textiles, and lines of furniture, such as the 1938 Shaker group for Herman Miller, as well as household products including lighting fixtures, a vacuum cleaner for General Electric, and door hardware for Yale & Town. She lent her expertise to international design efforts such as the 1945 program to revive postwar Italian crafts and design. In 1951 she was among a group of American designers selected to advise the Japanese government on design and merchandising; she served Israel's Ministry of Commerce and Industry in a similar role. She also consulted to stores and manufacturers in South Africa and Czechoslovakia. Her wide-ranging influence was described in a 1954 *Life* magazine article, "Designer for Everybody." She was a member of several design organizations and on the advisory board to the Cooper Union Museum, which later became the Cooper-Hewitt, National Design Museum, Smithsonian Institution.

H(albert) Creston Doner
Nevada, Ohio 1903–1991 Toledo, Ohio

H. Creston Doner was raised on farms and in small towns in Nebraska and Pennsylvania, as his family moved frequently to follow his father's work as a dairy operator. With little formal education after high school, Doner was a self-made man whose interests in how things worked moved him in his youth to install radios and work on oil wells in Oklahoma. Scant information exists on his early career. He returned to the family center in Ohio in 1932 to open a design office in Akron to work with B. F. Goodrich; he may have been working for Pittsburgh Plate Glass in 1937 when he was invited to Toledo by Libbey-Owens-Ford Glass Company. "Cres" Doner directed the Department of Design at L-O-F for thirty years, from 1938 to 1967, in close cooperation with the company's advertising and sales staff. Flamboyant in appearance and behavior, Doner operated in a supportive corporate environment. Under his direction, design was used to bring excitement to a generic product and to develop architectural and interior design applications for L-O-F glass. His most celebrated project, the Kitchen of Tomorrow conceived in 1942, forecast new family living and architectural trends while it displayed various uses of glass. Doner spoke at L-O-F sales meetings and participated in national professional conferences as an expert on color and lighting effects. He coordinated L-O-F promotional campaigns that included films, brochures, demonstrations, and retail and trade show displays. Always interested in apparel, he dressed in colorful attire and art-directed fashion shows. After his retirement in 1968, Doner opened an independent consulting practice in Toledo. He was an honorary member of the Environmental Research Foundation of Topeka, Kansas, and national secretary of the Industrial Designers Institute (IDI) in 1956 and president in 1959–60. In 1961 he served as public relations committee chairman and was named a Fellow of the Industrial Designers Society of America (IDSA).

Harley J. Earl
Hollywood, California 1893–1969 West Palm Beach, Florida

Harley Earl attended the University of Southern California in 1912 and studied engineering at Stanford University from 1914 to 1917. He began his career in his father's company, Earl Carriage Works, founded in 1889 near Los Angeles. Renamed Earl Automobile Works in 1908, the company began to design and build custom car bodies for early film stars. Around 1918 it produced its first entire car, designed by Harley Earl. The car's unusual lower, more rounded profile, decorative details, and color brought him attention. The company was purchased in 1919 by the West Coast Cadillac distributor Don Lee Coach and Body Works, and Earl became a designer and general manager for the new firm. In 1921 he patented a design that hinted at the wrap-around windshield he later pioneered. In 1926 the Fisher Brothers of General Motors hired him as a consultant to Cadillac. The success of Earl's 1927 LaSalle, the first American production car designed by a stylist, caused General Motors Chairman Alfred P. Sloan to establish a new Art and Color Section in 1927 to be headed by Earl, who then moved to Detroit. Retitled the Styling Section in 1937, this department directed body design and conducted research and development. Earl is credited with designing the first built-in luggage compartment (replacing the bolted-on trunk) and with the removal of the outside spare tire. In 1940 he was named vice president, a position unique for a designer in US corporate management. He trained a generation of stylists and model makers and challenged GM engineers and outside suppliers to develop a variety of innovations. Earl's use of full-size clay, rather than wood, models allowed designers to visualize more sculptural, complex body shapes. He also pioneered the practice of conceptualizing the automobile as a whole, rather than a collection of parts, and hired women designers in an effort to add features appealing to female consumers. In the 1950s, peak years for US car production, Earl's personal stamp—the hardtop convertible, tailfins, two-toned paint treatments, and heavy chrome plating—defined American car culture. Earl's contributions to the US auto industry remain unparalleled. Between 1927, when he joined General Motors, and 1959 when he retired, he influenced fifty million vehicles. Earl also formed an independent product design firm, Harley Earl Corporation, which developed consumer products for companies that did not compete with General Motors.

Gordon William Florian
Bridgeport, Connecticut 1909–1984 Bridgeport

Connecticut native Gordon Florian studied at Yale University School of Fine Art in New Haven, Connecticut, and the Grand Central School of Art in New York. Because of the Depression, Florian left school to seek employment in 1931 at the General Electric Company, where he worked in commercial research and market analysis. There he first heard of industrial design and approached the head of Appearance Design, Ray Patten, for a position. Florian worked in the design department from its inception in 1935 until 1945, becoming assistant director in 1940. At General Electric he designed consumer appliances and wartime military equipment. After heading design for Reeves-Ely Sound Laboratories in New York for one year, Florian opened an independent practice in 1946 in Bridgeport, Connecticut. He accumulated sixty design patents. His designs for clocks for Seth Thomas and appliances for Camfield Manufacturing Company and Sunbeam Corporation, office equipment for Dictaphone, locomotives for Fairbanks-Morse, and vacuum cleaners for the Air-Way Electric Appliance Corporation in Toledo were exhibited in US and international exhibitions of the

Plate 1

D. Benjamin Replogle, *Air-Way Sanitizor 55A*, 1938
Air-Way Electric Appliance Corporation
plated steel, zinc, paint, and fiber
25 × dia. 14 inches
Lucas County/Maumee Valley Historical Society, Maumee, Ohio

Gordon W. Florian, *Air-Way Sanitizor 77*, patented 1948
Air-Way Electric Appliance Corporation
aluminum and steel
22¼ × 9⅞ × 9⅞ inches
Anonymous loan (All rights reserved, The Florian Family Trust)

The 1913 establishment in Toledo of the Vacuum Cleaner Manufacturers Association indicated the city's prominent position in this appliance category. The Air-Way Electric Appliance Corporation, founded in 1920, and D. Benjamin Replogle, who developed

the products it sold through the 1940s, patented many firsts in the industry, notably the disposable paper bag. His 1938 "Sanitizor," the company's first canister vacuum, included a collar for storing hose and cord and a swivel hose connection that allowed the user freedom to clean without continually moving the unit. It was sold by in-home demonstrators until 1950, when Connecticut-based designer Gordon W. Florian updated it with a more fashion-conscious postwar model. The square design with four runners distributed the unit's weight evenly, allowing it to be used and stored vertically or horizontally. The runners doubled as handles, but the Model 77 added a carrying handle on the top. Few parts and lightweight materials reduced manufacturing costs. The die-cast parts, such as the foot pedal, were made in Toledo by Doehler-Jarvis; the Toledo-made motor was the same one used in the earlier Sanitizor models.

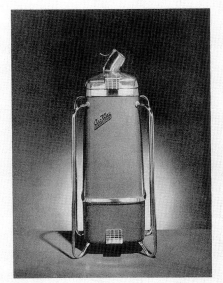

AIR-WAY SANITIZOR

AIR-WAY ELECTRIC APPLIANCE CORPORATION INDUSTRIAL DESIGNER—GORDON FLORIAN
ENGINEERED BY THE ENGINEERING STAFF OF AIR-WAY ELECTRIC APPLIANCE CORPORATION

RIGHT: PREVIOUS MODEL

55

Plate 2
Air-Way Sanitizor as It Appears in Society of Industrial Designers, U.S. Industrial Design 1949–1950 (New York: The Studio Publications Incorporated, 1949) photo panel

1940s and 1950s, including the Triennale exhibitions in Milan. In 1941 Florian taught industrial design at the Junior College of Connecticut which later became the University of Bridgeport. There, with others, he established a four-year industrial design degree program in 1949 and was named associate professor in 1950. A member of the Society of Industrial Designers since 1945, Florian lectured at the Harvard Graduate School of Business Administration in 1950 along with Raymond Loewy, Walter Dorwin Teague, Henry Dreyfuss, and other leaders in the profession; from 1950 to 1954 he lectured to engineering and business students at the Massachusetts Institute of Technology. Florian was also an award-winning artist whose watercolor and oil paintings were exhibited in many galleries in New York and New England.

Brooks Dwight Fuerst
Ottawa, Ohio 1905–1983 Toledo, Ohio

Dwight Fuerst studied at the Toledo Museum of Art School of Design. He began working at Owens-Illinois Glass Company in 1934, under his brother Edwin W. Fuerst, and in 1937 was named chief of the Package Design Group in the Glass Container Division; he remained in

that position until his retirement in 1970. During his career at O-I, Dwight Fuerst led a department that designed proprietary containers for clients in the food, beverage, and chemicals industries. The department designed glass bottles as well as closures, labels, and cartons. In the 1960s it developed and designed glass composite containers (glass bottles enclosed in plastic foam) and began designing plastic containers. Under his direction such notable achievements as the Wishbone salad dressing bottle of the 1960s were developed.

Edwin W. Fuerst
Ottawa, Ohio 1903–1988 Springfield, Massachusetts

Edwin W. Fuerst left high school during his junior year after the death of his father and went to work at the Detroit Steel Range Company. He then worked at Willys-Overland Motors, Inc., for a short time. He returned to Detroit Steel Range, where he learned tool and die designing while also working as a night superintendent and paymaster. While in the steel industry, he began attending classes at the Toledo Museum School of Design in 1927, continuing as a student until 1932. In 1929 he established his design office in Toledo, and in 1930 one of his first accounts, the Owens-Illinois Glass Company, hired him as designer and stylist of its design studio, which concentrated on glass containers and proprietary bottles. After Owens-Illinois acquired Libbey Glass in 1935, Fuerst organized and headed its design department. He is noted for his Embassy line of stemware, developed with Walter Dorwin Teague, for the 1939 New York World's Fair, and the 1940 Modern American line of handmade glassware. Fuerst left Libbey in 1944 and opened his own design office in Toledo, specializing in package design, which operated until about 1952. His studio facilities included a complete photographic and model shop. He did distinctive packages for Mott's Apple Sauce and Sunsweet Dried Fruits, among other products. From 1948 to 1949 he taught industrial design at the school of fine arts at Ohio State University. In the mid-1950s he became a freelance painter and moved to New England. He became special assistant to the vice president in charge of sales for the Plax Corporation of Hartford, Connecticut, from which he retired in 1966.

Stan Edward Fuller
born Akron, Ohio, 1938

Stan Fuller grew up in Pennsylvania and received a bachelor of science degree in design in 1961 from the University of Michigan. A year after graduation, Fuller came to Toledo to work in the firm of his former teacher, J. M. Little, where he gained experience in all aspects of product planning including concept development, human engineering, model building, and presentation techniques. Notable projects included the innovative 1963 Do-It-Yourself Greenhouse Kit for Ohio Plate Glass Company. After Little closed his firm in 1967, Fuller opened S. E. Fuller/Associates in Maumee, Ohio, designing graphics,

Introduction

The intent of this concept study is to suggest basic methods which would simplify the molding of motorcycle helmets, but would not destroy the esthetics of the finished product.

Primary attention has been focused on the possibility of molding two separate parts, which would be joined to produce the complete helmet assembly. One concept does suggest however, that a one part helmet design would be possible.

The ideas presented are basic concepts and not detailed studies of draft, material thickness, joint details or specific mold requirements. Some fundamental joint details and draft angles have been indicated where they might be appropriate.

Variations/combinations of these ideas may be considered, but design selections should satisfy both the molding process and the overall appearance of the finished product.

All concepts have considered the visor and the face opening as a single design problem. Both should appear compatible by reflecting the other's silhouette.

A two part helmet design would present an excellent opportunity to change color/texture of the individual parts and offer unique appearance options.

Design

s.e. fuller / associates

1 Molded as one part

2a Horizontal Joint—bottom of face opening

2b Horizontal Joint—thru face opening

3a Vertical Joint—front and rear sections

3b Vertical Joint—right and left sections

4 Added chin section

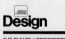

2b

Horizontal Joint—thru face opening

This concept also suggests molding two separate parts. These would be joined at an appropriate point midway in the face opening.

Each part would be approximately the same depth and would not require deep molds. These parts would offer excellent flexibility in shaping the final helmet contour and would allow more liberal radii around the total face opening.

This concept also offers the unique opportunity to utilize the upper section of the full helmet to produce a smaller helmet design. The joint detail should be carefully considered. It should not complicate the upper part, since it will be used for another purpose.

Color/texture changes of the individual parts or molded accents may also be considered.

a. Joint line between parts.
b. Upper part of the full helmet design.
c. Lower part may be rounded to control the head opening and to contour the total helmet shape.
d. Visor added to upper section may be attached at the same point used for the full helmet design.
e. Added chin strap and inside padding, would complete the small helmet design.
f. Visor for the smaller helmet may be molded into the upper part to simplify manufacturing.

Design

s.e. fuller / associates

packaging, and products for local and national clients. Fuller has
designed graphics and building products for Owens-Corning Fiber-
glas Corporation, automotive mirrors for Acme Specialty Company,
food service facilities for Gladieux Corporation, drive-in terminals for
Meilink Bank Equipment, industrial cleaning machines for National
Super Service Company, DeVilbiss industrial products, and cookware
accessories for the Commercial Aluminum Company.

James F. Fulton
born Cincinnati, Ohio, 1930

James Fulton earned a certificate in industrial design from Pratt Insti-
tute in 1951 and a bachelor's degree in 1976. In 1951 he joined the
Owens-Corning Fiberglas Corporation in Toledo where, as the com-
pany's first staff designer, he was responsible for exhibits, packaging,
and ceiling and plumbing products. Two years later he joined the
Harley Earl, Inc., product design firm in Detroit (1953–58). In 1958
he was appointed design director and subsequently managing director
of Raymond Loewy's Paris office, where he directed the redesign of
corporate identity for the British Petroleum Company and built the
office into an important force in European design. In 1960 Fulton be-
came director of product design, transportation, and housing compo-
nents in the Raymond Loewy/William Snaith Inc. office in New York.
Appointed a vice president in 1962 and senior vice president in 1964,
he was responsible for major client programs such as Shell Oil and the
US Pavilion at the Seattle World's Fair. He led the team that developed
the glass-ceramic Libbey Ware line for Owens-Illinois. In 1966 Fulton
founded Fulton + Partners, Inc. Planning and Design Consultants
in New York, and added a Paris affiliate, Endt + Fulton, in 1975. In
1968 he was retained as consultant design director by Owens-Corning

Fiberglas Corporation, where over a ten-year period he developed
applications for Fiberglas and organized the Owens-Corning Art
Collection. In 1977 Fulton and a group of colleagues formed the first
designer-owned publishing company, Design Publications, Inc., which
published *I.D.* magazine and the *Design Review.* He established the
Design History Foundation in 1987 to acquire items from the Ray-
mond Loewy archives for the Library of Congress. The foundation
took on the publishing responsibility for *Places: The Journal of Envi-
ronmental Design* in 1989. A member of the Industrial Designers
Society of America (IDSA) since 1958, Fulton was president and chair-
man in 1976–77 and was appointed a Fellow in 1977; he has served
as chairman of the ethics advisory and fellowship committees. In 1991
the IDSA New York chapter presented Fulton with the Bronze Apple
Award for significant contributions and dedication to the profession.
In 1969 he became a trustee of Pratt Institute, where he currently
serves as chairman. He is a trustee of the Worldesign Foundation,
where he also chairs the nominations committee.

Norman Melancton Bel Geddes
Adrian, Michigan 1893–1958 New York

Born a short distance north of Toledo, Norman Bel Geddes (né Geddes)
had little formal education. He did not finish high school and attended
only briefly the Cleveland Institute of Art and The School of The Art
Institute of Chicago before beginning work as an advertising drafts-
man in Chicago and Detroit in 1913. After his marriage to Helen Belle
Sneider of Toledo in 1916, the two created the surname of Bel-Geddes
as they pursued their careers as theater designers and writers. After
their divorce in 1932, Norman retained the name without the hyphen.
He wrote plays and designed theater sets, was a stage designer for the
Metropolitan Opera Company in New York, and in 1925 designed
sets for Hollywood film-makers Cecil B. DeMille and D. W. Griffith.
In 1927 Geddes ventured into the new field of industrial design by
styling New York department store windows and furniture for the
Simmons Company. Although the projects were not realized, in 1929
he designed products and buildings for the Toledo Scale Company,
a commission facilitated by his uncle, Frederick Geddes, who was
a director of the Toledo Scale Company and a trustee of the Toledo
Museum of Art. Also in 1929 Geddes was invited to design the theater
stage within the museum and, as a consultant to the Architectural
Commission of "A Century of Progress Exposition" in Chicago, he
submitted plans for the fair's theaters and restaurants, projects that
were not executed. Although he was noted primarily for his stream-
lined, teardrop-shaped aerodynamic automobiles, airplanes, and ocean
liners, General Motors' Futurama building at the 1939 New York
World's Fair, his books *Horizons* (1932) and *Magic Motorways* (1940),
and urban planning such as his 1945 Toledo Tomorrow concept, most
of Geddes's visionary designs were never built. He designed popular

household products such as radios, cooking ranges, and tableware in the 1930s and military equipment during World War II. One of the founders of the industrial design profession, Geddes influenced a generation of practitioners: Russel Wright, Henry Dreyfuss, and Eliot Noyes, among others, worked for him at formative moments in their careers.

Tom Geismar
born Glen Ridge, New Jersey, 1931

Tom Geismar concurrently attended the Rhode Island School of Design and Brown University and graduated in 1953. He went on to the Yale University School of Art and Architecture, where he received a master's degree in graphic design in 1955. As a principal in Chermayeff & Geismar Inc., the firm he founded with Ivan Chermayeff in 1960, Geismar has been responsible for the design of more than a hundred corporate identification programs for major US businesses, including Xerox, Chase Manhattan Bank, Knoll, Rockefeller Center, and Mobil Oil. He has also developed graphic programs for many public institutions, including The Museum of Modern Art and the National Park Service. As an exhibition curator and designer, he created major installations for international expositions for the US government, and exhibitions at the Hayden Planetarium, the Statue of Liberty Museum, and the Library of Congress. Geismar was chairman of the US Department of Transportation advisory committee that developed a new national system of standardized symbols. He has been a professor at the Cooper Union in New York and served on advisory committees at Yale's School of Art and the Department of Design at Carnegie Mellon University. His many honors include the Gold Medal in 1979 from the American Institute of Graphic Arts, an honorary doctorate from the Corcoran School of Art in 1995, and induction in 1998 into the Art Directors Hall of Fame. He was the author/designer of *Spiritually Moving*, a book on American folk sculpture (New York: Abrams, 1998). In 2000 Princeton Architectural Press published an anthology of Chermayeff & Geismar's trademark designs.

Vincent J. Geraci
born Pittsburgh, 1934

Vincent Geraci studied automotive engineering and design at the Chrysler Institute of Engineering (1952–55) in Highland Park, Michigan, and management at Wayne State and Michigan State Universities. He began his automotive styling career in 1955 as a designer for the DeSoto Division of Chrysler Corporation, and later served as a designer with the Imperial and Plymouth styling studios. He joined American Motors Corporation in 1959 as a staff designer, in 1961 became assistant manager of exterior design, and in 1965 was named manager of the Rambler and Ambassador studio. Appointed director

of interior design at American Motors Corporation in 1971, he remained in that position until the Chrysler and AMC design studios merged in 1987; he was responsible for the interior styling for American Motors passenger cars and Jeep vehicles. As director of interior design for the Jeep/Renault Division (1973–85), he coordinated design efforts between the AMC design office and the Renault office in Paris. From 1985 to 1992, he directed the interior styling of the Jeep Wrangler, the Wagoneer, and the Jeep Cherokee, the single most successful product in Jeep history. While chief of exterior design and product identity at Chrysler's central design office (1987–90), he developed themes for the all-new Chrysler LHS series vehicle. As design consultant to the Chrysler Corporation International Division (1990–92), he directed interior theme proposals for a future downsized Lamborghini sports car and trim details for the Austrian minivan program. Currently he heads VJG Design under contract to Johnson Controls, a leading supplier of interior systems to the automotive industry. He continues to consult on design issues related to Chrysler Jeep and passenger cars.

Bruce Alonzo Goff
Alton, Kansas 1904–1982 Tyler, Texas

Bruce Alonzo Goff's early years were spent in Kansas, Colorado, and Oklahoma; his family settled in Tulsa in 1915. Goff began his architectural career as a twelve-year-old apprentice at a Tulsa architectural firm. His eclectic work took inspiration from many European and American influences, most prominently Louis Sullivan and Frank Lloyd Wright. Goff also composed music and maintained active connections with professional and student musicians, dancers, and artists. He worked for the Libbey-Owens-Ford Glass Company in Chicago and then moved to Toledo to work at the company's headquarters, where he designed architectural applications for varied types of glass. Except for one year (1936–37) when he lived in Toledo—in an apartment house directly across from the Toledo Museum of Art—Goff spent 1934 to 1942 in the Chicago area. Prior to his year in Toledo, Goff collaborated

Plate 4
Sherman L. Kelly, *Ice Cream Scoop*, patented 1939
The Zeroll Company
aluminum
1½ × 7 × 1⅝ inches
Anonymous loan

Developed by Sherman Kelly, an inventor, designer, and entrepreneur, this aluminum scoop relied on a self-defrosting liquid within the hollow core that warmed in the user's hand and melted the contact layer of ice cream during scooping, thereby preventing the ice cream from sticking to the scoop's cup. The scoop benefitted ice cream parlor managers because it had no moving parts that could break or jam, increasing speed and ease of use. It also provided more servings per gallon, thus increasing profits, because it rolled the ice cream into a ball instead of squeezing it. Produced to Kelly's specifications by the Aluminum Company of America (ALCOA), the die-cast scoop was made in five capacities. The tool has been in continuous production since its debut in 1935 and was included in The Museum of Modern Art design collection in 1956.

with Alfonso Iannelli in his architectural and industrial design projects and taught at the Chicago Academy of Fine Arts. Upon his return to Chicago, he opened an independent practice; one of his projects was designing a home/studio in Chicago for Charles Turzak, a commercial artist who had done architectural illustrations with Goff at Libbey-Owens-Ford. After serving in World War II, Goff became chairman of the School of Architecture at the University of Oklahoma at Norman (1947–55), where he developed a curriculum that presented his organic approach to architecture. His unconventional buildings, primarily residences, in Oklahoma, Texas, and California, demonstrate Goff's visionary interpretations of unusual forms, spaces, and materials.

Gerald D. Gulotta
born Rockford, Illinois, 1921

Gerald Gulotta graduated from Rockford High School in 1939, studied commercial art in Chicago (1939–40), and then returned to his hometown to work as a draftsman/designer for an inventor. After military service in Europe, he entered Pratt Institute in New York in 1947 and graduated in 1950. He designed for Towle Silversmiths, Eva Zeisel, and George Nelson, and was working independently when he became a consultant to Raymond Loewy/William Snaith Inc. in New York in 1961–62. He participated in designs for Libbey Ware cookware for Owens-Illinois and experimental Fiberglas furniture and bathroom units for Owens-Corning Fiberglas Corporation. Since 1963 he has operated Gerald Gulotta Design, Inc., in New York and is internationally known for his ceramics and glass designs. His clients include Block China Corporation, Dansk International Designs (USA), and European and Asian manufacturers. Also an educator, Gulotta was a professor of design at Pratt Institute (1955–84) and developed design education programs in several countries. Under the Ministry of Economics, he organized and directed an industrial design workshop in Portugal in 1974 to form a professional staff for a design center to serve Portuguese industry. In 1976 and 1977 he formulated the industrial design curriculum for a new school of design at the University of Guadalajara in Mexico and trained the faculty. In 1982 he lectured at several colleges in China and was invited to design porcelain dinnerware lines for Chinese factories; seven of his miniature stoneware teapots made for the Violet Sand Factory were acquired for the permanent collection of the Cooper-Hewitt, National Design Museum, Smithsonian Institution.

Sherman L. Kelly
Reedsburg, Ohio 1869–1952 Toledo, Ohio

Inventor and entrepreneur Sherman Kelly attended rural schools in Pioneer, Ohio, and began his career as a clerk and apprentice ironworker in a hardware store. He later owned two hardware stores and became associated with the Wabash Portland Cement Company in Stroh, Indiana. In 1902 he developed a concrete block manufacturing machine and founded the Ideal Concrete Machine Company in Auburn, Indiana. In 1908 he sold his interest in the firm and devoted his time to developing a generator, which led to the formation of the Electric Auto-Lite Company in Toledo in 1911. He and his two cofounders sold the company to John North Willys in 1913. Kelly then founded the Standard Electric Stove Company in 1914, which he sold in 1924. He retired to Florida in 1930, but soon sought new opportunities. He returned to Toledo and in 1933, after seeing the struggles of a server in an ice cream shop, became intrigued with how to improve the ice cream scoop. After experimenting with metals, electricity, and special

fluids, he discovered that thin aluminum transmitted heat from a person's hand to a sealed-in liquid. He founded The Zeroll Company in Toledo in 1935 to produce the scoop he designed. The company changed names several times, becoming, after Kelly's death, Roll Dippers, Inc. in 1953 and Roll Dippers Company in 1968. Renamed The Zeroll Company in 1980, since 1990 it has operated in Fort Pierce, Florida, and continues to manufacture the original scoop patented in 1939.

Arthur H. Kibiger
Fort Wayne, Indiana 1907–1998 Canton, Ohio

Arthur Kibiger studied automotive and mechanical drawing in vocational school and high school from 1925 to 1929, then studied architecture through a correspondence school (1928–30). He began working in 1926 as a draftsman in a Fort Wayne architectural firm and later designed ornamentation for a building contractor. He began his automotive career in 1932, building and painting custom auto bodies for H. E. Campbell & Sons. From 1933 to 1934 he worked as an artist/draftsman at Auburn Automobile Company (Auburn, Indiana). He moved to Detroit and from 1934 to 1946 was assistant director of styling at Hudson Motor Car Company under Frank Spring. During that time he studied clay modeling at the Detroit Society of Arts and Crafts (1938–40). He worked on the 1936 Hudson and Terraplane, two cars with the same body but differing interior and exterior details. The 1936 Hudson was replaced by the daring 1948 "Step-down" Hudson, a milestone body design that resulted from wartime research by Spring and Kibiger. In 1946 Kibiger became director of styling at Willys-Overland Motors, Inc., in Toledo, where he developed five complete car programs under Delmar Roos, vice president of engineering. He oversaw the layout of the Jeepster body. In 1952 he began working for Chrysler in Highland Park, Michigan, where the following year he was named chief stylist of interiors for all divisions under Virgil Exner. He left Chrysler in 1958 and worked briefly as an independent stylist. In his later career his involvement shifted more toward the engineering aspects of design. He became chief engineer of design activities under Richard Teague at American Motors Corporation. He retired from AMC in 1973 after more than forty years in automotive styling and engineering.

Belle Kogan
Ilyashevka, Russia (present-day Ukraine) 1902–2000 Petach Tikva, Israel

Belle Kogan immigrated to the United States with her family in 1906. The first of eight children, she assisted her father in his jewelry store, where she developed her aesthetic sense and business acumen by selling silverware and gift items. She studied at New York University, Pratt Institute, and the Rhode Island School of Design. She began her career when the Quaker Silver Company hired her in 1929 and sent her to Europe to learn more about glass and silver manufacturing processes. In 1932 she opened her own design office in New York and over time earned an international reputation for her fine silver, glassware, and home furnishings. One of the first independent women designers, she worked for manufacturers of tableware, appliances, clocks, and radios, such as Warren Telechron, Samson United Corporation, Proctor Electric, Reed & Barton, Red Wing Potteries, Bausch & Lomb, Federal Glass Company, and Libbey Glass. From the 1930s into the late 1950s, she wrote articles in trade and consumer publications on the importance of design and lectured about sensitivity to materials. She pioneered uses of plastics, designed early products in Bakelite, and designed melamine dinnerware for Boonton Molding Company. Kogan closed her New York office in 1970 and moved to Israel, where she opened a design studio and worked for the country's Ministry of Commerce and Industry before her retirement. Her works are included in the permanent collections of many museums and have won numerous awards. She was one of the founders of the American Designers Institute in 1938 and served as an officer of the New York chapter, developing educational and ethical standards for the profession. The ADI and other organizations combined in 1965 to form the Industrial Designers Society of America (IDSA). A Fellow of the IDSA, she received the IDSA Personal Recognition Award in 1994 for her contributions to the profession.

Keith J. Kresge
born Franklin, Pennsylvania, 1946

Keith Kresge grew up in Bay Village, Ohio, and graduated from the Cleveland Institute of Art in 1969 with a bachelor of fine arts, majoring in industrial design with a minor in graphic design. He began working at the General Motors Technical Center in Warren, Michigan, where he focused on motor home interiors. After one year he left GM and worked independently in Ohio with consulting firms such as F. Eugene Smith Associates. In 1971 he joined Richardson/Smith, Inc. (now Fitch) in Worthington, Ohio, where one of his earliest assignments placed him on the team that developed the Time Control Bathroom System for Owens-Corning Fiberglas Corporation. Under Owens-Corning's creative director Merritt Seymour and Richardson/Smith project manager David Tompkins, Kresge generated alternative concepts and visual solutions in the complex design project. Skilled in concept development and refinement as well as the preparation of presentation drawings and illustrations, Kresge was named senior vice president at Fitch in 1997. He coordinates interdisciplinary programs in product development, systems, design languages, and strategies for clients such as Crown Equipment, NCR, Xerox, Eastman Kodak, Sanyo, Rubbermaid, Procter & Gamble, Hasbro, and Little Tykes.

Dominick Labino
Fairmount City, Pennsylvania 1910–1987 Grand Rapids, Ohio

After finishing high school, Dominick Labino worked at a Pittsburgh glass company and attended the Carnegie Institute of Technology. He began working at the Clarion, Pennsylvania, Owens-Illinois glass container manufacturing plant in 1934 and remained there until 1946, when he moved to Toledo to work for the Johns-Manville Fiber Glass Corporation. During his twenty years as vice president and director of research development (1946–65) and then an additional ten years as research consultant (until 1975) to Johns-Manville, Labino earned more than sixty patents for furnace designs, glass composition formulas, and new techniques in producing glass fibers. His most notable technical achievements were his invention of silica fibers as insulation against extreme temperatures in the Apollo, Mercury, and Gemini spacecrafts and astronaut suits as well as the tiles covering the space shuttle Columbia. When the Toledo Museum of Art sponsored its first studio glass workshop in 1962, Labino, who had studied at the museum's School of Design, was invited to participate. After this experience, Labino constructed a glassblowing studio on his farm in Grand Rapids in 1963 and, upon his retirement from Johns-Manville in 1965, concentrated on his art. He conducted artist workshops at his studio, taught glassblowing at Kent State University and the University of Wisconsin, and became an adjunct professor at Bowling Green University. His work was featured in solo exhibitions at The Corning Museum of Glass (1969), The Victoria and Albert Museum (1974), and the Toledo Museum of Art (1984), and his pieces are included in the permanent collections of many museums. He was named honorary curator of glass at the Toledo Museum of Art in 1968 and was elected to the museum's board of trustees in 1974.

J. Gordon Lippincott
White Plains, New York 1909–1998 North Haven, Connecticut

Walter Margulies
Paris 1914–1986 Hobe Sound, Florida

J. Gordon Lippincott earned an engineering degree in 1931 from Swarthmore College and then a master's degree in architecture and civil engineering from Columbia University. He joined the faculty at Pratt Institute in 1936 and, with Donald Dohner, established its design education program. He wrote *Economics of Design* in 1937. Dohner & Lippincott was formed in New York in 1943 and established a design laboratory within the Douglas T. Sterling Company, a management consulting firm based in Stamford, Connecticut. They designed stores, theaters, and hotel interiors as well as household

appliances, office and industrial equipment, and packaging. Upon Dohner's death in 1943, Lippincott assumed the editing of the industrial design section of *Interiors* magazine and reformed his firm as J. Gordon Lippincott and Company. In 1944 Lippincott hired Walter Margulies, who had studied architecture at the Ecole des Beaux-Arts in Paris and had designed interiors for several buildings at the Paris Exposition of 1937 and the 1939 New York World's Fair with Walter Dorwin Teague. Their partnership, which became Lippincott & Margulies in 1945, published *Design for Business*, a book that reviewed historical precedents and modern production and merchandising methods, and worked on the design team for the famed Tucker Torpedo automobile. In the early 1950s the firm helped design the interiors for the Nautilus, the first atomic-powered submarine. Most importantly, Lippincott & Margulies pioneered corporate and brand identity and image management consulting. They developed famous corporate trademarks, such as the Betty Crocker spoon and the General Mills "G," and served notable clients including Coca-Cola, Xerox, U.S. Steel, and Chrysler; Champion Spark Plug was one of their earliest clients. The firm organized a Market Research Institute that published *Design Sense* (begun in 1956 and continuing as *Sense* in 2000), a periodical for corporate managers on packaging, product styling, store planning, and merchandising trends. Lippincott retired in 1969 and sold his interest to Margulies. Lippincott & Margulies is now a unit of Mercer Consulting Group, a division of Marsh & McLennan, an international consulting firm.

John McLeod Little
Minneapolis 1906–1996 Cleveland

J. M. Little was educated at the Minneapolis School of Art (1925–27) and at the Art League of Minneapolis (1927–29), after which he worked for the BBDO advertising agency. From 1931 to 1936, Little maintained his own Minneapolis office, expanding his graphic design and packaging work to include product design. He relocated to Toledo in 1936 to become executive assistant to Harold Van Doren. Little assisted Van Doren in the writing of *Industrial Design* and managed the office while Van Doren was occupied with book preparation. When Van Doren opened a second office in Philadelphia in 1941, Little remained to direct the Toledo office (for clients west of Pittsburgh) until 1943, when he established J. M. Little and Associates. His firm designed consumer and industrial products, corporate identity programs, packaging, and trade show exhibits for clients such as Toledo Scale, Air-Way Electric Appliance Corporation. Hettrick Manufacturing Company, Crosley, Bendix, General Electric, Owens-Corning Fiberglas, B. F. Goodrich, Clevite Corporation, and Eastman Kodak. Little lectured at many universities and taught at the universities of Michigan and California at Berkeley. He wrote articles for trade and consumer magazines; his

design for a modern kitchen was featured in the April 1953 *Better Homes and Gardens.* He joined the Society of Industrial Designers in 1947 and was a member of the Inter-Society Color Council. After selling his firm in 1966, Little continued as a consultant in Florida and California. He studied silversmithing and crafted jewelry in California, New Mexico, and Texas before returning to Ohio in 1989.

Harvey K. Littleton
born Corning, New York, 1922

Harvey K. Littleton grew up with glassmaking, as his father was director of research at Corning Glass Works. In his youth, his visits to laboratories encouraged him to experiment in glass. He studied at the University of Michigan, Ann Arbor (1939–42), and at the Cranbrook Academy of Art. After military service in Europe (1942–45), he studied at the Brighton School of Art in England. He returned to the University of Michigan to receive a bachelor of design degree (1947). From 1949 to 1951 Littleton earned an MFA in ceramics at Cranbrook while also teaching ceramics at the Toledo Museum of Art School of Design. He taught at the University of Wisconsin–Madison (1951–77) and was chairman of the Department of Art in the 1960s. Study of glassmaking techniques in Europe helped Littleton develop his belief that an individual craftsman could make sculptural statements in this medium in his own studio. He organized the two workshops at the Toledo Museum of Art in 1962 that were the genesis of the Studio Glass Movement. These workshops brought the technical expertise from industry to artists, who came primarily from the ceramics tradition. In 1971 Littleton published *Glassblowing: A Search for Form,* which for several years was the only book on technique directed to artists. In 1974 Littleton pioneered the process of vitreography, printmaking on glass, which he exhibited throughout the 1990s. In 1977 he established a studio in Spruce Pine, North Carolina, which he maintains today. His achievements in sculptural glass have been recognized with research grants that include the National Endowment for the Arts Craftsman's Fellowship and six grants from the University of Wisconsin. He has been a trustee of the Pilchuck Glass School and a Fellow of The Corning Museum of Glass. He has received many honors, notably the Honorary Doctor of Fine Art from the University of Wisconsin–Madison as well as honorary doctorates from the Rhode Island School of Design and the Philadelphia University of the Arts, the Gold Medal of the American Crafts Council, the Lifetime Achievement Award of the Glass Art Society, and the Living Treasure of the State of North Carolina. Littleton's works have been featured in many solo and group exhibitions in the United States and Europe and are held in collections worldwide.

Raymond Loewy
Paris 1883–1986 Monte Carlo

Frenchman Raymond Loewy arrived in America in 1919 after service in World War I. Fascinated since childhood with how products looked and functioned, and trained as an engineer, Loewy quickly found success as a fashion illustrator for *Vogue* and *Harper's Bazaar,* and as a display designer for New York department stores. In 1929 he received his first product design commission: to restyle the Gestetner duplicating machine. This project launched his career, and in 1934 his model of an industrial designer's office, shown in The Metropolitan Museum of Art's design exhibition, created the image of the new profession. An astute and debonaire businessman who hired talented staff and used public relations to develop clientele, Loewy popularized the practice of industrial design through his lavish lifestyle and compelling personality as much as through his projects. He proposed the Most Advanced Yet Acceptable (MAYA) approach to introducing new design concepts to consumers and clients. In 1944, with four partners, he formed Raymond Loewy Associates (renamed Raymond Loewy/William Snaith Inc. in 1961), which by the mid-1950s was a very successful consultancy with a large staff in New York, Chicago, Los Angeles, and London. He began designing for Studebaker Corporation in 1938 and maintained an office in South Bend, Indiana, where his staff conceived stylistically advanced cars, including the 1947 Champion, the 1953 Commander Starliner, and the 1962 Avanti, which brought European elegance to American automobiles. His firm designed products, graphics, and interiors for the country's largest corporations. Under Snaith, the firm developed into a broad service organization that also provided marketing research and retail store planning. Loewy opened the Compagnie de l'Esthetique Industrielle (CEI) in Paris in 1952, which helped introduce American principles of office management and product styling to European commercial design. Loewy's notable projects include Sears Coldspot refrigerators (1935–40), the Lucky Strike cigarette package (1940), S-1 locomotive for Pennsylvania Railroad (1937), Greyhound buses, Nabisco products and packaging, Frigidaire appliances, the NASA Skylab, and trademarks for International Harvester, Exxon, and Shell Oil companies. In Toledo the firm studied consumer preferences and designed Libbey Ware cookware for Owens-Illinois (1963) and interiors for the J. L. Hudson store (1968–72). Loewy's portrait on the cover of *Time* magazine in 1949, along with his autobiography, *Never Leave Well Enough Alone* (1951), and the pictorial survey of his career, *Industrial Design* (1979), added to his stature as the most influential designer of his age.

Paul Angelo LoGiudice
born Toledo, Ohio, 1958

From 1977 to 1986, Toledo native Paul Angelo LoGiudice managed several gourmet specialty stores and was a housewares sales representative. After serving as product development and trade show coordinator for Now Designs, a kitchen textile company in California (1986–88), LoGiudice began working at the Commercial Aluminum Company in Toledo in 1988. He studied at Peter Krump's New York School of Cooking (1989) and at the Culinary Institute of America (1990). He directed Calphalon's culinary and product events until 1995, when he was named director of product design. He is responsible for new product design and development for all of Calphalon's cookware, as well as the company's utensils, textiles, and accessory product lines. He also identifies market trends and conceptualizes retail merchandising programs and trade show presentations. LoGiudice received the 1999 Newell Rubbermaid Achievement Award in Marketing for two successful new cookware lines: the Kitchen Essentials line, developed exclusively for Target Stores, and the Professional Nonstick II line, for which he designed the patented Cool Touch rolled steel handle. He studied new product management at the University of Michigan in 1996. He is a member of the Color Marketing Group, the International Association of Culinary Professionals, and the New Product Development Association.

Gary McNatton
born Evansville, Indiana, 1951

Gary McNatton earned a bachelor of fine arts degree from Western Kentucky University in 1975 and a master's in psychology from Vanderbilt University in 1977. As vice president of product, design and sales at C.M.A. (Charles Moore Associates) in Chicago (1977–87), McNatton designed home products for Crate & Barrel and developed gift products for museum shops. He moved to California in 1987 to open his own firm, Mottura (with offices in Los Angeles and San Francisco), which specialized in home products and body care. McNatton sold Mottura to fashion apparel leader and retailer The Gap, Inc., in 1994, and joined the corporation as senior director. Since 1997 he has held the position of senior vice president and is creative director of Gap Body. His fragrances for Personal Care for Gap, Inc., which includes Banana Republic, Old Navy, and Gap Outlet, and his packaging designs have won numerous awards and recognitions, including several Fragrance Foundation "FiFi" Awards and a Clio in 1996 for package design. Examples of his Mottura product designs are in the permanent collection of the San Francisco Museum of Modern Art.

A. Douglas Nash
(1885–1940, locations unknown)

A. Douglas Nash was the son of the English glassmaker Arthur J. Nash, who had been superintendent of the Tiffany Favrile Glass Works in Corona, Long Island, New York. The younger Nash worked in the sales office of the Louis C. Tiffany factories in Corona until 1919, when Tiffany withdrew from active participation in the firm. Nash purchased the assets of the factory, operating it as A. Douglas Nash Associates until 1920, when Louis C. Tiffany Furnaces, Inc., was formed. When Tiffany withdrew his financial support in 1928, Nash and his father formed A. Douglas Nash Corporation, which made art glass until it ceased operation in 1931. Nash was hired in that year by The Libbey Glass Manufacturing Company in Toledo to help the company regain prominence in the luxury tablewares market, particularly for liquor wares in anticipation of the repeal of Prohibition. He headed the company's recently formed Libbey Studios. Originally believed to be the sole designer at the company during this period, it is now thought that he worked with talented craftsmen to create a variety of handcrafted and machine-made products for institutional and domestic use. His New Era in Glass line which was thought to include superior examples of glassmaking techniques proved too expensive for Depression-era customers. Nash left Libbey's employ around 1934 and later worked at Pittsburgh Plate Glass Company and various other firms.

Robert Nixon
born Detroit, 1932

Robert Nixon grew up in Detroit, graduated from Cass Technical High School, and studied commercial art. Following military service, in 1955 he began studying automotive design at the Chrysler Institute of Engineering (Highland Park, Michigan) and joined Chrysler Corporation as an interior design technical illustrator. Over the next four years, he completed his degree in automotive design and became staff designer in the Dodge Exterior Design Studio. Nixon moved to American Motors Corporation in 1959. He developed the 1968 Javelin two-door hardtop and participated in the development of the 1984 Jeep Cherokee, which initiated the sport utility vehicle market and is still in production. From 1977 to 1987, he was director of exterior design for Jeep utility vehicles and trucks, passenger cars, and technical support functions. In January 1987 he was named design director of interior and exterior Jeep, passenger car, and van programs. When Chrysler purchased AMC in mid-1987, Nixon returned to the company where he had started, continuing as design director of Jeep with Dodge trucks added to his responsibilities. He holds the design patent for the 1992 Jeep Grand Cherokee, which represented a dramatic departure from the traditional trucklike appearance of most four-wheel-drive vehicles. Since his retirement in 1992, he has devoted himself to ceramics.

Amos Northup

Bellevue, Ohio 1889–1937 Pleasant Ridge, Michigan

After finishing high school in Bellevue, Amos Northup studied at the Cleveland Polytechnic Institute under Henry G. Keller. From 1908 to 1918 he designed homes, draperies, and interiors. He began his automotive career at Pierce-Arrow, maker of prestige automobiles, as manager of custom paint and trim. In the mid-1920s, as a designer for Murray Corporation of America (Detroit), a provider of auto bodies to many manufacturers, Northup consulted on design and color schemes for Packard, Graham, Reo, Hupp, and other makers. He assisted Edsel Ford in the design of the 1928 Model A, one of the most significant vehicles in US automotive history. He delivered lectures to engineering and professional organizations that were reported in key automotive journals. After visiting Europe during the late 1920s, Northrup compared seat comfort and contrasted coach-building practices in European and American vehicles. John North Willys, president of Toledo's Willys-Overland Motor Company, hired Northup as chief auto designer. During this period (1928–29) Northup restyled most of Willys's extensive line and created striking body designs such as the Plaidside roadsters and Great Six convertible models. Shortly before the 1929 stock market crash, Northup returned to Murray, where he was elevated to chief designer. In his later work Northup developed a dramatic streamlined style evident in his designs for the Willys Model 37 Coupe and the 1938 Sharknose Graham.

William Carroll Pahlmann

Pleasant Mound, Illinois 1900–1987 Guadalajara, Mexico

William Pahlmann spent his childhood in San Antonio, Texas. After high school, while working as a traveling salesman for a pipe company, he completed a correspondence course from *Arts & Decoration* magazine. He moved to New York in 1927 to study interior design at the Parsons School of Design and then at the school's Paris branch in 1930. He opened his own interior design firm in 1931 and quickly found success with New York high-society clients. From 1936 to 1942, he headed the decorating department at the Lord & Taylor department store in New York, where he established his reputation with fully decorated model rooms. He wrote the *Pahlmann Book of Interior Design* (1955) and a newspaper column, "A Matter of Taste," and was the home-furnishings editor of *Harper's Bazaar*. As head of William Pahlmann Associates since 1946, he designed interiors of homes, restaurants, boats, hotels, offices, and department stores, as well as textiles, carpets, and furniture. Pahlmann designed the interiors of important New York projects such as the 1958 Seagram Building and the 1959 Four Seasons restaurant. His unique color sense proposed palettes that defined the late 1930s, 1940s, and 1950s, and his eclectic style

mixed furniture and objects from differing time periods and cultures. In 1964 his influence on modern American home decoration was honored with the Elsie de Wolfe Award of the New York chapter of the American Society of Interior Designers.

Jean Otis Reinecke

Bourbon County, Kansas 1909–1987 Pasadena, California

Jean Reinecke attended Kansas State Teachers College and, after moving to St. Louis, Washington University's art school. Experience at a sign shop helped him get a job as a display artist at the General Display Studios in St. Louis, where he quickly rose to art director, designing retail and trade show displays and advertising. In 1930 Reinecke opened an office in Chicago to build exhibits for the 1933–34 Century of Progress. He and James Barnes, the company's salesman, founded the Barnes & Reinecke partnership in 1934. Capitalizing on Chicago's varied manufacturing industries, the firm grew rapidly, soon becoming the Midwest's largest and most influential design firm, with 375 employees during the war years. Reinecke left the partnership in 1948 to begin Reinecke Associates and devote himself exclusively to industrial design. In 1956 he opened a second location in California, but also continued the Chicago office until 1974. During his varied career, Reinecke maintained many long-term client relationships and created countless consumer and industrial products. His promotional materials boasted a client list representing nearly every letter of the alphabet, from Amana to Zenith. Reinecke's work includes some of America's most enduring forms and popular products: tape dispensers for 3M from 1937 into the 1970s and McGraw-Edison's Toastmaster, the top-selling kitchen toaster of the 1940s and 1950s, for which his staff also designed the signature triple-loop mark. His very successful promotion activity placed articles and sketches in trade and consumer magazines, and his firm earned industry and design awards over decades. A Fellow and past president of the Industrial Designers Society of America, and an officer of the Society of Plastics Engineers and the Color Research Institute, Reinecke served on the Council of Advisors to the Art Center College of Design (Pasadena, California) and as an instructor at the New Bauhaus (Chicago); he lectured at the Massachusetts Institute of Technology, the Illinois Institute of Technology, Stanford, and the University of Illinois.

John Gordon Rideout

St. Paul, Minnesota 1898–1951 Cleveland

John Gordon Rideout entered the University of Washington as an architecture student, but World War I interfered and he served in the Navy. In the 1920s he worked as a graphic designer in Chicago and was one of the founders of the Chicago Society of Typographic Arts. In 1931 Rideout came to Toledo to become Harold Van Doren's partner

Plate 5
William Pahlmann Associates, *Sales Sample for Prairie Flowers,*
1958
F. Schumacher & Co.
screenprint on Fiberglas fabric
27¼ × 24¾ inches
F. Schumacher & Co., Archives Collection

Home furnishings designer William Pahlmann explored exciting
fashion directions made possible in the 1950s by new synthetic
materials. His Southwestern-themed "Across the Border Group,"
which included patterns titled Prairie Flower, Laredo, Still Trees,
and Rio Grande, coordinated Fiberglas fabrics, wallpapers,
and carpets for F. Schumacher & Co. Owens-Corning Fiberglas
Company's noncombustible spun glass yarn, used during World
War II for naval and aircraft products, changed postwar interiors.
Featured in Owens-Corning's midtown Manhattan showroom
beginning in 1948, this versatile, lightweight, woven material was
moth- and mildew-proof, washable, and had the appearance of
silk and a tensile strength greater than steel. Most important,
it provided fireproof safety to public spaces such as hotels,
auditoriums, and offices.

in Van Doren and Rideout, one of the first of the emerging industrial
design firms. The company designed products and packaging for Air-
King Radio, Easy Washing Machine Corporation, American National
Company, Globe Machine and Stamping Company, DeVilbiss, The
Wagner Manufacturing Company, Swartzbaugh Manufacturing Com-
pany, and Toledo Scale. Rideout left Van Doren in 1935 and moved
to Cleveland, where he established John Gordon Rideout and Staff.
His clients included Wisconsin Chair Company, B. F. Goodrich, Stude-
baker Corporation, and McCaskey Register. Arthur BecVar was his
assistant (1935–39) and went on to head design at General Electric.

In 1944 Rideout brought in architect Ernest Payer to combine indus-
trial design and architecture; their relationship ended in 1946. In 1944
Rideout was one of the sixteen founders of the Society of Industrial
Designers (SID), the profession's first organization, which was com-
posed primarily of New Yorkers; he served as an "out-of-town advi-
sor" to the membership committee to recruit new members and also
on the editorial committee of the 1949 *SID Annual,* a publication
that presented the best of contemporary industrial design work.

Gilbert Rohde
New York 1894–1944 New York

Gilbert Rohde, son of a German-born cabinetmaker, studied at the Art Students' League and Grand Central School of Art in New York. His early employment included work as a drama and music critic, a newspaper cartoonist and reporter, an advertising illustrator and copywriter, and a furniture illustrator for the Abraham & Straus department store. Travel to France and Germany in 1927 inspired him to pursue Modernism. He opened his own office in New York in 1927 to design and produce custom furniture and soon established himself as one of the prominent designers of the 1930s, designing furniture and showrooms for companies such as Troy Sunshade in Ohio, Kroehler, Heywood-Wakefield, John Widdecomb, and Thonet, as well as interiors of residences and public spaces. He also served as a technical design consultant to manufacturers such as General Electric and Hudson Motor Car Company. He convinced D. J. DePree, president of The Herman Miller Furniture Company (based in Zeeland, Michigan), to produce modern furniture and was appointed director of design in 1932. His many versatile lines for Herman Miller pioneered modular and sectional furniture and incorporated innovative uses of plastics, metals, and glass. He designed furniture and clocks for the "Design for Living House" that Herman Miller furnished as an exhibit at the 1933–34 Century of Progress in Chicago. He served on the committee of architects and designers that developed the general plan for the 1939 New York World's Fair and designed four exhibits. Rohde was also an educator and organizer in the early years of the profession. From 1936 to 1938 he directed the Design Laboratory School, established in New York by the Works Progress Administration to train designers for employment. Rohde headed the Industrial Design department at the New York University School of Architecture (1939–43). A member of the American Union of Decorative Arts and Craftsmen (AUDAC), in 1936 he was one of the founders of the Designers' Institute of the American Furniture Mart in Chicago (later, renamed the American Designers Institute, the group relocated to New York). He also lectured and wrote extensively on design. His work was included in many exhibitions, including the 1932 "Design for the Machine" in Philadelphia, the 1934 "Machine Art" at New York's Museum of Modern Art, and the 1940 "Contemporary American Industrial Art" at The Metropolitan Museum of Art. For a short time after his death, his wife and partner, Peggy Ann, continued his work.

Eero Saarinen
Kirkkonummi, Finland 1910–1961 Ann Arbor, Michigan

The architect Eero Saarinen, son of architect Eliel Saarinen, came to America with his family in 1923 after Eliel won second prize in the famed competition for the Chicago Tribune Tower. Eero studied sculpture in Paris (1930), graduated from Yale University (1934) with a degree in architecture, and then traveled for two years in Europe, the Middle East, and Africa before returning to Michigan to work with his father.

Eero taught architecture (1939–41) at the Cranbrook Academy of Art, which his father had designed, and which his father directed from 1932 to 1946. Eero and his father designed the General Motors Technical Center and other projects. At Cranbrook, Eero met Charles Eames, who became his friend and collaborator; their experiments with wood molding technology resulted in sculptural wood shell furniture. They won first prize at the 1940 "Organic Design in Home Furnishings" competition and exhibition at New York's Museum of Modern Art. Beginning in 1943, Saarinen created furniture for Knoll Associates that presented new comfort and style for the American home and whose bold, organic shapes became icons of midcentury Modernism. His 1957 series of pedestal tables and chairs, such as his Tulip chair with Fiberglas seat and aluminum pedestal, are unified, fluid forms made possible by new materials. After 1950 Saarinen ran his own architectural office and soon became considered a leading architect of his generation. The St. Louis Gateway Arch (1948–64), an auditorium and chapel at the Massachusetts Institute of Technology in Cambridge (1953–55), the John Deere Administration Center in Moline, Illinois (1956–63), the 1962 TWA Terminal at New York's Kennedy Airport, and Washington, DC's Dulles Airport are but a few of the projects that expressed a strong sculptural presence in contrast to the predominantly rectilinear, functional contemporary architecture.

Merritt Whitman Seymour
born Providence, Rhode Island, 1936

After receiving a bachelor of fine arts degree in industrial design from the Rhode Island School of Design in 1958, Merritt Seymour began his career designing flatware for Oneida, Ltd., before turning to interior and exterior architectural products. An inventor and innovator who holds more than twenty patents, he has managed and directed new product development for three architectural product companies: Armstrong World Industries, Owens-Corning Fiberglas Corporation, and USG Corporation. As manager of industrial design for Owens-Corning Fiberglas in Toledo from 1964 to 1986, he and his staff, along with outside consultants, designed bath fixtures, ceiling systems, furniture systems, and roofing products. He joined USG Interiors in Chicago in 1987 as director of design and development and was promoted to vice president of product design and development in 1996. Seymour

Plate 6
Merritt Seymour, *Rendering of Residential Tub/Shower with Sheet-Molding Compound Technique*, ca. 1969–70
Owens-Corning Fiberglas Corporation
colored pencil, pastel, black and white chalk,
and white gouache on paper
16⅞ × 13⅞ inches
Merritt Seymour

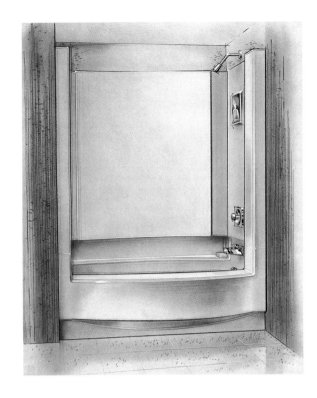

The Owens-Corning Fiberglas Corporation developed a host of applications for its molded Fiberglas material. The tub/shower components made of sheet-molding compound (SMC), a blend of thermoplastic and thermosetting resins, fillers, pigments, and reinforcing glass fibers, brought new efficiencies to mass housing construction. This lightweight, four-piece assembly, the first commercially successful sheet-molded Fiberglas bathroom unit, reduced construction and installation costs because the assemblies could be installed at any stage of a building's construction and offered design flexibility. The high capital investment required to enter this market prevented smaller companies from imitating this sheet-molding compound process. Owens-Corning devoted substantial resources to develop concepts, technologies, tools, and molds for the components that could be produced in high volumes.

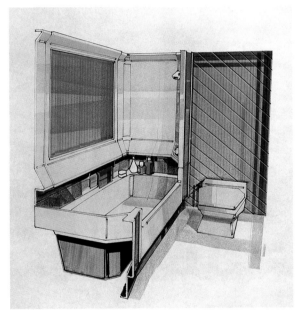

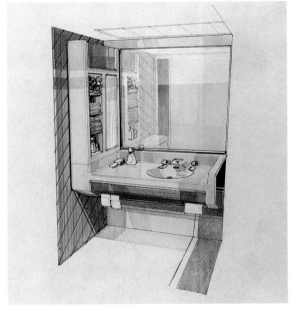

Plate 7
Merritt Seymour with David Tompkins and Keith Kresge of Richardson/Smith Inc., *Time Control Bathroom System— Tub/Shower and Toilet*, ca. 1971
Owens-Corning Fiberglas Corporation
felt-tip pen and colored pencil with graphite on paper
18 × 24 inches
Merritt Seymour

This sketch is an early concept for the Time Control Bathroom System (TCBS), a prefabricated module targeted for the hotel construction market designed to radically reduce the expense and time constraints of traditional bathroom construction. Key benefits were that bathtub units nested for efficient shipping and the interlocking shower panels could be rapidly and easily installed by a minimum of tradesmen. Safety grips and toiletry holders were integrated into the molded shape. Plumbing was installed in a shop off-site and needed only to be connected to water and drain lines on site. Tub supports transferred the weight of the tub/shower system to the floor, room walls did not bear any weight. Under Merritt Seymour's direction, Owens-Corning Fiberglas contracted Richardson/Smith to develop the TCBS from concept sketches through scale models, full-size mock-ups, and installation in the hotel of Detroit's Renaissance Center in the city's downtown.

Plate 8
Merritt Seymour with David Tompkins and Keith Kresge of Richardson/Smith Inc., *Time Control Bathroom System— Vanity*, ca. 1971
Owens-Corning Fiberglas Corporation
felt-tip pen and colored pencil with graphite on paper
18 × 24 inches
Merritt Seymour

The vanity was part of the complex design process for the Time Control Bathroom System. Formed in high-pressure hydraulic presses using heated matched steel dies, the system components had integrally molded assembly joints that interlocked to be watertight. Molded in one seamless, sculptured piece, the lavatory/vanity included a soap dish, facial, and toilet tissue holders, and a bowl with a sloping side (suitable for bathing an infant). The unit was placed off-center to create counter space.

Plate 9
Merritt Seymour, *Stand-Up Whirlpool*, 1986
Owens-Corning Fiberglas Corporation
graphite on translucent paper
16⅞ × 14⅟₁₆ inches
Merritt Seymour

This early stage drawing reveals Merritt Seymour's thought process in developing a combination tub/shower that would have whirlpool features. Its two parts, a vertical and horizontal component, offered compact shipping and storage during building construction. This speculative product, never implemented, was meant to compete with the jet spray bathroom fixtures that were becoming popular in luxury American homes.

leads the design and development of new interior products and systems and coordinates some of USG's innovation activities worldwide. He is a member and has been an officer of many design organizations, such as the American Institute of Architects/Chicago, the Color Marketing Group, the Industrial Designers Society of America, and the Design Coalition for Professional Development, and is an Honorary Member of the International Interior Design Association. Seymour has lectured to professional, industry, and academic audiences about market research, business-to-business market development, and market-launch processes.

Clifford Brooks Stevens
Milwaukee, Wisconsin 1911–1995 Milwaukee

Brooks Stevens developed his visual skills and imagination as a child when his parents encouraged him to draw while he was bedridden with polio. He studied architecture at Cornell University from 1929 to 1933, but as the Depression had curtailed construction, Stevens returned to Milwaukee and began work as a package designer at Jewett and Sherman. A commission to redesign the control boxes and logo for the Cutler-Hammer Company, an industrial equipment manufacturer, moved him to open his own office in 1934. He is popularly known for novelties such as the wide-mouthed peanut butter jar and the Oscar Mayer Wienermobile, but his prodigious output included products for hundreds of clients. His firm designed household appliances, farm machinery, motorcycles, buses, trucks, powerboats, trains, snowmobiles, and aircraft. It also designed children's toys, decorative surface patterns for Formica, plastic kitchenware, and packaging. The firm's clientele consisted largely of Midwestern manufacturers such as Evinrude Motors, Briggs & Stratton, Allis-Chalmers, Harley-Davidson,

Milwaukee Road Railroad, Webster Electric, and Miller Brewing companies. Stevens designed children's pedal cars for Toledo's American National Company in the 1930s. His article "Your Victory Car," published in the December 1942 *Popular Mechanics*, led to his consultant work for Willys-Overland's postwar Jeep vehicles. He designed for Studebaker from 1962 to 1967, designed the Excalibur cars that were manufactured (1964–86) by his two oldest sons, David and William C. Stevens, maintained a museum of his automobile collection, was a founding member of the Sports Car Club of America, and was elected to the Automotive Hall of Fame in 1985. Stevens was one of the founders of the Society of Industrial Designers in 1944, and in 1993 he received the Personal Recognition Award from the Industrial Designers Society of America. After retiring in 1983, Stevens taught at the Milwaukee Institute of Art & Design. His firm, Brooks Stevens Design Associates, directed by his son Kipp since 1979, is located near Milwaukee.

Carl W. Sundberg
Calumet, Michigan 1910–1982 Boynton Beach, Florida
Montgomery Ferar
Boston 1910–1982 Detroit

Carl Sundberg graduated from Northern High School and attended Wicker Art School in Detroit. He began his design career in 1927 as a designer of custom car bodies, working under Ray Dietrich at the Dietrich Body Company. He then worked in plastics design at Kurz-Kasch, Inc. He was working at the General Motors Corporation in Detroit as a body designer and model supervisor when he met his future partner, Montgomery Ferar. Ferar had earned bachelor's and

master's degrees in architecture (1932) from the Massachusetts Institute of Technology, and in 1933 won a travel fellowship that allowed him to spend more than a year in Europe. Upon his return, Ferar worked for several Boston architecture firms before moving to Detroit. He then worked for the Detroit Planning Commission and briefly at General Motors' Art and Color Section, like Sundberg, as a body designer and model supervisor. In 1934 the two men left GM to form Sundberg-Ferar, Inc., an industrial design and engineering firm. They designed refrigerators, radios, and stoves for the Crosley Corporation, for which they also designed a pavilion for the 1939 New York World's Fair. Drawing upon their GM experience in model building, in 1940 they formed an innovative in-house shop that enabled their designers to visualize and present full-size models. They designed household, office, and industrial products for clients around the country, including many product lines for Sears, Roebuck and Company and major appliances for Whirlpool. In Toledo the firm designed personal care products and machinery for The DeVilbiss Company and appliances for the Swartzbaugh Manufacturing Company. In the 1960s the firm aided IBM in conceptualizing early electronic typing and calculating equipment. In the 1970s Sundberg-Ferar designed mass transit programs for many US cities, including San Francisco; cars for the Penn Central and Illinois Central Railroads; and interiors for Lockheed airplanes. Ferar taught industrial design from 1970 to 1980 at the Center for Creative Studies in Detroit; upon his retirement he became a trustee of the school and also studied sculpture there. A compatible pair, Sundberg and Ferar both retired in 1975 and died the same week. In 2000 Sundberg-Ferar maintained four US offices and a location in the Far East to serve an international clientele.

Richard Teague
Los Angeles 1923–1991 Fallbrook, California

Richard (Dick) Teague was a child movie actor when an auto accident left him blind in one eye at the age of six. He developed a keen interest in cars and in his teens began racing hot rods. In 1942 he became a designer/illustrator at Northrop Aircraft Corporation. Teague studied at the University of Southern California and the Art Center College of Design during and after the war, worked for Henry Kaiser on the design of a small economy car, and drew magazine illustrations. He joined General Motors in 1948, where he worked on the 1949 Oldsmobile Rocket 88 and under Harley Earl and William Mitchell in the Cadillac studio. In 1951 Teague worked briefly for a defense contractor in California, but in 1952 was invited back to Detroit by the Packard Motor Car Company to be chief stylist. He restyled the Packard image with the 1953 Caribbean and a series of innovative production models and futuristic show cars. After the Studebaker Corporation merged with Packard, Teague led Packard styling. He then worked for Chrysler for a short time and in 1959 began his long career at American

Motors Corporation, becoming styling director in 1962 and design vice president in 1964; he retired in 1984. He and his staff developed cost-effective methods that reduced tooling expenses and pioneered economical interchangeable parts. His notable designs repositioned AMC for the youth market and included the Rambler American and Tarpon in 1964, the AMX and Javelin series of the mid-1960s, and the Gremlin, Matador, and Pacer in the 1970s. He led the design team that developed the 1984 Jeep XJ Cherokee, a successful sports utility vehicle, which remained in production into 2001. An avid collector and restorer of automobiles, he was an active member of several antique auto collector clubs and a member of the Society of Automotive Engineers.

Walter Dorwin Teague
Decatur, Indiana 1883–1960 Flemington, New Jersey

Walter Dorwin Teague studied at New York's Art Students' League (1903–1907), worked as an illustrator for advertising agencies, and opened his own commercial art office in New York in 1911. His elegant drawings with distinctive decorative borders advertised apparel, automobiles, and building products. After a visit to Europe in 1926, he turned to the new field of industrial design. His Depression-era consumer products, such as Kodak Brownie cameras and Sparks-Withington radios, popularized the Machine Age style. Teague enjoyed long-lasting relationships with corporate clients. For Ford Motor Company, he designed pavilions for the great fairs of the 1930s, including San Diego, Dallas, Cleveland, New York, and Paris. He headed the design committee of the 1939 New York World's Fair and designed pavilions for National Cash Register Company, Eastman Kodak, and U.S. Steel, as well as the Federal Building, for which he also designed glass tableware for Libbey Glass, a subsidiary of Owens-Illinois. In Toledo he designed advertising for The Libbey-Owens Sheet Glass Company in the 1920s, 1930s glass blocks for the Owens-Illinois Glass Company, and building products for Owens-Corning Fiberglas in the 1950s. In the 1930s he designed crystal for Steuben and architectural applications of structural glass for the Pittsburgh Plate Glass Company. His 1930s designs for Texaco auto service stations joined function with visual corporate identity. Teague promoted his design theories in his book *Design This Day: The Technique of Order in the Machine Age* (1940). In the mid-1940s, Teague opened a West Coast office to service the Boeing aircraft account. In the 1950s Teague's firm designed furniture for the Air Force Academy, as well as many household products and packaging. Teague's 1941 lawsuit in the state of New York on the subject of business taxes for industrial design practitioners resulted in the founding of the Society of Industrial Designers in 1944. As the society's first president, Teague led the profession in the establishment of educational standards and promotion to industry.

David Tompkins
born Glen Gardner, New Jersey, 1934

David Tompkins grew up in New York and received an industrial design degree from Pratt Institute in 1961. He worked at Mack Truck, at General Motors, and with Walter Dorwin Teague in New York. In 1963 Tompkins joined the now world-renowned design firm of Richardson/Smith Inc. (now Fitch, Inc.) when it was first founded in Worthington, Ohio. During fourteen years there, Tompkins designed a wide range of products for consumer, industrial, and medical markets, including products for Owens-Corning Fiberglas during the 1970s. Tompkins taught design history, presentation methods, and professional practice at Ohio State University (1972–78) and was a guest lecturer at US design schools. He left Richardson/Smith to found his own office in 1977. In 1981, after operating Tompkins & Associates in Colorado and Ohio, he joined the corporate staff of RCA Consumer Electronics in Indianapolis. As vice president of design, he was responsible for more than two hundred products and led a staff of forty in designing graphics, corporate identity, packaging, and model making. In 1987 he was hired by Himont, a subsidiary of Montedison SpA, Italy, a leading producer of polypropylene and related engineering products, to establish a design/engineering resource center at the company's headquarters in Wilmington, Delaware, for creating plastic-based products for consumer, industrial, and technical markets in the United States and Europe. Himont merged with the polymer divisions of Royal Dutch Shell in 1995. Tompkins retired in 1996 and now lives in North Captiva Island, Florida. He is a Fellow and past president of the Industrial Designers Society of America.

The Uhl Brothers
Toledo, Ohio

Philip Uhl (1868–1923), a member of a large Toledo family prominent in commerce and local organizations, was a partner with his brothers Joseph (1866–1935) and Clement (1878–1964) in several businesses. In 1897 they started Uhl's Cycle Shop to build and repair bicycles at a time when bicycles were an important Toledo industry. Their company also produced novelties, wall plaques, and campaign buttons. It was renamed the Toledo Metal Furniture Company around 1908 and developed the manufacture of steel furniture for office, school, and factory establishments. Clement patented many inventions for furniture construction in the 1920s and 1930s. The family sold the Toledo Metal Furniture Company in 1952 and the company ceased making furniture in Toledo in the 1970s.

Harold Livingston Van Doren
Chicago 1895–1957 Philadelphia

A native Midwesterner, Harold Van Doren finished high school in New Jersey, graduated from Williams College in 1917, and served in the Army during World War I (1917–19). He studied at the Art Students' League, New York (1920–21), then went to Paris (1922–24) with a fellowship in the history of art and worked as a lecturer at the Louvre, an artist for the *Chicago Tribune*'s Paris edition, an actor in a Jean Renoir film, and a translator of books on Cézanne and Renoir. He returned to the United States to become assistant director of The Minneapolis Institute of Arts (1927–30) while also serving as an art director for Minneapolis newspapers and writing articles for the *Saturday Evening Post* and *Encyclopedia Britannica*. Van Doren joined art with industry in 1930 when his college classmate H. D. Bennett recruited him to Toledo as a color consultant for Bennett's new enterprise in the development of synthetic materials. Van Doren generated applications for Plaskon, a plastic molding compound, and formed a partnership with John Gordon Rideout in 1931. Their clientele grew from Toledo companies—Swartzbaugh, DeVilbiss, American National, Air-Way Electric Appliance, Haughton Elevator, Electric Auto-Lite, Hettrick Manufacturing—to the greater Midwest with Wayne Pump (Fort Wayne, Indiana), Goodyear Tire (Akron, Ohio), and others. Van Doren and Rideout's practical business approach to creating consumer and industrial products resulted in streamlined goods widely publicized in 1930s US and British publications. The Toledo Museum of Art presented their work in a 1933 exhibition. After Rideout relocated to Cleveland around 1934, Van Doren invited J. M. Little (1936) and Donald Dailey (1937) to join him in Harold Van Doren & Associates, organized in 1936. Van Doren worked as a color consultant to Libbey-Owens-Ford's Vitrolite division in 1937. By 1940 his East Coast clientele, especially Westinghouse and Philco, necessitated a second office in Philadelphia, which was headed by Dailey in 1941. Van Doren relocated there, leaving the Toledo office under J. M. Little's management. In 1943 he ended his partnership with Little and in 1944 opened an office in New York with Roger Nowland and Peter Schladermundt. In 1950 the partnership split into two separate firms, with Van Doren remaining in Philadelphia and the others retaining the New York base. Van Doren's firm prided itself on its model-making shop, where full-size clay, plaster, wood, and plastic models helped with rapid visualization aiding research, engineering, and manufacturing. He presented his approach to joining artistic with business skills in his textbook *Industrial Design: A Practical Guide*

(1940, revised 1954). He authored numerous articles, lectured extensively, and judged competitions sponsored by *Modern Plastics* magazine. He organized a series of exhibitions at the Philadelphia Art Alliance (1943–46) and served on the board of directors of the Moore Institute design school, the education committee of the Society of Industrial Designers (SID), and the board of governors of the Philadelphia Museum School of Art. He was a Fellow of the Royal Society of Art in England and president of the SID in 1949–50.

Frederic Alexandre Vuillemenot
born in France, dates unknown

Frederic Vuillemenot grew up in northwest France, near the textile center of Roubaix, and attended schools specializing in textile design and decoration. With a foundation in the Art Nouveau style, he went to Paris on a scholarship to the Ecole des Arts Décoratifs. He received a classical studio education and chose to concentrate on the application of industrial art to architecture. He served briefly in World War I and in early 1915 was hired by the Libbey Glass Company. After three years at Libbey and a sojourn in France, in 1924 Vuillemenot was hired by Thomas DeVilbiss to head the design staff at DeVilbiss' perfume atomizer division. Vuillemenot and DeVilbiss visited the 1925 Paris Exposition, which inspired them to use new methods to produce sophisticated boudoir items in colored enameled glass. Vuillemenot brought elegance to the company's product design, packaging, and advertising. Following Thomas DeVilbiss' death in 1928 and the drop in luxury sales after 1929, Vuillemenot was reduced to a part-time freelance position in 1932, working also for The Libbey Glass Manufacturing Company. Returning to full-time status at DeVilbiss in 1934, he designed industrial spray-painting equipment as well as atomizers. He left the company in 1948. His son, Robert Vuillemenot, became a designer and was executive vice president at Donald Deskey Associates in New York in the 1950s.

Russel Wright
Lebanon, Ohio 1904–1976 New York

From 1921 to 1924, Russel Wright attended the Art Academy of Cincinnati, the Art Students' League in New York, and the Columbia University School of Architecture. He then worked with Norman Bel Geddes in stage design. Prolific in many fields, he is best known for his ceramic and plastic dinnerware, flatware, glassware, table accessories, textiles, and furniture designs of the 1930–50s. In 1930, along with his wife and business partner, Mary Einstein, he established

a company to make products he designed, such as spun aluminum tableware. The company continued until 1941 when the war curtailed civilian metal production. His wood furniture for companies such as Heywood-Wakefield, Conant-Ball, Samsonite, and Old Hickory, as well as do-it-yourself furniture for Sears, introduced fresh ideas in spare forms and finishings. His tableware, particularly the American Modern ceramic dinnerware line produced in 1939 for Steubenville Pottery and related accessories, his aluminum products, and chromium serving pieces for the Chase Copper & Brass Company, are considered landmarks in the development of a modern American casual style. The Wrights created and promoted the "American Way" program (1940–42) to join manufacturers, retailers, and designers in the production and distribution of home products. They published *Guide to Easier Living* in 1951 to describe how contemporary design could bring simplicity to everyday life. Mary's death in 1952 along with changes in American tastes caused Russel to reevaluate his practice. He continued designing products, interiors, and advertising—in 1955 he designed a Christmas gift decanter and promotional packaging for Calvert Distillers Corporation—and developed new concerns. In 1955 Wright was retained by the US Department of State to survey possibilities for developing cottage industries in Southeast Asia. He worked for the International Cooperation Administration in Japan, Taiwan, Cambodia, and Vietnam in 1958–60 and then devised ecological programs for US public parks. In 1965 Wright was invited to Japan to design more than a hundred products for Japanese manufacturers. In 1967 he left New York City to live in the experimental house and nature preserve he built in rural Garrison, New York, redirecting his efforts from designing products to designing natural environments. He became a planning consultant to the National Park Service and an advisor to developing countries.

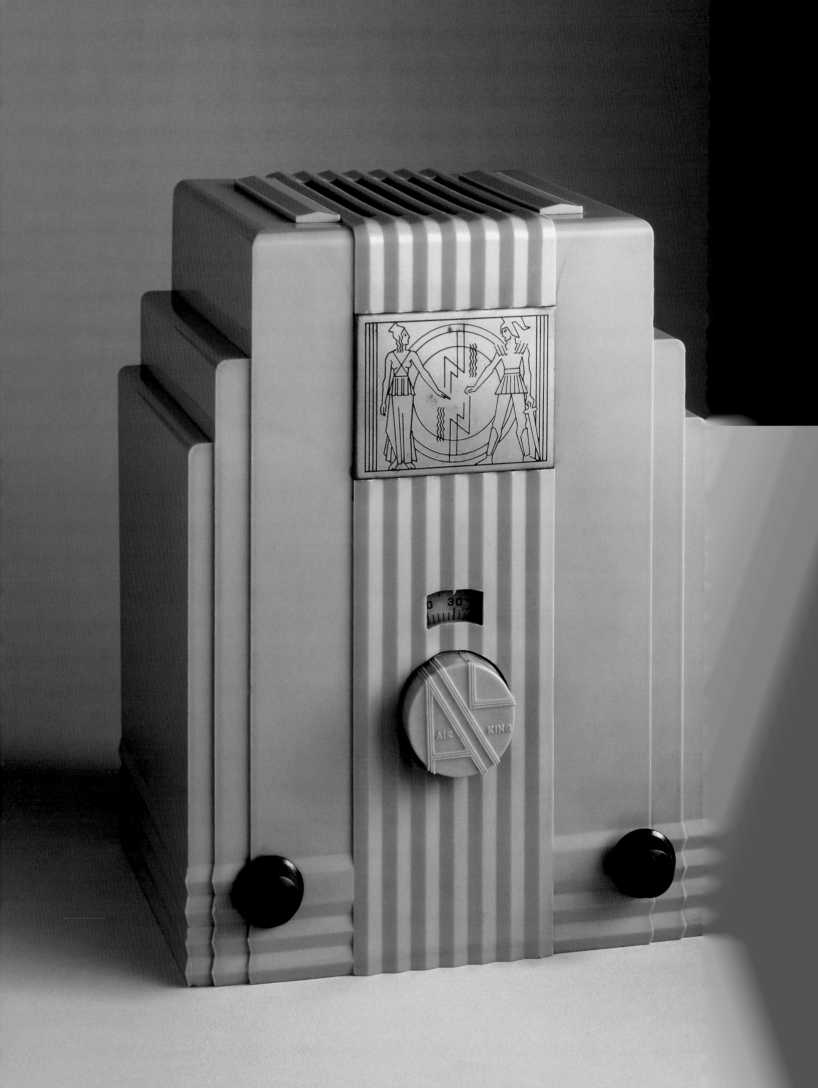

CATALOGUE OF THE EXHIBITION

Since it is difficult to identify the dates of design or introduction to the market of mass-produced goods, the date of patent is listed if it is the verifiable date. Objects are identified by the company name of the manufacturer at the time the design was developed. They are listed here according to their essay plate number.

Frontispiece
Hamilton Wright, photographer, *Norman Bel Geddes and Unidentified Man in the Toledo Tomorrow Model*, 1945
gelatin print
8⅛ × 10 inches
The Norman Bel Geddes Collection, The Performing Arts Collection, Harry Ransom Humanities Research Center, The University of Texas at Austin, by permission of Edith Lutyens Bel Geddes, Executrix

McMaster and Taragin
Pioneering the Alliance of Art and Industry

Plate 1
Toledo Museum School of Design First & Second Year Fashion Class, 1930
photo panel

Plate 2
Toledo Museum School of Design Exhibition, May 1929
photo panel

Plate 3
Walter Brough, *Factory Workers Operating the Owens Bottle Machine*, 1937
Owens-Illinois Glass Company
oil on canvas
59⅛ × 34¹¹⁄₁₆ inches
Libbey Glass Inc.

Plate 4
Edwin W. Fuerst, Owens-Illinois Glass Company, Patent Drawing no. 90.023: Bottle, patented 1933
photo panel

Plate 5
Edwin W. Fuerst and Toledo Museum School of Design, *The Duo-Oval*, patented 1933
Owens-Illinois Glass Company
glass and plastic
3¾ × 2½ × 1 inch
Toledo Museum of Art, Gift of Owens-Illinois Glass Company

Plate 6
Toledo Museum School of Design Exhibition, May 1929: Examples of Works Designed by Industrial Design Students from Owens Bottle Company and The Libbey Glass Manufacturing Company
photo panel

Plate 7
Toledo Museum School of Design Exhibition, 1930, Owens-Illinois Glass Company, Designed by Edwin W. Fuerst
photo panel

Plate 8
Edwin W. Fuerst and Toledo Museum School of Design
Owens-Illinois Glass Company

Taper Round Bottles, ca. 1932
glass and plastic
6½ × dia. 3¼ inches; 5¼ × dia. 2⅜ inches; 4¼ × dia. 2 inches

Cream Jar with Metal Closure, ca. 1932
glass and metal
4⅜ × dia. 3⅜ inches

The Museum of Modern Art, New York, Gift of the manufacturer, 246.34.1–3 and 247.34.SC

Plate 9
Toledo Museum School of Design Exhibition: DeVilbiss Atomizer Designs, 1929–30
photo panel

Plate 10
Harvey K. Littleton, *Vase*, 1962
glass
8 × dia. 2 inches
Harvey K. Littleton

Edith Franklin

Vessel Made at the Toledo Museum of Art Studio Glass Workshop, March/April 1962
glass
1¾ × 1⁷⁄₁₆ × 1½ inches

Pitcher Made at the Toledo Museum of Art Studio Glass Workshop, March/April 1962
glass
3¼ × 1¼ × 1⅜ inches

Edith Franklin

Plate 11
Toledo Museum of Art Studio Glass Workshop, June 1962: Elaine Lukasik Adding a Ladle to a Piece
photo panel

Plate 12
Clayton Bailey, *Necklace Made at the Toledo Museum of Art Studio Glass Workshop*, June 1962
glass
12⁵⁄₁₆ inches long
Betty Bailey

Plate 13
Dominick Labino, *Vitrana*, 1969
glass
88¾ × 104 inches
Toledo Museum of Art, Gift of Mr. and Mrs. Dominick Labino

Messer-Kruse
Out of the Bondage of the Commonplace

Plate 1
Frederic Vuillemenot and The DeVilbiss Company
design staff
The DeVilbiss Company

Atomizer, Dropper, Tray, and Powder Box with Puff,
1927
glass, enamel, gold luster, and rubber bulb with
textile
atomizer: 7¾ × 3 × 2⅛ inches; dropper: 7⅛ ×
dia. 2¼ inches; tray: ¼ × 10¾ × 7¼ inches;
powder box: 2⅛ × dia. 4 inches
Harvey K. Littleton

Pin Tray, 1927
glass, enamel, and gold luster
¼ × 5⅝ × 3³⁄₁₆ inches
James Fuller

Plate 2
Frederic Vuillemenot and The DeVilbiss Company
design staff, *DeVilbiss Perfumizers and Perfume
Lights Catalog,* 1926
The DeVilbiss Company
color lithography, printed text, and embossing on
paper
12 × 9 inches
Toledo Museum of Art Archives

Plate 3
Walter Dorwin Teague, *Sketch for Advertisement,*
1928
The Libbey-Owens Sheet Glass Company
graphite on tissue
16⅝ × 13⅝ inches
Department of Special Collections, Syracuse
University Library, Syracuse, New York

Plate 4
Walter Dorwin Teague, *Proof for Saturday Evening
Post Advertisement,* 1928
The Libbey-Owens Sheet Glass Company
offset printing
14⅞ × 10⅞ inches
Department of Special Collections, Syracuse
University Library, Syracuse, New York

Plate 5
Donald Deskey

Water Goblet, patented 1935
The Libbey Glass Manufacturing Company
glass
8¹¹⁄₁₆ × dia. 3⅛ inches
Toledo Museum of Art, Gift of Owens-Illinois
Glass Company

370 Pattern, patented 1936
The Libbey Glass Manufacturing Company and
Owens-Illinois Glass Company
glass
juice: 3¾ × dia. 2¾ inches; tumbler: 4⅝ ×
dia. 2⅞ inches
Libbey Glass Inc.

Plate 6
NYC Terminal, Toledo, Ohio, n.d.

Bird's Eye View of Shipyards, Toledo, Ohio, n.d.

Toledo & Hawking Valley Coal Docks, Toledo, Ohio,
1909

Ore Docks, Toledo, Ohio, n.d.

postcards, tinted relief half-tone
Toledo-Lucas County Public Library, Toledo, Ohio

Plate 7
The DeVilbiss Company design staff, *Perfume
Atomizer,* 1935
The DeVilbiss Company
glass, chrome-plated metal, and rubber bulb
with textile
2½ × 4⅞ × 1⅛ inches
Harvey K. Littleton

Plate 8
Frederic Vuillemenot and The DeVilbiss Company
design staff, *DeVilbiss Perfume Sprays Catalog
No. 30,* 1930
The DeVilbiss Company
rotogravure, color printing, and typeset on paper
11¹⁄₁₆ × 8⁷⁄₁₆ inches
James Fuller

Plate 9
Frederic Vuillemenot and The DeVilbiss Company
design staff, *DeVilbiss Advertising Service, 1927–
1928 Brochure,* n.d.
The DeVilbiss Company
printed text and electrotype with black illustrations
on paper
12 × 9 inches
Toledo Museum of Art Archives

Plate 10
Frederic Vuillemenot and The DeVilbiss Company
design staff, *DeVilbiss Advertising Service, 1928–
1929 Brochure,* n.d.
The DeVilbiss Company
printed text and electrotype with black illustrations
on paper
12 × 9 inches
Toledo Museum of Art Archives

Plate 11
Frederic Vuillemenot and The DeVilbiss Company
design staff, *Perfume Atomizer Box,* 1930
The DeVilbiss Company
printed silver, black, and green on cardboard with
paper
7⅛ × 2⅝ × 2⅝ inches
James Fuller

Plate 12
Earl Dean for Root Glass Company, *Coca-Cola
Bottle, Manufactured by Glass Container Division
Owens-Illinois Glass Company,* after 1932
Owens-Illinois Glass Company
glass
7¹¹⁄₁₆ × dia. 2¼ inches
Madison Avenue Galleries, Toledo, Ohio

H. J. Heinz Company Design Department,
Heinz Ketchup Bottle, ca. 1925–26
Owens Bottle Company
glass
9¼ × dia. 2½ inches
Senator John Heinz Pittsburgh Regional History
Center, Pittsburgh

Plate 13
Designer unknown, *Men's Safety Bicycle,* ca. 1897
Gendron Wheel Company
wood, painted steel, rubber, and nickel plating
39½ × 74 × 19 inches
Frederic W. Strobel, Gendron, Inc.

Plate 14
The Toledo No. 6, ca. 1929
The Toledo Machine & Tool Company
cast iron
116 × 56 × 68 inches
Acklin Stamping Company

Plate 15
Phillip Uhl, *Side Chair,* ca. 1910
The Toledo Metal Furniture Company
nickel-plated metal, plastic, and wood
34½ × dia. of seat 14¼ inches
Brooklyn Museum of Art, New York, Gift of
Mr. and Mrs. Jonathan Holstein, 75.108

Plate 16
Designer unknown, *O-HI-O Steam Cooker,*
patented 1901
The O-HI-O Cooker Company
copper, lead, tin, and solder
24 × 14 × 11¾ inches
Darryl R. Lippman

Plate 17
Designer unknown, *D.B. Smith, Mt. Zion, Ind.,*
Grocery Bag, n.d.
Manufacturer unknown
letterpress printing on paper
8½ × 4⁷⁄₁₆ × 2⅝ inches
Lucas County/Maumee Valley Historical Society,
Maumee, Ohio

Harris
Acres of Diamonds: Toledo and the Pursuit of Reputation

Plate 1
*Charles E. Thompson, You will do better in TOLEDO,
where rail and water meet . . . ,* 1913 (reconstructed
2002)
photo panel

Plate 2
*Corner, Cherry and Summit Sts., Showing Steadman
Monument, Toledo, Ohio,* ca. 1916

Summit Street Looking North, Toledo, Ohio, n.d.

Bird's Eye View of Toledo, Ohio, ca. 1909

Madison Avenue Looking West, Toledo, Ohio,
ca. 1909

postcards, tinted relief half-tone
Toledo-Lucas County Public Library, Toledo, Ohio

Plate 3
A Sunday Crowd at Toledo Beach, Toledo, Ohio, n.d.

Collingwood Ave., Toledo, Ohio, n.d.

Toledo Market, Toledo, Ohio, n.d.

The Casino, Toledo, Ohio, ca. 1905

postcards, tinted relief half-tone
Toledo-Lucas County Public Library, Toledo, Ohio

Plate 4
New White Marble $300,000 Art Museum, Toledo, Ohio, ca. 1912
postcard, tinted relief half-tone
Toledo-Lucas County Public Library, Toledo, Ohio

Plate 5
Aerial View of Toledo, Ohio, 1941
postcard, tinted relief half-tone

Looking Down the River, Toledo's Manufacturing District, ca. 1909
postcard, tinted relief half-tone

Aerial View Downtown Toledo, Ohio, n.d.
postcard, four-color mechanical tint

Portside, n.d.
postcard, four-color mechanical tint

Toledo-Lucas County Public Library, Toledo, Ohio

Plate 6
Norman Bel Geddes for Norman Bel Geddes & Company, Inc., Frank Scherschel, photographer, *Toledo Tomorrow, General View*, 1945
gelatin print
10 × 12⅝ inches
The Norman Bel Geddes Collection, The Performing Arts Collection, Harry Ransom Humanities Research Center, The University of Texas at Austin, by permission of Edith Lutyens Bel Geddes, Executrix

Doordan
Toledo Tomorrow

Plate 1
Norman Bel Geddes for Norman Bel Geddes & Company, Inc., Frank Scherschel, photographer, *Toledo Tomorrow: The Anthony Wayne Bridge and Shoreline of Maumee River*, 1945
gelatin print
7 × 9⅜ inches
The Norman Bel Geddes Collection, The Performing Arts Collection, Harry Ransom Humanities Research Center, The University of Texas at Austin, by permission of Edith Lutyens Bel Geddes, Executrix

Plate 2
Norman Bel Geddes for Norman Bel Geddes & Company, Inc., Frank Scherschel, photographer, *Toledo Tomorrow: Airport and Terminal (Union Tri-Terminal Depot)*, 1945
gelatin print
6⅞ × 9¼ inches
The Norman Bel Geddes Collection, The Performing Arts Collection, Harry Ransom Humanities Research Center, The University of Texas at Austin, by permission of Edith Lutyens Bel Geddes, Executrix

Plate 3
Norman Bel Geddes for Norman Bel Geddes & Company, Inc., Frank Scherschel, photographer, *Toledo Tomorrow: The Anthony Wayne Bridge and Shoreline*, 1945
gelatin print
9¼ × 6¾ inches
The Norman Bel Geddes Collection, The Performing Arts Collection, Harry Ransom Humanities Research Center, The University of Texas at Austin, by permission of Edith Lutyens Bel Geddes, Executrix

Plate 4
Norman Bel Geddes for Norman Bel Geddes & Company, Inc., Frank Scherschel, photographer, *Toledo Tomorrow: Express Highways—Woodville in foreground*, 1945
gelatin print
9¼ × 6⅞ inches
The Norman Bel Geddes Collection, The Performing Arts Collection, Harry Ransom Humanities Research Center, The University of Texas at Austin, by permission of Edith Lutyens Bel Geddes, Executrix

Plate 5
Raymond Loewy Associates, *Sales Sample for Dune Grass*, 1957
F. Schumacher & Co.
three-color screenprint and silver metallic ink on Fiberglas fabric
37 × 25¼ inches
F. Schumacher & Co., Archives Collection

Plate 6
Gerald Gulotta with James Fulton for Raymond Loewy/William Snaith Inc., *Prototypical Samples for Libbey Ware*, ca. 1963
photo panel

Plate 7
Gerald Gulotta, *Patent Drawing no. 197,574: Casserole or Similar Article—Filed July 15, 1963*

Gerald Gulotta, *Patent Drawing no. 197,575: Cover for a Casserole or Similar Article—Filed July 15, 1963*

photo panels

Plate 8
Gerald Gulotta with James Fulton for Raymond Loewy/William Snaith Inc.
Libbey Glass, Division of Owens-Illinois, Inc.

Three-Quart Saucepan, Freeze, Cook, Serve Libbey Ware, 1963
glass-ceramic material
4⅞ × 11 × 9⁷⁄₁₆ inches
Collection of Jim and Linda Tippett

Production Prototype for Libbey Ware, 1963
glass-ceramic material
3⁵⁄₁₆ × dia. 9⁷⁄₁₆ inches
Gerald Gulotta

Plate 9
Van Doren and Rideout, *Magnalite Covered Casserole*, ca. 1934
The Wagner Manufacturing Company
aluminum and nickel alloy
8 × 15½ × 8¾ inches
Pamela Heskett

John Gordon Rideout for Van Doren and Rideout, *Magnalite Large Teakettle*, ca. 1933
The Wagner Manufacturing Company
aluminum, nickel alloy, and lacquered wood
8½ × 11 × 10 inches
Toledo Museum of Art, Museum Purchase

Plate 10
Drawing for Magnalite Teakettle as It Appears in Harold Van Doren, Industrial Design: A Practical Guide (New York and London: McGraw-Hill, 1940)
photo panel

Plate 11
Rideout Giftware, Incorporated, *Prototype for Giftware Tray*, ca. 1939
The Wagner Manufacturing Company
Lunite and Andes wood
1 × 17 × 15 inches
Alyce Gordon Rideout

Plate 12
John Gordon Rideout and Staff, *Drawing for Wheelchair*, 1943
Gendron Wheel Company
graphite on tracing paper
11½ × 10 inches
Alyce Gordon Rideout

Plate 13
John Gordon Rideout, *Rendering for Wheelchair*, ca. 1950
Gendron Wheel Company
gouache and white chalk with graphite on cream paper, and gray pulp board
21⅞ × 20¹⁄₁₆ inches
Alyce Gordon Rideout

Plate 14
John Gordon Rideout and Staff, *Maquette for Folding Wheelchair*, ca. 1943
Gendron Wheel Company
wood, rubber, oil cloth, copper, nickel, chrome-plated steel, and aluminum
9 × 9¼ × 6⅛ inches
Frederic W. Strobel, Gendron, Inc.

Heskett
The Emergence of the Industrial Design Profession in the United States

Plate 1
"Selling in a Large Way" as It Appears in Glass Container Division Owens-Illinois Glass Company, Glass Containers, n.d.
photo panel

Plate 2
Dwight Fuerst and Glass Container Division design staff, *Bottle*, 1938
Owens-Illinois Glass Company
glass
16 × dia. 8½ inches
Gary L. Phipps

Plate 3
Donald Deskey, *Drawing for Sportshack*, 1940
gouache, partially airbrushed, stenciled, ink, and graphite on illustration board
21¹⁵⁄₁₆ × 29¹⁵⁄₁₆ inches
Cooper-Hewitt, National Design Museum, Smithsonian Institution/Art Resource, New York, Gift of Donald Deskey, 1988-101-1515

Plate 4
Champion Spark Plug Company

Designer unknown, *Champion Minute Spark Plug Cleaner Box with patented 1913 logo*, n.d.
blue and black lithographic printing on cardboard-bearing paper
6¹¹⁄₁₆ × 2 × 2 inches
Madison Avenue Galleries, Toledo, Ohio

Designer unknown, *Extra Range Spark Plugs 62S Box*, ca. 1936
color screen printing on cardboard-bearing paper
2½ × 6³⁄₁₆ × 3⅝ inches
Federal-Mogul Corporation

Lippincott & Margulies, *Spark Plug Box Containing Six Utility Line Type J-8 Spark Plugs*, ca. 1959
color screen printing on cardboard-bearing paper
exterior package: 2 × 5⅜ × 3½ inches; individual spark plug boxes: ¾ × 3 × 1 inch
Federal-Mogul Corporation

Designer unknown, *C-4 Champion Spark Plug Box with patented 1913 logo*, ca. 1932
blue and black lithographic printing on cardboard-bearing paper
3¹¹⁄₁₆ × 1⁵⁄₁₆ × 1⁵⁄₁₆ inches
Anonymous loan

Designer unknown, *J-18 Champion Spark Plug Box with Patented 1913 logo*, ca. 1932
blue and black lithographic printing on cardboard-bearing paper
3¼ × 1 × 1 inch
Anonymous loan

Plate 5
Lippincott & Margulies: *Champion/Pride and Dedication*, ca. 1980
Champion Spark Plug Company
plastic, metal, and wire
51⅞ × 73½ × 5¾ inches
Federal-Mogul Corporation

Plate 6
Lippincott & Margulies, *Dependable Champion Spark Plugs 1961 Size Chart*, 1961
Champion Spark Plug Company
offset lithography and relief half-tone on paper
¹⁄₁₆ × 11 × 14½ inches
Federal-Mogul Corporation

Plate 7
Tom Geismar for Chermayeff & Geismar Associates Inc., *Corporate Logo: Early Concept Sketches*, ca. 1971
Owens-Illinois, Inc.
felt-tip marker on blue lined paper
10¹⁵⁄₁₆ × 8⅜ inches
© Chermayeff & Geismar Inc.

Plate 8
Tom Geismar for Chermayeff & Geismar Associates Inc., *Corporate Logo: Ideas Being Developed*, ca. 1971
Owens-Illinois, Inc.
felt-tip marker with black ink on tracing paper
9¹⁄₁₆ × 11¹⁵⁄₁₆ inches
© Chermayeff & Geismar Inc.

Plate 9
Tom Geismar for Chermayeff & Geismar Associates Inc., *Corporate Logo: Ideas Being Developed*, ca. 1971
Owens-Illinois, Inc.
felt-tip marker, black ink, and graphite on tracing paper
8¹⁵⁄₁₆ × 11⅞ inches
© Chermayeff & Geismar Inc.

Plate 10
Tom Geismar for Chermayeff & Geismar Associates Inc., *Corporate Logo: Development of Final Logo*, ca. 1971
Owens-Illinois, Inc.
felt-tip marker with black ink on tracing paper
8¹⁵⁄₁₆ × 11¾ inches
© Chermayeff & Geismar Inc.

Plate 11
Usages of Owens-Illinois Corporate Identity Program, n.d.
photo panel

Abramovitz-Harris-Kingsland, architects, *Model for Owens-Illinois Headquarters Building (detail)*, Toledo, Ohio, 1982
photo panel

Plate 12
Gary McNatton, *Calphalon Arrondi Kettle*, ca. 1988
Commercial Aluminum Cookware Company
aluminum
9¾ × 9⅛ × 6 inches
Sara Jane and Bill DeHoff

Paul Angelo LoGiudice, *Commercial Hard-Anodized 10" Omelette Pan*, 1997
Calphalon Corporation
aluminum and stainless steel
3 × 18¹⁄₁₆ × 10¹¹⁄₁₆ inches
Calphalon Corporation

Meikle
The Midwestern City and the American Industrial Design Aesthetic

Plate 1
Van Doren and Rideout, *Skippy-Racer Scooter*, patented 1933
The American National Company
metal, wood, rubber, and paint
31¾ × 42½ × 5½ inches
Frederic W. Strobel, Gendron, Inc.

Plate 2
Van Doren and Rideout, *Skippy Sno-Plane Sled*, patented 1934
The American National Company
metal, wood, rubber, chrome plate, and paint
7⅛ × 43 × 25 inches
Frederic W. Strobel, Gendron, Inc.

Plate 3
John Gordon Rideout for Van Doren and Rideout, *Skippy Stream Line Racer*, patented 1934
The American National Company
metal, rubber, nickel plate, and paint
24½ × 40¼ × 16 inches
Frederic W. Strobel, Gendron, Inc.

Plate 4
Van Doren and Rideout
The American National Company

Streamline Velocipede, patented 1935
metal, nickel plate, rubber, and paint
29 × 40 × 18½ inches
Steve and Glenda Castelli

Pioneer Streamlined Tot Bike, patented 1935
steel, nickel plate, rubber, and paint
15½ × 21½ × 11 inches
Rick Bugner Collection

Plate 5
Van Doren and Rideout, *Atomizer*, 1932
The DeVilbiss Company
opaque white glass, metal, enamel, and rubber bulb with textile
3⅞ × 2½ × 1⅛ inches
Alyce Gordon Rideout

Plate 6
Van Doren and Rideout
The DeVilbiss Company

Box for Silver Crackle Glass Ginger Jar with Atomizer, 1932
metallic and color printing on cardboard with paper
5¼ × 4⅜ × 3¹¹⁄₁₆ inches

Perfume Atomizer Box, 1932
metallic and color printing on cardboard with paper
3½ × 2⅜ × 2½ inches

James Fuller

Plate 7
Van Doren and Rideout, *Air-King Midget Radio*, 1933
Air-King Products Company, Inc.
Plaskon, metal, and glass
11¾ × 8⅞ × 7½ inches
Brooklyn Museum of Art, New York, Purchased with funds given by The Walter Foundation, 85.9

Plate 8
Orwell Reeves, *Engineering Drawing for Sentinel Duplex Scale*, ca. 1934
Toledo Scale Company
pen and black india ink with graphite on linen
35¼ × 62 inches
Collection of Jim Clemens

Plate 9
Harold Van Doren & Associates with Thomas R. Smith (engineer), *Washer Model E*, patented 1939
The Maytag Company
metal, enamel, plastic, and rubber
44¼ × 38¾ × 26 inches
Anonymous loan

Plate 10
Van Doren and Rideout, *Wayne Pump*, ca. 1934
The Wayne Pump Company
metal, glass, chrome plate, and paint
72 × 24 × 18 inches
Ron Scobie

Plate 11
J. M. Little and Associates, Axelson Lathe, 1959, U.S. Industries, Inc., Chicago
photo panel

Plate 12
J. M. Little and Associates, *Industrial Dial Scale*, ca. 1960
Toledo Scale Company
painted steel, glass, aluminum, and nonferrous metal
67 × 25 × 29 inches
Peter Kern

Plate 13
J. M. Little and Associates, *Clevite Brush Head-phones,* 1961
Clevite Corporation
metal, steel wire, vinyl, polyurethane foam, and Velcro
7½ × 9⅞ × 2¼ inches
Erich Roeck

Plate 14
Donald Dailey for Harold Van Doren & Associates, *Electric Iron,* ca. 1940
Westinghouse Electric Manufacturing Company
metal and Bakelite
4½ × 9 × 4⅜ inches
Larry and Susann Spilkin

Plate 15
Sundberg-Ferar, Inc.
The DeVilbiss Company

Air Compressor, patented 1948
painted steel and copper wire
12 × 11¼ × 7⅜ inches

Spray Gun with Coil, 1945
spray gun: aluminum, zinc, and chrome plating;
coil: rubber, fiber, and steel
spray gun: 9½ × 6½ × 4 inches

Chuck Crandall

Plate 16
Sundberg-Ferar, Inc., *Air Compressor,* patented 1940
The DeVilbiss Company
painted steel and copper wire
12 × 14 × 8 inches
John C. Waddell

Plate 17
Carl W. Sundberg for Sundberg-Ferar, Inc., *Triangular Crystal Atomizer,* patented 1952
The DeVilbiss Company
glass, enamel, plastic, and rubber bulb with textile
3¾ × 2⅝ × 1½ inches
James Fuller

Plate 18
Sundberg-Ferar, Inc., J. B. Schmitt, and Frederic Vuillemenot
The DeVilbiss Company

Electric Steam Vaporizer, 1947
Bakelite
7⅝ × dia. 4 inches

Electric Steam Vaporizer, 1947
Bakelite
8 × dia. 4 inches

Anonymous loan

Plate 19
Reinecke Associates, *DeVilbiss Perfumizer,* 1948
The DeVilbiss Company
plastic, glass, and elastic ribbon
2⅜ × 3¾ × 3¾ inches
Connie Cuyler

Plate 20
Eero Saarinen for Eero Saarinen and Associates, *Pedestal or Tulip Armless Chair,* 1957
Knoll Associates, Inc.
Fiberglas-reinforced plastic, aluminum, and upholstery
32 × 19½ × 21 inches
Cranbrook Art Museum, Bloomfield Hills, Michigan

Plate 21
Russel Wright, *Preliminary Sketches for Calvert Reserve Special Gift Decanter,* 1955
Calvert Distillers Corporation
graphite on paper
10 × 8 inches
Department of Special Collections, Syracuse University Library, Syracuse, New York

Plate 22
Russel Wright
Calvert Distillers Corporation

Drawing for Calvert Reserve Special Gift Decanter, 1955
graphite, colored pencil, and chalk on paper
11¾ × 9⅛ inches

Drawing for Calvert Reserve Special Gift Decanter, 1955
graphite, colored pencil, and chalk on paper
11⅞ × 4⅝ inches

Department of Special Collections, Syracuse University Library, Syracuse, New York

Plate 23
Russel Wright
Calvert Distillers Corporation

Plaster Model for Calvert Reserve Special Gift Decanter, 1955
plaster and paint
12 × dia. 3 inches

Calvert Reserve Special Gift Decanter, 1955
glass, chromed plastic, paper, and textile
11⅞ × dia. 3¾ inches

Department of Special Collections, Syracuse University Library, Syracuse, New York

Plate 24
Russel Wright, *Artwork for Labels for Calvert Reserve Special Gift Decanter,* 1955
Calvert Distillers Corporation
colored papers, gelatins, foils, and textiles with ink, gouache, and graphite
various dimensions
Department of Special Collections, Syracuse University Library, Syracuse, New York

Porter
Toledo Wheels: The Design Story of Willys-Overland, the Jeep, and the Rise of the SUV

Plate 1
Amos Northup and Willys-Overland Company design staff, *Willys-Knight Model 66B, Plaidside Roadster,* 1930
Willys-Overland Company with Griswold Motor and Body Company
Joe and Rose Marie Lucks

Plate 2
Amos Northup and Murray Corporation of America design staff, *Willys Model 37 Coupe,* 1937
Willys-Overland Motors, Inc.
Mike O'Connor

Plate 3
Delmar Roos (engineer) and Willys-Overland Motors, Inc., engineering staff, *Jeep Military, Model MB,* 1941
Willys-Overland Motors, Inc.
Walter P. Chrysler Museum, Auburn Hills, Michigan

Plate 4
Esther Trattner, *Rendering for a Sportscar Proposal Based upon the Jeep Chassis,* ca. 1946
Willys-Overland Motors, Inc.
colored crayon with graphite on tracing paper and tape
8¼ × 10½ inches
Shelly Hirsch Schaefer and Lynne Hirsch Gaines

Plate 5
Esther Trattner, *Rendering of 1948 Jeepster Designed by Brooks Stevens,* ca. 1946
Willys-Overland Motors, Inc.
gouache on black medium-weight paper
9⁹⁄₁₆ × 14⅜ inches
Shelly Hirsch Schaefer and Lynne Hirsch Gaines

Plate 6
Robert Andrews, Arthur Kibiger under Delmar Roos (engineer), and Brooks Stevens, *Jeep Station Wagon, 4WD,* 1949
Willys-Overland Motors, Inc.
Walter P. Chrysler Museum, Auburn Hills, Michigan

Plate 7
Robert Nixon (exterior), Vincent Geraci (interior), and American Motors Corporation design staff under Richard Teague, *Jeep Cherokee XJ, 4 Door Sport Utility Vehicle,* 1984
American Motors Corporation
Walter P. Chrysler Museum, Auburn Hills, Michigan

Meikle
Weighing the Difference: Industrial Design at the Toledo Scale Company, 1925–50

Plate 1
Halvor O. Hem, *Engineering Drawing for the Person Weigher Model 8300,* 1928
Toledo Scale Company
pen and black india ink with graphite on linen
80 × 35½ inches
Collection of Jim Clemens

Plate 2
Orwell Reeves and George Frye, *Toledo Official Athletic Scale, Coin-Operated,* 1930
Toledo Scale Company
enameled steel, glass, nickel plate, cement, and brass
71 × 16¾ × 31 inches
The Christopher K. Steele American Coin-Operated Weighing Machine Collection

Plate 3
Designer unknown, *Cylinder Scale, 1928*
Toledo Scale Company
cast iron, porcelain enamel, aluminum, nickel-plated
steel, copper alloys, and glass
24¾ × 18 × 22¾ inches
Mettler-Toledo, Inc.

Plate 4
Norman Bel Geddes with Al Leidenfrost, *Rendering
for Island Scale,* 1929
Toledo Scale Company
graphite on paper
8⅜ × 10¾ inches
The Norman Bel Geddes Collection, The Performing
Arts Collection, Harry Ransom Humanities Research
Center, The University of Texas at Austin, by permis-
sion of Edith Lutyens Bel Geddes, Executrix

Plate 5
Norman Bel Geddes, *Rendering for Scale,* 1929
Toledo Scale Company
graphite on paper
10⅞ × 8⅜ inches
The Norman Bel Geddes Collection, The Performing
Arts Collection, Harry Ransom Humanities Research
Center, The University of Texas at Austin, by permis-
sion of Edith Lutyens Bel Geddes, Executrix

Plate 6
Norman Bel Geddes with Al Leidenfrost, *Rendering
for Counter Scale,* 1929
Toledo Scale Company
ink and watercolor on board
10 × 4⅝ inches
The Norman Bel Geddes Collection, The Performing
Arts Collection, Harry Ransom Humanities Research
Center, The University of Texas at Austin, by permis-
sion of Edith Lutyens Bel Geddes, Executrix

Plate 7
Norman Bel Geddes with Al Leidenfrost, *Rendering
for Counter Scale,* 1929
Toledo Scale Company
graphite on paper
10¾ × 8⅜ inches
The Norman Bel Geddes Collection, The Performing
Arts Collection, Harry Ransom Humanities Research
Center, The University of Texas at Austin, by permis-
sion of Edith Lutyens Bel Geddes, Executrix

Plate 8
Norman Bel Geddes, *Rendering for the Factory:
Precision Devices Group,* 1929
Toledo Scale Company
charcoal on paper
16 × 21 inches
The Norman Bel Geddes Collection, The Performing
Arts Collection, Harry Ransom Humanities Research
Center, The University of Texas at Austin, by permis-
sion of Edith Lutyens Bel Geddes, Executrix

Plate 9
Norman Bel Geddes, *Rendering for the Main
Entrance to the Factory,* 1929
Toledo Scale Company
charcoal on paper
16½ × 25½ inches
The Norman Bel Geddes Collection, The Performing
Arts Collection, Harry Ransom Humanities Research
Center, The University of Texas at Austin, by permis-
sion of Edith Lutyens Bel Geddes, Executrix

Plate 10
Edwin W. Fuerst, *Cocktail Shaker,* patented 1935,
with Tumblers, ca. 1936
Owens-Illinois Glass Company
shaker: glass and Plaskon; tumblers: glass and
enamel
shaker: 32¼ × dia. 3½ inches; tumblers: 3½ ×
dia. 2⅛ inches
Larry and Susann Spilkin

Plate 11
Edward Hoffman, *SWINGLINE® Electro-Pointer
Pencil Sharpener,* 1941
Triple "E" Products Company
Plaskon and Bakelite
9 × 8 × 3⅝ inches
Rick Bugner Collection

Plate 12
Van Doren and Rideout, *Stemware,* ca. 1933
The National Silver Company
Plaskon and plated metal
two water: 6¾ × dia. 3¼ inches; wine: 4⅜ ×
dia. 3⅛ inches
Larry and Susann Spilkin

Plate 13
Van Doren and Rideout
Toledo Scale Company

Toledo Public Health Scale, Coin-Operated, 1931
chromium plate, iron, porcelain enamel on steel,
paint, tile, and glass
42½ × 12½ × 22¾ inches

Toledo Public Health Scale, Coin-Operated, 1931
chromium plate, iron, porcelain enamel on steel,
paint, tile, and glass
42½ × 12½ × 22¾ inches

The Christopher K. Steele American Coin-Operated
Weighing Machine Collection

Plate 14
Van Doren and Rideout, *Toledo Public Health Scale,
Coin-Operated,* 1931
Toledo Scale Company
iron, porcelain enamel on steel, paint, concrete, and
glass
42½ × 12½ × 22¾ inches
The Christopher K. Steele American Coin-Operated
Weighing Machine Collection

Plate 15
Van Doren and Rideout, *Sentinel Duplex Scale,*
patented 1934
Toledo Scale Company
Plaskon, aluminum, glass, enameled steel, and
Bakelite
15½ × 17¹⁵⁄₁₆ × 14⅝ inches
The Mitchell Wolfson, Jr. Collection, The Wolfsonian-
Florida International University, Miami Beach

Plate 16
Harold Van Doren & Associates, *Guardian Duplex
Scale,* 1938
Toledo Scale Company
Plaskon, aluminum, enameled steel, and glass
20¾ × 17½ × 22 inches
The Mitchell Wolfson, Jr. Collection, The Wolfsonian-
Florida International University, Miami Beach

Plate 17
Harold Van Doren & Associates, *Speedweigh Scale,*
ca. 1939
Toledo Scale Company
polished aluminum and glass
15¹³⁄₁₆ × 6⅞ × 19½ inches
Anonymous loan

Plate 18
*"Eleven Stages in the Development of a Cylinder
Scale for Retail Store," Plates 16 and 17, in Harold
Van Doren,* Industrial Design: A Practical Guide
(New York and London: McGraw-Hill, 1940)
photo panel

Plate 19
J. M. Little and Associates, *Toledo Guardian 70
Duplex Scale,* 1948
Toledo Scale Company
Plaskon, aluminum, glass, and rubber
20¾ × 17¾ × 22 inches
Shorling's Market/Robert Anteau

Plate 20
F. E. Huss for J. M. Little and Associates, *Drawing for
Medallion for Plastic Duplex Scale,* 1946
Toledo Scale Company
pen and black ink, white correcting fluid, blue crayon
on rag card, and paper
9⅛ × 12¼ inches
Larry Markin

Taragin
Breaking Patterns: Libbey Glass in the Twentieth Century

Plate 1
*Libbey Glass Company Display, 1904 Louisiana
Purchase Exposition, St. Louis*
photo panel

Plate 2
Designer unknown, *Table,* 1902
Libbey Glass Company
glass
31⅜ × dia. 27⅝ inches
Toledo Museum of Art, Gift of Owens-Illinois Glass
Company

Plate 3
Designer unknown, *Safedge Bell Fountain Pattern,*
ca. 1928
The Libbey Glass Manufacturing Company
glass
soda: 5⅛ × dia. 3 inches; tumbler: 3⅞ ×
dia. 2⅝ inches
Libbey Glass Inc.

Toledo Museum School of Design, *Governor
Clinton Pattern,* ca. 1930
The Libbey Glass Manufacturing Company
glass
largest tumbler: 5¼ × dia. 2¾ inches; juice
(smallest): 3¾ × dia. 2¹⁄₁₆ inches
Libbey Glass Inc.

Plate 4
Libbey Studios, *Shape Drawing for Six-Inch Candle
Stick,* 1933
The Libbey Glass Manufacturing Company
graphite on tracing paper
11 × 8¼ inches
Libbey Glass Inc.

Plate 5
Libbey Studios, *Silhouette Pattern*, 1933
The Libbey Glass Manufacturing Company
glass
candlesticks: 5¼ × dia. 3¾ inches; claret: 5⁵⁄₁₆ ×
dia. 2⅛ inches; compote: 7 × dia. 5⅞ inches;
cocktail: 6 × dia. 2⅝ inches
Ruth and Bill Stewart

Plate 6
Libbey Studios, *Syncopation Pattern*, patented 1932
The Libbey Glass Manufacturing Company
glass
cocktail: 3¹³⁄₁₆ × 2¾ × 2⅜ inches
Toledo Museum of Art, Purchased with funds from
the Libbey Endowment, Gift of Edward Drummond
Libbey

Plate 7
Donald Deskey, *Shape Drawing for 6 oz. Saucer
Champagne*, 1934
The Libbey Glass Manufacturing Company
graphite on paper
11³⁄₁₆ × 8½ inches
Libbey Glass Inc.

Plate 8
Edwin W. Fuerst, *Greenbrier Pattern*, ca. 1938
Libbey Glass Company, subsidiary of Owens-Illinois
Glass Company
glass
wine: 4½ × dia. 2⅞ inches
Karen S. Laborde

Plate 9
Edwin W. Fuerst, *Vase*, patented 1940
Libbey Glass Company, subsidiary of Owens-Illinois
Glass Company
glass
10 × 5 inches
Toledo Museum of Art, Gift of Libbey Glass Company

Walter Dorwin Teague and Edwin W. Fuerst,
Monticello Pattern, 1940
Libbey Glass Company, subsidiary of Owens-Illinois
Glass Company
glass
wine: 7¹⁄₁₆ × dia. 2¹¹⁄₁₆ inches; cocktail: 7¹⁄₁₆ ×
dia. 4⁹⁄₁₆ inches
Toledo Museum of Art, Gift of Libbey Glass Company

Libbey Studios, *Knickerbocker Pattern*, ca. 1932
The Libbey Glass Manufacturing Company
glass
sherbet: 2½ × dia. 4⅜ inches
Toledo Museum of Art, Gift of Libbey Glass Company

Edwin W. Fuerst, *Cordial Decanter*, 1940
Libbey Glass Company, subsidiary of Owens-Illinois
Glass Company
glass
11⅜ × dia. 4 inches
Toledo Museum of Art, Gift of Libbey Glass Company

Libbey Studios, *Knickerbocker Pattern*, ca. 1932
The Libbey Glass Manufacturing Company
glass
cordial: 2⁵⁄₁₆ × dia. 2 inches; tumbler: 4⅞ ×
dia. 3¹⁄₁₆ inches
Toledo Museum of Art, Gift of Libbey Glass Company

Plate 10
Insulux Products Division design staff, *Insulux
Glass Block*, 1937
Owens-Illinois Glass Company
glass and metal
11¾ × 11¾ × 3⅞ inches
From the Collection of Derek Trelstad

Plate 11
Attributed to Walter Dorwin Teague, *Circon Pattern
Insulux Glass Block Used in the Coral Court Motel,
St. Louis*, ca. 1939
Owens-Illinois Glass Company
glass
7¾ × 7¾ × 3⅞ inches
Museum of Transportation, St. Louis, 95.10

Plate 12
Walter Dorwin Teague, *Drawing for Tumbler and
Stemware*, ca. 1939
Libbey Glass Company, subsidiary of Owens-Illinois
Glass Company
graphite on tissue
16¹³⁄₁₆ × 13¾ inches
Department of Special Collections, Syracuse
University Library, Syracuse, New York

Plate 13
Walter Dorwin Teague and Edwin W. Fuerst,
The Embassy Pattern, 1939
Libbey Glass Company, subsidiary of Owens-Illinois
Glass Company
glass
parfait: 8⅜ × dia. 2⅝ inches; cocktail: 6⅞ ×
dia. 2¹¹⁄₁₆ inches
Toledo Museum of Art, Gift of Owens-Illinois, Inc.

Plate 14
Freda Diamond
Libbey Glass, Division of Owens-Illinois Glass
Company

Stardust Pattern, ca. 1947
glass
cocktail: 6 × dia. 4⅛ inches

Classic Emerald Pattern, ca. 1948
glass
toddler: 3⅜ × dia. 3¼ inches; juice: 3½ ×
dia. 2⅝ inches

Libbey Glass Inc.

Belle Kogan, *Victoria Pattern Sample*, patented 1958
Libbey Safedge, Division of Owens-Illinois, Inc.
glass
ice bucket: 6 × dia. 6 inches
Libbey Glass Inc.

Plate 15
Freda Diamond, *Nob Hill Pattern*, 1963
Libbey Glass, Division of Owens-Illinois, Inc.
glass
highballs: 5 × dia. 2¾ inches; 4⅛ × dia. 2⅜ inches
Libbey Glass Inc.

Plate 16
Advertisement for Libbey Emerald Glass, Life,
June 26, 1950
offset printing
Anonymous loan

Plate 17
Advertisement for Stardust Stemware, House
Beautiful, December 1949
offset printing
Anonymous loan

Plate 18
Freda Diamond, *Libbey Every-Day Crystal Hostess
Set Box*, ca. 1955, *with Eight Golden Foliage Pattern
Beverage Tumblers*, 1956–57
Libbey Glass, Division of Owens-Illinois, Inc.
box: green and gold printing on coated paper
over cardboard; eight tumblers: glass and enamel
box, closed: 3⅛ × 12¾ × 10 inches; tumblers:
4¾ × dia. 3 inches
Anonymous loan

Plate 19
Freda Diamond, *Golden Leaves Pattern*, July 2, 1957
Libbey Glass, Division of Owens-Illinois, Inc.
black felt-tip pen, black ink stamp, gouache on
acetate, mounted on tracing paper
acetate: 4⅝ × 10⅝ inches; tracing paper: 8¾ ×
11 inches
Libbey Glass Inc.

Plate 20
*Worker Applying Satin Etch Background to Golden
Foliage Tumbler*, n.d.
photo panel

Plate 21
New Products Development Group, *Gibraltar
Pattern*, 1977
Libbey Glass, Division of Owens-Illinois, Inc.
wood and enamel paint model; Lucite acrylic model;
glass
wood model: 5 × dia. 3¼ inches; Lucite acrylic
model: 4⅜ × dia. 3 inches; rocks glass: 4⅛ ×
dia. 3¹¹⁄₁₆ inches
Libbey Glass Inc.

Plate 22
Designer unknown, *Floor Lamp*, 1904
Libbey Glass Company
glass and metal
57¾ × dia. 16¾ inches
Toledo Museum of Art, Gift of Owens-Illinois Glass
Company

Matranga
Clear as Glass: The Libbey-Owens-Ford Window to Better Living

Plate 1
Harley Earl and General Motors design staff,
Chevrolet Corvette, 1953
Chevrolet Motor Division, General Motors
Corporation
White Family Companies, Inc.

Plate 2
Gilbert Rohde, *Coffee Table*, 1939
The Herman Miller Furniture Company
plate glass, brass, Lucite acrylic, and plating
15⅞ × dia. 33¹⁵⁄₁₆ inches
William H. Straus

Plate 3
Owens-Illinois Building at "A Century of Progress Exposition," 1933–34
photo panel

Plate 4
Alfred S. Alschuler, Inc., for R. N. Friedman-E. A. Renwick Associates, *Alterations to Building for Kitty Kelly Shoes, Chicago, Illinois, Front Elevation and Section Through Front,* 1937
ink and graphite on linen
26 × 41¼ inches
Chicago Historical Society, 1980.311

Plate 5
Bruce Alonzo Goff, *Glass Blocks and Vitrolite House,* 1936
Libbey-Owens-Ford Glass Company
colored paint and ink on black construction paper
20 × 25½ inches
The Art Institute of Chicago, Gift of Shin'enKan, Inc., 1990.868

Plate 6
Bruce Alonzo Goff, *Ice Cream Parlor Alterations: Vitrolite Design,* 1937
Libbey-Owens-Ford Glass Company
colored pencil, ink, watercolor, gouache, and graphite on paper
22⅝ × 37⅛ inches
The Art Institute of Chicago, Gift of Shin'enKan, Inc., 1990.905

Plate 7
Designer unknown, *Restaurants That Win! Brochure,* ca. 1937–38
Libbey-Owens-Ford Glass Company
color printing with black and white photos on paper
11 × 8½ inches
Ward M. Canaday Center for Special Collections, University of Toledo, Toledo, Ohio

Plate 8
Bruce Alonzo Goff, *R. A. Stranahan Taproom Alterations: Vitrolite Design,* 1937
Libbey-Owens-Ford Glass Company
colored pencil, pastel or chalk, ink and/or watercolor, gouache, and graphite on lineprint paper
20 × 29¼ inches
The Art Institute of Chicago, Gift of Shin'enKan, Inc., 1990.906

Plate 9
Bruce Alonzo Goff, *D. H. Goodwillie Bathroom Alterations: Vitrolite Design,* 1937
Libbey-Owens-Ford Glass Company
colored pencil, pastel or chalk, ink, watercolor, gouache, and graphite on lineprint paper
25½ × 33⅝ inches
The Art Institute of Chicago, Gift of Shin'enKan, Inc., 1990.904

Plate 10
Libbey-Owens-Ford Glass Company Department of Design, *Visual Fronts Brochure,* 1945
Libbey-Owens-Ford Glass Company
black and white printing on paper with paper cover
8¾ × 11½ inches
Ward M. Canaday Center for Special Collections, University of Toledo, Toledo, Ohio

Plates 11–15
H. Creston Doner and Libbey-Owens-Ford Glass Company Department of Design, The Kitchen of Tomorrow, 1942
photo panels

Plate 16
Designer unknown, *Your Solar House Booklet,* 1947
Libbey-Owens-Ford Glass Company
color-printed paper covers and black and white printing for text and illustrations on paper
13⅛ × 9¾ inches
Anonymous loan

Plate 17
Skidmore, Owings & Merrill, New York, architects, Libbey-Owens-Ford Glass Company Corporate Headquarters, 1960
photo panel

Biographies of the Designers

Plate 1
D. Benjamin Replogle, *Air-Way Sanitizor 55A,* 1938
Air-Way Electric Appliance Corporation
plated steel, zinc, paint, and fiber
25 × dia. 14 inches
Lucas County/Maumee Valley Historical Society, Maumee, Ohio

Gordon W. Florian, *Air-Way Sanitizor 77,* patented 1948
Air-Way Electric Appliance Corporation
aluminum and steel
22¼ × 9⅞ × 9⅞ inches
Anonymous loan (All rights reserved, The Florian Family Trust)

Plate 2
Air-Way Sanitizor as It Appears in Society of Industrial Designers, U.S. Industrial Design 1949–1950 (New York: The Studio Publications Incorporated, 1949)
photo panel

Plate 3
Stan Fuller for S. E. Fuller/Associates
Owens-Corning Fiberglas Corporation

Concept Study: Compression-molded Fiberglas Motorcycle/Protective Helmet, Introduction, 1980
pen and ink with camera-ready copy on drafting vellum adhered to board and acetate
18 × 24 inches

Concept Study: Compression-molded Fiberglas Motorcycle/Protective Helmet, 2b—Horizontal Joint—thru face opening, 1980
pen and india ink over graphite, Chartpak colorfilm, and camera-ready copy on drafting vellum adhered to board and acetate
18¹⁄₁₆ × 24 inches

Stan Fuller, Designer, S. E. Fuller/Associates

Plate 4
Sherman L. Kelly, *Ice Cream Scoop,* patented 1939
The Zeroll Company
aluminum
1½ × 7 × 1⅝ inches
Anonymous loan

Plate 5
William Pahlmann Associates, *Sales Sample for Prairie Flowers,* 1958
F. Schumacher & Co.
screenprint on Fiberglas fabric
27¼ × 24¾ inches
F. Schumacher & Co., Archives Collection

Plate 6
Merritt Seymour, *Rendering of Residential Tub/Shower with Sheet-Molding Compound Technique,* ca. 1969–70
Owens-Corning Fiberglas Corporation
colored pencil, pastel, black and white chalk, and white gouache on paper
16⅞ × 13⅞ inches
Merritt Seymour

Plate 7
Merritt Seymour with David Tompkins and Keith Kresge of Richardson/Smith Inc., *Time Control Bathroom System—Tub/Shower and Toilet,* ca. 1971
Owens-Corning Fiberglas Corporation
felt-tip pen and colored pencil with graphite on paper
18 × 24 inches
Merritt Seymour

Plate 8
Merritt Seymour with David Tompkins and Keith Kresge of Richardson/Smith Inc., *Time Control Bathroom System—Vanity,* ca. 1971
Owens-Corning Fiberglas Corporation
felt-tip pen and colored pencil with graphite on paper
18 × 24 inches
Merritt Seymour

Plate 9
Merritt Seymour, *Stand-Up Whirlpool,* 1986
Owens-Corning Fiberglas Corporation
graphite on translucent paper
16⅞ × 14¹⁄₁₆ inches
Merritt Seymour

INDEX

225

Photography Credits and Permissions